Skyscraper Façade
of the Gilded Age

Skyscraper Façades of the Gilded Age

Fifty-One Extravagant Designs, 1875–1910

Joseph J. Korom, Jr.

McFarland & Company, Inc., Publishers
Jefferson, North Carolina, and London

LIBRARY OF CONGRESS CATALOGUING-IN-PUBLICATION DATA

Korom, Joseph J.
Skyscraper façades of the Gilded Age : fifty-one extravagant
designs, 1875–1910 / Joseph J. Korom, Jr.
p. cm.
Includes bibliographical references and index.

ISBN 978-0-7864-7072-3
softcover : acid free paper ∞

1. Façades — United States. 2. Skyscrapers — United States — History —19th century.
3. Skyscrapers — United States — History — 20th century.
4. Decoration and ornament, Architectural — United States — History —19th century.
5. Decoration and ornament, Architectural — United States — History — 20th century.
6. Architecture and society — United States — History —19th century.
7. Architecture and society — United States — History — 20th century. I. Title.
NA2941.K67 2013 720'.4830973 — dc23 2012050542

BRITISH LIBRARY CATALOGUING DATA ARE AVAILABLE

On the cover: Flat Iron Building, New York, New York,
Detroit Publishing Co., 1908 (Library of Congress)

Manufactured in the United States of America

*McFarland & Company, Inc., Publishers
Box 611, Jefferson, North Carolina 28640
www.mcfarlandpub.com*

Table of Contents

Preface

Architecture, by its simplest definition, is the art and science of building. I believe that architecture is so much more, of course, and I am convinced that architecture is also a superb intellectual discipline. I have felt passionate about it for some 40 years.

After graduating from the School of Architecture at the University of Wisconsin-Milwaukee with a Master of Architecture degree in hand, I had the good fortune to be employed at a number of accomplished design firms, after which I opened my own architecture office. I always stressed to the students I mentored at the school and, later, to my employees, that the final design on their drawing boards was only equally important as the *process* by which they arrived at that final design. I have since wondered to myself if that advice about the process, the path of the struggle, that personal test to come to terms with a myriad of structural, aesthetic, functional, social, and client-based issues, simultaneously had always been meted out to students or interns in the past, to those living, for instance, in the Gilded Age. I do believe that it was.

An architect's exact process of design is almost never evident to the casual viewer of the architect's end product. The final resolution of any architectural design problem has an infinite number of pathways to resolution, hence the variety of resolutions — buildings — that surround us. Those who resided in America's great cities during the Gilded Age were surrounded, just as we are now, by an unbridled variety of building designs.

With a particular interest in skyscrapers, I decided to investigate the relationships between the storied façades of Gilded Age skyscrapers and the history and mythology that we, as a people, bring to a building's design. Was the final product — the scheme that was shown to the client, the one that ultimately got built and which was the result of thousands of man-hours — the very best resolution to that particular design problem? And why did an architect who resided in Chicago, the cradle of modern architecture, include the face of Mercury on the façade of an American skyscraper? Questions like these transformed a casual investigation into the book that you are now holding.

It was with particular delight that I explored the truly preposterous elements found carved upon the walls of early skyscrapers. Bypassing all the really complicated and esoteric mathematical theories involved with traditional façade design — polemics I decided were clearly beyond the scope of this book — I was left with just the quirky components and the overall extravagance foisted upon tall walls.

The path of the struggle, the comprehensive undertaking of the process, is what ultimately can secure an aesthetically successful building. This is what I told my students — subjective though it was — and what was debated by my employees and colleagues. I am convinced that

1

the architect of the skyscraper, a practitioner who embraced different aesthetic values and who enjoyed a unique perspective in time, knew this 120 years ago. This is what this book is about.

Architecture is predicated upon beauty. A newly completed building, especially a skyscraper, is immediately and all too often judged by the public to be either an objectionable or a brilliant design; an ambivalent judgment is rare here in my hometown of Chicago. Some designs stumble while others rise to the occasion and ultimately become timeless things of beauty. In either case, the architect responsible partook in that indomitable struggle, the design process, but to varying degrees of success — again a subjective call. This, too, is what this book is about. And in the final analysis, this book is about questions, doubt, truth, and honesty with architectural accomplishments. After all, and especially in architecture, it is far better to do a good thing badly, than a bad thing well.

Of good things there are many, like those institutions which helped me with this book. During the four years it took to complete this manuscript, some institutions and people unselfishly shared information with me to make this book complete. I would like to thank the staff of the Astor, Lenox and Tilden Foundations of the New York Public Library, the staff of the Byron Collection of the Museum of the City of New York, and the staff at the Ryerson & Burnham Libraries of the Art Institute of Chicago.

A special recognition is reserved for the staffs of the Chicago History Museum, the Missouri History Museum, the Print Archives of the Museum of the City of New York, and the Science, Industry & Business Library of the New York Public Library. Photography specialists at Robert McMahan Photography, of Brooklyn, New York, also deserve heartfelt thanks. I am sincerely grateful to David Bergad, of the Saul Zaentz Company in Berkeley, California, for his understanding and assistance.

A very special "thank you" is due my friend, Wendy Bright. As an art and architectural historian and a person with a keen eye and mind, she correctly challenged some of my thoughts and assumptions as originally penned and revealed to me valuable insights regarding the architecture of medieval Europe and of the Gilded Age.

Finally, I wish to acknowledge and thank my wife, Sandy, for the unrivaled knowledge and expertise she lent to this project. A profound appreciation is reserved for her, whose encouragement, patience, and dedication to me during the years of this project never wavered.

Joseph J. Korom, Jr. • Chicago, Illinois • January 2013

Introduction

Where there is much desire to learn, there of necessity will be much arguing, much writing, many opinions; for opinion in good men is but knowledge in the making.—John Milton (1608–1674), *Areopagitica* (1644), p. 31

Skyscraper Façades of the Gilded Age contains opinions and knowledge, much arguing, extravagant façades, and many missed opportunities. It also discusses American architecture and architects, immigrants and success, history and taste. Dishonesty —financial and artistic — is addressed with regards to the development of the American skyscraper during the last decades of the 19th century and the beginning of the 20th. Much debate ensued in those days. A few contemplative contemporaries argued that, in too many instances, early skyscraper façades failed to participate in a struggle to free themselves from European design and European history; these were not American enough, they insisted. The walls of too many freshly drawn skyscrapers, some people maintained, failed to assert themselves and secure for America the skyscraper's rightful place in the history of world architecture; these failed, some said, to distinguish themselves by exhibiting an appearance that was altogether new, altogether different, and something altogether honest. Some critics demanded that if the skyscraper was indeed a new building type, then why were its façades antique? Much consternation resulted in ripped-up drawings and smashed plaster casts; there was heated debate, but there was also much "knowledge in the making." Contention was the American way.

Skyscraper Façades of the Gilded Age is essentially about tall decorated boxes. Every building is a box; some short, some tall. Every culture builds these "decorated boxes" for myriad reasons, but they all start out as simply ... boxes. What might appear initially as a sophomoric concept — the building as a box — is a rather complex issue. In its most elemental form, every building ever constructed began, unconsciously, as a simple box, a container for goods, for gods, for people; only later are these boxes decorated — adorned according to, and reflecting, a culture's values. Very tall decorated boxes were called skyscrapers, and they were constructed primarily for profit. Exteriors were decorated according to the demands of the building's owner and to the whims of his selected architect. The results were often, but not exclusively, agreeable to the architectural press and to the critics at large, the American public.

The 51 most extravagant skyscrapers completed during America's Gilded Age were carefully selected for study. Those chosen arguably represent the most flamboyant examples of the skyscraper art, those with fanciful towers or prominent domes, and those sporting façades that studiously borrowed from the architecture of Europe and that continent's history. And perhaps

most importantly, inherent in this definition of "extravagant" is the representation of classical mythology on the walls of America's tall business buildings. A host of images, both century-old vignettes and contemporary views, help set the context and explain the motives of Gilded Age artisans. Architecture, often considered the ultimate art form, responded with ostentatious exteriors satiating the country's thirst for an appropriate vehicle for the display of wealth.

Money determined extravagance, and the money a client provided to the project directly dictated the amount of embellishment a client's skyscraper would have. A client who was so inclined would commit vast sums to the skyscraper's façade; sumptuousness said much as an advertising vehicle for quality and good taste. Besides, it also advertised a client's wealth and aesthetic values, and a splendid over-the-top façade went far to promote the accommodations *inside*. It was the opinion of many, then, that architectural ostentation and wealth were inseparable, and it was argued that the skyscraper was the perfect platform from which to further that opinion. Like so many gold watch fobs and carved hat pins, Gilded Age skyscrapers were bedecked by tons of showy, disingenuous stuff.

This book is a modern-day study of century-old façades, of skyscraper walls replete with artistry and craftsmanship, of meaning, and of entertainment. These studied walls served as barriers, containers, and as marketing sign-

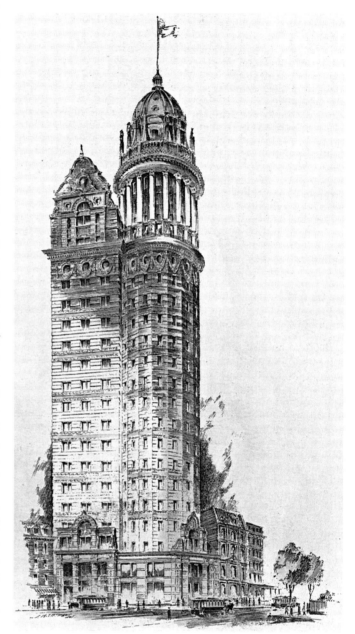

The Gilded Age produced some of the finest examples of architectural extravagance, and skyscrapers were no exception. This 23-story building was designed in the late 1890s by Brooklyn architects Henry Clay Carrel (1869–1915) and J. Graham Glover (b. 1852), and it was entered into a competition sponsored by the *New York Herald* newspaper for their new headquarters. Though this scheme was not selected, its Baroque/Beaux-Arts expressiveness would have added much in the way of an "imperial look" to the already majestic mid–Manhattan skyline ("Competitive Design for the Herald Building, New York, N.Y.," *American Architect and Building News*, No. 1180, August 6, 1898. Image: Heliotype Printing Company, Boston).

boards, and they are worth remembering; their purposes were to keep stuff out, keep stuff in, and to tell stories. This book is about those stories, those visual tales uttered more than a century ago by American architects and artist-craftsmen, people who were seduced and held captive by the allure of the antique and the romantic trappings of Europe and its history.

During the Gilded Age, convention and tradition in architecture demanded a rigorous following of established design principles. This philosophy was nowhere stronger than in the large Eastern cities of America, and it was especially true — even entrenched — in New York. With the dawning of the skyscraper emerged a new and exciting building form with endless artistic possibilities for exploration. New York architects, instead of acting on new aesthetic possibilities, looked to history and European traditions to address the issues of façade development and organization. They employed that which they knew; many of these timid architects designed the 20-story building as ten separate and distinct two-story structures heaped one upon the other. These architects, in their typical zeal for attention and correctness, drew façades filled with ornamentation that once delighted the toga-clad senator, feudal-period landowners, the Medici, and imperial despots who reigned during the 18th century. Most architects consciously chose safety over originality. In short, the Gilded Age was essentially a time of missed opportunities, a period of squandered aesthetic possibilities that overlooked the potential to create anew.

From the inception of the skyscraper, most architects opted to cheat, to shield the public from original modes of artistic expression. This majority stayed the course; they repeated history by repeating the architecture of centuries past. The technology and "progressive" aesthetics existed, but the will was absent except in one place in Illinois, the

Although inspired by the French Baroque, this iteration of the 13-story Albany Trust Company Building was never erected, despite its contemporary appearance. This was a popular style for the Gilded Age, and architect Marcus Tullius Reynolds (1869–1937) unabashedly chose to employ it here. In true classical form, Reynolds shared his name with the accomplished Roman poet, philosopher, and orator Marcus Tullius Cicero (106–43 BCE) (*The Architectural Record*, Vol. xii, no. 4, September 1902).

great city of Chicago. That city was fresh, not beholden to Eastern proprieties or to the traditions of European aristocracy. It was a bold and raucous place, a scrappy city of free-thinkers and innovators without the intellectual bindings and social trappings, without the architectural and artistic traditions prevalent elsewhere. It was in Chicago that the skyscraper façade deviated from the accepted norms and sought its own path, a bold and opinionated new path that celebrated the American spirit as nowhere else.

In many cities, immigrant businessmen, immigrant architects, and immigrant craftsmen, the "tempest-tost" of foreign shores, built these extravagant buildings of the Gilded Age. Their success stories, rife with persistence and luck, are included too. Some skyscraper builders wore two faces, one sincere and one of feigned honesty, and like the buildings they erected, they, too, displayed façade fakery. Like all historic periods, the Gilded Age was one of trickery and insincerity, and as some contemporaries had cited, one of crooks, financial and artistic. One must, as Milton would have certainly espoused, form opinions and participate as "good men" in the pursuit of "knowledge in the making." And, in that sense, the façades of 51 Gilded Age skyscrapers once more await critical examination.

Chapter One

Ways and Means

Architecture is the art which so disposes and adorns the edifices raised by man for whatsoever uses, that the sight of them contributes to his mental health, power and pleasures.[1]—John Ruskin (1819–1900)

The term "Gilded Age" was coined by none other than Mark Twain, one of the period's most beloved and admired novelists. Between pipe puffs and satirical anecdotes, this silver-mustachioed character of mythical Americana managed to produce, with the hand of editor, essayist, and writer Charles Dudley Warner (1829–1900), a piece entitled *The Gilded Age: A Tale of Today*. This novel, a product of 1873, satirized post–Civil War America by focusing on the nation's inequities, polarization, racism, materialism, corruption, and government graft. Various sources have cited the Gilded Age as one that spanned from the 1870s to the year 1900. Others, more persnickety, have pegged the period only from 1878 through 1889. Certainly, considering the novel's contents, any American period could suffice, with special honors given to the here and now. But for the purposes of this study, the Gilded Age's span of years applies to those from 1875 to 1910, since the social norms, personal values, and architectural aesthetics held in 1875 were, by and large, the same as those held in 1910.

The years 1900 through 1910 embraced another period in American history according to some, one that followed on the heels of the Gilded Age and known simply as the Progressive Era. Historical periods are rarely defined by exactitudes,

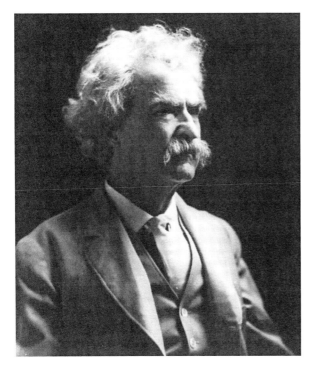

Mark Twain (1835–1910) once observed, "I am opposed to millionaires, but it would be dangerous to offer me the position" (Framingfever).

7

and they are often mercurial in the minds of many with specific dates and movements being most elusive. The Progressive Era, roughly defined as existing between 1900 and 1920, was a period marked by increased cultural enlightenment, social reforms, and the cleaning up of American politics so soiled by graft and corruption. This era was further characterized by reformers such as Presidents Theodore Roosevelt (1858–1919) and Woodrow Wilson (1856–1924) and identified with noted firebrands such as Wisconsin Senator Robert La Follette (1855–1925) and Chicago's preeminent social reformer and activist, Jane Addams (1860–1935). Others, too, championed the rise of labor unions, corporate regulation, women's suffrage, racial equality, and the general uplifting of America's foreign and domestic-born masses. Some even promoted new architectural languages, modes of communication that echoed the virility of the new nation. This new syntax was viewed as downright revolutionary by the architectural establishment and the public.

Besides the apparent negativity offered in Twain's 1873 novel, great things did indeed happen in this country during the period from 1875 to 1910. America's population surged from some 39 million to over 92 million people. There were advances in the human condition, significant gains regarding medicine, food, and drug purity, the advent of unionization and the introduction of the eight-hour work day, the ease and affordability of mass transportation, rapid communication, electrical labor-saving devices, and laws enacted to protect the natural environment. A giant copper statue was raised in New York Harbor, and a colossal ditch was dug in Panama. Motorized flight first occurred in North Carolina, and a phenomenal bridge was erected between Manhattan and Brooklyn. The assembly line appeared in factories everywhere, to the delight of some and to the chagrin of most. Incomes for unskilled and skilled workers increased, and a new middle class dawned. It was, at best, a period of contradictions, a period of strife, a period characteristic of a nation suffering growing pains, and a period which harbored a nation of insecurities in the malaise of its adolescence. America had claimed glorious achievements, significant things for a century-old nation, and still there were problems.

Despite these problems, or perhaps because of them, the Jewish-American poet Emma Lazarus (1849–1887) eloquently composed in her 1883 sonnet, "The New Colossus," the following potent message: "Keep, ancient lands, your storied pomp!" And with that, Lazarus implored other nations to do the following:

> Give me your tired, your poor,
> Your huddled masses yearning to breathe free,
> The wretched refuse of your teeming shore
> Send these, the homeless, tempest-tost to me,
> I lift my lamp beside the golden door!

The concept of a large allegorical figure rising in New York's harbor, only later known as the Statue of Liberty, inspired Lazarus to ask other nations for two things: a sense of American autonomy and the freedom of people to relocate here. America, though, was inextricably tethered to Europe, to its art, architecture, myths, and, ultimately, to its "storied pomp."

During the Gilded Age, Europe's tired, its poor, and its huddled masses poured into America yearning to breathe free and to make as much money as they could. Housing for these many millions of "tempest-tost" was cramped and, in some cases, nonexistent. Native American tribes in the West had untold acres of real estate to themselves, and then suddenly, they did not. Conditions were grim for thousands, but for other Americans a bad day was defined by a lost round of golf.

From 1836 to 1914 and the start of the First World War, some 30 million Europeans found a new home in America. Before 1890, 82 percent of America's immigrant population originated from northern and western Europe, and by 1900, one in five Americans was foreign born. The

year 1907 marked the greatest influx of European immigrants, when almost 1.3 million people decided to leave their "ancient lands." By 1910, almost 14 million immigrants lived here, further defining the Gilded Age as a period of enormous population flux and many inequalities. Most, though — and this is important — remembered the architecture of their native lands.

Money was the "means," and it was not equally distributed. The economics of that period was much like any other with its boom and bust cycles. Economic panics occurred on Wall Street in 1869, 1873, 1893, and in 1907; the 1873 panic required the closing of the New York Stock Exchange for two weeks, while the panic of 1893 was followed by a cruel four-year-long depression. Some rich got richer and some poor got poorer, but some poor became very wealthy. Many rags-to-riches stories were composed during the Gilded Age.

America went to war against Spain in 1898 and won; this and the Open Door Policy in China of 1899 made America a world power, an empire of sorts. From 1875 to 1910, America led the world in applied technology, inventions, and patents. Also during America's Gilded Age, two American presidents would be assassinated, James A. Garfield in 1881 and William McKinley in 1901. Such are the vagaries of empire.

During the period from 1875 to 1910 — the year Mark Twain died — marvelous things were dreamt of in the minds of American architects, and these things were constructed by men with the means, the money, to see them through; invention without cash yields naught. This period in American history saw, for the first time on a large scale, the cooperation between architect and corporate titan, or at least a company owner. Corporate "princes," such as they were, dedicated themselves to erecting large homes for themselves and large homes for the companies they headed. Various technologies provided the structural means to rise skyward, while investors, bankers, and the "princes" themselves provided the means to pay for the privilege of erecting a skyscraper. The Gilded Age was, in many ways, an age of excesses, a golden time for some on the *inside* of Emma Lazarus's "golden door."

Who were these "princes" that changed the financial and urban landscape? There were many wealthy people, many "princes," some quite despicable, who when asked to identify themselves may well have answered in a demonic voice, "My name is Legion, for we are many."[2] There were some with such quantities of cash — much of it ill-gotten — that even the cost of a skyscraper would make only the smallest dent in the silver-lined pockets of these self-styled entrepreneurs. For this time period was also labeled the Age of the Robber Barons.

America's super-rich were thought by many to have amassed their fortunes on the backs of the common man, the millions of factory workers, simple laborers, teenage shop girls, and others. Cries of economic exploitation and political corruption were voiced by many who lived and toiled for meager salaries. Observers and, later, reformers cited staggering inequities in income and personal wealth between the classes. In 1890, for example, it was reported that of America's 12 million families, 11 million of them had an annual income of less than $1,200. And of these families, the yearly take-home total averaged a paltry $380. By contrast, a few dozen industrialists and financiers had accumulated such immense fortunes that some "robber barons" on average made more money per hour than one of their employees would earn in three years.

Many, especially those in the press, concluded, and with good reason, that blue-collar workers, farmers, and overworked factory children held no monopoly on being exploited. Most folks seemed to know that many millionaire speculators and industrialist titans bamboozled, hornswoggled, and blatantly hoodwinked their own ranks as well. Unscrupulous millionaire "princes" were convinced that, by eliminating the competition, by driving their rivals into bankruptcy, and by undermining the markets — any markets — their own financial station in life would improve. Sometimes it did. The wealthy got wealthier while their underhanded schemes were, simultaneously, considered legal by themselves and wholly immoral by everyone else. There

may have been many of them, but their numbers were minuscule when compared to the melting-pot-masses they lorded over. It was in 1871 that our mustachioed muse Mark Twain asked:

> What is the chief end of man?— to get rich. In what way?— dishonestly if we can; honestly if we must.

Because of the rampant dishonesty involved with the stock markets, the bond markets, the metal markets, mineral speculations, real estate ventures, and almost every other vehicle used to make a buck, there were attempts to clean up and to regulate the methods and the madness involved in the pursuit of wealth. For the most part, the public was wise to the chicanery involved with investments, especially when playing with the "big boys," those with really fat wallets. It seemed that crooks were every place there was the opportunity to quickly and dramatically increase a person's net worth, and yet they — the public — knowingly came. Men and women with their few hard-earned dollars lined up to be fleeced. Still, and for the great majority, the public had no real hard cash to sacrifice; just providing tonight's dinner was chancy enough. But there were always some who were willing to take the risk.

Wall Street was then controlled by a small group, perhaps a few dozen, of very wealthy businessmen. Any one of these, if he controlled enough cash and was crooked, could single-handedly drive up the value of a stock; then, when that stock was perceived to be at its greatest value, sell it and make a killing. Through rumor, innuendo, and secret arrangements with others, these unscrupulous types would buy, then sell, the same stock and repeat the process. Over time the stock would draw attention to itself, and its value would rise as others were suckered into purchasing it. At a prearranged price point the stock would be dumped, and inflated profits were taken by the original buyers. Of course, those still holding the stock had nothing more than a pile of worthless paper. *Voila*, stock manipulation. The ways and the means were many.

One attempt at improving at least the perception of the speculation game occurred in Chicago in the early part of 1896. The recently completed (1894) Chicago headquarters of the New York Life Insurance Company was only partially occupied by that firm.[3] The rest was to be leased to various tenants, one of which was the newly formed Chicago Mineral and Mining Exchange.

In January of 1896, the exchange opened in the "rooms on the banking floor of the New York Life Building, directly in the rear of those occupied by the National Bank of the Republic."[4] This press release further states the purpose of this organization and one important, self-imposed, safeguard:

> The objects for which the Chicago mineral and mining board was organized are to provide facilities for dealing in the stocks and bonds of corporations which are in any manner engaged in the development of the mineral resources of the country, and also for bringing into immediate contact and intimate relations those who have mineral properties to sell or develop with those who have capital which they wish to invest in such properties. *The by-laws of the organization are carefully drawn, with a view to protecting the public against fraud and imposition in dealing in properties and securities.*[5]

Exactly how these by-laws read and their effectiveness "against fraud and imposition" is unclear. But an attempt was made to ameliorate what was, by any measure, a national embarrassment.

The day after the exchange's opening, the following article was published reporting that fact and summarizing the comments made by the board president:

> President John Warder delivered an address, explaining that the board would not be limited to dealing in gold and silver stocks and properties, but would extend its facilities to all valuable minerals. It would be the aim of the board to bring the dormant mining interests of the country into a vitalized activity. He regarded mining as *a perfectly legitimate business, not beneath the highest standard of banking, manufacturing or merchandising.* Many notable mining men from the western fields were

present. A rush of applications for listing is expected from the west, but all will have to pass a rigid examination.[6]

Many, then, would have said the ethical standards of "banking, manufacturing or merchandising" could not have gone beneath what they already were. Still, the exchange's board president was obliged to say something profound and memorable on such a day. It is evident he attempted to allay the fears of the investing public with regards to the organization he headed and insisted that it was indeed "perfectly legitimate."

The list of these super-rich individuals includes the names now more commonly associated with foundations, museums, and libraries; yes, for some of these men their later contributions and bequests were also legion. The king of the Gilded Age was unquestionably John D. Rockefeller (1839–1937). He was far and away the wealthiest of them all, amassing a fortune worth $1.4 billion dollars, America's first *billionaire*. Upon Rockefeller's death his wealth was calculated to be equal to 1/65th of America's Gross National Product. Others with staggering totals were Andrew Carnegie (1835–1919) at $475 million, John Pierpont Morgan (1837–1913) with $119 million, Cornelius Vanderbilt (1794–1877) worth $105 million, Russell Sage (1816–1906) at $100 million, Jay Gould (1836–1892) with $77 million, Claus Spreckels (1828–1908) with $50 million, James Clair Flood (1826–1888) and Joseph Pulitzer (1847–1911) each claiming $30 million, John W. Mackay (1831–1902) with $15 million, Isaac Merritt Singer (1811–1875) at $13 million, and August Belmont (1816–1890) worth a measly $10 million. These are but a few of the Gilded Age giants, the men who controlled whole industries, including oil and sugar refining, ore mines and steel production, railroad acquisition and expansion, and those who played with the unregulated New York Stock Exchange, the commodities markets, the banks, and real estate. There were other speculators though, and one of the most colorful characters in this often-bitter financial drama was a woman known simply as the "Witch of Wall Street."

Hetty Green (1834–1916) was rich financially, but not rich in a personal sense. Green was a financial genius, but also miserly, argu-

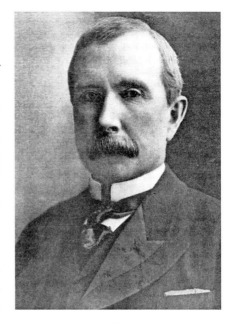

John Davison Rockefeller (1839–1937) was an American industrialist and philanthropist. In 1870, Rockefeller founded the Standard Oil Company, and on September 29, 1916, he became the world's first billionaire. His was a true Gilded Age rags-to-riches story (author's collection).

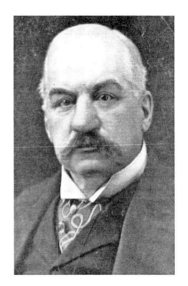

John Pierpont (J. P.) Morgan (1837–1913) was born into a banking family and grew to become one of America's premier financiers and banking magnates. Morgan was one of the founders of the banking house of Drexel, Morgan & Company, and he helped to form large corporations, too; perhaps the greatest were General Electric and United States Steel. At his death Morgan was estimated to have been worth some $68 million—more than $1.4 billion in today's dollars. An avid yachtsman, Morgan often deflected questions posed by the press regarding the maintenance of his yacht. Once, when asked the value of his yacht, Morgan was reported to have barked, "If you have to ask the price, you can't afford it." It was pure Gilded Age bravado (author's collection).

mentative, domineering, vengeful, and friendless. Here was a woman jousting in a man's world, a financial dragon slayer committed to avarice. Hetty Green, while alive, was also described as being America's wealthiest woman, with a mountain of cash and securities totaling more than $100 million ($17 *billion* in today's dollars).

She was born in New Bedford, Massachusetts, into a family that controlled a successful whaling business. Her fortune was founded upon an inheritance; in 1864 this 30-year-old received the princely sum of $7.5 million from her father's estate.

Green was the ultimate Wall Street speculator at a time when the markets were not subject to the restrictions in place today. During much of the Gilded Age, she walked the shadowed streets of lower Manhattan, traded between the skyscrapers and connived with brokers and bankers. When the "Witch" approached, the phrase "caveat emptor" was whispered by those who feared her pathological extremes and her infamous wrath. Hetty Green invested in corporate and government bonds, conservative company stocks, and real estate. She specialized in railroad bonds and loaned money to other speculators, especially real estate developers, always assigning a high rate of interest. Green was the ultimate venture capitalist with substantial cash reserves; she was a money hoarder and guarded her wealth with a vengeance. These were her ways and means.

Millionaire Green maintained offices in multiple locations — her paranoia was legendary — but could most often be found in the confines of the Chemical National Bank Building (Trowbridge & Livingston, 1907) at 80 Chambers Street. She was fearful of assassination, unwilling to purchase anything, and lived in a one-room hovel where she never turned on the heat, owned only one dress, ate unheated scraps, despised doctors, lawyers, judges and, most of all, the tax man. She did not live; she eked out an existence in direct contrast to others of her financial status. In many ways her values, attitudes, behaviors, and lifestyle echoed that of Charles Dickens's miserly character, Ebenezer Scrooge.[7] Perhaps she even read the famous Victorian novel; but if so, she most likely did not purchase it, but only borrowed it.

Commonly, Gilded Age millionaires employed an army of workers to satisfy their every whim. Their country mansions and lavish townhomes demanded as much, and consequently in the millionaires' service were secretaries, accountants, lawyers, butlers, maids, cooks, gardeners, stable hands, and chauffeurs. The business titan built skyscrapers to house the many, constructed factories to employ the many, and created jobs by way of their wealth for the masses. Millionaire businessmen, then, were credited with the creation of the modern industrial economy, and, during the 1870s and 1880s, the American economy grew at the fastest rate in history. Great gains were realized nationwide: between the end of the Civil War and the turn of the century coal production increased by 800 percent, the miles of railroad track completed was increased by 567 percent, the output of wheat grew by 256 percent, and corn production was increased by 222 percent. History has revealed that Hetty Green's direct contribution to this nation's well-being and prosperity was at its most minimal, and that is regrettable. As diverse as were the personalities of those in power, so it was with the skyscrapers that were erected in America's cities.

At the advent of the Gilded Age, the *skyscraper* was considered a relatively new invention, a new box of technology that quickly and emphatically changed the faces of American cities. Technology, defined partly by metal framing, foundation science, and the passenger elevator, provided the "ways" or paths to achieving the goal of erecting successful towers. Tall office buildings were constructed in city centers, where before only five- and six-story buildings existed. Even the word "skyscraper" was new to most people. The term "skyscraper" originally referred to the highest part of a sailing ship's mast. Sailors were privy to the term; architects were not, at least not most. Wealthy yachtsmen, if they could name the parts of their expensive toys, were familiar with skyscrapers, but only in a nautical context. By 1900, the word was commonplace

and spelled with a hyphen, "sky-scraper." Before long the hyphen was dropped, and tall buildings sprang 30 floors, claiming the highest parts of a city.

Within a decade of the Civil War's end, skyscrapers appeared in dozens of large cities. Economic pressures resulting from high land values, the need for like businesses to group together, and the requirement of smaller "supplier" firms to be nearby, demanded that taller business buildings be constructed. The availability of mass transit, reasonably priced housing nearby, and a pool of readily available workers helped to ensure skyscraper developers of a financially profitable enterprise. Companies clamored to fill leases, and clients eagerly moved into these state-of-the-art structures. The new ten-story-and-taller buildings became business incubators. After the Civil War and during post–Civil War industrialization, entirely new ways of earning income came to the fore. Opportunities for Americans in real estate, banking, insurance, law, marketing, communication, investments, transportation, and an array of manufacturing, promotion, and distribution venues were eagerly pursued by the public. These industries, represented by thousands of firms, were what filled the great skyscrapers.

As early as 1885, a study was conducted and sponsored by the periodical *American Architect* to identify the country's "best ten buildings."[8] No skyscrapers, then still in their infancy, ranked in the top ten by magazine respondents. But the next ten entries included such luminaries as Philadelphia's City Hall and New York's Produce Exchange Building (George B. Post, 14 floors, 1884). Other skyscrapers mentioned, but failing to garner enough votes for a high ranking, were New York's Metropolitan Opera House (Josiah Cleveland Cady, seven floors, 1883) and that city's Mutual Life Insurance Building (Charles W. Clinton, nine floors, 1884). Chicago's two entries were the Pullman Building (Solon Spencer Beman, ten floors, 1885) and the Chicago Board of Trade Building (William W. Boyington, nine floors, 1885). Perhaps aesthetic criteria

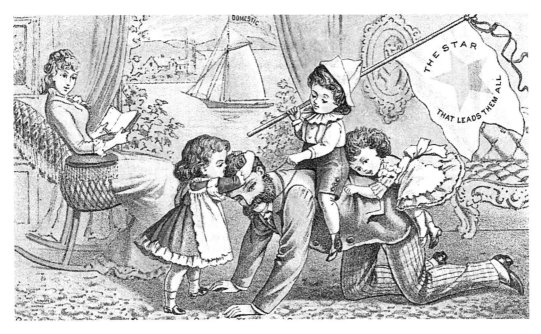

Perhaps too much has been made of the Gilded Age's robber barons and not enough said about a typical middle income family, as depicted here, c. 1885. A comfortable home with the expected accoutrements was the reality; the unattainable, as evidenced by the drawn curtain and image of a single-masted yacht in the distance, was always the dream. Besides, "daddy-be-a-horsy" was much more fun (Advertisement: Domestic Sewing Machine Company, New York, G. Schlegel & Son, 75–77 Duane Street, New York, printer) (author's collection).

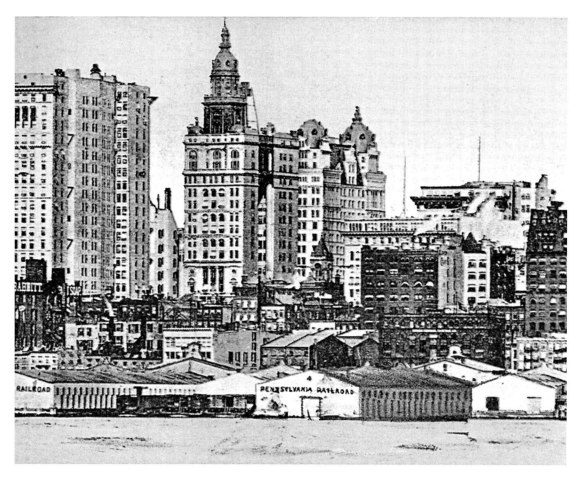

This 1905 view of lower Manhattan features the steepled, 19-story, 348-foot-tall Manhattan Life Building (Francis Hatch Kimball, 1894) at left center, and at right center, the twin-domed top of the 21-story, 304-foot-tall Commercial Cable Building (Harding & Gooch, 1897) (author's collection).

had not yet been developed for this new type of tall structure; perhaps it had and professional practitioners simply did not find the "skyscraper" a visually satisfying product. In all, 175 buildings were named and only six were skyscrapers; still, one must remember that there were comparatively few skyscrapers then.

Basic Questions

Within the discipline of architecture, the Gilded Age marked the second generation of the skyscraper. The first generation of these tall office buildings, spanning 1850 to 1874, became the preferred home to the new and emerging corporations of America, and their beginnings can be traced to 1850 and to the completion of Philadelphia's ten-story, 130-foot-tall Jayne Building (William L. Johnson and Thomas Ustick Walter). In quick succession there followed the seven-story Tower Hall (Samuel Sloan, 1855), also in Philadelphia, and in New York, the Equitable (Gilman and Kendall, George B. Post, 1870), Domestic Sewing Machine (Griffith Thomas, 1873), and the Bennett (Arthur D. Gilman, 1873) buildings, each standing seven stories. These early skyscrapers were the progenitors, some of which were constructed with iron columns and

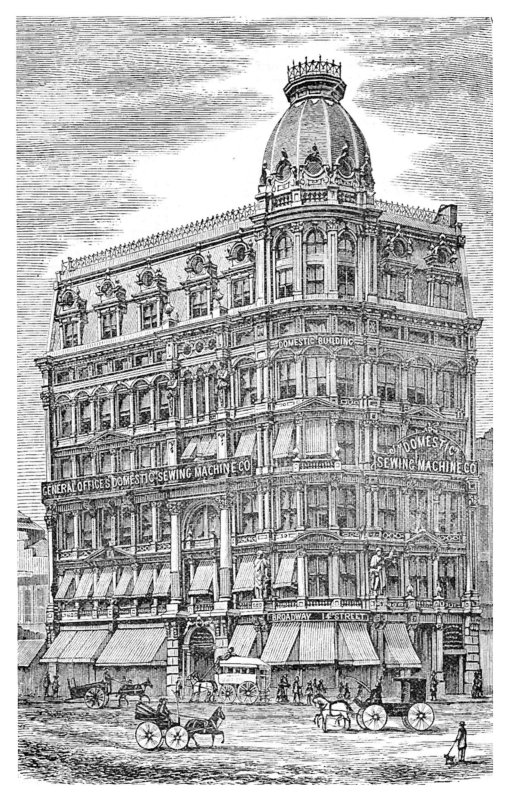

New York's Domestic Sewing Machine Building (Griffith Thomas, 1873) stood until 1927. It rose eight stories, 110 feet above Broadway. This early skyscraper referenced the French Baroque style and was topped with a pronounced mansard roof and metal-ribbed dome (Domestic Sewing Machine Company brochure, c. 1885).

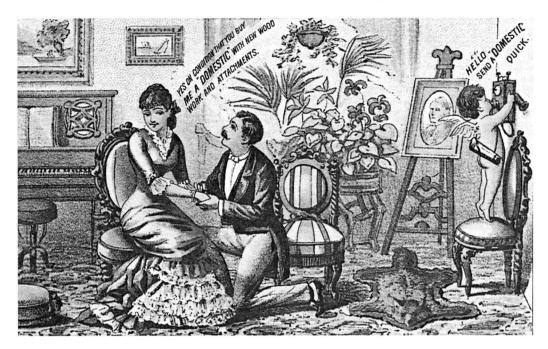

Appealing to America's middle class, the Domestic Sewing Machine Company printed this 1895 trade card as an advertisement for their signature product. Like its home office skyscraper, the portrayed parlor was formal, stiff, and visited by supernatural figures; a chair-standing cherub eagerly orders a Domestic sewing machine by telephone only after realizing a pending marriage would be impossible without it. The ridiculousness of the situation provided both commerce *and* comedy (Domestic Sewing Machine Company trade card, 1885).

wood girders, some partially supported by bearing walls, while some rose without passenger elevators. These *were* skyscrapers, early skyscrapers, the courageous infants of an industry — they were *tall*, and they scraped the sky; their upward thrust gave modern skylines to their respective cities.

 The second generation of the skyscraper, defined by those constructed between 1875 and 1910, was marked by even greater height due to certain engineering and technological advances and by fierce displays of corporate one-upmanship. A metal frame of iron, iron and steel, or of just steel, now acted more often than not as the armature from which the wall was "hung." Termed a "curtain wall," this system of construction was developed and improved upon during these years, as well as the passenger elevator, advances in plumbing, air conditioning, and lighting. The inclusion of electronic communication and the threading of electrical wiring throughout the tall buildings contributed mightily to their advancement and to their acceptance by the public. Manhattan's nine-story, 260-foot-tall New York Tribune (Richard Morris Hunt, 1875), the ten-story, 230-foot-tall Western Union Telegraph (George B. Post, 1875), and Boston's seven-story, 234-foot-tall New York Mutual Life (Peabody & Stearns, 1875) buildings led the charge to the sky. The skyscraper, originally considered a novelty by some, became a fixture of American life. Privately held companies became larger and more commonplace, and by 1910 thousands of employees were housed in thousands of skyscrapers, in very tall, very decorated, and extravagant "boxes."

 Fundamentally there are two parts to any skyscraper, the sub-structure (the building that is below the sidewalk), and the super-structure (the building that rises up from the sidewalk, the "office box"). Furthermore, a skyscraper has many systems. Primarily, it possesses a *structural*

system (the metal or concrete frame that holds everything up and together), a *circulation system* (entries/exits, corridors), a *spatial system* (public and private areas and rooms), and finally an *enclosure system* (the exterior walls and roof that keep inhabitants warm and dry). The architectural treatment of the *enclosure system* — the *decoration* of the super-structure — was paramount, especially to a culture where image and money so wholly determined the success of the skyscraper as a real-estate investment. By 1910, there were many tall, decorated boxes of architecture, super-structures of much extravagance. A handsome return on one's investment ensured the continuation of a system where grandiose façades translated into wealth; it appeared that building owners favored fancy façades and that architects simply complied.

For the moment it seemed that most technological issues were solved, and the problems of excessive height were tackled with typical Yankee ingenuity. Americans knew how to build skyscrapers and did so employing various formulas according to soil conditions, wind loads, dead and live loads, occupancy requirements, girder and column charts, plumbing manuals, and a host of code and zoning requirements. But how does one build a skyscraper *aesthetically*? What should a skyscraper look like? Shall a skyscraper appear as a three-story building, just taller?

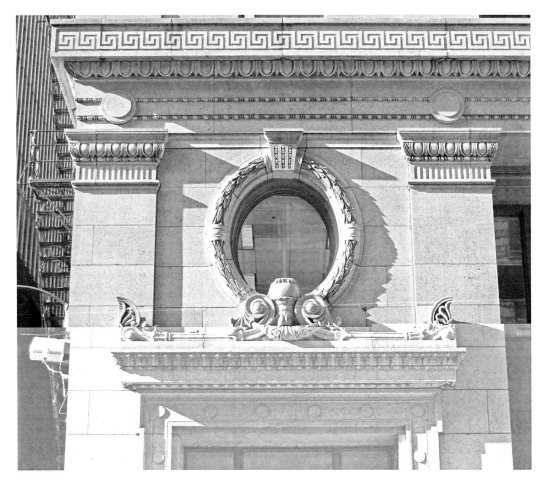

It seems that every Renaissance detail known can be found somewhere at this entrance to People's Gas Company Building (D. H. Burnham & Co., 1911). These rich, plastic forms were executed in granite and were intended to add an air of dignity to this 20-story, 297-foot-tall commercial office building. Chicago residents entered here, the corporate headquarters of this utility company, to pay their gas bills in regal splendor. Togas were not required, just cash or checks (photograph by author).

How do scale and proportion fit into the equation? If one had never been built before, what should a skyscraper look like? How was the design arrived at of America's first skyscraper, Philadelphia's Jayne Building?

For example, during the 1930s, public air travel was a novel and expensive amusement. Commercial airlines required a building where passengers could embark and disembark, in relative comfort and grace. Architects were charged with designing something called an "airline terminal." Commercial air travel was in its infancy, and a new building *type* had to be invented. What model should be used? Should an architect copy a train station with its storied columns, clock tower, and a two-block-long iron shed? This formula, repeated endlessly, was well suited to the inter-city rail traveler, so why not for the air traveler? It was realized that somehow a commercial airplane taxiing up to a Roman-columned doorway bracketed with fruit baskets, or a Romanesque arcade complete with figures, would be preposterous. Intensive inquiry and clever invention resulted in a low-slung, glass and steel structure. It was the correct response; it worked, and *that* formula was repeated endlessly.

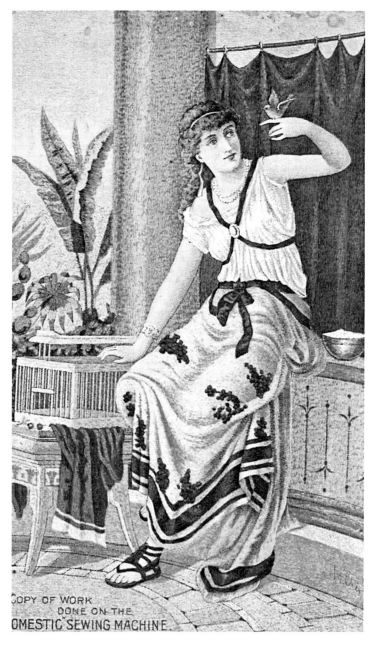

The skyscraper, like the twentieth century airline terminal, was a totally new concept, a new type of structure for a *new purpose*. Was it destined, then, to have a Roman-columned doorway bracketed with fruit baskets, or was it to be faced with a Romanesque arcade complete with figures? Should this new building type be clothed in the garb of

With unabashed reference to the classical world, the Domestic Sewing Machine Company published this advertisement in 1880. The caption reads, "Copy of Work Done on the Domestic Sewing Machine," and the image features a woman dressed in a full Roman costume, complete with sandals and a Roman-period hairstyle (Domestic Sewing Machine Company trade card, 1880).

earlier ages, or does it deserve a new wardrobe, a new aggressive *American look* with a three-piece suit, dangling gold watch fob, and snappy tie? Most architects instead argued in favor of the toga of the temple or voted in favor of the hooded robe of the cloister.

Traditional Options

> The Past! The dark, unfathom'd retrospect!
> The teeming gulf! The sleepers and the shadows!
> The past! The infinite greatness of the past!
> For what is the present, after all, but a growth out of the past?[9]
> — Walt Whitman (1819–1892)

Some Americans had extravagant tastes. The Gilded Age was all about extravagance; the common, the mundane, or the pedestrian were never employed in the same sentence with "gilded." The end of the nineteenth century and the beginning of the twentieth was a time of excesses, a period when the wealthy flaunted their possessions and their social status as never before. And never before, in America, had so much wealth been concentrated in the hands of so few. As a consequence, the size of one's home, or yacht, or jewelry was mighty important in certain social circles. Some people's tastes were grandiose, their personalities pompous, and the architecture that appealed to these tended to mimic their tastes and personalities. Well-traveled socialites enjoyed the past, the romantic past, the past of ancient civilizations, of chivalry, of foreign potentates, and of the empire-building Napoleonic era. The picturesque nature of European castles dazzled some, while others favored the cerebral and sophisticated look of the temple forms of Pompeii and Paestum. Renaissance palaces in Italy impressed most, while a few unabashed Francophiles fancied the sprawling French estates of long ago. Many people felt America could also possess the aesthetic richness that Europe offered, if only this country would construct buildings like those of Europe's storied history.

Grand mansions, the personal homes of the stratospherically wealthy, were erected simultaneously with the very first skyscrapers. In Manhattan, a mansion would rise on Fifth Avenue, and an office tower would rise on Pine Street. An elegant townhouse would be completed on Gramercy Park, while a ten-story office block would be completed on Broadway. The façades of all these owed much to the dreamlike and picturesque qualities of the architecture of Europe's history. The difference was that private homes had existed for centuries, not so for the skyscraper.

Many skyscrapers constructed during the Gilded Age reflected the extravagant nature and desires of the architects, developers, lenders, and the business owners responsible. If a little extravagance or downright opulence was considered to be a good business strategy, perhaps a lot of extravagance was better; perhaps the more lavish buildings would lease-out faster than less-adorned buildings.

These were the extravagant skyscrapers: tall buildings that employed every and any type of European form from antiquity forward, skyscrapers resembling temples, basilicas, churches, monasteries, and fairy castles. These had tops sporting cones, domes, and oversized sculpted doodads. Extravagant skyscrapers were covered by mythological frosting, sweet icing that included images of characters that never lived, of almost-human creatures with wings, and beasts with discordant body parts. These were not skyscrapers possessed of only a hint of the Renaissance or of a small sculptural offering, but were those that were slathered with historical imagery and mythology, those that borrowed heavily from the past, and those that were the products of former, foreign cultures; they existed without much restraint. Extravagant skyscrapers were

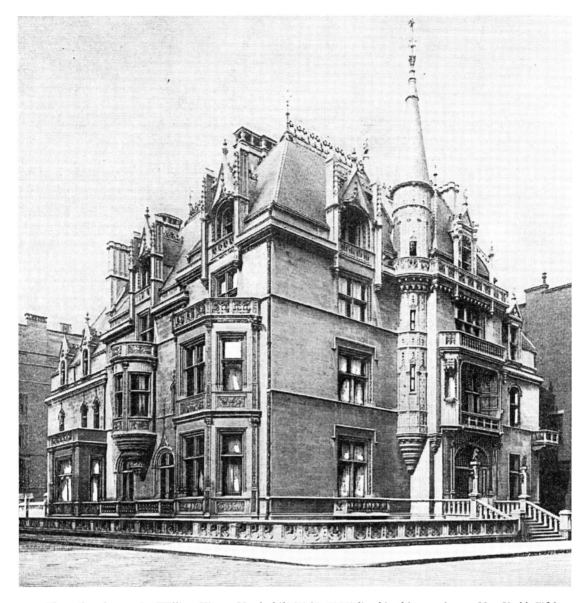

The railroad executive William Kissam Vanderbilt (1849–1920) lived in this mansion on New York's Fifth Avenue. This Vanderbilt mansion (Richard Morris Hunt, 1882) employed many of the architectural devices also found on Gilded Age skyscrapers; the French chateau style worked equally well for three-story- and 23-story buildings. The mansion, constructed to echo the palaces of Europe and to promote the lifestyle of European royalty, was demolished in 1925 (*Munsey's Magazine*, Vol. XXII, January, 1900, no. 4, in "The Vanderbilts and the Vanderbilt Millions," pp. 467–477).

grandiose, pompous things with over-scaled classical columns that emerged from the minds of architects to delight their patrons and the public, and they provided urban amusement on a grand scale.

 The world had seen tall buildings, but the world had not seen anything quite like the American skyscraper. After all, high finance demanded high buildings. The American skyscraper was, by its very nature, tall; it was a tall box, and the exterior of this tall box had to be decorated. How was that to be accomplished? What were the means, and what were the ways? American

Any 1890s homeowner who would condone the placement of a large vegetable-form atop his roof would probably be content working in a dome-topped office building decorated with goat-legged gnomes and dragons. Even Frank Lloyd Wright mused, "Unless the householder of the period were poor indeed, usually the ingenious corner tower as seen in monograria, eventuated into a candle-snuffer dome, a spire, an inverted rutabaga, radish or onion" (quotation from Frank Lloyd Wright, *Frank Lloyd Wright: An Autobiography* [Petaluma, Ca.: Pomegranate Publishers, 2005], 140).

architects had the ways, many ways. The American bankers had the means, lots and lots of means.

Options for Tired Eyes

> Tell me … do you really think that Greek columns and fruit baskets are beautiful on a modern, steel office building?[10] — Ayn Rand (1905–1982)

Tired eyes and tired minds merged to forge a type of disgust and honest revulsion for the architecture being produced by traditionalists and historicists. The hands of a few architects, Midwesterners mainly, even refused to draw an image of an entablature, and then refused to produce a finely detailed pediment. A full refusal was reared by some architects' hands for a correctly proportioned Corinthian column, with an entasis, with a capital. Outrageous!

It had often been stated, mostly by Eastern academics, that architecture was a discipline not to be trifled with, yet some felt that much trifling had occurred. A few self-styled architects also felt that this intellectual discipline was becoming totally undisciplined, that the buildings produced during the Gilded Age were trite, self-referential, and simply too flamboyant to be considered seriously. The bombast had come home to roost. America deviated to the derivative. Some felt that these tall, decorated boxes of extravagant architecture had become so common that public opinion verged on the blasé. There was one place in America which cultivated a homegrown crop of freethinkers, a few architects who rejected centuries-old forms and foolish decoration, and that place was Chicago.

Louis Sullivan (1856–1924), decidedly one of America's greatest architects, died penniless in a rented room on Chicago's south side. Still, he was greater than Atlas himself (author's collection).

One of the Chicagoans, perhaps the most vocal rabble-rouser of them all, was architect-extraordinaire Louis Henri Sullivan. This bright young man was born in Boston and studied architecture at the Massachusetts Institute of Technology. He served a tour of duty overseas studying at the École des Beaux-Arts from 1874 to 1875, a total of 11 months, and then made his way to the plains and prairies of Illinois, to the great metropolis of the grasslands.

Sullivan was a free-thinking architect and, as such, was considered by the more establishment minded of his profession to be a radical, a revolutionary, and a malcontent. Sullivan felt that American architects should not ape the work of their contemporaries in Europe. He was revolted by the incessant copying of the work originally produced by the ancients, the architectural designs that serviced those of some 100 generations before him. He cited the skyscrapers he viewed in New York and Philadelphia as "decadent" and as "the most bumptious architecture in the country." Sullivan went so far as to say, "An architect who acknowledges no obligation to society at large, who gives no heed to the just claims of posterity, is not an architect in my sense of the word — he is an outlaw!"[11] American architects must leave the past and embrace the future, he insisted, and they must search out a new architectural reality more suited to the modern culture and ideals that best represent the new American nation. Sullivan railed against the blind historicism, the shallow-minded copying of historical styles and of the misunderstandings of ancient cultures. Most of all, it seemed, he despised the architecture of Manhattan, and he expressed his views in a scathing 1901 epistle when referring to New York's skyline:

> It means tainted architecture. It means a virus implanted for generations to come, that is appalling to think of. Some day the future New Yorkers will wish to spend vast sums to pull down these screaming nightmares of its [sic] morbid early sleep, and be rid of them; and they

The restrained tower of Chicago's 270-foot-tall Auditorium Building (Adler & Sullivan, 1889) was devoid of any meaningless extravagance. Floors 15 and 16, identified respectively by a stout Doric-columned colonnade and a row of small windows, marked the location of the offices of Adler & Sullivan. It was behind these smooth limestone walls that Louis Sullivan created landmarks (photograph by author).

will most heartily curse the generation of architects that made them, and the money-crazy people who not only let them be done but wished them to be done.[12]

He was defiant and adamant, but he was not a clairvoyant; some of these skyscrapers still remain. "Screaming nightmares"? "Money-crazed people"? Sullivan was risking much with such comments, not least of all his professional reputation and the respect of his colleagues. But he had other ambitions, and those at least in part were to make the architecture of America not the exemplar of the world, but the most meaningful possible for Americans themselves, for the people who built it, paid for it, and inhabited it.

It was in Chicago, during the early 1920s, that he wrote about an *idea* that he had, a philosophy that he formulated decades earlier about how a tall building should appear with regard to its purpose, its very nature, and about the causes and the culture that brought it into being. Though he was an architect during the Gilded

The base of Chicago's Auditorium Building best expresses the influence Henry Hobson Richardson — through his design of the Marshall Field Warehouse — had upon the early work of Louis Sullivan. Absent here were any references to classical gods, nudes, myths, or monsters. Only with the word *cyclopean* (used to describe such large granite blocks) is there a hint of the classical past. A *cyclops* in Greek mythology was a one-eyed giant described as a being of brute force, a creature of violence who served only Zeus (photograph by author).

The terra cotta details of Chicago's eight-story, 112-foot-tall Gage Building (Louis Sullivan, 1899) can be described without contradiction as being "purely American" (photograph by author).

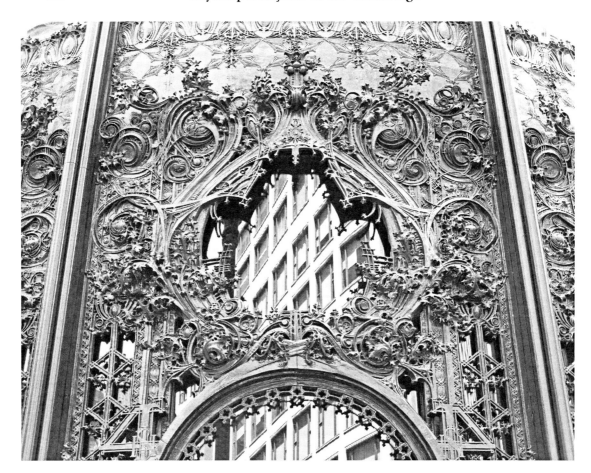

This sumptuous cast iron detailing can still be seen at the entrance to the Louis Sullivan-designed Schlesinger & Meyer Store (later renamed Carson, Pirie & Scott) in Chicago's Loop. Erected in stages beginning in 1899, this early skyscraper stands 12 floors, 168 feet tall, all of it in modern splendor (photograph by author).

Age, he dreamt about a different age, a future time when America's architects would be free from the yoke of antiquity. He decided to record his thoughts for posterity: *Kindergarten Chats* and *The Autobiography of an Idea* were the results. Sullivan insisted that buildings be ornamented, but ornamented in a logical way, meaning that decoration would grow "organically" out of the very bowels of the building, out of the very spirit of the building. Sullivan likened the building's structure to an armature from which the decoration emerges, grows from the steel beneath like the bark of a tree emerges from within the tree. This tree, like a skyscraper, must be of one thing, of one creative genius. Decoration cannot simply be glued onto the walls. He wrote about something called organic architecture, which he defined (writing of himself in the second person):

> And amid the immense number and variety of living forms, he noted that invariably the form expressed the function, as, for instance, the oak tree expressed the function oak, the pine tree the function pine, and so on through the amazing series. And, inquiring more deeply, he discovered that in truth it was not simply a matter of form expressing function, but the vital idea was this: That the function *created* or organized its form.[13]

Continuing, Sullivan explained the relationship between function and the building as a completed entity like a modern machine:

Louis Sullivan designed the Chicago Stock Exchange Building in 1893-4. It was arguably his best sky-scraper and stood 13 stories, 173 feet above LaSalle Street in Chicago's financial district. Although a masterpiece of fresh and original ornamentation and the very embodiment of Sullivan's ideas regarding design and organic architecture, the Chicago Stock Exchange Building was demolished in 1972 (photograph by author).

Each part must so clearly express its function that the function can be read through the part.[14]

In the following passage, Sullivan argues persuasively for a rational kind of design and building, a kind of architecture of functional honesty:

Whether it be the sweeping eagle in his flight or the open apple-blossom, the toiling work-horse, the blithe swan, the branching oak, the winding stream at its base, the drifting clouds, over all the coursing sun, *form ever follows function*, and this is the law. Where function does not change form does not change. The granite rocks, the ever-brooding hills, remain for ages; the lightning lives, comes into shape, and dies in a twinkling. It is the pervading law of all things organic, and inorganic, of all things physical and metaphysical, of all things human and all things superhuman, of all true manifestations of the head, of the heart, of the soul, that the life is recognizable in its expression, *that form ever follows function. This is the law.*

Shall we, then, daily violate this law in our art? Are we so decadent, so imbecile, so utterly weak of eyesight, that we cannot perceive this truth so simple, so very simple? It is indeed a truth so transparent that we see through it but do not see it? Is it really then, a very marvelous thing, or is it rather so commonplace, so everyday, so near a thing to us, that we cannot perceive that the shape, form, outward expression, design or whatever we may choose, of the tall office building should in the very nature of things follow the functions of the building, and that where the function does not change, the form is not to change?[15]

In all of this, there was no room for temples, or gods, or the mythic tales of Zeus and Poseidon. Carved busts of Mercury were not to be found on any of Louis Sullivan's buildings.[16] He reinvented the tall building, he redefined the "skyscraper" in *modern American* terms. Sullivan dismissed the rest with the following:

> I believe, in other words, that the Greek knew the statics, the Goth the dynamics, of the art, but that neither of them suspected the mobile equilibrium of it: neither of them divined the movement and the stability of nature. Failing in this, both have forever fallen short, and must pass away when the true, the *poetic architecture* shall arise — that architecture which shall speak with clearness, with eloquence, and with warmth, of the fullness, the completeness of man's intercourse with Nature and with his fellow men.[17]

Louis Sullivan, perhaps in his best prose, told the world what an American skyscraper should look like:

> It must be tall, every inch of it tall. The force and power of altitude must be in it, the glory and pride of exaltation must be in it. It must be every inch a proud and soaring thing, rising in sheer exultation that from bottom to top it is a unit without a single dissenting line — that it is the new, the unexpected, the eloquent peroration of most bald, most sinister, most forbidding conditions.[18]

Architecture without "a single dissenting line" speaks of a unity, a unity of the parts to the whole and to each other. Also, too, a unity in *time*, a unity in and of the generation that created the building, a unity of collective being, a unity of human endeavor. Finally, Sullivan insisted upon a redirection of architectural thought; he spoke of a progressive design approach, one consisting of a rational and creatively *modern* approach to the problem of tall office building aesthetics:

> All of these critics and theorists agree, however, positively, unequivocally, in this, that the tall office building should not, must not, be made a field for the display of architectural knowledge in the encyclopaedic [*sic*] sense; that too much learning in this instance is fully as dangerous, as obnoxious, as too little learning; that miscellany is abhorrent to their sense; that the sixteen-story building must not consist of sixteen separate, distinct and unrelated buildings piled one upon the other until the top of the pile is reached.
>
> To this latter folly I would not refer were it not the fact that nine out of every ten tall office buildings are designed in precisely this way in effect, not by the ignorant, but by the educated. It would seem indeed, as though the "trained" architect, when facing this problem, were beset at every story, or at most, every third or fourth story, by the hysterical dread lest he be in "bad form"; lest he be not bedecking his building with sufficiency of quotation from this, that, or the other "correct" building in some other land and some other time; lest he be not copious enough in the display of his wares; lest he betray, in short, a lack of resource.[19]

Sullivan formulated, and clung unwaveringly, to his ideas about architecture and the role of architectural ornament until his death some 40 years later. Sullivan biographer Robert Twombly stated, "Sullivan simply would not design in an alien, historic style, no matter how expensive the commission. If he could not do it his way, he would not do it at all." Continuing, Sullivan "always gave clients exactly what they wanted. His buildings were known to be practical and efficient, solidly based on the program's requirements. But on questions of style and aesthetics, he would not compromise."[20]

It is a fact, though, that one skyscraper designed by Louis Sullivan did include embellishments other than intertwined foliate patterns and the complex geometries for which he was so acclaimed. One client that he gave "exactly what they wanted" were the men of the German Opera-House Company, one center of German culture in Chicago. It was headed by the German-born businessman and financier Anton C. Hesing (1823–1895), the man responsible for the construction of the 16-story, 211-foot-tall Schiller Theater Building, a home to German the-

ater and music, completed in Chicago in 1892. Hesing was one client with whom Sullivan did agree to include the images of humans on the façades of one of his skyscraper designs. At the second-floor level appeared the sculptured busts of renowned Germans, men whose accomplishments in the worlds of music, poetry, and literature were legendary. Among the 12 greats featured were Johann Wolfgang von Goethe, Richard Wagner, and Ludwig van Beethoven. It is true that Sullivan did not include any Greek gods, superheroes, or muses — those foreign and historic elements he so abhorred. But the frieze at the 18th-floor level did display the oversized busts of characters from traditional *German folklore.* Here was not so much a celebration of nature, but an acknowledgment of the accomplishments of men and the indomitable will of the client.

As a result of Sullivan's usual insight and tenacity, there gathered around him perhaps a dozen colleagues, students, interns, young and old architects alike, who understood and accepted him and his ideas. Because Sullivan practiced in Chicago there were ample opportunities to test out his theories of form, of ornament, and of the function of architecture as applied to the skyscraper; Chicago was reinventing itself after its 1871 fire, and it was in this milieu that *new* ideas could become most fertile. Sullivan was very much a romantic, a romantic who drank in the nectar of nature, and he became a poet of the earth. He was shunned by some and hailed by others as a Master. He was not just a man, he was a force. After his death he was honored with the titles, "Father of the Skyscraper," and "Father of Modernism."

The philosophy of a skyscraper's creation, the *process* of its design is what was important to Sullivan. The "idea" derived from nature was paramount if the American tall building was to be judged an aesthetic success. Sullivan urged architects to examine their design motives and to develop their own creativity rather than copy the past. He advocated that architects employ new solutions, explore new sources for skyscraper-façade design by looking within themselves. Only then can honest creativity emerge.

Those few fountainheads, those followers of Sullivan's philosophies of form, ornamentation, and organic architecture, suffered from tired eyes and tired minds, the results of an industry and a culture steeped in European historicism. It was these fountainheads who produced some of the most compelling skyscraper designs of the Gilded Age and for long after. At most there were just a handful of skyscrapers (the majority of these were completed during the 1890s) that followed the modern precepts as set down by Sullivan and his adherents. Despite the small numbers, these "organic" skyscrapers showed there were other visual languages available to be employed, other design philosophies than the traditional options. Most often, though, European-based extravagance dominated; the tall boxes of architecture, the chess pieces of investors and bankers, were products of old world taste.

Chapter Two

Hopes and Dreams

Architecture is a thing of art, a phenomenon of the emotions, lying outside questions of construction and beyond them. The purpose of construction is to make things hold together; of architecture to move us.[1]— Le Corbusier (1887–1966)

The Gilded Age was a time of hopes and dreams. The hopes of the investment community were for wealth. The dreams of architects were for fame. These were the forces that helped to drive buildings in America's cities higher than ever. Skyscrapers were singular achievements that were now clustered in groups; there were lots of them, and they were rising in both large and small cities, in towns, and in smaller towns. Like religion, jazz, or architecture, and to paraphrase Le Corbusier, skyscrapers, especially, were meant to "move us." America appropriated the sky-scraper as a homegrown invention and even touted some as "proud and soaring things." The Gilded Age skyscraper symbolically allowed Americans to feel good about themselves and their achievements; after all, America was the heir to Greek democracy, Roman law, and Renaissance humanism. Virtues such as these deserved to be expressed by means of either wealth or architecture. Both investors and architects wished to make their mark, to leave something of themselves for posterity. One wished to do so with a brick of gold, the other with a brick of clay.

Our national identity derived not only from the ancients, as there were other design sources, other inspirations that entered into the country's collective consciousness. Tall office buildings helped to shape the nation's identity and these provided sources of regional and national pride.

American skyscrapers were diverse animals, creations that appeared in a multitude of styles; their forms were limitless and downtown America evolved into an architectural zoo. There were, though, many that defied any sort of neat categorization. Hybrids of hybrids sprang from the minds of educated architects, men well versed in the arts, cultures, and histories of that big, and old, continent across the Atlantic. Designing skyscrapers was challenging fun, and almost anything passed for serious work. Façades could include almost anything: angels, dragons, mythological creatures, animals, gods, goddesses, even nudes. Skyscrapers could rise to resemble castles, basilicas, chateaux, palaces, campaniles — almost anything dreamt of. It was an intellectual free-for-all that included combining these in any number of permutations. In 1981, architectural historian Frederick Koeper observed the following:

Nineteenth-century scholarship provided architects and their clients with an ever-increasing choice of styles. In the uninhibited postwar [Civil War] years, the urge to mix them was indulged to the full. Governed only by subjective taste, the result was a synthetic eclecticism beyond all rules and precedent.[2]

A decades-old adage declared that modern architects (including those of the late 19th century) tended to glorify originality through copying it. What is more, it was often cited that developers built for the real estate market, not just for their clients and not just for the good of society. One conclusion that can be drawn from these statements is that image borrowing, to satiate the real estate market and, in turn, the masses, worked well financially and that the *modus operandi* should not be changed. For the most part it was not, and architects dutifully produced drawings of historically inspired façades to the delight of developers, financiers, industrialists, and the shoeshine boys who plied their trade on the streets.

Architecture, like all art, is an art of perception. The public became accustomed to viewing the results of what architects happily churned out with colored inks on reams of treated linen. Architecture was also an industry, an industry devoted to many things, one of which was a certain modicum of expected continuity. People got what they expected to get, and generally they were pleased. English-born scholar and distinguished professor Sir Herbert Read (1893–1968) insightfully addressed this phenomenon:

> The whole history of art is a history of modes of visual perception: of the various ways in which man has *seen* the world. The naïve person might object that there is only one way of seeing the world — the way it is presented to his own immediate vision. But this is not true — we see what we learn to see, and vision becomes a habit, a convention, a partial selection of all there is to see, and a distorted summary of the rest. We see what we want to see.[3]

Seeing becomes a convention, and we see what we want to see. Seeing has certain expectations, and those *learned* expectations were satisfied by people like the Piccirilli brothers.

Giuseppe Piccirilli (1844–1910) was one of those "tempest-tost" immigrants who, through determination, hard work, and an unassailable talent, helped to make America great. Piccirilli (*peach-er-really*) and his "huddled mass" of six sons entered this country in 1888 from a place called Massa di Carrara, in Italy. There, Giuseppe Piccirilli and his sons became renowned marble cutters and carvers. The Piccirilli family settled in the Bronx, where they established an atelier from which they pursued their artistic aspirations. Commissions were plentiful and these originated from some of the most prominent architects and artists of their time. Sculptors like John Quincy Adams Ward (1830–1910), Frederick MacMonnies (1863–1937), Augustus Saint-Gaudens (1848–1907), Paul Wayland Bartlett (1865–1925), and Daniel Chester French (1850–1931) were awarded commissions from architects to embellish the façades of their latest buildings. These celebrated sculptors fashioned *maquettes* (small detailed models) in clay or plaster and, in turn, delivered these to the Piccirillis "to bring their inspirations to life." In actuality, then, it was the Piccirilli family who physically carved, from immense blocks of stone, many of the greatest civic monuments in New York and elsewhere.

The Piccirilli brothers were responsible for hundreds of marble, granite, and limestone sculptures to be found on many of New York's most prestigious buildings, including noted skyscrapers.[4] One of their most famous Gilded Age works was the sculptural group located within the pediment of the New York Stock Exchange Building (George B. Post, 1903). The other was that of the 12 allegorical statues and the sculptural groups found at New York's United States Custom House (Cass Gilbert, 1907). The actual designs were composed by artists John Quincy Adams Ward and Paul Bartlett, and by Daniel Chester French, respectively. With both these examples, architects, sculptors, and stone carvers dutifully produced monuments of "high ideals" that sprang from the Renaissance and, more specifically, a host of romantic traditions. These talented ones produced what was expected of them and what the public and the American culture as a whole expected to see. Convention was placated, and clients were satisfied because they saw what they expected to see. Not every large city claimed a Piccirilli family, but there were other stone carvers and, later, terra cotta manufacturers throughout America that did

indeed design and execute monumental sculpture in a familiar style, as expected, for the adornment of buildings both short and tall. Like the architects they served, the Piccirillis dutifully produced that which was called for. The Renaissance and the romantic styles prevailed; nostalgia was in vogue.

There was one standout skyscraper, though, one building so different, so aesthetically revolutionary that its status as a landmark can be considered an understatement. It was a skyscraper that, for its time, arrested the eye; it jolted people's perceptions of skyscraper architecture and forced them to see that which they perhaps did not wish to see. And that building was the Monadnock.

> What I dream of is an art of balance, of purity and serenity devoid of troubling or depressing subject matter ... a soothing, calming influence on the mind.[5]— Henri Matisse (1869–1954)

Monadnock

As a valid point of departure from the architectural extravagance of the period, one must examine the antithesis of the pompous, of the antique, and of the quaint. One American skyscraper rises above all others in this arena of design complacency, and that is Chicago's Monadnock Block.[6] Still proudly standing in the Loop, this office building's importance to the development of skyscraper aesthetics cannot be exaggerated. Here is America's first "less is more" skyscraper, a structure of grace, of harmony, an exemplar of poise and taste, an altogether polite building without nuances.

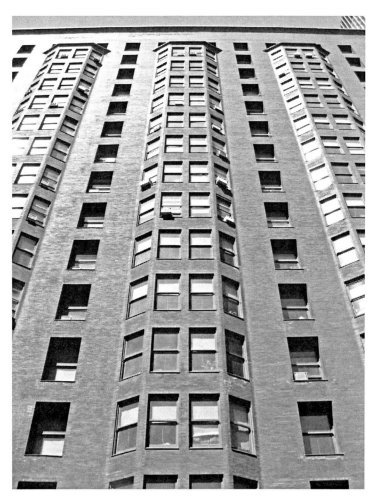

The Monadnock Block was the product of the hopes and dreams of three men: an attorney, a real estate developer, and an architect. Without these three and their combined chemistry, there would be no Monadnock as we now know it. Owen Franklin Aldis (1853–1925) was a St. Albans, Vermont-born attorney who migrated to Chicago in 1875. Aldis established a law practice in

Chicago's Monadnock Block remains a modern majesty (photograph by author).

Chicago that included property management for out-of-state clients ready to make their fortunes in the post-fire, reemerging prairie city. Bostonian Peter Chardon Brooks (1831–1920), a native of Watertown (now Belmont), Massachusetts, figured as the speculator, the "money man," the investor responsible for all the check writing. Brooks graduated from Harvard University in 1852, was a member of one of the most prominent families of Massachusetts, and controlled vast amounts of cash. Joining these adventurous "Easterners" was architect John Wellborn Root (1850–1891), a Chicagoan, born in Lumpkin, Georgia, and one of the most respected of American architects. It was Root's succinct and altogether pointed observation that "living in the full light of the nineteenth century, freed from the thralldom of our less fortunate brothers across the sea, we men can do what we please."[7] The Monadnock Block was indeed a full manifestation of this idea, as well as a Gilded Age design anomaly. And for a short time, it occupied the hopes and dreams of these three men.

The Monadnock Block was unlike any skyscraper of its time, and perhaps it was the most beguiling. It was named by Brooks (as early as 1885) after Mount Monadnock, located in southwestern New Hampshire. The source of its name was grounded in the Native American Abenaki language: "smooth mountain" was its meaning. Though only one-14th the height of the mountain, the Monad-

The Monadnock Block's Dearborn Street entrance is a superb essay in minimalist design, and to some no finer skyscraper entrance exists in America. Its only embellishments are the beaded mortar joints and its carved pinkish granite lintel; this skyscraper defines simplicity coupled with visual power (photograph by author).

nock Block was Chicago's own "smooth mountain"; it stood by the determination of its brick and granite and steel, the stuff of the earth, fashioned into a force immobile — and perhaps as eternal.

The Monadnock Block was erected as a tool, a moneymaker, a tall investment machine. Its developer, Peter Brooks, insisted upon economy in design, and he, with Aldis's technical advice and consent, demanded a building without any fussiness. These aesthetic rebels wanted a brick box, devoid of overt ornamentation, a simple shaft, unyielding to the tastes of the time, a building whose image was necessarily timeless. Harriet Monroe, the celebrated poet, author, and sister-in-law of John Root, wrote in 1896: "For this building, Mr. Aldis, who controlled the investment, kept urging upon his architects extreme simplicity, rejecting one or two of Root's sketches as too ornate." Monroe further added:

> Mr. Burnham [Root's partner] ordered from one of the draughtsmen a design of a straight-up-and-down, uncompromising, unornamented façade.... [Root] was indignant at first over this project of a brick box. Gradually, however, he threw himself into the spirit of the thing, and one day he told Mr. Aldis that the heavy sloping lines of an Egyptian pylon had gotten into his mind as the basis of this design, and that he thought he would "throw the thing up without a single ornament."[8]

Root responded accordingly, and Brooks's desire was fulfilled despite the prevailing thought that a lack of ornamentation signaled a lack of wealth and of good taste. It is, however, interesting

to note that "many persons remember his [Root's] desire to grade the color of the building from brown bricks at the bottom to yellow at the top — a project which only lack of time for the manufacture prevented."[9] Many critics were relieved.

After two years of construction, the Monadnock Block was completed; it stood to be judged, all 16 stories, and all 215 feet of pure defiance. The skyscraper's footprint measured 70 by 200 feet, and its exterior walls were self-supporting and, thus, six feet thick. The structure's base profile curved inward, with walls rising uninterrupted to the top where they flared outward to echo its bottom. It was suave, sophisticated, and severe. Its "I" form was a delight to the eye, that is to say, a treat to the tired eye of the discontented observer. No ornament was supplied in the conventional Gilded Age sense; there were no classical columns, mythological statues, carved fruit baskets, or picturesque domes to muddy up the surfaces or summit. There was only a tall, brick box, but one with enormous personality based wholly upon line and mass. In the Monadnock the discontented saw hope for something new. Many, though, saw this new skyscraper as an artistic and architectural failure; it was trim in an age of architectural obesity.

Another significant point of departure from conventional and contemporary design was the tower's "softness," or the lack of sharp or abrupt edge conditions. Viewed in plan, at all spandrel levels, a single, uninterrupted, sinuous line is drawn around the building's perimeter, one without any angle … seamless. Window bays merge into walls with gentle curves; bay sides dissolve into each other, all with rounded brick. This curving device is repeated where, traditionally, a classical cornice was located; in its place is a simple bowing of brick, a gentle blooming of sorts, a flowering wall "without a single dissenting line." The Monadnock Block's image and profile hailed not from European precedent, but from *African* imagery, from Egypt. This was the first, perhaps only, skyscraper whose form was based upon an Egyptian motif, specifically the aquatic papyrus plant. When viewed from the north, the tall papyrus stalk form becomes clear, its lines and mass melt into an altogether single and powerfully abstract architectural statement. Undoubtedly, to the Piccirillis the Monadnock would have appeared naked, a box stripped of ornamentation, an architectural revulsion.

What Root achieved artistically most assuredly surpassed the whims of Aldis and Brooks. Although inspired by an ancient foreign culture, Root did not slavishly copy, he reinterpreted natural forms for a new building *type* and *purpose*. And in that spirit, the Monadnock rests in the realm of the modern.

It can be argued that Chicago's Monadnock Block was famous not for what it possessed, but for what it lacked. This Gilded Age skyscraper did not have Greek or Roman gods fixed to its façades; the Monadnock's walls featured no antique heroes — *it* was the hero. There was no carved American flag or national shield on any façade. Unlike so many other skyscrapers then, the Monadnock even lacked a flag pole, rooftop or wall-mounted. This skyscraper was not a national symbol, nor did it need to support one.

Here stood a monument not to one nation, nor to one people, but to humanity. It was a building for our species, a building for all people, a structure that was truly democratic; the Monadnock could be appreciated for what it was, and only for what it was to

John Wellborn Root (1850–1891) (Chicago History Museum, Max Platz photographer, ICHi-30622).

Left: Like the sleek prow of a great ship, the corner of the Monadnock slices effortlessly through the air (photograph by author). *Right:* This is the Monadnock Block's curving edge that separates its base from its upper floors. It is modern, simple, yet pregnant with power. Lewis Mumford perceptively wrote of the Monadnock Block, "The success of it comes from a series of subtle refinements and nuances" (photograph by author).

become to some, a monument to mankind and to achievement. There was no need to brush up on one's knowledge of ancient Greek legends, gods, or heroes to truly appreciate the Monadnock's beauty, its simplicity, its grandeur. In this way it was *democratic*, it could be valued and its beauty recognized exactly for what it was by any race, nationality, tribe, or clan — anywhere. All this building required of the pedestrian was to be looked at and to be admired for what it was, and it was a simple brick box erected to house people — and yes, to ultimately make a profit. In a delicious ironic twist, it turned out to be so much more.

Rooftop Dialogs

Buildings, especially like the Monadnock Block, are similar to books, and occasionally their texts do indeed "move us," as the architect Le Corbusier promulgated. Good architecture should do that; a society's hopes and dreams are embodied in good architecture and in good prose — or they should be. Buildings speak to people. They read out loud to people and to each other. Visual conversations are constant; sentences jockey to be heard, to participate in that very human "phenomenon of the emotions." From building base to rooftop, dialogs persist. Two buildings in Boston and one in Chicago, although long gone, still speak to us; they were the hopes and dreams of entrepreneurs also long gone.

One such building was Boston's Masonic Temple (Merrill G. Wheelock, 1867). Here was a seven-story building decked out in full Gothic costume. The temple's cornerstone was laid

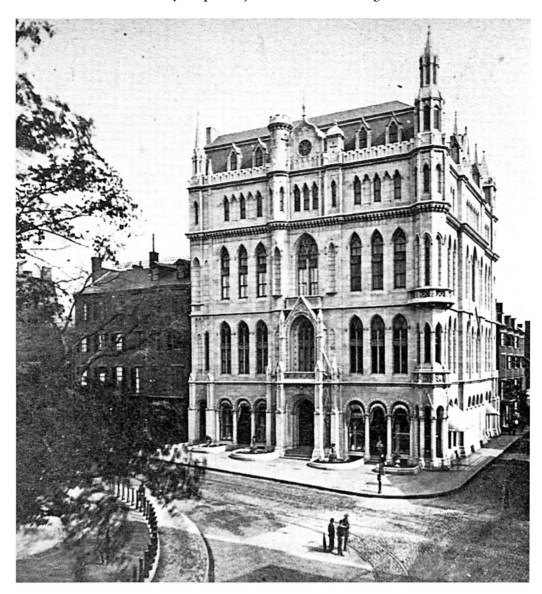

Boston's Masonic Temple was Louis H. Sullivan's childhood inspiration (John P. Soule, "Boston and Vicinity," view number 624, c.1880).

on October 14, 1864, and on June 24, 1867, the building, located at the intersection of Tremont and Boylston Streets, was pronounced completed. The Masonic Temple measured 85 feet wide and rose 90 feet to its roofline, with one of its octagonal towers piercing the sky at 121 feet. Like the cathedrals of Europe, its exterior was mainly composed of light gray granite and glass, with awe-inspiring verticality. Architect Wheelock (1822–1866) drew this exquisite Gothic Revival office and fraternal headquarters building to include "three large halls for meetings, on the second, fourth, and sixth floors, finished respectively in the Corinthian, Egyptian, and Gothic styles. On the intermediate floors are ante-rooms, small halls, and offices; while in the seventh story are three large banqueting-halls."[10] Extravagance was a hallmark of the Gilded Age, and Boston's Masonic Temple complied without hesitation. But one day, a 12-year-old boy would view the Masonic Temple, become enthralled by it, and vow some day to be an architect. It

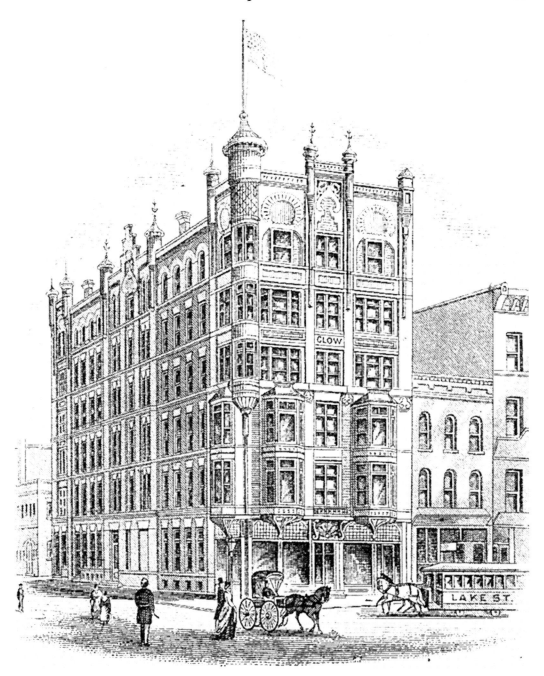

Chicago's Clow Building of 1880 ironically spoke a language of mystery and exotic places on simple and unadorned Lake Street (author's collection).

spoke quietly to him; it talked of verticality, of permanence, of a direct expression of materials. Some 55 years later, this one-time little lad would write about it, in *An Autobiography of an Idea*. This building, a Gothic Revival mass of stone, is what inspired architect Louis Sullivan to eventually accomplish great things.

Speaking eloquently, yet with a decidedly exotic accent, was the Clow Building of 1880. From the flat and broad-shouldered city of Chicago, the Clow Building represented much of

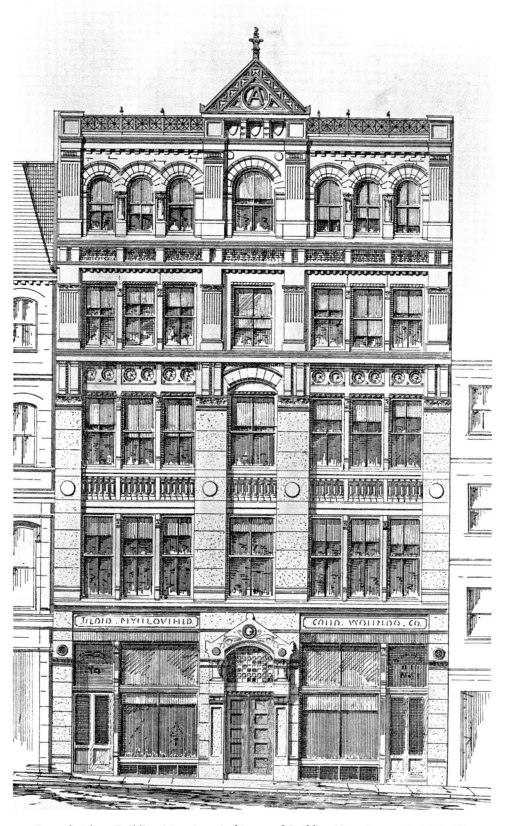

Boston's Adams Building (*American Architect and Building News*, August 11, 1877, 85).

the hopes and dreams of the Gilded Age. In 1878, at the age of 18, entrepreneur William E. Clow founded a plumbing supply and distribution company. In this rags-to-riches tale, Clow's early success allowed him to inhabit, and rename for himself, a seven-story office building once located on the northeast corner of Lake and Franklin Streets. His business line included "cast-iron pipe, plumbing goods, steam, water, and gas specialties, gas steam radiators, and fabricated marble." Years later, he and his sons, James and William, included various water valves and boasted the distribution of municipal fire hydrants. The Gilded Age was rife with opportunity.

The headquarters of the James B. Clow & Sons Company resided in a skyscraper that advertised its height with attenuated piers and an elongated bartizan (fanciful tower) with flagpole. Middle Eastern or Moorish motifs wrapped the building with unabashed romanticism. This skyscraper did not serve a bank, brokerage, or major insurance firm, but a plumbing supply company. True, the structure was small, but the *idea* was there, the concept of communicating success by occupying a *tall* building. Though diminutive, this skyscraper was a potent visual force.

Shortly before the advent of the Civil War, Charles Amos Cummings (1833–1906) and Willard T. Sears (1837–1920) formed an architectural partnership in Boston. In 1877, the firm of Cummings & Sears saw to the completion of an office and commercial structure called the Adams Building. This Boston building stood five floors and employed vague references to Romanesque architecture. This building was never considered a skyscraper. It is, though, a fine example of a typical urban business block of the early Gilded Age. There was "tallness" to it, a decided verticality, and it is from buildings like these that the idea of the skyscraper evolved. America was filled with "Adams Buildings." Entire districts of similar commercial buildings proliferated throughout America: New York, Philadelphia, Baltimore, and Chicago, too, counted thousands of four- or five-story business blocks. Styles varied, but the seeds were well planted in all great cities for the eventual growth of the skyscraper.

Buildings like Boston's Adams did not just happen. They were planned, designed according to long-established rules and laws of façade organization; windows were not serendipitously punched into a wall.

But first the architect had to come to terms with various structural constraints placed upon buildings by natural forces, including the wind and gravity, live and dead floor loads, zoning restrictions, local codes and covenants, capricious building inspectors, budgets, lawyers, engineers, and, lastly, the whims of clients. Having waded through this professional river of treacherous waters and hidden quicksand, the architect would be fairly certain that he would emerge unscathed on the opposite shore, a dry place from where he could employ the artistry and creativity that was expected of him. The tenants, the public, and the daily passersby were the ultimate judges of the architects' skills and tastes by the manner in which he handled the building's façade. Beauty, though subjective, was all-important during the Gilded Age, and this illusive quality ultimately decided if the architect was to be awarded future commissions. Architects simply had to follow the rules.

To the Gilded Age man and woman, the Adams Building was considered a visual success because it followed the rules. The architectural firm of Cummings and Sears saw to it that no aesthetic standards were ignored, and they created for their client an altogether harmonious building, polite to the street and the neighborhood. It fit in well in its context, made no visual blunders, and adhered to long-established organizational principles and proportioning systems.

This commercial building served its owner-client in three principal ways. The first floor featured retail spaces, the upper floors housed office spaces, and the whole of it brought in cash.

The first of these principal ways can be recognized by the manner in which the façade was organized: The first floor is marked by large window panes, a strategy employed to allow pedes-

trians to easily view whatever goods were for sale within. A glass-panel pedestrian door was located adjacent to each storefront for public access. The center of the composition was occupied by a prominent hooded doorway, trimmed in stone, highly ornamental, and marked by two large wood-panel doors; there was to be no mistake where the important office firms were located and how one could access them. A small vestibule was just inside. Here one encountered a coat rack, umbrella stand, full-length mirror, and a wall-mounted office directory. A spittoon was optional. A fancy staircase, usually with ornately carved newel posts, balusters, and banister was present, and the steps were carpeted for a quiet entry. Gas fixtures provided the indoor lighting. On the exterior, commercial signage was typically fixed in the sign zone positioned between the first and second floors.

Floors two through five marked the locations of multiple offices for rent. These medium-size spaces were usually occupied by lawyers, accountants, physicians, brokers, and other small businesses. The offices' ceilings were tall, their floors were of hardwood, and they usually had a wash sink in the corner; a bathroom was shared and usually anchored the end of a common hallway. Again, lighting was provided by multiple ceiling-hung fixtures.

In so many ways the building's exterior sold the building. A handsome or memorable exterior façade was responsible — of course, with the building's location, monthly rent, age, and office amenities — for attracting renters and for assuring the retention of tenants, both office and retail. Simply stated, ugly buildings often had higher vacancy rates than others.

A handsome and memorable exterior adhered to certain principles. During the Gilded Age, symmetry was held in high esteem. Applied generously were proportioning systems established during the Renaissance and centuries before to bring balance through mathematical harmony to the façades of buildings. Nothing was haphazard, nothing was left to chance. The ratios of height to the width of each door and window opening was calculated and fixed to a specific formula. The ratios of the lengths of the sides of vertical and horizontal bays were fixed in relation to each other, and also to the overall proportions of the building.

Mathematically precise formulas were expeditiously used by the ancient Greeks and Romans for buildings constructed as early as the fifth century BCE. Proportional perfection was paramount in the minds of temple designers and builders for some 24 centuries before the Adams Building's scheme was put to paper. The Golden Section — defined by the ratio 1:1.618 … and represented by the Greek letter *Phi*— was but one of these proportioning systems, or visually "correct" ratios employed to bring harmony and repose to the public buildings of Greece and Rome. These magical and unchangeable ratios were, according to Renaissance thinkers, mathematicians, and the European clergy, products of Divine Law; their religious zeal and prejudices allowed such thinking the credence it did not deserve. Along with the Golden Section (sometimes also referred to as the Golden *Mean*), the root-two-rectangle, the root-three-rectangle, and a host of other ratio-based formulas were employed by architects.

It is impossible to definitively say which, if any, of these proportion devices were used in the laying out of the Adams Building's principal façade; but without the notes and original drawings of this building, one can only hypothesize that some sophisticated mathematical equations were employed to achieve a visually harmonious and overall pleasant *symmetrical* result.

Regarding its overall balance, the stone and terra cotta façade of the Adams Building was, indeed, symmetrical. It was divided into three bays (left to right), and four sections (bottom to top). The relatively flat façade was sectioned by three vertical masonry walls or pilasters, and three band courses with the inclusion of a rooftop cornice. Within the divisions were found decorative shields, medallions, consoles, pilasters, capitals, balusters, colonettes, dentils, a baluster course, arcaded windows, and a host of other decorative elements. A rooftop pediment, topped by a poppy-head finial, caps the central bay. All the Gilded Age architectural components were

here, assembled to preordained proportions and carefully positioned within the compositional framework. Pretty, but not much was new; Cummings and Sears appropriated forms from the Classical, Romanesque, Gothic, and Renaissance sources and used them in a competent but common way. The Adams Building did not achieve architectural greatness. The Adams Building was no Monadnock Block.

Whether a building whispers of Romanesque, Gothic, Moorish, or other exotic typology, America's tall office buildings were, at the very inception of the Gilded Age, stylistically diverse. The Masonic Temple, Clow, and Adams buildings were only three business blocks of thousands that represented the hopes and dreams of professional men, shopkeepers, fraternal organizations, and blue-collar businessmen. These structures were American storytellers, communicators of history, myth, and entrepreneurial success. Future skyscrapers would be built upon the shoulders of buildings like these; they were functional, and they were necessary. But future skyscrapers would also come to be symbols, extravagant symbols of success, of accumulated wealth, and apt symbols of power. That is to say, they were simply the result of human endeavors, of the human heart and mind; these were expressions of humanity, of our species. Each culture, each society for millennia, has done the same thing; they all built *symbolically*. These symbols just happened to be taller than those of earlier times, with only a few exceptions. Egypt's Great Pyramids and some Gothic cathedrals rose higher for a time, but eventually they, too, would be scaled by America's contribution to this art form called architecture and to its most vibrant achievement, the skyscraper.

The Piccirillis, Aldis, Brooks, Root, Wheelock, and Clow all shared the desire to communicate their achievements to their peers, to the public, and to posterity. For these the selected modes of speech were sculpture and big buildings acting as armatures upon which to place the results of the chisel and hammer. These men derived great satisfaction from their buildings; hopes came true, and dreams were fulfilled. Gilded Age prosperity was on display; these personal and financial accomplishments made most Americans feel good about themselves and their country.

There was one man who did feel good about himself and his country, and he attempted, although he was not totally successful, to fully understand the aesthetic issues at stake for the skyscraper form during the Gilded Age and after. American architect, historian, and noted author Frank E. Wallis (1860–1929), was largely a self-taught Easterner, a man who initially learned about architecture by drawing and traveling, by seeing and recording the buildings of America firsthand. He was born in Maine, just before the advent of the Civil War, and as a young man he traveled extensively throughout America. For a short time, Wallis was schooled in the Boston office of Cabot and Chandler, and in 1882, Wallis left to make the obligatory pilgrimage to Europe, as many architects did back then, to study the buildings of that continent and to absorb the styles and meanings of that continent's ancient buildings. There he sketched and climbed the structures that profoundly influenced the architecture of this country.

Despite his European wanderings, or perhaps because of them, Wallis was fascinated by America's colonial architecture and its furniture, and, in 1887, he published his first book on the subject.[11] One year later, he settled in New York and for a time was employed in the office of architect Richard Morris Hunt. While with Hunt, Wallis designed homes for wealthy New Yorkers, for the celebrated clients that formed the bedrock of a large and successful Manhattan firm during the Gilded Age.

Frank E. Wallis, the consummate Easterner, was one celebrated member of the generation of architects who worked during the Gilded Age. He opened his own architectural office in midtown Manhattan in 1895 and continued to write and critique. He was a contemporary of Louis Sullivan and other Chicago architects who, together, promoted the far reaching "organic"

design philosophies that Sullivan espoused. Wallis was also intimately familiar with the work and writings of his Eastern colleagues, of both critics and architects alike, men like Schuyler, Ruskin, Post, White, McKim, Kimball, and Robertson — those professionals who freely borrowed from European models no matter what type or how tall.

Wallis, being a scholar, writer, and critic, was undoubtedly aware of Louis Sullivan's position regarding architecture and building ornament, and the relationships between these and the treatment of the wall with regards to the supporting structure beneath. Sullivan's "radical" opinions, his ideas regarding ornament and historical architectural borrowings, were published serially beginning in 1901; besides, Sullivan was a celebrated critic and very accomplished architect of whom every Eastern-practicing architect was undoubtedly aware. Wallis was cognizant of the advances that were possible with the invention, or perhaps more specifically the *development*, of the curtain wall and the aesthetic possibilities that it promised for the future of the skyscraper. In 1910, Wallis had published the following commentary in a book titled, *How to Know Architecture: The Human Elements in the Evolution of Styles*:

> With steel construction it is no longer necessary to use walls for supporting the structure. They may, in fact, be built from the top story down, and their sole purpose is protection from the weather. Are we, then, to treat this great self-supporting steel framework as if it needed additional support, and pretend to carry it with walls made in imitation of the supporting walls of former styles, or are we to look at it with a fresh eye, recognize its real structure as inherent and self-sufficient, and, meeting the issue honestly, enclose the building logically and at the same time beautifully?
>
> The first sky-scrapers were designed in the classic style because that was the style of *convention* [italics added]. So we had the astonishing incongruity of a Greek temple, with all its niceties of detail elongated to an extraordinary height and much of its fine detail wholly lost to the naked eye. Our tall buildings are still usually surmounted by a heavy and elaborate classic cornice at a height of two or three hundred feet — a thing incongruous, useless, and unfit.[12]

Wallis sounds to be a progressive in these two preceding paragraphs, an adherent of the ideas of Sullivan, a proponent of a modern approach to façade design, a defender of Sullivan's arguments regarding organic architecture. Wallis confirms the power of the "style of convention," a translation of habitual copying. He derides the Greek-temple-styled skyscraper, as did Sullivan, and proclaims that those ancient forms are being misused. Wallis continues:

> We [architects] have been experimenting since then, and have learned many things about the treatment of tall buildings, but we still use the horizontal lines of the classic and divide the wall surface into base, shaft, and capital, with the attendant entablature somewhat after the division of the classic column.
>
> It is astonishing that no one for so long thought of building many-storied office structures in pure Gothic, for here surely is the logical treatment of the problem, at least within existing traditions. The so-called sky-scraper is as essentially expressive of height as the Gothic churches were. The long vertical lines are its dominant lines, yet in almost all existing types these are broken as far as possible by heavy horizontal lines, as if the intent were to make it a superimposition of disconnected stories and group of stories. If pure Gothic forms were used the horizontal lines would retire, and the vertical lines be accented to the fullest, carrying up from story to story in a way that would immensely increase the impression of height. The plain surface between the lines of support would be treated probably in terra-cotta slabs, or some plastic form that would honestly express the mere intention of enclosing the building. This would, in the Gothic style, be much more feasible than in a classic form; and it would be more economical because of the simplification and repetition of manufactured decorative details.[13]

Here, architect Wallis unashamedly promotes the "Gothicization" of the American skyscraper. In this passage, Wallis was suggesting the replacement of one historical form for another. Instead of a Greek-temple-skyscraper, a better substitute would be a Gothic-cathedral-skyscraper; he

boldly and simply suggested replacing one deity-based-building type for another. Wallis continues and concludes his observations thusly:

> While the big cities with their great sky-scrapers are working out their peculiar and special problems, and may find the solution in Gothic lines, the line of growth in all other kinds of buildings is thus distinctly toward the classic — one might almost say the more classic. These seem the dominant tendencies, but almost equally significant is the frequent and sound use of almost every style we have named. It is, as has been said, a period of analysis and experiment. Young America is trying to express herself, and because she is a conglomerate of many elements, the expression is still various and uncertain, but with fixed tendencies growing more and more apparent.[14]

Wallis, in so many words, epitomized the thought processes of some architects designing skyscrapers during the Gilded Age. Curiously and ironically, Wallis realized the foolishness of dressing skyscrapers like Greek temples, of stretching these to improbable heights out of pure "convention," yet he admonishes architects to design new tall buildings like the centuries-old Gothic cathedrals he observed and drew while in Europe. This philosophical dichotomy was indeed indicative of a nation "trying to express herself." The writings of Wallis and of others of those times, reveal much about a struggle to discover or to create a proper architectural language for America's newly invented building type, the skyscraper.

As for Frank E. Wallis, his Eastern clients chose buildings of conservative design, buildings within a preconceived "convention" that looked to the past for their inspiration. Wallis happily obliged them and doggedly designed buildings that employed American Colonial, Georgian, and Gothic Revival styles. In 1921, Wallis retired from professional practice and removed to France, where he died eight years later among the Gothic buildings he so admired.

Building Walls and the Power of Mythology

The Gilded Age was a time of profuse architectural decoration — inside and outside — where buildings were wrapped with historical detailing, most of it plagiarized from antique sources. Today's streamlined structures, our tall buildings, retail outlets, strip malls, gas stations, fast-food restaurants, and expensive public and cultural buildings, exhibit almost no external ornamentation. All extraneous carving, moldings, or sculpture has been systematically sponged from the faces of contemporary buildings, much to the chagrin of cultural observers. It may be

difficult for contemporary pedestrians to understand the reasoning that occurred in the minds of Gilded Age architects and developers to create and to pay for buildings with such ornate façades; a stroll in lower Manhattan or Chicago's Loop may pose more questions than answers.

There was a time, during the Gilded Age, when Greek and Roman mythology was most often mined by American architects for the precious treasures they imparted to mankind, gems symbolic of courage, honesty, thrift, forgiveness, and yes, profit. Mythological creatures,

James Cook Ayer (1818–1878) was president and founder of a nationally known patent medicine business, the Dr. J. C. Ayer & Company. His enterprise published an almanac filled with descriptions of ailments, their treatments, a variety of product advertisements, and a host of allegorical images. Due to their familiarity with the American public, Ayer's firm of "Practical and Analytical Chemists" selected images from antiquity, as did contemporary architects, to embellish pill advertisements and skyscrapers alike (Dr. J. C. Ayer & Company, Lowell, Massachusetts, 1879).

The Roman god Jupiter appears at the entrance of the tall William H. Dorothy Apartments (Oscar Lieventhal, 1895) in Chicago. The divine bust serves as the keystone in a typical roman arch (photograph by author).

gods, goddesses, allegorical figures, and a host of other sources unearthed from the ancients were recorded upon the walls of America's skyscrapers. Given their powerful penchant for antiquity, America's Euro-centric architects were curiously selective in their choices of subject matter with which to impart desired human qualities to society via the medium of architecture.

On no skyscraper of the Gilded Age appeared a bust or image of any member of a European royal house. No king or queen who actually lived and made profound contributions to history is carved in stone or terra cotta on any skyscraper wall. No real people; only imagined people appear. None of the Charleses or Louises or Frederickses or Habsburgses appeared. Absent, too, were Alexander, Charlemagne, Peter the Great, and Napoleon. In short, there seemed to be no interest whatsoever in portraying actual historical figures from Europe's long and checkered past on the walls of America's business towers. Sculptures of Atlas, Neptune, and Mercury do appear.

Theodorus of Samos (born 584 BCE) was an accomplished architect, sculptor, and scientist. He is credited with inventing the ruler, carpenter's scale, the level, the lathe, bronze casting, and the lock and key. Archimedes of Syracuse (c.287–c.212 BCE) was a mathematician, an inventor, and a physicist. Archimedes was also a noted engineer and astronomer, and he was regarded as a military genius due to his explorations into the design of siege engines. Architects Callicrates and Ictinus designed Athens' Parthenon (447–432 BCE), the icon of ancient Greek architecture. What of Herodotus, Homer, and Aristophanes?

Poseidon, the Greek god of the seas and oceans, characteristically appears in the center of a sea shell. This terra cotta creation appears on the façade of an 1882-completed commercial building in Chicago (photograph by author).

Ptolemy, Plato, Pythagoras, Phidias, and dozens of ancient Greek artists, writers, poets, scientists, and others can be included in the list of the intentionally overlooked. The images of these ancient champions appear nowhere on any Gilded Age skyscraper. Sculptures of Atlas, Neptune, and Mercury do appear.

The ancient Roman world was equally snubbed. Marcus Tullius Cicero, recognized most often as simply Cicero (106–43 BCE), was a Roman historian, writer, orator, philosopher, statesman, lawyer, linguist, and translator. Marcus Vitruvius Pollio (c.75 BCE–c.15 CE), known by every student of architecture merely as Vitruvius, was an accomplished architect, philosopher, historian, engineer, writer, and the author of the profoundly influential *De Architectura*, known more commonly today as *The Ten Books of Architecture*. Gaius Plinius Secundus, otherwise simply known as Pliny the Elder (23–79 CE), was a philosopher, author, scientist of nature, and a general of the Roman army. He authored the famous *Naturalis Historia*, an encyclopedic work summarizing his study of nature and geography. Here, too, were men to be reckoned with. And still, on the façades Gilded Age skyscrapers, sculptures of Atlas, Neptune, and Mercury do appear.

The ancient Greek muse Thalia was carved in limestone on the façade of a large Chicago commercial building designed by the firm of Faber & Pagels and completed in 1893 (photograph by author).

As if to appease the gods, renowned humans from antiquity, people who accomplished extraordinary things, were overlooked in favor of the inclusion of imagined deities, heroes, and monsters upon the walls of America's tall business buildings. But not only gods and goddesses were displayed; strange and horrible monsters joined the panoply of acceptable decorations. The hopes and dreams of the ancients and of contemporary architects, builders, and financiers not only tolerated the inclusions of dragons, centaurs, chimaeras, mermaids, sirens, and nymphs, but they insisted upon these being included in the designs of Gilded Age skyscrapers.

The following dragon-creation scenario would be typical in a large architecture firm, the type of firm most often associated with the design of a large American skyscraper. A staff architect would have to draw a European-based (contrast Asian) dragon image in pencil or India ink, perhaps in multiple colors, on a sheet of paper or prepared linen. He or she would have to consciously design the thing after locating it exactly where it was to be positioned on the building façade, correctly proportion it, and explain how it was to be permanently and securely affixed to the wall. Pattern books would be consulted for the correct or desired image. The creature's design would have to be reviewed and accepted by a studio head or job captain, approved by an architect-in-charge or the firm's principal, and ultimately receive the blessing of the client. In short, it would have to pass a rigorous inspection, be included in the building's specifications, and receive a production, delivery, and installation cost. This would have been a budget item,

and the client would have to pay for this extravagance. This mythological beast would have to be inserted into the building's façade, and it would have to be resident in the composition of the wall for the life of the building. People would have to be able to see it. Its inclusion would be deliberate; its meaning was expected to be understood by the public and the building's tenants.

In another professional scenario, an architect would simply specify the inclusion of a dragon, and an artist in a metal shop or a terra cotta factory or an

In Roman mythology, Mercury was the messenger of the gods and protector of commerce and travel. This iteration appears in metal on the façade of the tall Mid-City Trust and Savings Bank (Horatio R. Wilson, 1910) in Chicago (photograph by author).

An unknown architect of a commercial building in Chicago, completed in 1902, saw fit to include this image of the Greek god Hymen, an ancient deity responsible for marriage, who stealthily presided over all wedding ceremonies (photograph by author).

Mercury often appears, especially on the walls of early skyscraper bank buildings. The façade of Milwaukee's seven-story Mitchell Building (Edward Townsend Mix, 1876) offers this version. Grotesque demons look on (photograph by author).

architectural stone-carving studio would invent the dragon, draw it to scale, and actually manufacture it for review by the building architect. In either scenario, and after receiving the endorsement of the architect-in-charge, the dragon drawings — plans and multiple elevations — would be sent to a factory or to the studio floor for production. A small but properly proportioned plaster casting or model, a *maquette*, would be made for the architect's review with the sculptor's hope that production would commence shortly on the full-size piece. Weeks, possibly months, of fabrication time would be required depending upon the material chosen and the number of items contracted; some skyscrapers featured dozens of creatures in a wide variety of poses, and often limestone or granite was employed as the medium, requiring much carving time and higher costs. In any case, a series of meaningful, expensive, and time-consuming decisions and activities were required by many individuals to include a mythological creature, like a dragon, into the façade matrix of an American skyscraper.

And who could possibly choose whom or what to carve on the façades of this or that building? Which image will it be today? And, in perhaps the strangest of ironies, more often than not a Manhattan-based, Euro-centric, *Christian* architect was given the honors.

From just the world of Greek and Roman mythology there was a galaxy of celebrities from which to select. Exempting the mythologies and fables of ancient

A griffin was a guardian creature having a lion's body with an eagle's head and wings. It was said to "possess the strength of eight lions and one-hundred eagles" and was sacred to both Athena and her brother Apollo as a symbol of vigilance and vengeance. Two of these ten-foot-tall creatures stand sentinel at the entrance to Milwaukee's Mitchell Building (Edward Townsend Mix, 1876) (photograph by author).

Details of the iron casting of this monster reveal an extraordinary attention to detail. It was produced in 1876 by the Younglove Architectural Iron Company of Cleveland, Ohio; a contemporary advertisement boasted that they "manufacture and erect store fronts, cornice, window caps and complete iron buildings." After gilding, Younglove shipped the components to the firm of Gould Brothers & Dibblee of Chicago for assembly at the entrance to Mitchell's banking floor (photograph by author).

Egypt, Britain, Scandinavia, Africa, Polynesia, the Middle and Far East, and, of course, the rituals and belief systems of the native nations of North, South and Middle America and the Eskimos, there were still hundreds of sources from which to choose. The ancients established an ironclad hierarchy of beings and beasts, a pecking order of who reigned over whom, and of who could mess with whom without any retribution. There were rules and laws governing the conduct of each dreamt-up creature and extraterrestrial being.

As an ancient Greek or Roman child, or as a Gilded Age American architect, there were many mythological entities and families of beings with which to contend. There were the deities of the highest order, the inferior deities, and the demigods or heroes. Mingling in and with these were the muses, graces, fates, furies, rural deities, water deities, the winds, wood-nymphs, sea-nymphs, the titans, the monsters (chimeras, centaurs, pygmies, griffins, etc.), and the giants (cyclopes, circe, sirens, etc.).

The Roman god Mercury presides over the bow of a vessel encumbered with cornucopia, shields, ridiculously decorative oars, and windblown ribbons. This Beaux-Arts assemblage graces the façade of the 11-story Board of Trade Building (Winslow and Bigelow, 1903) in Boston's financial district. Being a coastal city with international interests and a 300-year history of overseas trade, this skyscraper's architects employed a particularly potent symbolic image to help define the goings-on within (photograph by author).

The chimera was a hybrid monster that was composed of a lion's head, a goat's body, and the tail of a dragon; it breathed fire and roasted its enemies alive. The centaurs were depicted with the body and legs of a horse and the torso and head of a man; these were known to rape women. Pygmies were a nation of vicious dwarfs. A griffin had a lion's body with an eagle's head, talons, and wings; it was immensely strong and ferocious. Each could be found on the fronts of tall business buildings in major American cities, including New York, Chicago, and Boston. Often, educated people of the late 19th century could name and understand the meanings of these creatures. It is certainly doubtful, though, if these beasts really had any profound relevance to the pedestrian on Broadway, on LaSalle Street, or on Milk Street.

Centuries ago Christianity superseded European paganism and set about replacing some of the ancient superstitions with new ones. Occasionally, old monsters were dredged up from antiquity as warnings to sinners to repent and behave. Enter the phoenix, the basilisk, the unicorn, and the fatal salamander. Each of these creatures, too, had some particularly gruesome

attributes that played well for keeping the flock on the straight and narrow. Add to these mean dwarfs, spooky sprites, leprechauns, and elves, and you could have scared the average medieval family half to death. How so, the family in the industrialized American city of 1890?

Ancient Greek and Roman mythologies were collections of stories, timeless tales about wisdom and life's pitfalls. Centuries ago, these stories helped people come to terms with their life struggles, disappointments, and tragedies. These were at once adventuresome, entertaining, informative, frightening, and, occasionally, strangely consoling. Often the mythic images these stories created were consciously passed from generation to generation, eventually becoming manifest on the walls of some tall building downtown. Though supposedly "timeless," few people today are even remotely aware of their existence on a building's façade, or are cognizant of the tales and lessons they purport to tell.

It is understood that ancient mythology can give meaning to modern life —*if* properly taught and understood. It is true that upon the exteriors of ancient temples one can only find the carvings of mythical

The son of Saturn and the king of the seas was the Roman god Neptune. He appears here on the façade of Boston's six-story Cunard Building (Peabody and Stearns, 1901). Appropriately an adjacent Vitruvian scroll (stylized ocean waves) stretches across the building's façade. In lieu of a contemporary transatlantic steamship, the architects of this home office for the Cunard Lines Company opted for carved images drawn from antiquity to give the building meaning, albeit ancient (photograph by author).

and allegorical figures, often in various heroic escapades. If the American skyscraper is but the distant descendant of these temples, it would be expected that some Gilded Age façades would be equally treated, and indeed some were. But Greek and Roman mythology's appearance on some of the façades of American skyscrapers of the Gilded Age, *and for decades afterward*, seems to cheat, to preempt, *America's* modern industrial culture of celebrating in stone *America's* own heroes, tales, and accomplishments.

Chapter Three

Togas and Parasols

There will never be great architects or great architecture without great patrons.[1]— Edwin Lutyens (1869–1944)

Great patrons were everywhere. Each city had its Medici family which derived wealth from steel, coal, lumber, real estate, or banking; a few families amassed fortunes from all these. Seemingly never at a loss for words, Louis H. Sullivan colorfully described the tenor of the Gilded Age and those individuals who were potentially "great patrons" of architecture:

In the turmoil of this immense movement [the Gilded Age] railroads were scuttled and reorganized, speculation became rampant, credit was leaving terra firma, forests were slaughtered, farmers were steadily pushing westward, and into the Dakotas; immense mineral wealth had been unearthed in Colorado, South Dakota, Northern Wisconsin, Peninsular Michigan, the Mesaba Range in Minnesota. The ambitious trader sought to corner markets. The "corner" had become an ideal, a holy grail. Monopoly was in the air. Wall Street was a seething caul dron. The populace looked on, with open-mouthed amazement and approval, at the mighty men who wrought these wonders; called them Captains of Industry, Kings of this, Barons of that, Merchant Princes, Railroad Magnates, Wizards of Finance, or as Burnham said one day to Louis: "Think of a man like

Classical imagery was popular in advertising. Courtesy of the New York–based Metropolitan Life Insurance Company was this trade card of 1895. "His" and "hers" togas, complete with hearty plants and dropped fruit, set the stage for a Greco-Roman fable. In this instance, one should purchase industrial insurance lest tragedy occur (author's collection).

Those of the café society, or the leisure class, were blessed with discretionary income and much free time. Between tennis matches, discussions may have evolved around the exploits of Odysseus or the works of Titian and the glories of Rome. Then again, perhaps not; *love* was in the air ... and on the tennis score card (author's collection).

Morgan, who can take a man like Cassatt in the palm of his hand and set him on the throne of the Pennsylvania!" And thus, in its way, the populace sang hymns to its heroes.

This image from 1900 depicts a svelte woman with all the necessary accoutrements. Parasol, fringe purse, and fashionable hat mark her as a trendsetter. Being impeccably dressed meant the wearing of an oversize hat, one more element that emphasized the eccentricities of the day (author's collection).

And with equal accuracy and zeal, Sullivan continued his observations of American culture, democracy, and the upward mobility of society:

The people rejoiced. Each individual rejoiced in envious admiration, and all rejoiced in the thought that these great men, these mighty men, had, with few and negligible exceptions, risen from the ranks of the common people: That this one began as a telegraph operator at a lonely way-station, and this one was boss of a section gang on such and such a railroad; another started in life as a brakeman; that one was clerk in a country store; this one came to our hospitable shores as a penniless immigrant; that one was a farmer boy; and their hymn arose and rang shimmering as a paean to their mighty ones, and their cry went up to their God, even as a mighty anthem, lifting up its head to proclaim to all the world that this, their Country, was vastly more than the land of the free and the home of the brave; it was the noble land of equal opportunity for all; true democracy for which mankind has been waiting through the centuries in blood and tears, in hope deferred. This, they cried, as one voice, is the Hospitable Land that welcomes the stranger at its gates. This is the great Democracy where all men are equal and free. All this they sang gladly as they moved up the runways.[2]

All these "equal and free" men, all these humble, democracy-blessed workers developed tastes and opinions drawn from a myriad of sources. And these sources, to the chagrin of Sullivan himself, all too often originated with the ancient world and the Renaissance.

Classicism and the Renaissance

The nation as a whole was of the opinion that it must maintain the virtues of the Renaissance and its ideals: classical literature, philosophy, art, and especially architecture. It was widely felt, especially by academics, that these would bestow upon America all the glories of classical civilization. Furthermore, the study of the classical world was seen as *essential to the education of a gentleman.*

If the study of the classical world was seen as essential to the education of a gentleman, a gentleman of the times could acquire street smarts by observing the buildings of lower Manhattan. An expensive excursion to Europe and to the lands of the Mediterranean was available for the price of a subway token. Exiting from the din of the BMT station at Wall and Broad Streets, that proverbial gentleman would have been confronted by astonishing examples of neo-classical and Renaissance-based architecture. Temple fronts, featuring all three classical orders, could be viewed by just turning one's head: the New York Stock Exchange (George B. Post, 1903) boasted Corinthian columns; the Bankers Trust Building (Trowbridge & Livingston, 1912) featured Ionic columns; and the Federal Hall (Town & Davis, 1842) displayed columns of the Doric order. *Voila,* a living — still much occupied — architectural museum, all for a nickel's ride.

Two of capitalism's most iconic buildings remain the Federal Hall (formerly the U.S. Subtreasury Building), and the New York Stock Exchange. The Federal Hall is a chaste, almost severe composition whose design was borrowed from the many Greek temples sprinkled throughout the Mediterranean re-

The consummate Gilded Age businessman wore a brushed derby, dark topcoat, vest, leather gloves, and watch chain with fob. These mustachioed, dapper dandies filled the streets and offices of the financial districts in every major American city, and almost all dressed alike (cabinet card, c.1885) (author's collection).

No other building has influenced American corporate architecture as much as the Parthenon (Ictinus and Callicrates, 447–432 BCE). For decades, Greek temple-fronts, colonnades, pediments, and sculptural groups sprouted upon the façades of hundreds of American skyscrapers (Dodd, Mead & Company, Julius Sien & Co. Lithographers, 1902).

gion. The New York Stock Exchange was designed as a muscular, visually powerful building, a structure of both pomp and circumstance. Both are magisterial, and both hold special places in the hearts and minds of the Wall Street community. When the New York Stock Exchange Building officially opened on April 22, 1903, the *building* secured the position of "safekeeper" of the country's future and wealth, the *building* became "the very embodiment of the nation's growth and prosperity." It spoke in a classical language, its image conveyed timelessness, order, and resiliency. Its façade

The Renaissance delighted in manufacturing many exotic forms. A terra cotta panel depicting a lush flower garden complete with seahorses appears on the façade of a "modern" Chicago skyscraper. Businesses of the 15th century often employed seahorse imagery to signify that they conducted business overseas, so too for Loop towers. Dolphins — symbols of good luck, safety, speed, and virtue in the Greco-Roman world — often appeared on the façades of American skyscrapers in many creative variations (photograph by author).

The pediment of the New York Stock Exchange as viewed from across Broad Street (Singer Sewing Machine Company brochure, New York, 1906).

was didactic, as was that of the Federal Hall. Working in tandem, only some 200 feet apart, they form an American "acropolis," and synergistically celebrate the myth and allegory of commerce and finance like the Gilded Age skyscrapers that surround them.

The pediment of the New York Stock Exchange embraces a white marble sculptural group designed and executed by the celebrated American sculptors John Quincy Adams Ward and Paul Wayland Bartlett. It is entitled "Integrity Protecting the Works of Man," and it echoed similar designs found on the façades of many nearby and considerably earlier skyscrapers. The Stock Exchange's sculptural ensemble includes the allegorical figure "Integrity," a 22-foot tall female figure flanked by others of her ilk named Agriculture, Mining, Science, Industry, and Invention. Ward and Bartlett decided to convey one quality, and five industries, that they deemed vital to the progress, prosperity, and future of America. There was no doubt in their minds that the public would be able to decipher the messages displayed through symbol and metaphor. Ward and Bartlett knew, without any reservation, that

Chicago's eight-story, 112-foot-tall Ludington Building (William Le Baron Jenney, 1891) echoes much from the Renaissance. Masks, putti, and foliate designs contribute to the overall 15th-century effect. Sheaves of wheat fittingly appear as Chicago was the center of the grain markets during the 1890s (photograph by author).

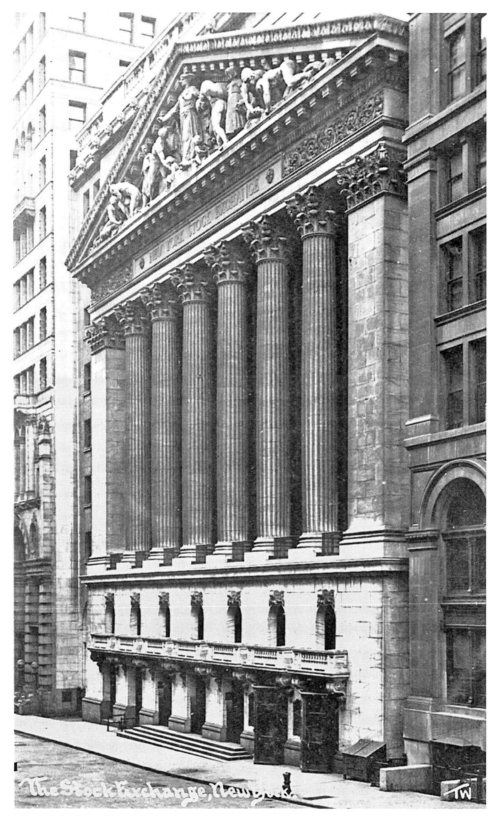

The New York Stock Exchange (George B. Post, 1903), as viewed in 1905, displayed its iconic Roman-inspired Broad Street façade (Thaddeus Wilkerson [1872–1943], New York photographer, 1905).

their creation would clearly convey the concepts of morality, hard work, and perseverance to the pedestrians below. People of the Gilded Age were familiar with allegorical figures and were trained in the "reading" of such characters in understanding the messages being conveyed. This ability was primal to the education of a gentleman. While not expecting a personal epiphany, the artist and architect did expect viewers of their work to be inspired to attempt greatness for their country.

Earlier, in 1882, and momentarily breaking sharply from the allegorical world, J. Q. A. Ward created the larger-than-life bronze likeness of George Washington. Located in front of Federal Hall, America's first president stands with boundless confidence. Here the "Father of Our Country," the one-time boy who would not tell a lie, overlooks the very crossroads of commerce and finance. The message is clear, and it is delivered without classically inspired allegory. Washington, the general, the politician, the honest statesman, was sculpted without horses and chariots,

Inspired by a classical frieze, this terra cotta panel shows Greek youngsters supporting a warrior's shield. The shield, a symbol of defense, is surmounted by an anemone, a flower often associated with the transitory nature of life. In Greek mythology, the anemone grew out of the blood of the shepherd Adonis, killed by the tusk of a wild boar. Curiously, this story panel is mounted upon a tall residential building of the early *20th* century (photograph by author).

or fruit baskets, or forest nymphs. He stands alone; he stands unbridled from classical props and layers of meaning derived from classical mythology. Washington exists in real space; he stands in modernity as an honest and faithful representation of the *man*. Despite his location in front of an ancient-inspired "Parthenon," one understands the meaning; the statue's modernity makes the dichotomy all the more enticing. Classicism was not mandatory, nor was it always desirable.

But why was it so important to have a building, especially a bank, designed with columns out front, tall white things like so many pickets on a fence? Because a temple-front conveyed a sense of permanence, and permanence was fundamental to the world of money. The safety and security of one's hard-earned cash was of more than just passing interest to depositors due to national depressions, recessions, and multiple bank failures instigated by crooks or incompetents. Depositors yearned for institutions where the probability that one's money deposited on Tuesday would still be there on Friday. To Gilded Age depositors, temple-fronts with tall white columns were symbolic of both financial strength (a positive cash flow) and security (the bank will not be robbed). And because these temple-fronts were seen as timeless, depositors reasoned that any bank that would pay a substantial amount of cash to look like the eternal Parthenon must certainly expect to remain solvent "eternally," or at least remain solvent until the bank's mortgage is paid.

Insurance companies, too, bought into these philosophies. It was either through subtle, or maybe not so subtle, means that financial institutions throughout the country found it mandatory to promote the concepts of corporate honesty and integrity through the architecture employed for their home office buildings. People knew through formal education the significance of lion heads, noble allegorical figures, and cornucopia. It was through education and through architectural symbolism that banks and other financial institutions promoted their own security and promised solvency.

Education of the Gilded Age gentleman materialized in many guises; he was in a multitude of ways inundated by the arts and the values of antiquity. Even the balusters and railings of the BMT station beneath Wall and Broad Streets were fashioned from the designs of fluted classical columns; his nickel ride not only transported this gentleman downtown but also back in time.

The Gilded Age was a time when many women carried parasols, and they often viewed marble people, up high on buildings, dressed in togas. Their parasols shielded them from the sun's harmful rays, but these also protected their carriers from the light of anything *not* originating in antiquity. A woman's parasol was her shield; it protected her like Athena's shield, and it symbolized feminine power and chastity in Western culture.[3] No togas could be found in Fifth Avenue dress shops though; they were sold out, seemingly purchased by the statuary that adorned nearby skyscrapers. Some argued modern American culture was also sold out.

Of Myths and Merriment

Renaissance revival styles, accounting for the majority of Gilded Age architectural borrowings, served America and Americans well. The public admired neoclassical and Renaissance-styled buildings; they drank in the columns, the statuary, and the marble doodads because these things "moved" them, as Le Corbusier claimed. In 1931, the Swiss-born modernist further stated, "Architecture is a matter of 'harmonies,' it is 'a pure creation of the spirit.'"[4] To many architects and novices, America's Gilded Age skyscrapers possessed "harmonies" and "spirit." In retrospect, they possessed much more. Some Gilded Age skyscrapers were lavish with decoration and oozed with "harmonies" and "spirit."

Although seven continents exist, only one was the source of the decoration

The main entrance to New York's Cable Building (McKim, Mead & White, 1894) featured this classically draped sculptural group by John Massey Rhind. Two allegorical female figures flank an oculus with a clock. One figure clutches a firebrand, symbolic of the "light of knowledge"; the other grasps a sword, an item usually associated with valor and power. These were important attributes to possess if your company was to prosper (*The American Architect and Building News*, June 16, 1894, no. 964. The Heliotype Printing Company, Boston).

heaped upon the walls of America's most lavish sky-scrapers. European forms, gleaned from the last two thousand years of human achievement, were affixed to masonry walls from sidewalk to rooftop. These elements of carved stone and terra cotta comprised a visual vocabulary as abstract as an alphabet and just as decipherable; skyscraper walls, like the contemporary tabloids, were items of pure entertainment.

Americans of the Gilded Age looked back in history for inspiration, architectural and otherwise. They delved into the realm of the Renaissance and before, to classical scholarship — to classicism — to the age and values of ancient Athens and Rome. American colleges, universities, and high schools were immersed in the toils and foibles of Greek and Roman gods, deities of the highest order, inferior deities, of ancient heroes, writers, poets, and generals. Students at all school levels were taught about the exploits of Hercules, Venus, and Jupiter, and they read about the heroic adventures, philosophical essays and dialogs, poems, and classical tragedies composed by Sophocles, Euripides, Cicero, Seneca, Aeschylus, and Aristotle. Required readings included two poems by Homer (c. 900 BC) the *Iliad* and the *Odyssey*, and students were urged to complete the exhausting *The History of the Decline and Fall of the Roman Empire* by Edward Gibbon (1737–1794). High school students were introduced to *Antigone* by Sophocles (495–406 BC) and the heroic epic *Aeneid* by Virgil (70–19 BC).

Americans were delighted with visits to various art museums, salons, and galleries where works based upon Greek and Roman mythology were in great supply and in great demand. Faces and bodies could finally be attributed to the celebrities of that day; the exploits of Mars and Mercury were made almost palpable for those who for years only read and imagined how these figures appeared. Giant canvases portrayed the adventures of the sirens, the nymphs, the muses, the fates, and the graces. Impish smiles of cherubs and the shadowed faces of scornful imps peered

During the Gilded Age, ancient Rome was personified in America's coinage and currency. This type of silver dollar was designed by George T. Morgan and was minted from 1878 to 1921. It depicts the bust of Lady Liberty as a decidedly *Roman* female. The *Latin* motto "E PLURIBUS UNUM" (out of many, one) figures prominently (author's collection).

This idealized image of a little girl belonging to middle-class America was produced in 1880. Her likeness resembles that found on the American silver dollar, an idealization of a young woman belonging to the Roman middle class. America and ancient Rome had a powerful kinship (trade card, 1880).

Male and female cherubs celebrate abundance provided them by the fields, the fruit trees, and the vineyards. Grapes appear on the left, fruits and vegetables on the right, and a large urn stuffed with the results of a plentiful harvest centers the composition. The source of this cream-colored terra cotta story panel points clearly to the Italian Renaissance, and, more specifically, to very similar images found in the Forum of Trajan in Rome (see: Owen Jones, *The Grammar of Ornament*, page 132, plate XXVI, image 2) (photograph by author).

from behind trees and rock walls to the delight of the viewer but were oblivious to the nakedly portrayed Cupid, Pan, and Psyche. The jokes were played. The audiences chuckled. Americans were also entertained and inspired by way of large books, and art catalogs from European galleries and museums. In these leather-bound books, printed plates of works such as *The Birth of Venus* (Sandro Botticelli, c.1485), *Allegory with Venus, Cupid, and Time* (Bronzino, c.1545), or *Mars Disarmed by Venus Before the Three Graces* (Jacques Louis David, 1824) could be viewed. Frivolity and tragedy were portrayed by such works as *Apollo Pursuing Daphne* (Giovanni Battista Tiepolo, 1760), *The Death of Socrates* (Jacques Louis David, 1787), and *The Rape of the Sabine Women* (Nicolas Poussin, 1637). Painting and sculpture were replete with the stories of ancient Greece and Rome, and the subjects of these stories would eventually migrate to the façades of American skyscrapers.

During the Gilded Age the

Following in the tradition of the Gilded Age, this Ionic column is one of a colonnade that marks the giant banking room of Chicago's Continental Bank Building (Graham, Anderson, Probst & White, 1924) (photograph by author).

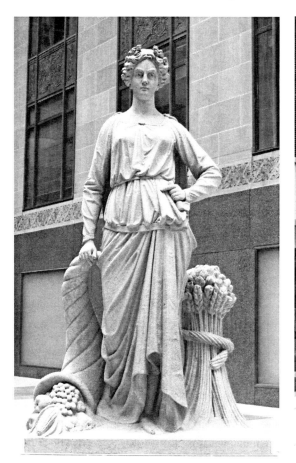 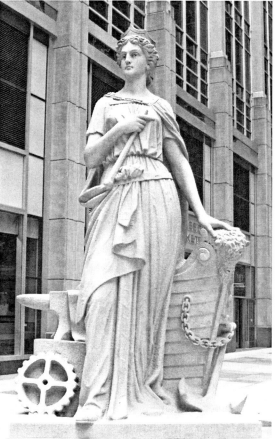

Left: Ceres, the Roman goddess of grain and agriculture, stands flanked by a spilled cornucopia and a sheaf of wheat. She clutches the small scroll of a record keeper, as she was the safeguard of debts and profits. Her face belies one who is a serious contender, a tenacious achiever, an individual who is determined to shape the future of the new city surrounding her. These stoic figures are the epitome of Gilded Age neo-classicism: their poses are contrived and stiff, and their centuries-old symbolism is clear and unmistakable. Both Minerva and Ceres formed a statuary group that graced the front façade of the Chicago Board of Trade Building (William W. Boyington, 1885). After the nine-story, 322-foot-tall skyscraper's demolition in 1929, the two statues — each stands 12 feet and together they weigh five tons — were positioned on a small plaza adjacent to the current Chicago Board of Trade Building (Holabird and Root, 1930) (photograph by author). *Right:* Minerva, the Roman goddess and protector of industry, commerce, overseas trade, and education, is aptly portrayed with an anvil, a gear, and the bow of a ship. She holds a steel pin, or spike, symbolic of the steel mill or of the railroads. Minerva displays a quiet demeanor; she stands reserved yet forthright. This statue and its neighbor, Ceres, were products of neo-classical ideals, which in turn were inspired by excavations conducted in the ancient Roman cities of Herculaneum and Pompeii centuries after their demise. In true Roman form, their attitudes were cool and aloof, and their sculptor's name is long forgotten (photograph by author).

opera house became the venue to *see and hear* about the ancient mythologies. Opera began based upon ancient Greek tragedies, was further developed in Renaissance Italy, and was refined by classical composers. As one of the most important art forms in the history of Western culture, opera introduced much in the way of ancient mythology. Operas such as *Dido and Aeneas* (Henry Purcell, c.1689) were offered to a public eager to *see and hear* of the exploits of the "mythological age."

The public knew of Atlas. People knew of his character, his strengths and weaknesses, and

the role that he played in the world of the ancients. It was the same for Ulysses. It was the same for Perseus, Prometheus, Penelope, Pericles, and Pandora. These were the sports stars, the celebrities of the Gilded Age, and their exploits were common knowledge. Teenage boys could name each of the 12 labors of Hercules as if they were major-league batting averages. Whether or not one had the benefit of a college education, there was substantial knowledge of antiquity and its mythology among the general populace. Americans also lived in cities named after those of ancient Greece and Rome; they appropriated the names of Attica, Ithaca, Seneca, Syracuse, Utica, and Rome, among others. America was governed by a Senate which met in a Capitol, and this same nation adopted the motto *E Pluribus Unum.* And in these same cities, in all American cities, the architecture of the Gilded Age reflected the near-obsession with Greek and Roman culture in all of its various "elevated" forms. The following exchange belies as much, even in 18th century Vienna, Austria:

Located at the main entrance to the multi-story Congress Bank Building (Alfred S. Alschuler, 1925) in Chicago, depositors were greeted by this profile of a *Roman* citizen. This unglazed terra cotta image, although not produced during the Gilded Age, emphasizes the influence of the classical artistic tradition as carried even into Chicago's Roaring Twenties (photograph by author).

> Baron Van Swieten to Wolfgang Amadeus Mozart: "Surely you can choose more elevated themes."
>
> Wolfgang Amadeus Mozart: "Elevated! What does that mean, elevated? I am fed to the teeth with these elevated things. Old dead legends. Why must we go on forever writing only about gods and legends?"
>
> Baron Van Swieten: "Because they do. They go on forever. At least what they represent: the eternal in us. Opera is here to ennoble us, Mozart. You and me, just the same as His Majesty."
>
> Wolfgang Amadeus Mozart: "Come on now, be honest! Who wouldn't rather listen to a hairdresser than Hercules? Or Horatius or Orpheus. So lofty, they sound as if they shit marble!"[5]

The Beaux-Arts

Straying from the classical parent, but still within the family of columns, entablatures, and pediments, was a style of architecture known as the Beaux-Arts. The École des Beaux-Arts (School of Fine Arts) in Paris was originally founded in 1671 as the Royal Academy of Architecture. The *École* became the largest and most influential school of architecture, painting, and sculpture anywhere during the 19th century. Its curriculum was focused upon the traditions of the Renaissance, and its attendees pored over drawings of the Renaissance masters and deciphered the mysteries of the temples, basilicas, baths, and palaces of the ancient world. And who were many of its attendees? Americans. After all, the appearance of the Columbian World's Exposition was the epitome of Beaux-Arts aesthetics. The Beaux-Arts was both a school *and* a style.

In the post–Civil War years through the 1890s, America had few places where one could learn the art and science of architecture. Young men would study architecture from published manuals, books, and journals. Apprentice draftsman positions were sought by teenage boys yearning to become accomplished draftsmen first, then later, architects. Since formal training — that is, a university-level architecture education — was almost nonexistent, the trade school played a decisive role. Architecture sketch clubs were founded in some cities and provided for the exchange of ideas and for the development of skills required to become proficient in the

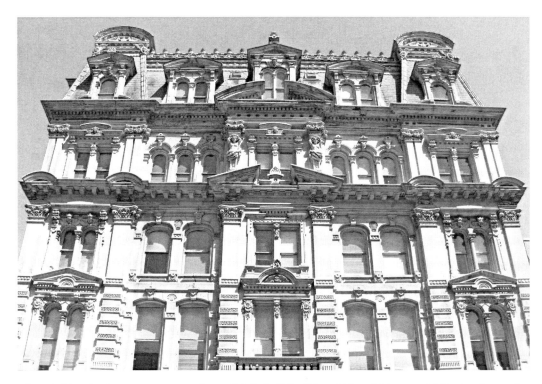

Above: Milwaukee's seven-story, 130-foot-tall Mitchell Building (Edward Townsend Mix, 1876) was that city's first skyscraper and remains a masterpiece of the Gilded Age. Its French Second Empire style was all about excess and the desire to impress, and it delighted in featuring sculpture based upon ancient mythology. The bust of Mercury, the Roman god of commerce and communication, appeared often. At a time when bank failures were prevalent, a substantial-looking headquarters building was considered infinitely more reassuring to investors and depositors (photograph by author).

A corner pavilion of the Mitchell Building includes bare-breasted angels and two variations of Pegasus, the great winged horse with reptilian hindquarters and a dragon's tail. An example of pure theatricality, this dreamlike architecture appears some 100 feet above the sidewalk, forcing its audience to search out this stage set and its meaning (photograph by author).

design of buildings. If a young man was fortunate, he would enter an architecture firm and learn his craft from established professionals. If he was really fortunate he would acquire training at the École des Beaux-Arts in Paris.

The École des Beaux-Arts did not copy the past, but rather it closely interpreted it. The whole soup of the classical world provided sustenance for this French movement, a movement that was based upon the evolution of architecture — new materials and methods — as much as it was upon the study and utilization of ancient symbols and images. It drew inspiration from Greek and Roman prototypes from the buildings of Renaissance Italy, and chateaux of rural France of earlier centuries. The École des Beaux-Arts was a major influence on the architecture of America, principally the civic and corporate buildings of urban America.

A close cousin of the Beaux-Arts style was an architectural movement referred to as the French Second Empire. Napoleon Bonaparte's nephew, Louis-Napoleon (1808–1873) assumed the title emperor of France in 1852, and under his reign enormous civic buildings and monuments were erected throughout the capital city. The Beaux-Arts style, the resurrected Renaissance according to French precepts, was elevated to an almost preposterous level of embellishment. To Louis-Napoleon this treatment of architecture, this level of visual enrichment, this pursuit

Opposite: It appears nothing was held in reserve when the façade of the Mitchell Building was designed. Melodrama was one motive as historical forms and proportions were trifled with to please Gilded Age eyes. Of course, the mythology of ancient cultures was liberally included (photograph by author).

of the grandiose, meant *Empire*. The French Second Empire style was the politicization of architecture on a grand scale. Its unmistakable features included buildings topped by large mansard roofs, and façades organized about a symmetrical, three-part pavilion motif. The crowning examples of the French Second Empire were the new additions to the Louvre (Louis Visconti and Hector-Martin Lefuel, 1857) in Paris. Some American architects fancied the robust French Second Empire look, and if that style once pleased Louis-Napoleon, the emperor of France, American designers reasoned, it should certainly please the bankers and their parasol-toting wives.

World's Columbian Exposition

In 1893, in the midst of America's Gilded Age and, paradoxically, in a worsening nation-wide economic recession, the city of Chicago hosted the World's Fair, officially known as the World's Columbian Exposition. Defeated rivals, those places also wanting to host the exposition, included New York, Washington D.C., and St. Louis. Chicago was the victor, and for six months it held the attention of the world. As its name suggests, the exposition was held in honor of Christopher Columbus, as a tribute and celebration of the 400th anniversary of his

The exposition's Administration Building was designed by New York architect Richard Morris Hunt. To the top of its gilded dome it measured 265 feet, the equivalent of a 24-story building. It was demolished at the end of Chicago's Columbian World's Exposition (*The Dream City: A Portfolio of Photographic Views of the World's Columbian Exposition*, Prof. Halsey C. Ives, St. Louis: N.D. Thompson Publishing Company, 1893, unpaged).

landing in the New World. The exposition also announced to the world that Chicago was back; it had survived the Great Fire of 1871, and it was once more a player on the world's stage of commerce.

The World's Columbian Exposition was no corner carnival. The exposition occupied 630 acres of land on the south side of Chicago, right along the Lake Michigan shore. It featured over 200 buildings, parks, lagoons, canals, and exhibits of every type. Some 46 nations contributed entire structures characteristic of their cultures, various American states erected buildings promoting their industries and agriculture, and foreign and domestic corporations hosted large exhibits touting modern technologies. Included were the Administration Building (Richard Morris Hunt), the Agriculture Building (Charles McKim), the Manufacturers and Liberal Arts Building (George B. Post), the Mines and Mining Building (Solon Spencer Beman), the Electricity Building (Henry Van Brunt), and the Machinery Building (Robert Swain Peabody). The colossal Fine Arts Building (Charles B. Atwood) housed thousands of art objects, including rare oil paintings. Visitors could view the racy "Invasion of Cupid's Realm" by William-Adolphe Bouguereau (1825–1905) or any number of "lofty" nude or semi-nude works from European easels and marble blocks. Mythological sources were as popular as ever, with hundreds of ancient heroes and creatures sprinkled inside the museum, on building tops, and throughout the entire exposition grounds. The World's Columbian Exposition opened on May 1, 1893, and it closed on the 30th of October of that same year. In all, those many millions who visited returned home

The exposition's Palace of Fine Arts was the work of Chicago architect Charles B. Atwood. The "huge temple" is today the home to Chicago's Museum of Science and Industry (*The Dream City: A Portfolio of Photographic Views of the World's Columbian Exposition*, Prof. Halsey C. Ives, St. Louis: N.D. Thompson Publishing Company, 1893, unpaged).

This 1885 trade card advertisement for the R. P. Hall & Company of Nashua, New Hampshire, depicts a strange happening indeed, especially to 21st-century eyes. Eight putti attend to their mistress in an open field, while two rabbits, traditional symbols of puberty, sit spellbound. The image for "Hall's Vegetable Sicilian Hair Renewer" seems somewhat incongruous for this young maiden, as it promises to prevent "gray hairs and baldness." Putti and animals, the stuff of popular advertisements, became commonplace on the façades of skyscrapers, too (author's collection).

richer for the experience. What does this exposition have to do with Gilded Age skyscrapers? Everything.

Chicago's World's Columbian Exposition was a watershed event for the future of American architecture. The exposition was, in fact, a small city; it was laid out expertly — that is, it was conceived on paper and developed into the third dimension, all of it orchestrated by design impresario Daniel Hudson Burnham and by landscape architect and planner *par excellence*, Frederick Law Olmsted (1822–1903). Extraordinary organization according to Beaux-Arts precepts, overall unity and harmony, and classical architecture on a grand scale defined the exposition in terms urban, urbane, and architectural. The exposition introduced, or reintroduced, classical architecture to this continent. Certainly before 1893, there were classically inspired buildings that dotted the

This drawing depicts an example of the Greek composite style. Its decorative frieze features reclining nude figures (gods) being amused by a chimera, a mythological creature with a lion's head and a serpent's tail. Louis Sullivan, and others, too, thought this all absurd (*A Textbook on Architectural Drawing* Scranton, Pennsylvania: International Textbook Company, 1897).

American landscape, but because of the aesthetic influence of the exposition and its huge popularity, there was a powerful resurgence of temple fronts, colonnades, and domes on civic and private buildings everywhere. The dream world that was produced in bright white immense Roman-like buildings, concretized in the minds of architects, developers, and bankers that antiquity could be resuscitated for future projects on even grander and much taller scales.

Some 27 million people visited the extravaganza, an amount equivalent to about half of the country's population. Many of the attendees were farm folk, city folk, the recently "tempest-tost," or the financially comfortable from many American places and foreign lands. No matter their hometowns, visitors to the World's Columbian Exposition found its buildings awe-inspiring; a greater grandeur was unknown. The splendid structures were of "proper proportions," they were symmetrical, and they possessed a distinct air of formality and of dignity which epitomized European classical architecture. These well-behaved buildings, many felt, did what architecture was supposed to do — they inspired and they impressed. Visitors loved the exposition, recalling the grandiose architecture to those at home.

But not everyone was satisfied. One man in particular was disgusted by it all. Louis Sullivan was that man, a man who contributed one building to the Exposition.[6]

Precisely at a time when Sullivan was promoting to his colleagues his "idea" that architecture

The façades of Chicago's 14-story, 166-foot-tall New York Life Insurance Building (Jenney & Mundie, 1894) are replete with references to the designs of ancient Greek temples, specifically those of the Erechtheion (c.409 BCE) in Athens. A capital displays an anthemion (center), a design based upon the honeysuckle flower, flanked by lotus buds or palmettes. To the ancient Greeks the honeysuckle flower was symbolic of love; the palm leaf suggested the birth and rebirth of all living things. Architects Jenney and Mundie appropriated the *forms* and were not necessarily cognizant of their symbolic contents (photograph by author).

A simple yet richly disposed variation of the already severe Doric-style capital resides on the façade of the New York Life Building in Chicago's Loop (photograph by author).

is a "functional art," an art of "modern form-making" that should reflect a building's reason-for-being, or its *raison d'être* … along came the architecture of the exposition. From their outward appearances, one could not tell what any of these classically inspired buildings was to represent. They were symbolic, but of what? The modernist, the free thinking Sullivan wondered why, in the new and modern city of Chicago and in the new and modern country of America, were *American* architects dredging up building designs from ancient and distant lands. Sullivan, later known as "The Father of the Skyscraper," saw the new and "modern skyscraper" as a building *type* inescapably succumbing to design trivialization, to classicism — if indeed it had not already. Three decades after the exposition ended, Sullivan committed his thoughts to paper. He wrote: "The damage wrought by the World's Fair will last for half a century from its date, if not longer."[7] The exposition iced it. Sullivan was convinced that, from then on, the "classical world" would reign supreme in the "land of the free and the home of the brave."

Sullivan verbally skewered the designs and the designers of many, if not all, of the significant buildings constructed for the World's Columbian Exposition. It wasn't until 1924, with the publication of his book, *The Autobiography of an Idea*, that Sullivan's revulsions surfaced, *in printed form*. By this time, all the main players in this architectural drama — Charles B. Atwood, Solon Spencer Beman, William W. Boyington, Daniel Hudson Burnham, Willoughby J. Edbrooke, Richard

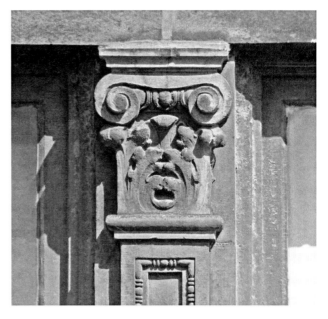

Terra cotta pilasters with composite capitals and bead-and-reel detailing appear in ample supply on the façades of the *south half* of the Monadnock Block. For this project, architects Holabird & Roche felt the Renaissance was still a potent visual force in 1893. After all, the Columbian World's Exposition was in full vigor and only five miles away (photograph by author).

This flowering geometric abstraction owes much to the designs of architect Frank Furness, former employer and mentor of Louis Sullivan. These delicately incised stone decorations appear on the façade of the five-story Jewelers Building (Adler & Sullivan, 1882). Purely *American* in spirit, these carvings can be considered fossils deposited for future generations by the "Father of the Skyscraper" (photograph by author).

Morris Hunt, William LeBaron Jenney, Charles Follen McKim, Robert Swain Peabody, George B. Post, John Wellborn Root, and Henry Van Brunt — were dead! Henry Ives Cobb was the lone survivor of the original group of noted exposition architects (he died in 1931); and while still alive after the book's debut, it is impossible to know if he read it. Louis Sullivan said of Edbrooke's contribution, "The structure representing the United States Government was of an

incredible vulgarity," and he called Boyington's State of Illinois Building "a lewd exhibit of drooling imbecility and political debauchery." In assessing Atwood's Palace of Fine Arts, Sullivan groused that it was "the most vitriolic of them all — the most impudently thievish."[8] Perhaps it was a good thing that Edbrooke, Boyington, and Atwood were dead.

Sullivan likened European classicism to a disease, to a virus that had infected the sensibilities of the *American* artist and especially of the *American* architect:

> Meanwhile the virus of the World's Fair, after a period of incubation in the architectural profession and in the population at large, especially the influential, began to show unmistakable signs of the nature of the contagion. There came a violent outbreak of the Classic and the Renaissance in the East, which slowly spread westward, contaminating all that it touched.... Thus Architecture died in the land of the free and the home of the brave, — in a land declaring its fervid democracy, its inventiveness, its resourcefulness, its unique daring, enterprise and progress.[9]

Was Sullivan a curmudgeon? Probably, especially in his later life. In his final salvo, "The Autobiography," published just before his death, Sullivan spoke with conviction and courage. He felt bitter and betrayed by forces not in his control. But he did have a point, perhaps many points. The World's Columbian Exposition had an enduring affect upon building design, an affect that can still be recognized on the exteriors of hundreds of America's skyscrapers.[10]

American culture yearned for a past it never had. In some respects it appropriated the past and customs of its European ancestors. As a result, American architecture was the direct stepchild of the "old world," of the forms and myths of the millions of European immigrants who sought refuge in the land that boasted a "golden door." The memories of America's new arrivals, the influence of a Parisian school, and the recollections of a world exposition galvanized the appearance of America's skyscrapers for decades. In this chapter, 14 buildings were selected that best describe how classicism and the Renaissance affected the appearance of America's tallest buildings.

The chief enjoyment of riches consists in the parade of riches.[11] — Adam Smith (1723–1790)

EQUITABLE BUILDING, BOSTON, 1875

The Gilded Age was about many things, but probably the thing most associated with that period was the genuine love of, and the enthusiastic displaying of, one's accumulated wealth. What better way to accomplish this than through the vehicle of architecture? American corporations were particularly involved in this contest, and they parlayed substantial amounts of their gross earnings into large and splendid office buildings for themselves and for the selfish sake of ostentation. This was not necessarily a bad thing; it was just the way of things, and, after all, this philosophy did indeed bequeath to the country a substantial selection of compelling buildings. The New York-based Equitable Life Assurance Company left America more grandiose buildings to ponder than any other company.

Equitable had just completed its world headquarters, a giant and splendid edifice on Manhattan's lower Broadway, in 1870.[12] With the Boston project, Equitable intended to duplicate what had been accomplished for New York, and since the Manhattan-based architect Arthur D. Gilman (1821–1882) participated in the design of the New York structure, he was again summoned to provide plans for the Boston office tower.[13] Boston had just experienced the Great Fire of 1872, which devastated much of the city's financial district. It was hoped by Boston politicians and the business elite that the Equitable project would not simply be just another office building, but that the new skyscraper would also instill a new spirit of vitality to the city and become a symbolic *civic* accomplishment. With its completion in 1875, Boston's Equitable Building succeeded in being that *civic* monument, as well as attaining prominence as a splendid *corporate* monument. Gilman again pleased Equitable.

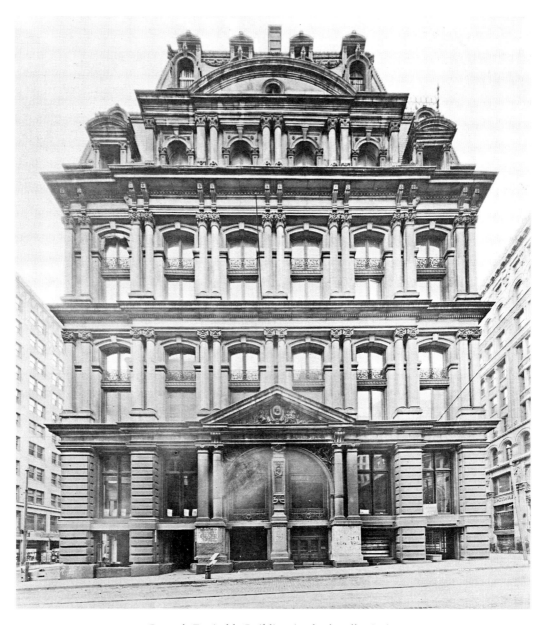

Boston's Equitable Building (author's collection).

Arthur D. Gilman was accustomed to much praise as he was an accomplished professional with a devoted following and an impressive architectural repertoire. He was a native of Newburyport, Massachusetts, studied architecture at Trinity College (New Haven, Connecticut), was a student in a number of European schools, and collaborated with some of the most noted and accomplished architects of his day (Bryant, Kendall, Post) on a host of prominent commissions. Arguably, Gilman's two Equitable Buildings are the ones for which he is best remembered.

Boston's nine-story Equitable Building, an architectural cousin of New York's, was located at 67–69 Milk Street on Post Office Square, and it cost the handsome sum of $1.1 million. Like the New York headquarters, it originally had three steam-driven elevators, marble-slathered interiors, and ample office suites to rent to outside businesses. Concrete floors and thick internal

brick walls served as fireproofing. An iron "canopy" bore the weight of its slate mansard roofs. The building's structural support was provided by iron girders and trusses combined with massive load-bearing walls.

This exquisite stone pile was the epitome of the Gilded Age office building. Here stood a French Second Empire office palace, a structure with all the trimmings expected from such a pedigree. A giant pedimented entry, classical columns, sculpted busts, and rounded dormers wrapped its façades. The whole of the composition was surmounted by a stacked pair of mansard roofs encrusted with additional columns, pilasters, rounded pediments, garlands, finials, and rooftop cresting. The façades were of carved Quincy (Massachusetts) granite and, surprisingly for its time, a substantial amount of glass. The building was both vertically and horizontally disposed; it wanted to be tall (it was higher than it was wide), but it read as a horizontally themed composition due to the unyielding entablatures that visually divided it into what amounted to be four stacked and separate structures. This dynamic tension, this push-and-pull effect, enhanced the notion of movement and made the Equitable Building's main façade a thing of energy.

This was the *corporate* look that predominated during the 1870s. Civic buildings such as post offices, city halls, and court houses also complied and, before long, most major cities boasted at least one structure of this ilk. The influence of the French Second Empire would not relinquish its hold on American taste for another 20 years. As for the Equitable Life Assurance Company, it would go on to secure an enviable status among American corporations. Founded in 1859 by Henry Baldwin Hyde (1834–1899), the company grew phenomenally during the Gilded Age, made substantial amounts of money, and by 1900 it operated in almost 100 foreign countries. No company of this stature could inhabit buildings of less ostentation than those "palaces" it erected during the 1870s. Fate was not kind to these early skyscrapers: New York's Equitable Building was destroyed by fire in 1912, and Boston's was demolished in 1920.

WESTERN UNION TELEGRAPH BUILDING, NEW YORK, 1875

The Western Union Telegraph Building was completed when Ulysses (note the Greek inspiration, *Ulysses*) Simpson Grant was president of the United States, the completion of the Brooklyn Bridge was eight years in the future, and the Washington Monument would not be finished for another ten years.

The designer responsible for this extravagantly decorated box was George B. Post (1837–1913), one of the nation's most prolific and respected architects. Post entered the atelier of Richard Morris Hunt in 1858, after graduating as an engineering student from New York University. He began his own practice in 1860 and earned a fine reputation as a designer of large hotels, tall office buildings, and imposing commercial structures. The Western Union Telegraph Building was the tallest achievement to date for architect Post. This *grand dame* of Broadway was opened on February 1, 1875, and at seven floors, 230 feet tall, it immediately ranked as America's tallest skyscraper, a title it held for only a few months. Its footprint measured 75 by 150 feet, and it was considered a giant for its time.

In the January 1875 issue of *The Aldine*, a popular periodical of the day, the following was stated regarding Manhattan's newest skyline addition:

> In height it is especially pre-eminent, being, today, the highest in America, the body of the building alone considered, and matched only in that regard by two or three of the high-shouldered cathedrals of the *Old World*. There is really something almost oppressive in the effect produced by its height, forcibly reminding the traveler of Strasbourg Cathedral as seen at the upper air and even its very body above the tops of the ordinary steeples. There will eventually, however, be nothing incongruous in the altitude of the Western Union Building owing to the fact that so many other buildings in

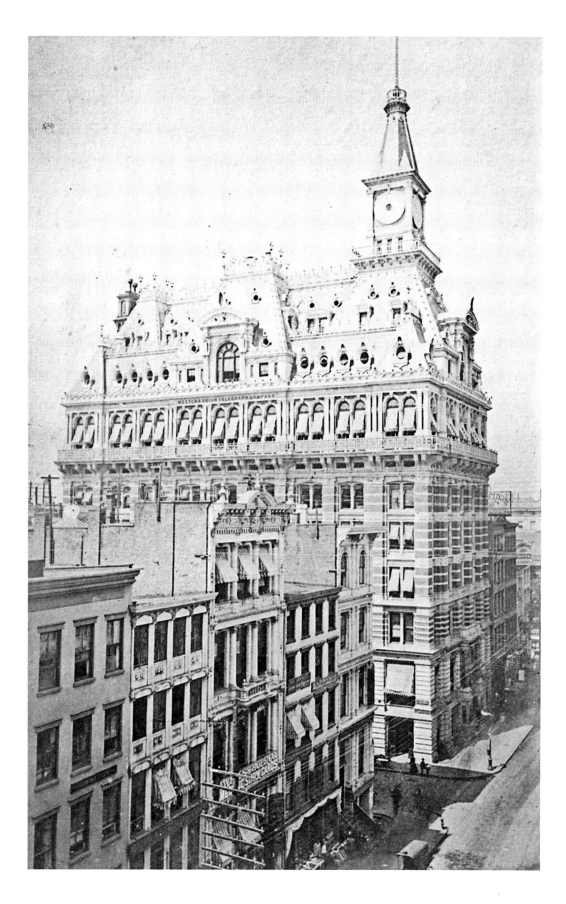

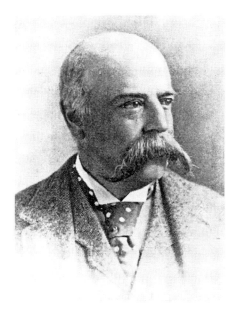

Architect George B. Post *(Harper's New Monthly Magazine*, Vol. LXXXV, November 1892, "The Designers of the Fair," p. 874+).

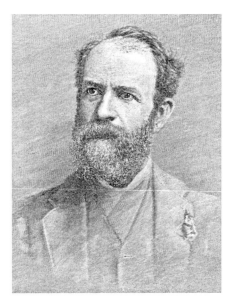

the neighborhood are creeping up to a height that would not many years ago have been considered monstrous.[14]

Regarding the Western Union Telegraph Building's architectural pedigree, *The Aldine* commented:

Of the order, or orders, of architecture, employed in this building, even the most instructed in the science would find it necessary to speak very guardedly. So far as there can be said to be a predominance, it must be toward the Italian-Gothic; though the Mansarding and railing of the roof are so distinctively French and Flemish as to dispute the former distinction. The Italian aspect is materially increased by the cross-striping of gray granite and red brick, so common in the more prominent old buildings of Northern Italy.[15]

No matter what the Western Union Telegraph Building looked like, this was Jay Gould's home, his castle. Jay Gould (1836–1892) controlled much in America including this company (once a Vanderbilt holding that he acquired in 1881) and its famous building; his office was inside on an upper floor. Born into poverty on a farm near Roxbury, New York, Gould worked in his father's hardware store, and in school he mastered surveying, mathematics, and business. He briefly worked in the lumber, tanning, and banking industries, eventually finding his way to New York and the world of financiers and stock traders. Along the way, Gould made both friends and enemies, made money and lost money. Gould quickly outmaneuvered those business associates who gathered around him to gain control of the stocks of railroads, gold mines, real estate, and communication concerns, which ultimately allowed him the final say over vast quantities of coal, metals, grain supplies, and foodstuffs. Gould was the epitome of the Gilded Age "robber barons," those men and women existing without conscience, those considered greedy and unscrupulous. This building, too, was his — and his alone.

Although eclectic in styling, the Western Union Telegraph Building was a masonry mountain executed

Jason "Jay" Gould (1836–1892) cut a flamboyant figure during the Gilded Age. He possessed a controlling interest in the Western Union Telegraph Company and was an American financier, a railroad developer, and tycoon; he was worth an estimated $72 million at his death. Gould was also known as a "robber baron" due to his penchant for stock manipulation, insider trading, and hostile corporate takeovers. Perhaps Mark Twain put it best in *The Adventures of Huckleberry Finn* with his pithy observation: "All kings is mostly rapscallions" (*Harper's New Monthly Magazine*, Vol. LXXI, November 1885, No. CCCCXXVI, "New York Stock Exchange," p. 829+).

Opposite: Western Union Building (American Views Stereoscopic Company, New York, c.1895) (author's collection).

in the French Second Empire style. Its red brick and gray granite walls were profusely decorated with Corinthian columns, arched windows, sculptured pediments, mythological carvings, finials, and iron cresting. The structure's mansard roofs, pierced by both circular and oval lucarne windows, topped the structure with a profound flourish. Above these roofs, and rising still higher, was a square clock tower topped with an eight-sided cap for a final fanfare. Despite its grandeur, this monument to the Gilded Age was pulled down in 1915.

AMERICAN SURETY BUILDING, NEW YORK, 1894

Few skyscrapers constructed during America's Gilded Age were so admired upon completion as this one, New York's American Surety Building. It remains a pillar of propriety and an unquestioned landmark in lower Manhattan. The distinguished Bruce Price (1843–1903) was the building's architect. Price, a native of Cumberland, Maryland, studied architecture as a youth and entered his first professional office as an apprentice in 1862, at the age of 19. He traveled to Europe and spent much time studying the buildings and the art of Paris. The year 1873 was significant for Price as he married and opened his first solo architecture practice in Wilkes-Barre, Pennsylvania. After four years there, Bruce Price moved to New York to pursue greater professional success. During his 41 year career, Price's versatility accounted for the design of college buildings, palatial city homes and suburban mansions, substantial commercial structures, hotels, and office skyscrapers. He was described posthumously as "an architect who attained prominence in the profession," and an individual who "was identified with all that stood for progress in the field of archi-

This is a view of the American Surety Building as it first appeared in 1895. In later years, the skyscraper would be widened from seven to 11 bays; two more statues would be added for continuity (*Munsey's Magazine*, "The Tall Buildings of New York," 1898, pp. 833–848).

tecture and art."[16] The American Surety Building ranks as one of his most significant contributions.

The American Surety Company of New York, a diversified financial firm, was founded in 1881. Within only ten years of its inception and due to substantial financial success, company directors demanded a new home office building be constructed, one from which its 40 branch offices and its 15,000 agents could be directed. Its headquarters would be at One Hundred Broadway (between Pine and Wall Streets), a prestigious corporate address indeed. An architectural competition was sponsored by the American Surety Company (these were popular during the Gilded Age) to foster the development of the finest office skyscraper in the city. Nine of the most notable design firms of that day participated in the competition including McKim, Mead & White, George B. Post, Carrere & Hastings, and Napoleon Le Brun & Sons. The entry submitted by the firm of Bruce Price, a skyscraper of unabashed classicism, was chosen as the finest and most representative of the company's aspirations.

In 1894, after two years of construction, the American Surety Building was completed. The new skyscraper stood 21 stories, 312 feet tall, and it ranked as the city's second tallest, only 36 feet shorter than the nearby Manhattan Life Insurance Building. It rose shear on a site measuring roughly 85 feet-square, was faced with white Maine granite, and contained eight passenger elevators.

The significance of this structure resides in its style. Price looked to ancient Greece, or perhaps he remembered the classical buildings he so admired in Paris, for an appropriate design. He likened his skyscraper to that of a classical column: he produced a three-story "base," which supported a "shaft" of repetitive office floors that, in turn, was surmounted by an elaborate "capital," which marked the top seven floors. This tripartite organizational scheme would be used often by Price and others. In 1909, noted architect and critic, Claude Bragdon (1866–1946) penned the following regarding this design phenomenon:

> They [New York architects] have approached that problem more in the Classic than in the Gothic spirit, demanding, in the name of the Classic tradition, a threefold vertical subdivision — a beginning, a middle, and an end — unrelated (or only accidentally related) to any analogous differentiation in the plan. Something they must have corresponding to stylobate, column, and entablature base, shaft and capital. The late Mr. Bruce Price was, I believe, the first to formulate this into a principal [*sic*] for the tall building, and he applied it with notable success in his American Surety Building, a gigantic pilaster, which has its base, its many windowed, fluted shaft, and its intricately ornamented capital.[17]

The first three floors of the office tower were, and remain, a study of classical Greek architecture. Originally six tall Ionic columns completed an impressive colonnade along Broadway.[18] Above this colonnade, and in line with the Ionic columns below, stood six sculpted granite figures. These were the work of John Massey Rhind (1860–1936), a native of Edinburgh, Scotland. Rhind studied art under the instruction of his sculptor father, spent two years studying in Paris, and then, in 1889, relocated to America, as did millions of others. Rhind achieved much recognition, being responsible for dozens of major commissions, principally in the East, mostly in New York City. Contemporary accounts stated that he "has exerted a very important influence upon the development of architectural decoration." Because of that influence, Rhind was a favorite choice for major public monuments, including four in the Civil War battlefield at Gettysburg and one in the United States Capitol. He also designed civic and private fountains, and, of course, architectural sculpture.

The following 1895 account gives a rare and valuable insight into the thought processes involved in the creation of such works, in this case those on the façade of the American Surety Building from Rhind's perspective:

> While composing this scheme of figures, I have constantly kept in mind the idea with which I first started; that is, applying the symbols which suggest the titles of the figures in such a manner as to represent the industrial and other branches in which the corporation occupying the building is engaged. I have thus endeavored to modernize the symbols; while in the treatment of the whole, I have striven to keep it severely Classical, simple and strong. I have, also, tried, as far as possible, and where the subject would permit, to compose them as though they were part of the building, rather than as decoration or addition; in this way keeping the figures, in pose and drapery, in accord with the architectural lines of the building proper.

Within the preceding text, Rhind reveals that he consciously reinterprets the classical figure through modernization, and he tries to integrate the statuary with the building proper so that sculpture and architecture speak with one voice, where there exists *organic* integration. Rhind continues:

> The symbols used in connection with these figures are so arranged as to show rather the types of "progress" than could be shown if the old, conventional types were adhered to. Of course, they can be changed, if desired, in working out the "full size" figures. In fact, the whole scheme is in the nature of a suggestion, more than anything else, although the arrangement as it stands embodies my ideas of a well-balanced composition.

Rhind appears open to constructive criticism and, ultimately, to the alteration of his sculptural group. It is in the next few paragraphs that John Massey Rhind —*the sculptor*— really addresses the salient issues involved and truly concentrates upon the crux of the design problem and the allegories involved:

> Reading from left to right, "Fidelity" is the first; "Science," second; "Manufacture," third; "Agriculture," fourth; "Art," fifth; "Fortitude," or "Surety," sixth. It will be seen by this arrangement of figures that I have carried out my idea of making the figure "Fidelity," or "Honesty," on the left, and the figure "Fortitude," or "Surety," on the extreme right, serve as a guard, or "bond," for the others; suggesting more strongly the nature of the American Surety Company's business.
>
> "Fidelity," sister to "justice," [*sic*] Goddess of Honesty, is represented erect in carriage, the pose indicating "honesty" and "candor," the two hands clasped together in front suggesting "faith" given and received.
>
> "Science" is represented holding in her right hand a small stand, from the top of which an electric light is shown with its radiations. A wire passes in front of the body to the left hand, which hangs by the side, and which holds a small "coil battery," with which the wire is connected. The idea conveyed in this figure is the embodiment of the sciences, feeling that Electricity is the greatest of all, both as a means of progress and consequently, a benefactor to man.
>
> "Manufacture" is represented holding in her right hand the "governing balls." I have concluded that this is the

Angels were employed, it seemed, almost everywhere during the Gilded Age as promotional devices and as architectural decorations; angels were popular religious and cultural "pop" figures. The common man and the not-so-common man on some ideological level identified with these beings, and if medicine and the doctor failed a patient (as in this case), the poor soul could hope for angelic deliverance (Dr. J. C. Ayer & Company, Lowell, Massachusetts, 1874) (author's collection).

most comprehensive symbol of [the] manufacturing industry, and one which covers more generally all the branches which are included under that head. The left arm and hand of the figure is extended along the side of the body.

"Agriculture" is represented with a "reaping hook" in the right hand, which rests at full length along the side of the body, the blade of the "hook" pressing against the drapery. In the left hand, and running up above the shoulder, is carried a stalk of "Indian-corn." While the variety of "corn" may not be strictly Classical, it is intended to make the application of agricultural resources more in accord with modern times. I have, therefore, used the "Indian-corn" in preference to the conventional "wheat sheaf." The general composition of this figure is intended to represent "Fidelity, the Goddess of Prosperity, and Peace."

"Art" is represented holding in her right hand a mallet, suggesting the "working stage of sculpture." In the left hand she holds a small "finished figure," not necessarily as applied to sculpture, but to all the arts.

"Surety," the Goddess of Fortitude, is represented with stern, determined air, the two hands clasped in front over the hilt of a sword, which rests on the left arm, and extends up to and above the shoulder.[19]

The above was composed in the midst of the Gilded Age when building decoration included allegorical figures that could be interpreted and understood by even the most pedestrian in society. Here, Rhind interprets the various meanings for the public and reveals his strategies involved with their making and placement. What Price and Rhind produced over a century ago still acts upon those who view the American Surety Building and its granite maidens. Here remains the epitome of the extravagant classical skyscraper, a landmark skyscraper that still whispers messages to the generations that have passed and to those to come.

HOME LIFE INSURANCE BUILDING, NEW YORK, 1894

New York's Home Life Insurance Building was designed in a very French style, by a very American architect with a very French name. Philadelphia native Napoleon Eugene Charles Henry LeBrun borrowed the architecture of French Renaissance chateaux to grace the skyline of lower Broadway. When completed in 1894, this skyscraper pleased the architectural establishment and delighted New York socialites. This was a "New York building" if ever there was one; it spoke of wealth, of empire, and of an historic lineage unbroken to the 16th century.

Countless chateaux in the rural valleys of France were the models for a building such as this. Extravagance in the forms of lively façades of reinterpreted classical forms and a grandiose top of fussiness satiated not only Francophiles but streetwise New Yorkers as well. Here, a large and expensive country house was seemingly pried from the Loire Valley and plopped atop a skyscraper. Then the whole was inserted into a very urban, mid-block Broadway site.

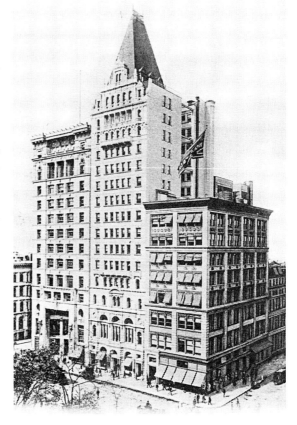

Home Life Building (author's collection).

Location and image meant everything to this client and to this architect. The client company was founded in Brooklyn in 1860 and was well aware of the advantages of a dynamic location and positive corporate image. The Home Life Insurance Company relocated to Manhattan and chose the prestigious firm of Napoleon LeBrun & Sons to produce an instant corporate landmark.

Napoleon LeBrun was the son of a French diplomat; his father served as the French ambassador to the United States during the administration of Thomas Jefferson. While living in Philadelphia, LeBrun studied architecture in the office of the accomplished Thomas Ustick Walter (1804–1887). For many years LeBrun practiced architecture in Philadelphia, but he relocated to New York following the end of the Civil War. With his sons Pierre (1846–1924) and Michel (1856–1913), now also architects, the firm and its staff produced many substantial churches, courthouses, office buildings, and even a prison. Skyscraper design and construction was in its infancy during most of the firm's early years, but skyscrapers, too, would figure prominently in this firm's repertoire.

For the Home Life Insurance Building, Napoleon LeBrun & Sons invented nothing new. They approached this design problem as almost all firms did then; designers thumbed through pattern books and history books. They leafed through the picture files of buildings already built, especially those buildings constructed by Europeans many centuries before. They found what they wanted to find; they discovered the already discovered. Napoleon LeBrun & Sons decided upon a design that would please their clients and that would delight the bankers who had to pay for it. Tried-and-true architecture trumped honest exploration; classical columns, arches, and pediments proliferated. A 14th-floor loggia was included, along with elaborate dormers and a steeply pitched hip roof topped by iron cresting. All of it secure stuff, all of it from the past. And all of this was positioned into a rigid tripartite framework. Its French Renaissance Revival style was well suited for Gilded Age New York. The Home Life Insurance Building took two years to complete. It rose 16 floors, 280 feet high from a site measuring 56 by 109 feet.

Upon its completion, the press and the public no doubt gushed over the tons of Tuckahoe marble slathered over the building's steel framework. With all probable certainty, they marveled over the carvings and the doodads affixed everywhere. The new skyscraper reminded many of their European wanderings and of the old and romantic chateaux. No one thought of the three-year-old Monadnock Block.

New York Life Building, New York, 1896

When completed, the New York Life Building was considered by most of Manhattan's money-men to be the ultimate business palace. This still-standing skyscraper was completed in 1896 to the designs of the prolific and prestigious New York firm of McKim, Mead & White. Its once-gleaming white walls and rooftop clock tower were visible along the lower Broadway corridor and for blocks around by parasol-toting coquettes, cabmen, doormen, carriage riders, and street vendors. Located in the fashionable Dry Goods District at 346 Broadway, this skyscraper provided a psychological and visual anchor to the calamity that was the "street" during the Gilded Age:

> The streets were seemingly thronged before, but now, almost before the last strokes of the 5 o'clock bell have died away, a flutter of excitement runs up and down the street. It is to be seen the length of Broadway, Wall, Fulton, Park row [sic], Pearl, Fourteenth — of every down town street and court in great New York.... It is the broker, the lawyer, the agent, the clerk, the typewriter-men of every profession, men of every trade, people of all degrees — leaving the office, the counting room, the laboratory, the workshop. The tide of travel on the streets before was hurried, but regular. Now it has broken — a rush, a seeming disorder, as if some disaster had happened. What a mingling! What a tide of humanity! What a gathering of costumes, complexions, ages and nationalities![20]

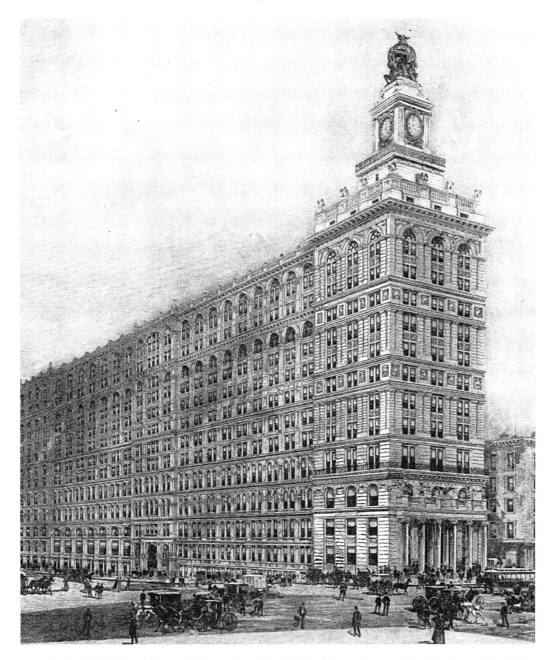

New York Life Building (*Munsey's Magazine*, "The Tall Buildings of New York," 1898, pp. 833–848).

The New York Life Building was not just any American skyscraper, not just any home to another large life insurance company. It was a participant in the pageantry of lower Broadway; it was an inanimate object, but it was also an actor in the drama of city life, a landmark dressed to impress, an object to be seen by the multitudes on the great Broadway stage. *Architecture* was employed as the means to fulfill that role, not only to be the daily destination of thousands, but to be *the* nexus of human endeavors. Three-forty-six Broadway was, too, the "palace of policies."

To the public, the financial strength and integrity of any insurance company were judged by its headquarters building; corporate image was deemed critical. The Italian Renaissance pro-

vided an apt template for such musings, and, ironically, many architects and corporations borrowed the imagery once used by an unscrupulous lot for a very scrupulous industry. Such was the situation when the New York Life Insurance Company chose, from the field of entrants sponsored by the company's architectural competition for a new home office building, the New York firm of McKim, Mead & White. The scheme picked was that from the mind, and the history books, of Charles Follen McKim (1847–1909), one of the firm's principals. McKim was a Pennsylvania native who migrated to Paris to study architecture at the École des Beaux-Arts. In 1870, he became employed as an architect in the office of Henry Hobson Richardson, and in 1877, McKim founded his own practice with fellow architect William Rutherford Mead (1846–1928). These two were joined in New York by Stanford White (1853–1906) in 1879, when the firm of McKim, Mead & White was born. The team, with its large office staff, was responsible for such revered buildings as the Boston Public Library (1887), the campus plan and buildings for Columbia University (1893), and New York's gargantuan Pennsylvania Station (1910). The New York Life Building was completed in the midst of these, and it was one of the few skyscrapers completed by this firm.

McKim, the principal designer of the New York Life Building, drew inspiration for this tall project from the buildings of the Italian Renaissance.[21] Founded in 1845 as the Nautilus Insurance Company (its original name was derived from the Greek meaning "sailor" or "mariner"), the New York Life Insurance Company continued its infatuation with all things ancient. Selected was a design that trumpeted the architecture of the 15th century. The skyscraper's white marble façades included all the usual classical design devices, such as Ionic columns, Renaissance-style openings and carvings, entablatures, balustrades, cornucopia, and a telescoping tower with a four-faced clock featuring, of course, Roman numerals. One dozen carved marble eagles were situated at the clock tower's base, each recalling the role this bird played in ancient Rome as an animal of strength and majesty. Originally, the tower's highest location was reserved for an extravagant sculptural group featuring four *Atlantes* supporting a metal-ribbed sphere; the implication was that only financial strength sustains the world.

Upon its completion, the New York Life Building was widely acclaimed as "the finest office building in the world." The skyscraper stood 12 floors tall, 244 feet above the busy sidewalks of Broadway. It marched east with an unrelenting rhythm for 400 feet, while being only 60 feet wide along Broadway. Modern conveniences included "twelve swift-running elevators, steam heating, scientific plumbing, electric lighting, and commodious toilet-rooms, lava-

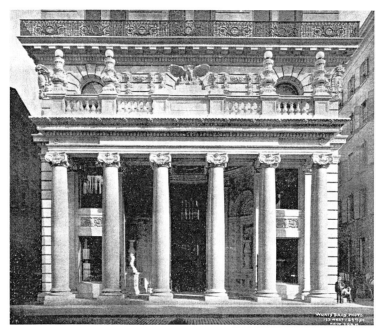

This is the magisterial colonnade and Broadway entrance to the New York Life Building (*Architecture and Building*, Vol. XXVII, No. 14, October 2, 1897).

tories, and closets." The building was constructed with a steel frame, and it was advertised as being "absolutely fireproof." Real estate advertisements claimed that the new building contained "every new aid now contributed by science to the speedy dispatch of business" which included "public telegraph and telephone stations," and "mail chutes on every floor."[22] Inside, the skyscraper was considered modern and scientific. Outside, the skyscraper was dignified and proper. This was Beaux-Arts at its finest, designed by one of the preeminent Beaux-Arts practitioners.

EMPIRE BUILDING, NEW YORK, 1898

Francis Hatch Kimball was responsible for the design of this early Manhattan skyscraper. The Empire Building, still standing at 711 Broadway, is located on the historic southwest corner of Broadway and the ancient lane known as Rector Street. Few buildings in America better reflect the age in which they were built than this; the country's aspirations, aesthetic values, cultural norms, politics, wealth, and optimism remain embedded in its street walls. Its very name, like New York's motto, suggests a degree of potent influence and of considerable authority.

The Empire Building was completed in 1898, the year that America declared war on Spain. National symbols in the forms of American five-pointed stars, statuary of American eagles perched upon globes — symbolic to some of continued and future world economic and military domination — and the very employ of the architecture of imperial Rome said much to the hurried pedestrian. In many ways this skyscraper is one of the finest classically inspired skyscrapers anywhere, with its dozens of columns, pilasters, pediments, Roman-arched openings, balustraded balconies, and full entablature at the roofline. Formality, symmetry, and an overall adherence to the Renaissance are displayed in this one skyscraper.

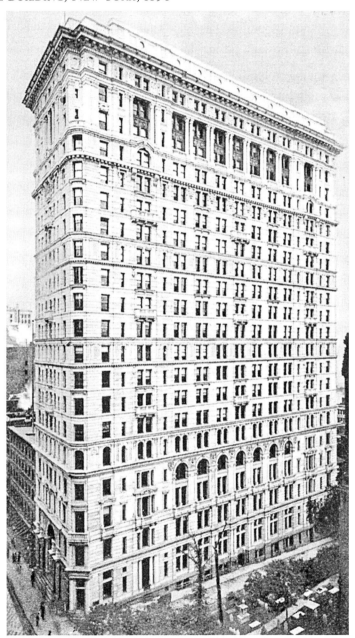

Empire Building (author's collection).

Seventy-One Broadway, as the Empire Building is now known, occupies the site where the noted, some say infamous, Russell Sage (1816–1906) conducted his business affairs. Sage was a politician, financier, and bank director. He held a seat on the New York Stock Exchange with Jay Gould, and by means of vast amounts of stock ownership, he controlled multiple profitable railroads and the Western Union Telegraph Company. At the time of his demise, Sage's personal fortune amounted to a staggering $100 million. But for the privileged few during the Gilded Age, life was not entirely secure. In 1891, in an old brick block known then as 71 Broadway (the site of the current Empire Building), an attempt was made upon the life of Russell Sage, the "railroad manipulator," money-lender, and convicted usurer. A "deranged" man, after being denied the pleasure of extracting "over a million dollars" from Sage, detonated dynamite within Sage's office, killing the extortionist and a nearby clerk:

> The recent attempt to extort money from Russell Sage, and that attempt failing, to kill him with dynamite, has attracted wide attention to several facts. One is that for every millionaire there are numberless cranks who want his money; another is that the discovery of high explosives is by no means an unmixed blessing, and a third is that men like Sage, who are called grasping monopolists, often do good in secret, and that their charities rarely if ever become known to the general public.[23]

Although Russell Sage survived, his office and the old brick building that housed his business did not fare as well:

> Partitions collapsed, walls bulged, the glass in the building was shattered, safes were toppled over and their valuable contents scattered, the occupants of the office were thrown in every direction and terribly lacerated while one victim was propelled through a window into the street and killed. If it can be proved that this man was one of a band of conspirators determined to destroy men of wealth — solely because of their wealth — the incident is portentous.[24]

What makes this story so compelling is not so much its location, but the circumstances and the tabloid qualities of the journalists of that time. Much insight can be had by studying the following Gilded Age report:

> A noticeable thing in connection with the excitement that followed the throwing of a dynamite bomb with intent to kill Russell Sage at 71 Broadway, New York, the other day was the makeup of the crowd. The wildest rumors had startled Wall street [sic] the financial center of the country, almost before echoes of the explosion died away, and brokers, bankers, capitalists and speculators rushed to the scene of the tragedy. With them went jewelers from Maiden lane [sic], leather merchants … wholesale traders of all sorts and descriptions — in fact, a well informed onlooker estimates that the throng surging about Sage's office could raise enough cash in twenty-four hours to pay off the national debt and "not use up 50 per cent of their assets at that."[25]

The reporter continues with emphasis placed upon some of the social values of the times:

> It was emphatically a "swell crowd," and a very assertive one too. In the presence of so much wealth the police seemed paralyzed. They recognized the fact that it is one thing to club some poor laborer and quite another to whack a man whose check is good for a million dollars…. Consequently there was little intervention with the ebb and flow of the human tide. After the capitalists had learned that Sage was but slightly hurt, and that the only dead were a clerk and the bomb thrower, they went back to their offices and then laughed at the utter insanity of any one "trying to make Pap Sage give up his money."[26]

Further emphasis was placed on the position that New York held in the worlds of investment and finance:

> Nowhere else in the world are the representatives of wealth so closely hived together as in New York city [sic], and nowhere else in the world could such a crowd of "plutocrats" have been assembled at such brief notice.[27]

Because of the partial demolition of the *old* Seventy-One Broadway and due to increased land values and numerous real estate speculators' desire for profit, the stage was set for new development at this storied site. And the plutocrats were ready. A consortium of businessmen, including the legendary capitalist John Pierpont (J. P.) Morgan, assembled a site measuring 78 feet along Broadway and 224 feet along Rector Street, which included the old Seventy-One Broadway Building site, and paid for the construction of what was to become the present Empire Building. The location was ideal: to the north across Rector Street was Trinity Church and its graveyard — a sacred place where no investor could build any view-blocking structure — and to the south a row of low-rise office buildings. Architect Kimball conceived of a slab-like skyscraper that filled the entire parcel and stood 21 stories, 304 feet tall. His concep-

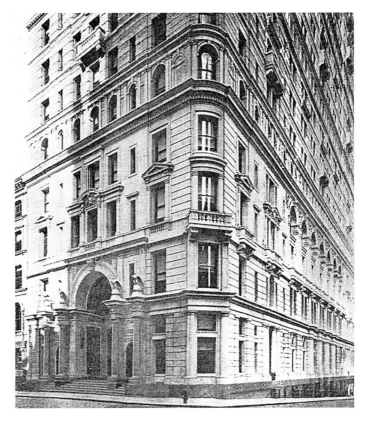

Empire Building, Broadway entrance (*The Architectural Record*, "The Skyscraper Up To Date," Vol. VIII, January–March, 1899, No. 3, pp. 231–257).

tion was realized, complete with ten passenger elevators and 340 office suites. Completed in 1898, it was faced with cream-colored limestone and was wrapped with enough classical ornaments to make a Roman emperor feel right at home.

For those firms that wanted to impress their clients, this was the perfect building, for here was a true Gilded Age "trophy tower." The Illinois Steel Company had offices on the 17th floor. Elsewhere were the confines of the Consolidated Coal Company of Maryland, the Empire Trust & Security Company, the Union Trust Company and many international concerns. Various stock and bond traders, law firms, and real estate brokers rounded out the roster here. It was also in this steel-framed skyscraper that the Manhattan offices of the United States Steel Corporation were first located; New York tycoon J. P. Morgan formed that corporation in 1901 with the merging of several companies, including Illinois Steel.[28] Many "empires" prospered here.

St. Paul Building, New York, 1899

Could this be one of the New York buildings that Louis Sullivan referred to as "bumptious"? On an excursion to Manhattan, did Sullivan's viewing of this building compel him to write later of the "screaming nightmares" of New York, of the skyscrapers conceived by "money-crazy people who not only let them be done but wished them to be done?" Was this building designed, as Sullivan put it, in "a rather rancid New-Yorky flavor," as it obviously recalled the architecture of the ancients? Perhaps.

Scathing criticism of the St. Paul Building reared not only from Chicagoans, but also from

the Eastern press and the artistic elite. Upon completion, this skyscraper, once located at 222 Broadway, was not admired by the public, but it was used by them in a very functional way. It was the home to multiple law and advertising firms, to trust companies and publishing houses, and it was even referred to as "the architectural wonder of New York." Tallest building bragging rights, even intentionally in error, were often bandied about to lure potential tenants, as evidenced by the following advertisement:

> The Highest Office Building in New York
> The only building giving a magnificent unobstructed view from every window,
> and dazzling daylight in each and every room.
> 26 stories high and built to solid bed-rock.
> Constructed after the most approved plans
> known to modern structural art.[29]

At its completion in 1899, the St. Paul Building rose 313 feet tall, effectively ranking it New York's *third tallest* behind the Park Row (382 feet) and the Manhattan Life Insurance (348 feet) buildings. Nevertheless, this speculative skyscraper immediately made oodles of money for its owners from the rents levied upon dozens of tenants. In return, building management offered tenants an elegantly appointed lobby, steam heat, gas and electric light, hot and cold water in every office, six electric passenger elevators, a centralized telephone switchboard, and "elegant

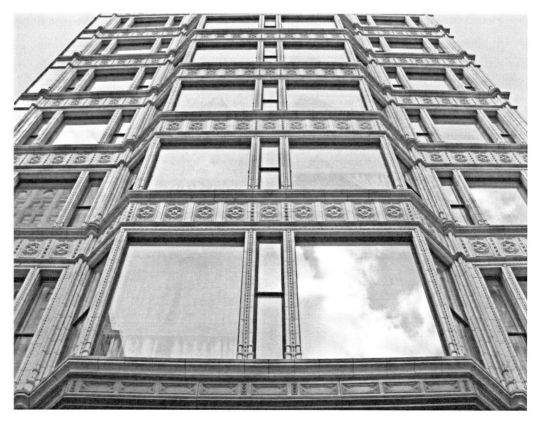

Compare the St. Paul Building (George B. Post, 1899) with Chicago's 14-story, 200-foot-tall Reliance Building (Charles B. Atwood of the firm D. H. Burnham & Company, 1895), also a product of the Gilded Age, but **not** an extravagant one. The Reliance Building, an unquestioned architectural masterpiece, was completed *four* years before New York's St. Paul Building, but from a design perspective it was decades ahead of anything Manhattan could muster (photograph by author).

toilet rooms with sanitary plumbing." A law library was also provided for the use of the building's many attorneys. To many, though, this skyscraper's architecture was secondary to the building's many advantages, which also included its proximity to the courthouses, post offices, newspaper headquarters, city hall politicians, Wall Street financiers, and a superb transportation network that encompassed elevated and surface railroad lines, ferries, and the recently completed Brooklyn Bridge. Broadway was at its doorstep.

As classically inspired skyscrapers went, the limestone-faced St. Paul was one of the strongest examples. Its architect, George B. Post, conceived of a building dripping with three-story tall Ionic columns and pilasters, a structure with layer upon layer of full entablatures. Its street façades rose without setbacks to an elaborate crown, a veritable Renaissance palace of three stories, replete with heavily decorated walls. By occupying the whole of a difficult site, the skyscraper seemed to have twisted and writhed the higher it climbed, yet it climbed with façades of unyielding repetition. This neoclassical *tour de force* recalled no singular building from antiquity; instead, it seemed to have mimicked all of them.

America's "Sugar King" was the principal behind the construction of the St. Paul Building. Henry Osborne Havemeyer (1847–1907) was the founder of the American Sugar Refining Company in 1891 (renamed "Domino" in 1901) and ruler of the "Sugar Trust." New York–born Havemeyer, considered a Gilded Age "robber baron," controlled 15 sugar refineries, and by the early 1890s his sugar empire controlled almost 90 percent of the industry.[30] In addition to his sugar interests, Havemeyer was briefly the president of the Long Island Railroad, the American Coffee Com-

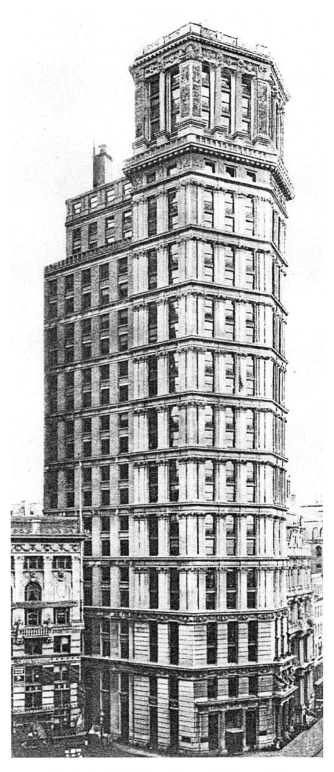

New York's St. Paul Building (George B. Post, 1899), a Gilded Age monument to excess (The Rotograph Company, New York, 1901) (author's collection).

pany, and, when time afforded, he tinkered in real estate and actively pursued Wall Street business connections. In short, Havemeyer was the East Coast equivalent to the West Coast's Spreckels.

In the late 1890s, a parcel of land became available for development directly across Broadway from St. Paul's Chapel (1766), the skyscraper's namesake. Havemeyer gained control of the site and promptly employed George B. Post to complete the plans for the St. Paul Building. The Havemeyer family's sugar empire was headquartered in *their* Post-designed Havemeyer Building, a 14-story skyscraper completed in 1892 on nearby Church Street.[31] Havemeyer, evidently pleased with the results of that commission, awarded Post the commission for *his* St. Paul Building. By doing so, and due to the courtesy of Post, the St. Paul Building echoed the façade design of the Havemeyer Building in one important way: the *atlantes* (plural of "Atlas"). Marcus Vitruvius Pollio (c.75– c.15 BCE), respected Roman architect and engineer explained their existence as

> figures in the form of men supporting mutules or coronae, we term "telemones"— the reasons why or wherefore they are so called are not found in any story — but the Greeks name them *atlantes*. For Atlas is de-

An upper-story floor plan of the St. Paul Building (George B. Post, 1899) reveals a very idiosyncratic, but rational for the site, scheme that did work well for its tenants — in 1899 (William H. Birkmier, *The Planning and Construction of High Office-Buildings*, New York: John Wiley & Sons, 1898, 73).

scribed in story as holding up the firmament because, through his vigorous intelligence and ingenuity, he was the first to cause men to be taught about the courses of the sun and moon, and the laws governing the revolutions of all the constellations. Consequently, in recognition of this benefaction, painters and sculptors represent him as holding up the firmament ... [and he is] consecrated in the firmament among the constellations.[32]

A less ancient text reveals Atlas's (*atlantes*) purpose from a slightly different viewpoint:

> In mythology, Atlas was a Titan punished by Jupiter for his part in the War of the Titans. He was condemned for ever [*sic*] to hold the heavens on his shoulders. His home became identified with the Atlas mountains in North Africa, from the legend that they supported the heavens.[33]

For some long-forgotten reason, Post insisted that giant figures from mythology be attached to the façade of a 19th century skyscraper of his own design.[34] What Post gave Havemeyer above his building entrances, although designed by noted sculptor Karl Bitter, was bombast.[35] Statuary that might have worked some 170 feet above the heads of pedestrians on Church Street (as on the Havemeyer Building) was brought down to earth without a change in scale for the St. Paul Building. Were these gigantic *atlantes* included here for the amusement of passersby on Broadway? Was there a connection between mythological giants, revolutions of the constellations, and the lawyers who labored within? Did these statues not elicit "a rather rancid New-Yorky flavor"?

Mythological giants called *Atlantes* (also referred to as *telemones*) leer downward from above the Broadway entrance to the St. Paul Building (George B. Post, 1899) (*American Architect and Building News*, October 7, 1899, No. 1241, Heliotype Printing Company, Boston; Negative by H. H. Sidman).

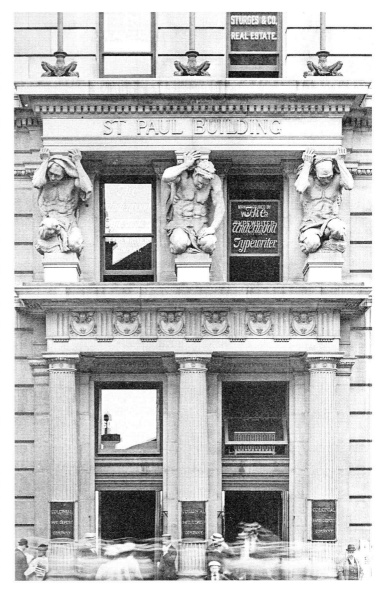

FLATIRON BUILDING, NEW YORK, 1902

But if clarity of structural expression was not Burnham's first priority, the Flatiron's remarkable triangular shape made it a real esthetic triumph.[36] — Paul Goldberger (b. 1950)

The Flatiron Building's façades were designed to resemble those found on French and Italian palaces constructed during the 15th century. Its walls, coated in terra-cotta, were thick with decoration derived from the Renaissance. This New York skyscraper was made to mimic buildings that stood by traditional masonry means, and that, it seems, was indeed architect Burnham's "first priority," not structural expression. Though never New York's tallest, the 20-story, 286-foot-tall Flatiron Building was, for most of its existence, easily the most recognizable.[37] Its triangular shape, elegant proportions, and overall heroic stature commanded instant respect and admiration from the public and from the critics. Its prominent location at the crossing of Broadway, Fifth Avenue, and 23rd Street certainly aided in its popularity and iconic status.[38]

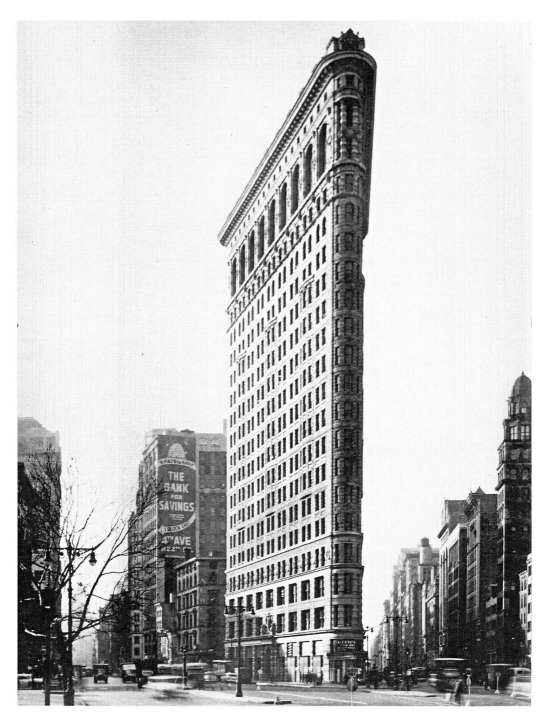

Flatiron Building (author's collection).

Four men, all products of the Gilded Age, were responsible for the Renaissance pile known as the Fuller (later renamed Flatiron) Building: these were Burnham, Dinkelberg, Black, and Starrett. Daniel Hudson Burnham (1846–1912), the consummate neoclassicist, and Frederick Philip Dinkelberg were the primary creative forces behind the Fuller Building. Dinkelberg, the building's architect, worked for the Chicago-based firm of D. H. Burnham & Company, the architecture firm of record. Frederick Philip Dinkelberg (1861–1935), a devoted Renaissance-

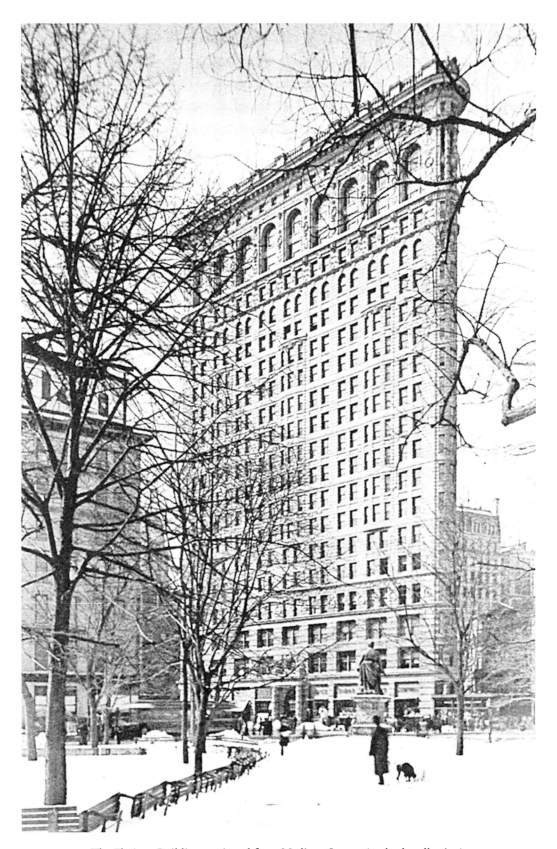

The Flatiron Building as viewed from Madison Square (author's collection).

style designer, was born in Lancaster, Pennsylvania; he graduated from the Pennsylvania Academy of Fine Arts in Philadelphia, and moved to Chicago to join the Burnham firm. Though Burnham oversaw some aesthetic aspects of the Fuller Building, it was Dinkelberg who conceived of its design and drew its plans.

Black and Starrett were the primary economic forces behind the Fuller Building. Black worked for the George A. Fuller Company, which served as the general contractor and financier of the Fuller Building, a structure planned as its corporate headquarters. The company was founded in Chicago in 1882 by George Allon Fuller (1851–1900), a native of Templeton, Massachusetts.[39] The George A. Fuller Company, one of the world's largest of its type and the firm best known then for erecting skyscrapers, would eventually occupy the top three floors of the Flatiron Building.[40]

Harry St. Francis Black (1863–1930), corporate vice president and Fuller's son-in-law, became the company's president upon the death of its founder.[41] Canadian-born Black was described as "a fighter — dynamic, stocky, with dark hair, piercing dark blue eyes, powerful hands," a man who quickly became a major force in the promotion and construction of New York office buildings. His first great project was "probably the most talked about skyscraper ever built, the 'Flatiron' Building."[42] He would be perfect for such a daring enterprise; Black would serve as president of Fuller from 1900 until 1903, the complete period of construction of the Fuller Company's headquarters building. In 1900, Black brought Paul Starrett (1866–1957), the head of the Chicago office, to New York to oversee the construction of the Fuller Building; Starrett would succeed Black as president and remain so from 1903 until 1922.[43] The stage was set for these four men of action — Burnham, Dinkelberg, Black, and Starrett — to design, construct, and pay for New York's great triangular pillar.

These four fellows were accomplished men. Three of them bossed the work of others, all were admired in their social circles, and at least two of them were very rich — or soon would be. Each, though, seemed to be very comfortable with architectural conformity, specifically with

Renaissance-inspired design being applied to the façades of the modern American skyscraper. At the turn of the century, New York was rife with Renaissance-inspired buildings, especially in the neighborhood once known as "Ladies Mile," where the Fuller Building was to be located; it would fit right in. Preliminary and final presentation drawings of the new skyscraper clearly depicted three façades of Beaux-Arts origin, revealing that its design destiny was preordained. No building that looked like Chicago's glassy Reliance (Charles B. Atwood, 1895) would be constructed on Broadway at Fifth Avenue, despite the ironic fact that its "modern" design was the product of the traditional D. H. Burnham & Company, albeit with Atwood as architect. After two years of construction, the Fuller Building was declared complete, and on October 1, 1902, the skyscraper officially opened.[44]

When viewed from the north, the Fuller Building

Charles B. Atwood (1848–1895) was the genius behind the design of the glassy and streamlined Reliance Building. It would have been impossible to build the Reliance Building in New York then due to entrenched customs and a stuffy culture (*Harper's New Monthly Magazine*, Vol. LXXXV, November 1892, "The Designers of the Fair," p. 874+).

resembled a stove-heated "flatiron," a hand-held iron employed to take the wrinkles out of Father's white shirt and Mother's shirtwaist. Because of the public's and the press's imaginative simile, the stodgy name "Fuller" was replaced, to the delight of almost everyone, by the quirky moniker "Flatiron." Despite the change, the George A. Fuller Company remained holed up at its top.

Above the heads of Black and Starrett at the Flatiron's north corner roofline, was placed a giant escutcheon flanked by two putti (perhaps interpretations of Black and Starrett as infants?). Surrounding their offices and occupying all the building's façades was a whole arsenal of Renaissance design weaponry included to delight citizens and rival firms alike. The Atlantic Terra Cotta Company, headquartered in New York City, supplied all the cream-colored terra cotta that wraps the walls of the third through the 20th floors.[45] On these façades can be found images of Greek masks, lion heads, floral motifs, frets, garlands, dentils, and vermiculated (a carved worm-eaten design) stone. Multiple band courses ring the building, with a pronounced cornice and balustrade capping all. The Flatiron Building's façades are accented by gently rippling bay windows; it remains an exquisite composition, delicate in its details, handsome in its overall execution. The Flatiron Building was, quite simply, Dinkelberg's masterpiece, a Beaux-Arts triumph. And what of other possibilities for the site? Could a three-sided Reliance Building have been constructed there? How would transparency have fared at that location rather than the opacity of masonry walls? In honest reflection, the "Four Men of the Gilded Age" would never have favored such a progressive approach in lieu of the proper language of the French-Beaux Arts. In the final analysis, Burnham and Dinkelberg received accolades, and Black and Starrett got what they paid for.

The New York Times Building, New York, 1904

> But the question of how to design the tall building has never been resolved; it continues to plague, disconcert, and confound theorists and practitioners alike. The answers were first sought in models of the past, which were later rejected and then still later rediscovered, carrying reputations up and down…. In the final analysis, the results are controlled less by any calculated intent than by those subtle manipulators of art and ideas — taste, fashion, and status.[46] — Ada Louis Huxtable (born 1921)

The "calculated intent" of the American architect was indeed based in a direct response to America's "taste, fashion, and status." In the final analysis, the American architect gave to his client what his client wished; to do otherwise would have guaranteed a very short professional career for the long-suffering architect. The American architect was, for the most part, a slave to fashion, to the fashion and tastes and whims of his clients. The New York Times Building reflected the values of the newspaper's owner and board of directors, and its appearance represented the resurrection of one of those "models of the past." This skyscraper was the home to a large metropolitan newspaper that often manipulated or echoed the "taste, fashion, and status" of its time.

Unlike the visually buried skyscrapers of the Wall Street district (including the Commercial Cable, the Manhattan Life Insurance, and those standing cheek-by-jowl with other tall buildings), the New York Times Building sprang free from any touching neighbors. And like the Flatiron Building, all its sides told its story. This skyscraper was not a bastion of wealth, a forbidding "great keep," it was a peoples' palace with complete visual and pedestrian accessibility.

The New York Times Building was modeled after the Campanile of the Cathedral of Florence, begun in Italy in 1334.[47] This free-standing bell tower measuring only 45 feet square but rising 275 feet is adjacent to the cathedral and stands on the Piazza del Duomo in Florence. It

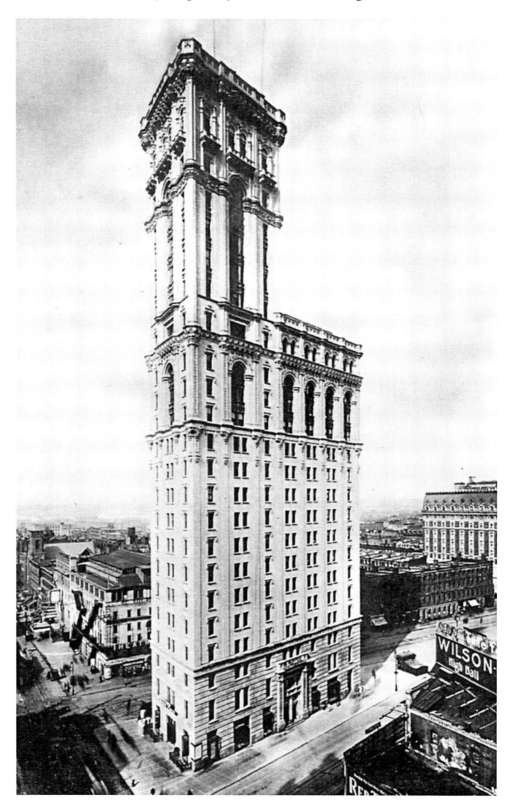

New York Times Building (author's collection).

was built to the designs of Giotto di Bondone (c.1267–1337), the Florentine painter and architect. The New York Times Building was by no means a slavish copy of the Campanile, but it was instead one of "casual inspiration." And the man inspired by Giotto's Campanile was New York architect Cyrus L. W. Eidlitz.

This extravagant skyscraper was completed to the plans of architects Cyrus L. W. Eidlitz and Andrew C. McKenzie. Cyrus Lazelle Warner Eidlitz (1853–1921) was the son of the noted New York architect Leopold Eidlitz (1823–1906), from whom he learned much. Cyrus's formal architectural education included study in Geneva, Switzerland, after which he entered the Royal Academy at Stuttgart, Germany. He returned to New York at the age of 18 and entered his father's office as an apprentice. Sometime after 1876, Cyrus L. W. Eidlitz formed his own design firm, also in New York, and immediately garnered numerous commissions. He began his career as a devotee of the Romanesque, but he quickly delved into the various Renaissance styles employed judiciously during the 1890s by others of his profession. By the time that Eidlitz received the Times Building commission, he was regarded as a well-seasoned skyscraper designer, having drawn the plans for no less than six of them in New York alone.[48] Andrew Campbell McKenzie (1861–1926), a native of Dunkirk, New York, entered Eidlitz's office around 1900 and remained with him until Eidlitz retired from practice in 1910.[49]

Eidlitz and McKenzie were awarded the commission to design the new headquarters of the *New York Times* by the company's board of directors, of course with the blessing of the newspaper's owner, Adolph Ochs (1858–1935). Born in Cincinnati, the son of German-Jewish immigrants, Ochs was a skilled businessman and opportunist. With borrowed funds, he purchased a controlling interest in local newspapers. Ochs eventually garnered enough borrowed cash to purchase the *New York Times* in 1896. As owner, it was his decision to move the newspaper to midtown from lower Manhattan and into a new skyscraper that would be built there to house his company. The cornerstone for the new skyscraper was laid on January 19, 1904 (with much construction already underway or completed) and by January 2, 1905, the first issue rolled off the presses at the new location.

What Eidlitz and McKenzie created for Ochs and the *New York Times* was nothing less than an Italian Renaissance spectacle. Its design was criticized by some as heavy-handed, stern, and serious, a building without much delight. This stony cliff of a building lacked the "modern streamlined" appearance of the Flatiron Building. The New York Times Building looked heavy, a weighty composition drawing upon unseemly precedent. Still others admired the attempt if not the building. The new tower was a curtain-wall skyscraper designed not to look like one; its thick limestone façades had tiny windows. Walls were covered with Italian Renaissance detailing, with arcades, prominent band courses and balusters, and with porches adding to the mix. Upon its completion in December, 1904, the New York Times Building ranked as Gotham's second-tallest building, rising 25 floors, 363 feet tall; by 19 feet only, the Park Row Building was taller. From its narrow sliver, the newspaper commanded the whole of Longacre Square, soon to be renamed Times Square.

The New York Times Building was the ultimate marketing tool for the newspaper, whose motto (an Ochs contribution) was: "All the news that's fit to print." The skyscraper itself was an advertising statement (especially with electric signs girding its walls), and it stood above one of the busiest subway stations anywhere. In this way, architecture, even during the Gilded Age, served as both icon and as headquarters with chutzpah. Ochs got more than he paid for.

After 60 years (and with the newspaper's headquarters having already relocated one block to the west), the New York Times Building suffered a terrible fate. In 1965, at the hands of real estate investors wielding fistfuls of architectural drawings and dollars, the venerable New York Times Building's walls were stripped of its stone and brick and brutishly remodeled. After more

damage was visited upon it in subsequent years, the skyscraper now "exists" only as a giant signboard, a victim of fleeting "taste, fashion, and status."

WABASH BUILDING, PITTSBURGH, 1904

For only 49 years, Pittsburgh's Wabash Building reigned as the greatest Beaux-Arts skyscraper in that city. It combined the triangular shape of the Flatiron with a dome like that of the World Building, and it dripped with Renaissance details like the American Surety, columns and all. It even housed a train station. In short, this skyscraper was "every building," a magisterial interpretation of one man's dream, an apt symbol of the Gilded Age and the folly that scuttled a titan.

The Wabash Building was constructed because of the unbridled determination of George Jay Gould (1864–1923), one of six children of Jay Gould, the noted New York financier, railroad manipulator, and tycoon. When his father died in 1892, George Jay Gould acquired almost total control of the Gould estate, a $77-million kingdom that included the management of the Western Union Telegraph Company, Manhattan's elevated commuter carriers, and four intercity railroad companies.[50] "Boss Gould" would also come to control the Denver and Rio Grande Western Railroad, making him a true "empire builder." Gould's aim was to form a single, powerful corporation that would control

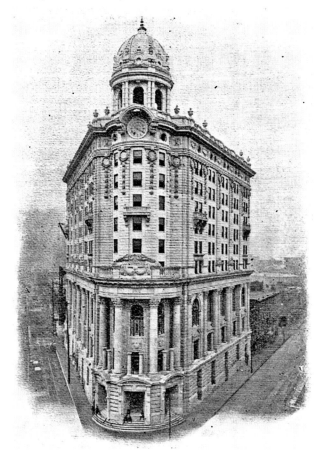

Wabash Building (author's collection).

all the nation's transcontinental freight and passenger rail service.

The Wabash Building was to be the empire's nexus, a multi-purpose facility with hundreds of offices and enough rail lines to connect Pittsburgh to the East and West coasts. Intense competition, court battles, and the expenses associated with engineering such a feat like the construction of innumerable bridges and tunnels, not to mention the lines themselves with stations, combined to exhaust Gould's ability to raise and preserve the required capital. What had much promise in 1904 dissolved into bankruptcy by 1908; America's notorious financial panic of 1907 hastened the collapse. Gould lost control of the Western Union Telegraph Company and all his railroad holdings. He lost, too, the confidence of his brothers and sisters, who filed a mismanagement suit against him to recover whatever money was left of their father's estate. At the death of Gould in 1923 on the French Riviera, he was purportedly worth an estimated five-million dollars (after all lawsuits were settled), an altogether substantial sum to be further divided. This was truly a Gilded Age *riches-to-rags* saga, one whose lone symbolic remnant was a grand piece of urban architecture.

Gould's Wabash Building, named, of course, after his Pittsburgh-based Wabash Railroad, was all about empire. Not only was it a skyscraper, it also served as a castle, a protective fortress from which Gould could take refuge from his creditors, courts, and rival robber barons. For decades this skyscraper and its adjacencies fulfilled its intended role as office building and train station. A large, passenger train shed stretched back from the skyscraper for more than a block, with a generating plant, warehouses, and train approaches huddling nearby. The skyscraper was symbolic in a way that the support structures could never be. It adamantly spoke to *Pittsburg*, saying that Gould had arrived, that the future was boundless, and that wealth and prosperity had come to the city that then spelled its name without an "h."[51] The Wabash Building spoke with architectural conviction. Its style, manner, and its very presence spoke volumes; it demanded respect in a town of steel mills, furnaces, and coal piles. Its Beaux-Arts pedigree was the result of another man's vision, of the skills and training of architect Theodore Carl Link (1850–1923).

Link arrived in New York from his native Germany in 1870. He studied architecture at the University of Heidelberg, in London, and lastly at the École des Beaux-Arts. In 1882, after practicing in a number of cities, Link chose St. Louis in which to open his own architecture and civil engineering firm. In 1891, Link won a major architectural commission to design the greatest train station of the era, the St. Louis Union Station.[52] He also served as one of the most prominent architects for the St. Louis World's Fair of 1904. At some point, the paths of Link and Gould crossed, and Link secured the commission for his tallest project.

Pittsburgh's Wabash Building, completed in June 1904, stood 11 stories, 197 feet tall. It housed hundreds of offices on floors four through 11; within the upper stories were the hushed confines of Gould's Wabash Railroad. Floors one through three contained the station's public ticket areas, railroad waiting rooms, and various retail spaces. The skyscraper cost Gould $800,000 to erect.

Architect Link could have used any number of Beaux-Arts prototypes for the inspiration of this design. He did, though, execute his concepts with all the necessary pomp and pageantry at his disposal. His façades were simply displays; they were more about show than about shelter. Included were rounded pediments and Corinthian columns, garlands, urns, and six freestanding Doric columns above the skyscraper's main entrance. At the cornice level was inserted the proverbial train station clock. Higher still was the building's *piece de resistance*, its ribbed, metal dome. This, too, could have been inspired by a multitude of religious buildings erected during the 17th or 18th centuries. Urns danced around its rim while a finial emerged on top. The skyscraper's delicate façades stood in marked contrast to its immediate surroundings of warehouses and small industrial concerns.

Though Gould's railroad dream failed to materialize, for almost a half-century his skyscraper did fulfill its role as an income producer and gateway to the city. On July 5, 1953, it was announced that the Wabash Building would be demolished for reasons of urban renewal, and exactly three months later, demolition commenced.[53]

CITY INVESTING BUILDING, NEW YORK, 1908

In style of architecture the building will be what is technically known as free Italian.[54]

The term "free Italian" could have meant many things when recorded in 1906, but in current parlance the Beaux-Arts style first surfaces when describing the architecture of the City Investing Building. Inspired by the many French chateaux of the 16th century, this Beaux-Arts behemoth was one of the most grandiose, pompous skyscrapers ever built in New York. It was a giant for its time, and it displayed all the splendor the French Renaissance and its architect could muster for a 20th century American office tower.

This skyscraper, like so many during the Gilded Age, conveyed much symbolically. Its centuries-old styling communicated timelessness, a continuity based upon wealth achieved by business acumen. And that was important to the building's owner, the City Investing Company, a firm devoted to real estate development, management, and the acquisition of other skyscrapers for profit.[55] Founded in 1904 by New York entrepreneur Robert E. Dowling (d. 1943), this structure represented the culmination of his career and that of his corporation. As president of the City Investing Company, Dowling spearheaded the purchase and development of properties throughout New York, and during his professional career he served as the director of numerous large corporations.[56] In 1909, and with characteristic Gilded Age bravado, Dowling exclaimed: "No property in the world is held in stronger hands than the real estate on Manhattan Island. For the investor, there is about a small probability of loss as there can be in any investment."[57]

The City Investing Building meant real estate. This skyscraper served as a symbol of what real estate could produce, and what real estate often produced was wealth. This bastion of wealth was completed in 1908 after 22 months of construction. The skyscraper, located at 165 Broadway in lower Manhattan, stood 34 stories, 487 feet and ranked as the city's second-tallest building, bettered only by its neighbor, the Singer Building. It was a monument with monumental proportions: it contained some 500,000 square feet of floor space and was billed as the world's largest office building. It housed 6,000 tenants and visitors every business day, people who were served by 21 electric elevators.

Architect Francis Hatch Kimball did the design honors. He adhered to the familiar tripartite organizing principle with the skyscraper's base being profusely decorated; the building's 25 story shaft was comparatively unadorned, only to be upstaged by one of the most flamboyant summits anywhere. A giant gable, pushing upward through the building's core, topped off seven additional office floors and two attic stories. Dormers, statuary, and ridge cresting added further delight to the steeply pitched gable. Elsewhere on the façades were balconies, carved stone eagles, and fanciful cornices. The Beaux-Arts exterior was

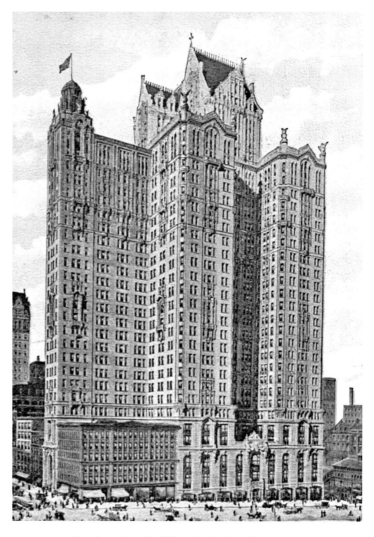

City Investing Building (author's collection).

wrapped with a combination of white brick, terra cotta, and limestone. Its prominent copper roof was green.

What Dowling and Kimball created in 1908 was destroyed in 1970. And what Louis Sullivan would have undoubtedly labeled a "screaming nightmare" was indeed pulled down by spending vast sums (*Kindergarten Chats*). But while it stood, the City Investing Building must have been a glorious sight to behold, Gilded Age pompousness and all.

METROPOLITAN LIFE TOWER, NEW YORK, 1909

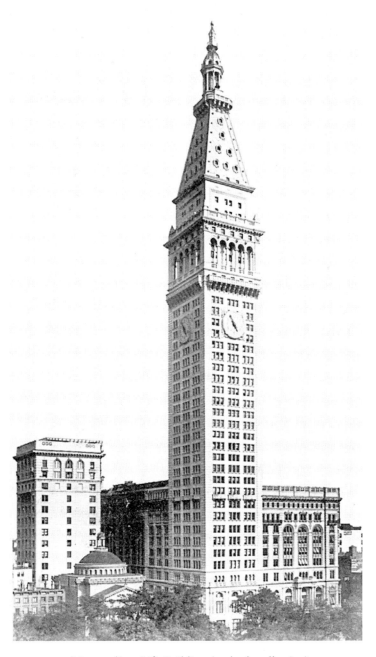

New York's Metropolitan Life Tower was trumpeted as the "World's Tallest Building" in December 1909. It stealthily stole the record from the Singer Building that so proudly stood 88 feet shorter and a few miles further south on Broadway. Rising over Madison Square, the new skyscraper counted 50 stories, and was an even 700 feet tall. The delightful tower was both a home to hundreds of Metropolitan Life Insurance employees and served as an unmatched advertising coup. It was also a "relic," a building that paid homage to the architecture of 16th-century Venice. By employing Italian Renaissance façades, the design of the Metropolitan Life Tower gave an *assumed* elegance and an air of dignity to this new skyscraper. But also, and by association, its walls embodied intellectualism, scientific inquiry, secular and religious art, music and literature, and a promised degree of timelessness to contemporary eyes. Certainly, to the Tower's architects and to those men who paid for it, these were truths that were to be espoused publicly. And architecture, as a tool, does that especially well.

Metropolitan Life Building (author's collection).

The Metropolitan Life

Insurance Company was founded in Manhattan in 1863 as the National Union Life and Limb Insurance Company; mercifully in 1868, it adopted its present name. For many years, the company was headquartered in a seven-story building on lower Broadway. Proving to be too cramped for the successful firm, Metropolitan Life decided to move to Madison Square and erect an 11-story building to the plans of architect Napoleon Le Brun. Completed in 1893, this block-wide structure was soon deemed obsolete, and the construction of a skyscraper was decided upon.[58]

What is occasionally misunderstood, or overlooked altogether, is the degree to which a company president or its board of directors determined the style, indeed the entire appearance, of a company's headquarters building. During the design phase for the new tower, Metropolitan Life's president and vice president took active roles in the project. Regarding the Metropolitan Life Tower, it was suggested that the campanile-form originated from the "inspiration" provided by the company's president, John Rogers Hegeman (1844–1919).[59]

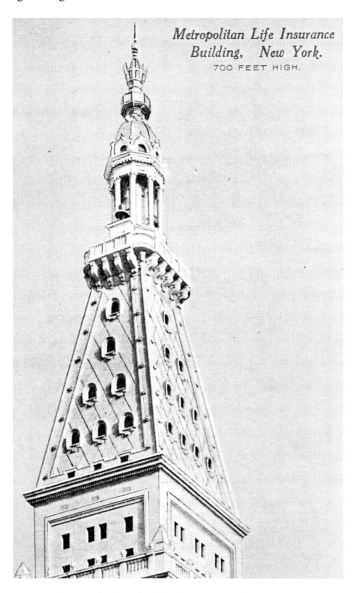

Metropolitan Life Insurance Building, New York. 700 FEET HIGH.

Hegeman was born in Brooklyn, of modest means. He attended public school there and later graduated from the Brooklyn Polytechnic Institute. In 1866, Hegeman entered the insurance business as an accountant with the Manhattan Life Insurance Company; then, in 1870, he joined Metropolitan Life as a secretary. Only months later, Hegeman was promoted to vice president, a position he held until becoming president in 1891. Like many of his ilk, Hegeman was active in many business and social affairs and was a skilled yachtsman, maintaining memberships in the American, Larchmont, and the prestigious New York Yacht clubs.[60] Throughout his tenure as president with Metropolitan Life, Hegeman was responsible for the enormous success of the company and personally oversaw all of the company's office building construction in New York City. From a small insurance firm that counted only 10,000 policies in 1870, Hegeman increased the number of insurance policies in force to almost 20 million by 1918; Metropolitan Life's income skyrocketed from $11 million when he became president in 1891, to $200 million by 1918. Serving as vice president during

Metropolitan Life, detail of building top (author's collection).

this time was Haley Fiske (1852–1929). Born in New Brunswick, New Jersey, Fiske was educated as an attorney and was generally credited with increasing the company's insurance value in force to a staggering $1.47 billion by 1905. Without the keen financial acumen of both Hegeman and Fiske, there would not have been a Metropolitan Life Tower, at least not as it currently stands. This was really Hegeman's baby; he took an avid interest in the great skyscraper yet to come.[61]

Hegeman and Fiske were not architects, but Napoleon Le Brun was. Le Brun was summoned again to submit plans, not for another 11-story structure, but for a skyscraper destined to be the tallest anywhere. By 1909, the Metropolitan Life Insurance Company was the largest such enterprise in America. Plans for the Tower were published by the *New York Times* on January 4, 1907, and the public was fascinated. Immediately to the north and adjacent to the palazzo-styled home office of 1893, an office tower with a pyramidal cap would be constructed. It appeared that Hegeman got his wish for a campanile, a taller version of the famous Campanile of San Marco in Venice. Italy's original was completed in 1514 and still stands 325 feet above the Piazza San Marco; New York's, or more appropriately Hegeman's, was completed in 1909, and it still stands 700 feet above the lawn of Madison Square. The resemblance was striking despite the 400 years and 4,200 miles that separated them.

The appearance of the Metropolitan Life Tower was due in great part to the desire and tastes of one man or possibly two, depending upon how much creative input Le Brun was allowed. With the Metropolitan Life Tower, New York's skyline was awarded a reserved and altogether elegant Venetian dowager, a composition that drastically contrasted with the Singer Company's Parisian, giggling coquette. Though architecturally different, they shared an American attitude regarding corporate propriety, image, and the marketing value inherent in a very tall skyscraper. Neither was "American"; they both were based on the architecture of a different culture and a different epoch. This attitude was *de rigueur* for the Gilded Age, and it suited John Rogers Hegeman just fine; his large mausoleum in Woodlawn Cemetery in the Bronx was modeled on a Roman temple.

MARYLAND CASUALTY BUILDING, BALTIMORE, 1910

In a manner similar to the Metropolitan Life expansion of grafting a skyscraper onto its much shorter home office building, the Maryland Casualty Company decided to erect an 18-story tower adjacent to its own five-story headquarters. In both cases, the companies occupied earlier buildings derived ultimately from classical sources and in each the tower's design inspiration was complimentary to the existing headquarters. In both, centuries-old European models were employed to exploit the marketing advantage of having the city's tallest skyscraper, if only for a short while.

The Maryland Casualty Company was incorporated in Baltimore in 1898 "to do a general casualty business." In operation for only ten years, the successful firm commissioned the Boston-based partnership of Parker, Thomas & Rice for an appropriate design. J. Harleston Parker (1873–1930) and Douglas H. Thomas, Jr. (1872–1915) became associates in 1900, with Arthur Wallace Rice (1869–1938) joining in 1907. All three were well educated (Parker was an 1893 graduate of Harvard University; Thomas and Rice both graduated from the Massachusetts Institute of Technology in 1895 and 1891, respectively), and perhaps most importantly, all three studied architecture in Paris, Parker and Thomas at the École des Beaux-Arts. The lessons learned at the École determined the architecture of the Maryland Casualty Building.

At the time of the completion of this skyscraper in 1910, Baltimore possessed many fine buildings that were of French inspiration. An early skyscraper, the Baltimore American Building (Dixon & Carson, 1875), stood six stories in the regal French Second Empire style. But unquestionably the most prominent Beaux-Arts building was the Baltimore City Hall, also of 1875 and

completed to the plans of German-born architect George A. Frederick (1842–1924). Its elegant dome rose 227 feet high and only one block from the Maryland Casualty Building, which stood 341 feet, for years the tallest in Baltimore. What Parker, Thomas, and Rice created was very French, contextual, and yet very derivative. Although completed in the 20th century, this skyscraper could easily have passed for a 19th century skyscraper found in lower Manhattan; it was old when it was new.[62] The tower was theatrical, a tall decorative stage set with a fancy, telescoping top. Its highly ornamented base was contrasted by a simple, unadorned shaft. Its top consisted of a three-story explosion of terra cotta finials, escutcheons, consoles, and garlands. A copper jacketed tower similar to New York's Manhattan Life Building emerged from the body of the building. It featured a four-faced clock with a 17-foot wide face and a pyramidal roof with a decorative cluster on top. At night, this summit of sumptuousness was lighted so that all of Baltimore could see the city's highest point.

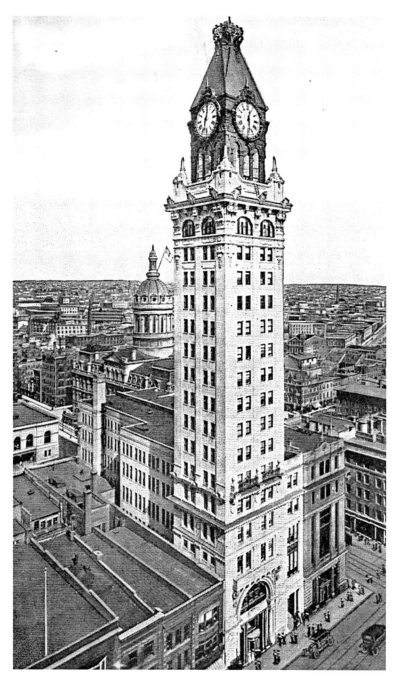

Maryland Casualty Building (author's collection).

By 1921, the Maryland Casualty Company abandoned its downtown skyscraper, moving its headquarters instead to a suburban location.[63] In 1923, the newspaper magnate William Randolph Hearst (1863–1951) purchased the Baltimore landmark and renamed it after himself. Planned as a publishing house, Hearst discovered the skyscraper's structure was ill-fitted for modern heavy presses, and he retained the building for investment purposes only. What the

Gilded Age produced, modern America eventually took away. In 1984, the Maryland Casualty/ Hearst Building was demolished.

NATIONAL REALTY BUILDING, TACOMA, 1910

With the National Realty Building a bit of Paris was reinvented in Tacoma, Washington. Here was a building executed in the best tradition of the Beaux-Arts style, yet with a hint of the Chicago School added for interest and modernity. Its tripartite organization provided a highly decorative and very Parisian two-story base and an 11-story Chicago School-style shaft. As a nod to the skyscrapers of New York, an extravagant four-story "capital" topped the tower. Its bottom "public domain" was balanced by its "aristocratic domain" at the very top, a giant hip roof that closely resembled the tower roof of the *Hotel de Sens* (1474–1519) in Paris and numerous New York prototypes.[64]

The National Realty Building was the product of the Tacoma firm of Heath & Twichell. The skyscraper's design inspiration was an eclectic blend invented in the minds of architects Frederick Henry Heath (1861–1953), a native of La Crosse, Wisconsin, and Luther Twichell (1867–1939) of Hastings, Minnesota. Heath arrived in Tacoma in 1893 and Twichell

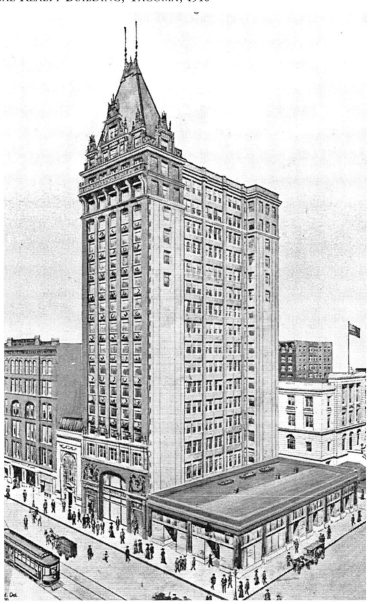

National Realty Building (author's collection).

in 1907. They formed a brief two-year partnership beginning in 1908. It was Heath who was the most prolific, designing some 600 projects principally in Tacoma and the Northwest United States. Though located in faraway Tacoma, Heath and Twichell desired to be in the mainstream, to design buildings whose popularity in New York and Paris was legendary. Through design magazines and books, these two saw the faddish towers of Manhattan, and in their youth they undoubtedly studied the architecture of Paris. There was no reason why a city of 83,743 souls

(1910 census), located in the Pacific Northwest, could not, or should not, have buildings like those elsewhere. Glamour knew no geographic boundaries during the Gilded Age.

Completed in 1910, the thin-slab National Realty Building was billed as the city's tallest and one of the highest on the West Coast. It rose 16 floors, 232 feet above downtown Tacoma's sidewalks. Recalling Chicago School design, its rise skyward was not impeded by any setbacks, its brick piers rose uninterrupted, and its terra cotta spandrels were clearly recessed, giving a streamlined quality to the building's shaft. Certainly, the skyscraper's exclamation point was its decorative top featuring a slate-covered roof complete with iron cresting, finials, and prominent dormer windows surrounded by French Renaissance-inspired decoration executed in tan terra cotta. During a 2001 "modernization," all this Gilded Age extravagance was erased, the result being a dismal echo of its Parisian pedigree.

Chapter Four

A Time for Funny Hats

Look at a man's hat to see how he wishes to be judged. Look at a man's shoes to see how he lives. — Anonymous

Some Gilded Age skyscrapers wore funny hats. These hats were delightful things, building bumps that were plopped on skyscraper tops to impress people; quite unintentionally they also provided homes for birds and bats. A visual cacophony, a parade of plumed dowagers was the result of a vigorous one-upmanship staged by architects and moneyed clients. Extravagant tops complemented extravagant walls, and these, in turn, echoed the extravagance of the times and of men. The variety of funny hats knew no bounds, and some people thought this situation was no laughing matter; Louis Sullivan found no humor in these.

No one architect was responsible for the oddly shaped domes and bizarre concoctions that curiously appeared hat-like atop America's tall office buildings. Baroque Europe was the inspiration, and the flamboyance of the style made it a perfect fit for the Gilded Age.

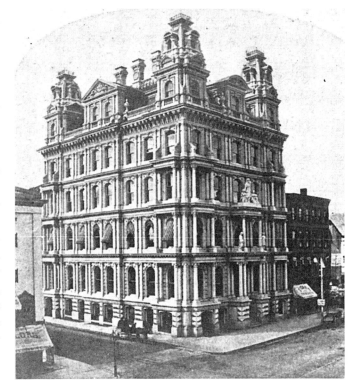

Hartford, Connecticut, was home to this extravagant early skyscraper, executed by Francis Hatch Kimball (1845–1919) in the popular French Second Empire Style. It was completed in 1870 for the Connecticut Mutual Life Insurance Company and was once described as "Hartford's Greatest Office Structure." In 1926, its pomposity judged unfashionable, the company abandoned this building for another location, and in 1965 it was razed (American Views Stereoscopic Company, New York) (author's collection).

101

Variations on a Theme: The Neo-Baroque Skyscraper

The classical idiom was only *one* such artistic source to be appropriated by America for its great skyscrapers; no architectural monopoly was had by the Greek and Roman gods. Classicism was the antecedent that spawned various architectural languages or dialects; it was remembered and reemployed in various forms, culminating in the flamboyant Baroque style.

American architects of the Gilded Age worked in and through a wide range of styles to give added meaning to the buildings they designed. The Renaissance variations — Italian, French, Flemish, German, and English — provided a model from which architects could study and come to terms with various aesthetic problems posed by the design of the new tall buildings.

The Renaissance, born in Italy during the 14th century, championed a resurgence of classicism. This all-encompassing rebirth was in reaction to the medieval world of Christian autocracy, and this reawakening was also due in part to the generally poor living conditions of Europe. The Renaissance arose because there was a genuine need for change, for questioning, and for new interpretations of the world around the "thinking man." Renaissance architecture, the direct

Many of the sources of America's Baroque and neo-classical skyscrapers can be found in the design of the Church of Santa Maria in Carignano (Galcazzo Alessi 1512–1572). Some Gilded Age architects thought of buildings like this as a large toy box, an architectural storehouse from which they could pry off the parts and pieces of the façades for reuse elsewhere. Being the consummate Italian Baroque building, it has the central dome of the World and Call Buildings, the twin-domed towers of the Park Row Building, and the façade-centered, pediment-topped, extravagant entrance that was repeated often during America's Gilded Age (author's collection).

descendent of the buildings of antiquity that were studied by 14th century scholars and architects in Athens and Rome, was alive with the columnar orders (Doric, Ionic, Corinthian), entablatures, pediments, and colonnades. The Renaissance façade offered beauty and organization in the forms of symmetry, "correct" proportions, proper spatial hierarchies, and dramatic perspectives. There was absolutely no reason why, many thought, American architects could not, or should not, employ the designs of a movement associated with such high ideals. The new American skyscraper provided the canvas upon which these elevated themes would be applied.

Within this classical framework was born a 16th century movement known as the Baroque. As a reaction to Protestantism, Humanism, and the general challenge of authority directed toward the Roman Catholic Church, an architectural style featuring theatricality was devised by the Church as a way of enticing the flock back to the "only revealed word." Baroque architecture was simply a set of variations on a theme, with the Renaissance used as the model. The Baroque style, also a product of Italy, featured a visual pageantry of brightly colored frescoed walls, dramatic interior lighting effects, emotive statuary, impressive marble domes, and flying shapes and forms that energized the interiors and exteriors of churches and public buildings alike. Classical proportioning systems were tampered with, and these produced enlivened walls affixed with statuary, giant volutes, broken pediments, colonnades, clocks and, rising above all, towering "hats." The Baroque meant domes and theatricality, and if it once pleased the popes, architects reasoned, it should certainly please the bankers.

The following 16 skyscrapers represent some of the most idiosyncratic office buildings erected during the Gilded Age. These descendents of the Baroque were the strange ones, the odd fellows, the most loudly dressed visitors in a room of demure gentlemen. Misshapen domes, elongated towers and strangely proportioned façades argued with neighboring towers sporting manners. These ill-dressed skyscrapers drew attention to themselves not by pleasantries but by brashness and undulating façades. To varying degrees the neo-Baroque skyscraper gave spice to the skyline and energized the street with preposterous proportions. They were nothing if not enticing in their perversity.

Variety's the very spice of life, that gives it all its flavour.[1]— William Cowper (1731–1800)

McLean Tower Block, St. Louis, 1876

James Henry McLean (1829–1886) was a self-made man in the best tradition of the Gilded Age. Born in Ayrshire, Scotland, McLean grew up in Nova Scotia, Canada, and eventually arrived in America in 1842. At that time he was described as "a poor young man, but plucky, and determined to secure a fortune by honest industry and perseverance." He settled in Philadelphia and found employment as a clerk in a drug store. While there, he gleaned some knowledge of human ailments and the medicines with which to treat them. As a teenager he became interested in pharmacology and decided to enter the medical profession. McLean completed one medical course at the University of Philadelphia, after which he moved to St. Louis, Missouri, in 1849. In 1863, at the age of 34, James Henry McLean graduated from the St. Louis Medical College after completing the required courses in medicine and surgery.

Sometime around 1865, and while he was a practicing doctor, McLean began the manufacture and distribution of medicines and health-restoring remedies. He founded the Dr. J. H. McLean Medicine Company, a purveyor of blood purifiers, liniments, syrups, balms, and pills. There were remedies such as Dr. J. H. McLean's Liver and Kidney Balm, Dr. J. H. McLean's Celebrated Catarrh Snuff, and Dr. J. H. McLean's Volcanic Oil Liniment, among others, and all for a price. It was claimed by some that his liniments were composed of nothing more than gussied-up crude petroleum, and that his various potions contained up to 100-proof alcohol.

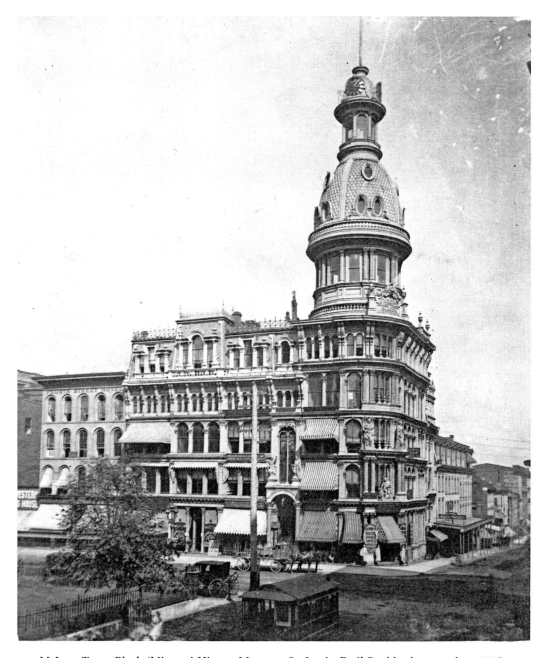

McLean Tower Block (Missouri History Museum, St. Louis, Emil Boehl, photographer, 1876).

Despite their effectiveness, or *perceived* effectiveness, Dr. James Henry McLean became quite a wealthy man.

The scope of McLean's expanding business required that a large building be constructed to efficiently house the company's sales, distribution, international mail order, and various other office functions. In 1874, a site was selected in downtown St. Louis as the location for the company's headquarters building, and shortly thereafter, the St. Louis architecture firm of Stewart & Jungenfeld was chosen to create a design worthy of the company.

James Stewart and Edmund Jungenfeld formed their firm in 1880 after each had been in

the employ of other St. Louis practitioners. Edmund Jungenfeld (1839–1884), the more famous, was born and educated in Germany and was one of the founding members of the St. Louis chapter of the American Institute of Architects. As a specialist in brewery architecture, he was responsible for designing parts of the Anheuser & Company's (later Anheuser-Busch) St. Louis brewing complex in 1869. His talents were known nationwide and, consequently, his firm specialized in the design of brewery buildings in various other cities.[2]

It is impossible to know exactly how McLean and Jungenfeld met, or what prompted McLean to select this firm so intimately associated with brewery architecture for a downtown St. Louis office building. But, it happened. Stewart & Jungenfeld submitted plans for a large skyscraper, a bombast-looking office building to be executed in a neo-Baroque style for a prominent downtown corner.

These architects knew that the sky was theirs to do with what they wished, and into it they pushed the seven-story, 180-foot-tall McLean Tower Block. Completed during America's centennial year, this skyscraper towered over St. Louis and was described hyperbolically as possessing "striking and effective features [that] are revolutionizing architectural plans and introducing lightness, grace and elegance of style."[3] The Block sported a 54-foot-wide skylight that allowed sunlight to pierce the building's interior, one hydraulic elevator, and speaking tubes "through which communications can be held with every office in the building." A contemporary description of its exterior follows:

> The front of Dr. McLean's Block is a pleasing commingling of Italian and Florentine architecture, which presents a charming and graceful appearance. The composite style of the Missouri granite columns, which ornament and support the grand entrance, exhibits exquisitely symmetrical form. Over this portico is a niche, in which a marble group represents Hercules combating with a Lion [*sic*], and in which the sculptor has placed the head of Dr. McLean on the shoulders of the son of Jupiter. As the doctor is a man of large frame, splendid physique, and has a remarkable face, the design is very appropriate. Surmounting the canopy there are two finely carved, double life-size statues, representing Commerce and Industry"[4]

Of course, the most prominent feature of the McLean Tower Block was its corner tower and dome. This bulbous behemoth seems to have been designed for a structure many times the size of the building upon which it rests. The dome was outfitted with oval lucarne windows, a balustraded balcony, and, at its very top, a lantern topped with four illuminated clock faces. Because the glass-walled drum and dome were placed upon a building without apparent proper façade organization, i.e., a rational fenestration pattern, the whole of the building appears to be totally undisciplined. To the contemporary eyes of one author, the McLean Tower Block design evidently appeared satisfactory:

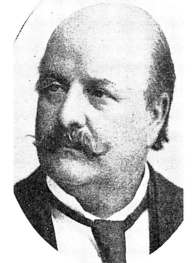

> A rare genius is exhibited in the design and thorough good judgment is manifested in every detail of construction…. In its various arrangements for imposing appearance, convenience and utility of space, Mr. James Stewart, the celebrated architect, has secured a happy medium, combining grandeur, beauty and usefulness.[5]

The skyscraper's architectural description continues:

> The dome, which is the most conspicuous feature of the structure, is over a hundred feet high, presents a massive and pleasing appear-

James Henry McLean (1829–1886) (The Dr. J. H. McLean Medicine Co., St. Louis, Mo., almanac, 1914).

ance, and is the first object that catches the vision of persons coming to the city from all points of the compass. From the gallery, which surrounds the dome, there is a commanding and beautiful view of the city and an area of over two hundred square miles of the surrounding picturesque country. Surmounting the dome is a tower, in which are located the immense reflectors, around which a large frame is made to revolve every five minutes, by the power of a magnetic clock. This is illuminated every night, and its kaleidoscopic colors present a pleasing and attractive novelty to the wondering multitude who watch it slowly turning its unceasing round. This unique curiosity is the newest of all the odd and interesting inventions incident to Western enterprise. On each side of the beacon there are transparencies, which exhibit the business of the most prominent occupants of the Block. The principal of these are handsome cards, on which are painted the names of Dr. McLean's Celebrated Strengthening Cordial and Blood Purifier; Volcanic Liniment; Wonderful Healing Plaster; Chinoidine Pills; White Crystal-coated Universal Pills, Cough and Lung-healing Globules, Catarrh Snuff, etc. The latter two remedies involve a new principle and way of curing consumption, throat and lung diseases. These new remedies have been lately introduced, and are creating a vast deal of interest in all sections of the country, on account of the relief which the use of them furnishes to invalids. Trial boxes costing only twenty-five cents can be sent by mail everywhere. The clock is situated in the extreme pinnacle of the tower, a hundred and seventy feet above the street, and its four large dials are always illuminated at night. To these fingers of time thousands of people daily and nightly turn their eyes, and other thousands regulate their duties and appointments by the music of its bells, which accurately announce the hours and fractions. The large bell for telling the hours with wonderfully clear and powerful tones was on the *Leviathan* when that famous steamboat was burned.[6]

The McLean Tower Block's extravagance was hardly matched; it was not so much architecture as it was pure theater. Where else could one go to see medicinal "globules" advertised in the night's sky, and lighted transparencies hawking pills and salves revolving overhead? This is a one-building Times Square *before* that storied crossroads became the world's advertising mecca. And a bell rescued from a burned ship and hoisted into place in a skyscraper's bell tower clanging out the hours?

This monstrosity had something for everyone, excepting those who yearned for serious architecture. Its colliding parts and pieces, rambling floor levels, multitude of window types, over-scaled sculptural themes, and attention-getting tower and dome make this structure unique in the annals of skyscraper history. And in one final salute to ridiculousness, the façade featured the marble-carved body of a Greek god with James Henry McLean's head placed upon the torso! McLean was the ultimate huckster.

From December 15, 1882, to March 3, 1883 — not even a full three months — James Henry McLean even served as an elected United States congressman representing Missouri to fill a vacancy in that noble body; he ran again as a Republican, and lost.

The McLean Tower Block has long since vanished, its demolition considered a blessing, no doubt, by a few. On August 12, 1886, James Henry McLean died in Dansville, New York. His body was returned to St. Louis, where he was interred in that city's famous Bellefontaine Cemetery. But in Doctor McLean's typical indomitable and flamboyant style, his remains were marked by something quite extraordinary: He was placed in a large granite-walled mausoleum designed in the Egyptian Revival style and surmounted by a 20-foot-tall obelisk. In all Egyptian Revival design instances, either the grave was marked by a mausoleum *or* by an obelisk, *not both in the same composition.*[7] McLean's cubical mausoleum is adorned with polished granite columns topped with papyrus capitals that flank the door and, above, the carving of a pair of vulture wings emanating from a circle (symbolizing the sun). In a rather disconcerting manner, the obelisk punches upward from the center of the mausoleum's mass. Like the unconventional St. Louis skyscraper he occupied, his final resting place invites critical examination.

WORLD BUILDING, NEW YORK, 1890

Joseph Pulitzer was a visionary. He was also the epitome of the "poor immigrant boy who made good." Pulitzer, a Hungarian native, was the son of a Jewish grain merchant. He immigrated to America in 1864, and when it came to making a buck, Pulitzer seemed to possess the golden touch. He entered the publishing and newspaper arena and emerged a worthy financial contender. Pulitzer persuaded the controversial New York tycoon Jay Gould to sell him the popular New York *World* newspaper, and in 1883, the one-time "tempest tost" teenager became the owner and publisher of the largest circulating newspaper in America. Pulitzer's grandest dream could now be realized: he would build the World Building.

New York architect George B. Post was summoned to prepare plans for a new headquarters building for Pulitzer's newly acquired enterprise. A giant skyscraper, the city's tallest, was planned: it would stand 23 stories, 309 feet in the center of Newspaper Row, a neighborhood in lower Manhattan crowded with newspaper and book publishers. Pride was the motivation for this tower. Pulitzer achieved greatness, an American greatness garnered by hard, relentless work and shrewd dealings. He was also a New Yorker and a skyscraper builder. Lavish and expensive were terms that best described the grand opening for the pompous new skyscraper:

> The formal completion [*sic*] the Pulitzer building will be celebrated to-night. Nearly twenty Governors, ex–Governors and Governors-elect will be present. The New York World will run a special train from Washington to bring to this city the members

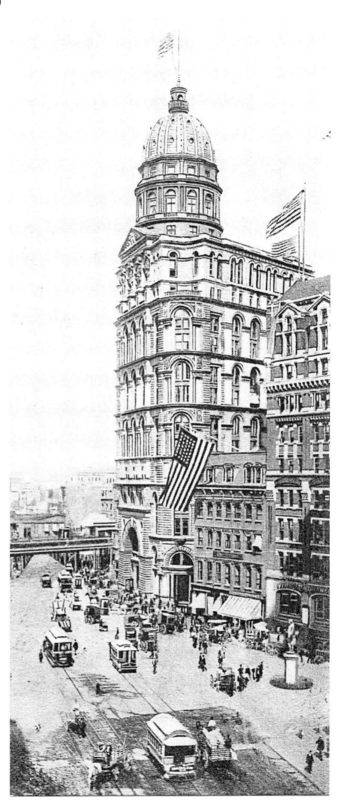

World Building (author's collection).

of the Cabinet, Senators and Representatives who have accepted the invitation to participate in the exercises. A caterer has been ordered to prepare for the entertainment of 4,000 guests. At noon nearly one thousand carrier pigeons will be sent out from the dome, and at night the whole roof and dome of the building will be ablaze with fireworks, the reflection from which can be seen for fifty miles.[8]

Hyperbole notwithstanding, the press was enthralled with the new skyscraper; after all, the World Building represented and, indeed, was a significant symbol of *their* industry. The edifice would house a daily population of some 600 Pulitzer employees and some 300 tenants. Daily, 10,000 visitors would pass through the front doors. Nationwide, reports hailed New York's newest skyscraper as attested to by a North Carolina correspondent:

> The new World building [*sic*] is the last and tallest of the immense structures about Printing House Square.... The main front rises nearly two hundred feet from the curb to the parapet on the thirteenth story. A domed tower rises five stories higher. The occupants of the uppermost room of the domed tower [*sic*] will be eighteen stories above the ground floor. The compositors will be in the thirteenth story, under the flat roof. Eleven stories contain 150 large offices. The tower, which is fifty feet in diameter, is to be devoted to the writing force of the newspaper. The pressroom, in the sub-basement, has a capacity of ten quadruple presses. The new building cost a million dollars.[9]

Others, even Chicagoans, hailed the new edifice:

> The New York World yesterday went into its new home in the Pulitzer building [*sic*], whose lofty dome overtops the most ambitious of the new newspaper brotherhood, throwing in the shadow of the tall tower of the Tribune.... The Tribune tower [*sic*] was a wonder in its day; two years ago we took occasion to congratulate the Times on the occupation

Paris's Church of Saint Louis des Invalides (Jules Hardouin-Mansart, 1679–1756), constructed between 1679 and 1691, could have been the inspiration for any number of American skyscrapers. Though the lantern atop the dome originally featured four gilded statues of the Virtues, New York's World Building (George B. Post, 1890) comes as closest copier (author's collection).

of the splendid monumental structure reared in its name; and now the new World building [*sic*] is a competitor for commendation, and is worthy of the progressive spirit born of the West. The home of a newspaper means much more than it did a generation ago, and a paper pleasantly housed ought to reflect its fine surroundings.[10]

The World Building's footprint measured roughly 115 by 136 feet, on the corner of Park Row and Frankfort streets. The skyscraper boasted some 130,000 square feet of floor space, 18 passenger elevators, imported marbles and various species of exotic woods, 500 doors, and over 1,000 windows. Its exterior walls were faced with a combination of materials: Quincy granite, Scottish-quarried stone, buff brick, terra cotta, copper, gold leaf, and glass. Astonishingly, the building was completed in only one year, and Pulitzer paid for it all in cash.

Structurally, the skyscraper had a metal frame, which in 1890 was considered state of the art:

> There are in reality two structures in one. All the floors and the dome are carried independently by a system of wrought iron columns and steel beams and girders. This is really a framework around which the walls are built. It [the framework] weighs 68,000,000 pounds. In the dome there are 850,000 pounds of iron and steel. If the walls were knocked away this metal structure would still stand unmoved.[11]

What was not state of the art was the skyscraper's provenance. The design of the World Building was described by one newspaperman: "In style it is Romanesque as far as it is anything, though the eclecticism which is now so prevalent in the art of the architect has full swing."[12] Indeed, "in full swing" the World's design, in current parlance, was decidedly neo-Baroque. Pulitzer no doubt remembered the architecture of his native soil, of the Baroque architecture of Hungary, of the bulbous and domed towers of farm villages, of the active façades found on centuries-old civic and ecclesiastical buildings. When architect Post presented to Pulitzer the drawings for his personal monument, Pulitzer rejoiced in the design and reveled at the immense dome, pronounced arches, classical columns, statuary, and overall applied decoration. Budapest was reborn on Park Row.[13]

The World Building's façades were urban theater on a grand scale. "Pulitzer Building" was displayed in large, gold leaf letters upon a polished granite frieze. One marble statuary group consisted of eight bearded male figures, 12 feet tall. Just above these, stood four, 13-foot-tall "female torch bearers"; each of these allegorical figures represented a different virtue: art, literature, science, and invention. At the time of the skyscraper's opening, it was stated: "This colossal statuary, which meets the approval of the foremost sculptors, completes most artistically the grandest entrance possessed by any business building in existence."[14]

As if these sentries were not enough, the 12th-story piers carried pedestals that supported four huge "black copper" caryatides. The caryatides were symbolic of the "Caucasian, Indian, Mongolian, and Negro races." Interspersed across the World Building's façades were classical columns and pilasters, carved medallions, balustrades, garlands. Certain spandrels were carved in Arabesque patterns, while other spandrels included the carvings of allegorical female figures representing "Justice" and "Truth." The tympanum (the recessed triangular form at the roofline) included "a carving of conventionalized beasts holding a central terra cotta panel with the monogram J. P. and the date "1889." "Conventionalized beasts"? Where available, windows were inserted into the walls.

Reentrant corners, those areas "chiseled" from the office block's top, provided dynamic tension to an already "active" façade. These recalled the best of European Baroque models; positive and negative spaces vied for the viewer's attention and provided drama and surprise to what ordinarily might have been a conventional corner. The drum and dome, which loomed overhead, convincingly added to the building's overall plasticity.

Unquestionably the most compelling aspect of the skyscraper was its domed top. A 12-sided drum of five stories supported the great, gilded dome. The dome measured 52 feet in diameter and measured 109 feet to the top of its lantern. Iron ribs served as structural support, with copper and brick infilling employed between the exposed ribbings. Some 24 lucarne windows peppered the dome in characteristic Baroque form. The lantern, ringed by an iron balustrade, marked the public observation point. In true romantic prose, it was amply described at the building's completion:

> As the horizon of vision from this observatory is forty-five miles away, the view on every hand can be imagined by any one at all familiar with the metropolis and its vicinity. The dome is gilded and is the first New York object visible to ocean voyagers. There are to be revolving congeries of electric lights around the lantern at the foot of the flagstaff and they will be 340 feet above tide level.[15]

During the Gilded Age, public observatories atop skyscrapers were a novelty to be enjoyed by most as mechanized flight was still years away; the impact of public aeries was all the more phenomenal. Even the celebrated participated:

> Mrs. Stonewall Jackson was in town the other day, making a tour of the Pulitzer Building. She is rather a stout, elderly lady, with gray hair. Mrs. Jackson professed herself much pleased with the glory of the World Building, and exclaimed several times that the ascent up into the *gilded* dome was well worth the trouble of toiling up the corkscrew stairs beyond the floor where the elevator ends its flight.[16]

Joseph Pulitzer's World Building displayed uncharacteristic extravagance, even for an age immersed in the flamboyant. George B. Post and Joseph Pulitzer quite consciously appropriated a historical architectural style that, by its very nature, was decidedly theatrical because *they* demanded the theatrical. The World Building was symbolic of wealth, power, achievement, and, to a lesser degree, communication through the written word. *Their* skyscraper, once New York's tallest, so expressed its time, its period in American history, that it could be considered one of the finest examples of its genre. In 1955, after standing for only 65 years, this landmark office building was, shamefully, destroyed. Its little, memory-filled observatory, where generations of immigrants once stood shoulder to shoulder with rather stout, elderly, gray-haired ladies, went to the landfill.

BROOKLYN EAGLE BUILDING, BROOKLYN, NEW YORK, 1892

The Brooklyn Eagle Building's demolition was finished in 1956. It was wrecked like most buildings were wrecked: its dome was removed, and its walls were savagely punched with a giant ball until they fell over. It was an ignominious end. Only one reminder survived: a 200-pound bronze eagle from the very top of the dome. A hungry landfill was satisfied; its insatiable appetite was appeased with the structure's remains except for one big bird.

Brooklyn-based architect George L Morse designed an older Brooklyn Eagle Building in 1890. He was proud of what he did and so was the *City* of Brooklyn (the consolidation of the *City of New York* was six years away), and civic pride was rampant in the soon-to-be borough. After two years of construction, the Brooklyn Eagle Building was completed and was ceremoniously opened on September 23, 1892. The structure housed 630 employees, some of which would become famous; others, like their building, would endure an ignominious end. Walt Whitman edited the *Brooklyn Eagle* newspaper from 1846 to 1848, and he would become famous. So too, H. V. Kaltenborn — at the turn of the century the celebrated reporter collected a paycheck from the *Eagle.*[17] Thousands of nameless others, many new arrivals to America's shores, also labored for Brooklyn's celebrated favorite son, its hometown, homegrown child of the Fourth Estate.

In 1898, the eight-story building became a nighttime news symbol. In an age when few

Brooklyn Eagle Building (author's collection).

had a telephone, the *Brooklyn Eagle* would announce the results of political elections with the "romance of light"; rooftop-mounted colored lights would reveal the results of political contests. One such event occurred in 1898, when Republican Theodore Roosevelt staged a narrow victory over the Democratic candidate, Augustus Van Wyck, for office of governor of New York. The *New York Times* recorded the event:

> Brooklyn's Exciting Night:
> Trolley Cars and Revelers Combine to Make the City
> A Veritable Bedlam for Noise
>
> The immense crowd in front of The Brooklyn Eagle Building had a more exciting time of it than any other. Early in the evening The Eagle flashed a red light, which it had promised to show in case of Roosevelt's election. The Roosevelt men cheered and the Van Wyck men looked glum.[18]

Within a little more than a decade, The Brooklyn Eagle's owners decided to erect a substantial addition to house its management, sales, editorial, and production operations. This new structure would include a tower, making it one of Brooklyn's tallest skyscrapers. The November 20, 1902, edition of the rival *New York Times* took note of the announcement and of the construction ceremonies:

> New Building of the Eagle
> Cornerstone of Newspaper Structure in Brooklyn Laid
> Pressroom's Novel Features
>
> The cornerstone of the new Brooklyn Eagle Building, in Washington Street, Brooklyn, was laid yesterday morning. The present building had its cornerstone laid just twelve years ago, but the prosperity of the newspaper has made necessary an addition, and the new structure is to immediately adjoin the building now standing.... When the new building is completed the main office of The Eagle will be one of the best equipped newspaper offices in this country. The new building will cost about $500,000. It will cover a plot of ground 60 by 106 feet and will be nine stories high. The tower will be surmounted by a sphere representing the world, and perched upon the sphere will stand an illuminated eagle with outstretched pinions — the emblem of this newspaper.... In exterior architecture the new building will follow the lines of the structure now standing.[19]

The result was an extravagant building standing nine stories and topped by a domed tower. This skyscraper was a bold and swaggering structure that exhibited characteristic late-19th century "Brooklyn bravado," an attitude aimed primarily at its journalistic rivals across the water in Manhattan. The skyscraper's rusticated stone base was replaced by orange brick and terra cotta walls, its surfaces replete with classically derived imagery. No less than three large bronze eagles were strategically perched on its cliff-like walls. Classical pilasters, decorative panels, garlands, rope-twist columns, and a dozen rooftop urns contributed to its lively façades. This pompous repository of writing culminated in a giant neo-Baroque tower and dome, elements endowed with more carvings, pediments, lucarne windows, and massive arched openings. A 200-pound bronze eagle rested atop the dome, and its presence reinforced the symbolism and the newspaper's namesake.

In 1955, the *Brooklyn Eagle*, that neighborhood nexus of news, would succumb to, among other things, a prolonged labor dispute. Its presses ceased to run in that year, and the *Brooklyn Eagle*, founded in 1841, was no more. That which architect Morse built was brought down in 1956. One bird sculpture, though, an eagle, the one from the very top, survived. Civic treasure hunters saw to that — all 200 pounds of it.

Columbus Memorial Building, Chicago, 1893

Two self-made men built this Chicago skyscraper. Both were attorneys, and neither were Chicago-born. One of those men was Van H. Higgins (1821–1893), a native of Genesee County,

New York. Higgins became an attorney in 1844, first practiced in St. Louis, and permanently settled in Chicago in 1852. He was the consummate businessman, having investments in manufacturing, insurance, and real estate. At his death, *Judge* Higgins's personal fortune was estimated at $1 million. Higgins's law partner, Henry Jewett Furber (1840–1916), was the other self-made man. He settled in Chicago in 1879, was once a candidate for Chicago mayor, and amassed a fortune in real estate. The Columbus Memorial Building was their most tangible contribution to the city and perhaps the most tangible culmination of their financial careers.

William W. Boyington (1818–1898), also a self-made man, was the architect who was commissioned by Higgins and Furber to design their tall investment. Boyington, originally from Massachusetts, studied engineering and architecture in New York and relocated to Chicago in 1853. He was responsible for dozens of large projects in Chicago, including office, commercial, warehouse, residential, and church buildings, many of which were destroyed by the Chicago Fire of 1871.[20] Higgins, Furber, and Boyington, three out-of-towners, teamed up to make it happen in Chicago. And in 1893, their $1 million, 251-foot-tall project was completed.

The 14-story Columbus Memorial Building rose from a parcel measuring 90 by 100 feet, on the southeast corner of State and Washington Streets. This high visibility location, just south of the popular Marshall Field's Store and in the heart of Chicago's retail district, proved to be beneficial for its office tenants and its first-floor retailers. The skyscraper included over 100 office suites served by four elevators, and it featured a richly decorated central hallway of marble, colored mosaic tiles, and polished bronze that served three first-floor stores.

Ostensibly, the Columbus Memorial Building was erected as a commemoration of the founding of the North American continent by Christopher Columbus in October of 1492. In actuality, the skyscraper was a speculative

Columbus Memorial Building (author's collection).

venture constructed to create income for its investor owners. The naming of the skyscraper and its very design were products of the excitement created by the World's Columbian Exposition, hosted by Chicago and staged just five miles south of the skyscraper. The building rode the coattails of the exposition to substantial financial success for its owners. After all, its name could easily have been the Higgins-Furber Building.

The Columbus Memorial Building was so very typical of the Gilded Age skyscraper. Its extravagant, even pompous design echoed the histrionics of the World's Columbian Exposition. For the tower's design, architect Boyington drew inspiration from the Spanish Baroque — it was *Spain* that financed Columbus's original exploration — to create for Chicago an architectural extravaganza like none before. The building was topped by an elaborate eight-sided tower dripping with terra cotta details and capped by an illuminated glass globe representing the world; in a truly romantic act, a faceted jewel was fixed to its surface, marking the location of Chicago. A balcony ringed the corner tower so guests could enjoy a close-up view of the building's detailing and giant carved eagles. Two rounded pediments included terra cotta panels that displayed Christopher Columbus's ships. The building's main entrance vestibule featured 11 bronze wall panels highlighting scenes from the life of Christopher Columbus, his ships, and his crews. The skyscraper's theatricality, especially its dramatic top, was not only a foil to the quiet and dignified walls of neighboring Marshall Field's, but it became a civic monument to the multitudes that crowded the sidewalks and viewed the exploits of Columbus on its walls.

The owners of the Columbus Memorial Building, Higgins and Furber, commissioned a statue of Christopher Columbus to be placed within a niche just above the State Street entrance. Sculptor Moses Jacob Ezekiel (1844–1917) cast a ten-foot-tall bronze likeness of Columbus in 1893 in Rome and ordered it delivered to Chicago. The sculpture, as planned, was first displayed in the Italian Pavilion at the World's Columbian Exposition, and only afterward was it removed to its niche in the skyscraper. It presided over the entrance until the building's demolition in 1959; the statue currently stands in Arrigo Park in Chicago's Little Italy.

NASBY BUILDING, TOLEDO, 1893

> With the steady growth of European travel among the richer classes, the acquisitive spirit throve; and presently the most fashionable architect of The Gilded Age, R. M. Hunt, was building French chateaux on Fifth Avenue, while less eminent rivals were designing Rhine castles for brewers, or weird combinations of architectural souvenirs — an eclecticism that reached its climax in a brilliant design, unfortunately not executed, for a building exhibiting a different style on every storey.[21] — Lewis Mumford (1895–1990)

Horace S. Walbridge (1828–1893) was the man who commissioned the construction of Toledo's Nasby Building. A native of Syracuse, New York, he and his family relocated to what is now Toledo, Ohio, when he was three years old. Although he was raised in poverty, Walbridge came to own or attain substantial control of a host of companies involved in commodity trading, banking, insurance, manufacturing, railroads, and real estate. By the time of the Civil War, it was estimated Walbridge had achieved millionaire status.

According to Toledo architect Edward Oscar Fallis, he was asked by Walbridge to design what was destined to be Toledo's first skyscraper:

> E. O. Fallis, the well known Toledo architect, states that in 1893 Horace Walbridge commissioned him to make plans for a new office building, which would be sufficiently different in architectural style to attract attention. He studied the history of the ancient Toledo and designed a building of Spanish model.[22]

E. O. Fallis was very comfortable designing historically based buildings for modern purposes. He designed in all the "popular" European styles, in the Gothic — almost any sub-style,

Nasby Building (author's collection).

Flemish, French, German, Spanish, etc.—in Romanesque, and in various Renaissance modes, too. Fallis was a regional practitioner, an architect who drew the plans for over 100 buildings in northwest Ohio and Indiana. He is fondly remembered for his small-town civic buildings, such as court houses and libraries, but he is especially remembered for his tallest design, Toledo's neo-Baroque Nasby Building.[23]

Regarding the building's name, there was never a "Mr. Nasby." In a bizarre twist, this skyscraper was named after a person who never existed. David Ross Locke (1833–1888), journalist and satirist for the Toledo *Blade*, composed and published a series of letters during the Civil War. These were supposedly written by one very popular "Petroleum Vesuvius Nasby." This newspaper character, Locke's pseudonym, was a Civil War favorite in the North only; Nasby was an unflattering caricature of Confederate attitudes and sympathies. How, why, and by whom Toledo's newest skyscraper was named "Nasby" remains a mystery.

In another bizarre twist, architect Fallis chose the Giralda Tower to be the basis for his design of the Nasby Building. The Giralda Tower, located in Seville, Spain, began its existence in the year 1196 as a minaret for a Moorish mosque. During the Spanish Renaissance and under Christian control, four levels were added to the tower, including balconies, a belfry, and gold crosses. Having been completed in 1560, it was this final iteration of the tower's design that Fallis consulted for architectural inspiration. After all, he was required to provide "a building of Spanish model."

The Nasby Building was a two-part composition: an eight-story slab was surmounted by a sculptural seven-story tower. The slab-like office block recalled the Chicago School of design due to its repetitive office floors, three-sided bay windows, large glazed openings, and simple lines. The seven-story appendage was different; it resembled a Spanish Renaissance bell tower with Moorish overtones—the Giralda Tower! Together, the two discordant parts were faced with red-colored brick with matching terra cotta. The 15-story skyscraper, now gone, stood exactly 187 feet above the sidewalks of Toledo; its antecedent still stands at 275 feet above the sidewalks of Seville.

The culmination of this Gilded Age "fantasy" skyscraper was, of course, its seven-story telescoping tower. Piled cubic forms, reduced in size, were abruptly supplanted by telescoping cylinders and a finial-topped dome. Inside were office suites and outside were some 50 giant urns that paraded around the building's periphery. Unusual arched openings, profuse carvings, broken pediments, and oversized balustrades contributed to the overall phoniness of the tower — as in the choice of the building's name. Fallis's design was an unfortunate and misguided interpretation of a very noble late-Renaissance/early-Baroque landmark. The selected prototype, the Giralda Tower, is in Seville — not Toledo. Client Walbridge supposedly asked architect Fallis to design a building "sufficiently different in architectural style to attract attention." Fallis decided upon the Spanish Baroque as a vehicle to "attract attention" and to quench his own thirst for mimicking old European buildings. The confused-looking Nasby Building was the result of dubious decisions and a serious lack of true creative genius. As fate would have it, the Nasby Building's faux Spanish Baroque tower was removed due to structural problems in 1934. In 1964, the Nasby Building was wrapped by colored asbestos panels and tinted glass windows.

Manhattan Life Insurance Building, New York, 1894

Many a pendulum clock that has kept accurate time for years in old-fashioned, low structures has refused to run at all when moved into some one of the new tall steel-framed buildings in the lower part of the city. On the lower floors of the buildings the clocks run fairly well, but when higher up in the buildings they become more whimsical, and on the top floors will not run at all.

Mr. Dunn of the weather bureau has a fine pendulum clock in the tower of the Manhattan Life

Building, which has not done an honest day's work since the weather bureau was moved into the new offices. It has stopped so often that it is no longer to be relied upon.[24]

The pendulum clock at the top of the Manhattan Life Insurance Building was a metaphor for the building itself; for clock and building alike, time had stopped. The architecture of the Italian Baroque period spoke volumes here, whispering of times long past and of a style in its final role. The shapes, pieces, and parts that used to delight people of the 17th century were performing an encore for those of the 19th. Architects eked out a few more performances, then this ancient style finally bid adieu.

The architects responsible for the design of this magnificent, albeit anachronistic, skyscraper were Francis Hatch Kimball and George Kramer Thompson. These two men forged a partnership in 1892 which lasted a brief five years. But in those five years, they produced some of the most daring and imaginative skyscrapers ever constructed in New York. Romantics to be sure, their contributions transcended mere style; Kimball and Thompson created "gifts" for the city and endowed New York with appropriate Gilded Age eccentricities.

Francis Hatch Kimball (1845–1919) loved history. He was born in Kennebunk, Maine, studied old buildings as a youth, served in the Civil War, and at the age of 21 became a Bostonian. While there, he was apprenticed as an architect and was encouraged to travel to London, which he did in 1875. After his five-month London sojourn, which included a "serious investigation" of that city's great buildings (especially those of Gothic persuasion), Kimball relocated to Harford, Connecticut, to complete work on that city's Trinity College. In 1879, like most young men of architecture then, Francis Hatch Kimball moved to New York to practice his craft. While in Manhattan, Kimball "the revivalist" designed many prestigious homes, churches, and theaters. He had not yet met Mr. Thompson.

George Kramer Thompson (1859–1935) was a native of faraway Dubuque, Iowa, a town officially chartered only 26 years before his birth. This

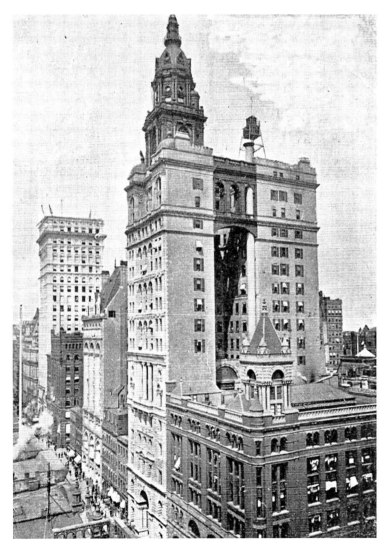

Manhattan Life Building (author's collection).

was a rugged place, a center of the tim-
ber and mill-working industries, of
breweries, of railroads, and of Catholic
immigrants. In 1874, at the age of 15,
Thompson entered the Chattock Mili-
tary Academy to study architecture,
and in 1876 to further his studies, he
enrolled at the Franklin and Marshall
Academy in Lancaster, Pennsylvania,
where he spent an additional two years.
In 1879, like Kimball, he moved to
New York. Thompson apprenticed in
Manhattan and studied architecture
there. By 1883, Thompson opened his
own New York office "and soon acquired
a large and varied patronage." He had
not yet met Mr. Kimball.

Thompson had become well known
in important social and professional cir-
cles, having belonged to no less than
eight private clubs and societies, a pre-
requisite to being a successful practi-
tioner. In 1890, Thompson completed
some design work for the Manhattan
Life Insurance Company. Years later, he
was remembered and was invited to
submit plans to a design competition
for a new building the insurance com-
pany was planning to erect. In 1892,
Mr. Kimball met Mr. Thompson, and
together they submitted a set of win-
ning plans to the competition. In 1893,
the firm of Kimball & Thompson was
formed, with their first project being
the Manhattan Life Insurance Building.

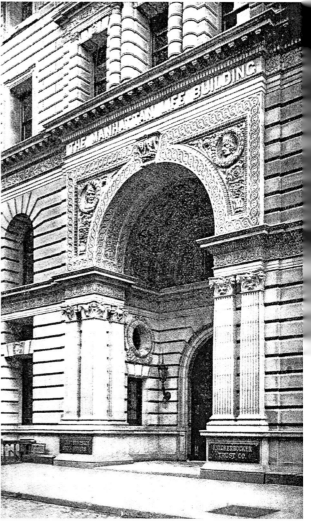

The main entrance to the Manhattan Life Building was a
neo–Renaissance delight, intended to impress (author's
collection).

From two relatively obscure places emerged two men who were destined to design the world's
tallest building in the world's greatest city. The Manhattan Life Insurance Building topped out
at 23 stories, 348 feet, making it the tallest skyscraper anywhere. The headlines in the *New York
Times* boasted as much:

Highest In The World
The New Home of the Manhattan Insurance Company
New Constructive Ideas in the Great Building
Caissons Sunk Fifty Feet Below the Surface of Broadway
For its Foundations and Structural Supports Held Up by a
System Of Cantilevers — Spacious Offices for the Company,
With Dining Rooms in the Lofty Tower and Dome.[25]

The Manhattan Life Insurance Building, faced with white limestone and terra cotta, was
much admired and was certainly the talk of the town. The skyscraper was officially opened to

the public on November 30, 1894. It was a giant among giants, and slices of its fanciful tower could be seen only occasionally from the narrow brick streets of Lower Manhattan. But from the rivers and the bay, its copper-clad tower was unmistakable on the craggy skyline. The skyscraper's great tower had a functional aspect to it, too:

> The New York Weather Bureau is located in a tower built on top of the Manhattan Life Insurance Building on Lower Broadway, one of the modern "sky-scrapers" 18 stories in height. The tower itself is about 25 feet in diameter and some 35 feet high [that being the portion *above* the dome]. There are four floors connected by a circular staircase, which goes up to the great red lantern on the top of the tower from which signals of fair weather or foul are flashed out to sea. Here a force of eight men under the direction of Local Forecast Official E. B. Dunn is constantly at work, receiving observations, making records, etc. The instruments themselves are all in a separate observatory about 35 feet high, which is also built on the roof near the main tower.[26]

The other distinguishing feature of its roof was a more diminutive tower placed to the rear, to the east of the prominent Baroque-inspired mass. Its function was not to impress, but to collect data and to ultimately inform:

> This observatory is a wrought-iron structure, very strongly bolted together to resist the pressure of storms, and the thermometers, barometers, etc. are contained in a sort of box, the sides of which are of lattice work to allow the air to circulate freely, the slats being tilted so as to exclude rain or snow. They are all self-registering, and represent the very latest appliances of science, from the weather vane on top to the instruments which measure sunshine.[27]

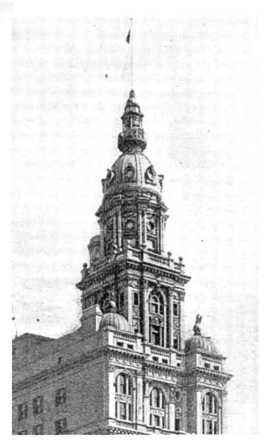

Manhattan Life Building, detail of its famous tower (*Munsey's Magazine*, 1898, in "The Tall Buildings of New York," pp. 833–848).

The romance of this skyscraper resided in its flamboyant tower. From its flat roof atop its 17-story office block, the tower soared another 102 feet to the top of its lantern. This copper-clad belvedere, accounting for almost one-third of the skyscraper's overall height, also ranked the Manhattan Life as one of the tallest metal-clad structures anywhere. Housed within this patinated pinnacle were another six floors: the 18th floor housed the "clerk's dining room," the 19th floor housed the "officer's dining room," and the floors 20 through the 23rd contained small offices and private observatories for the New York Weather Bureau. The insurance company that sponsored the skyscraper occupied the first seven floors, with various tenants filling out the remainder of the building. The skyscraper's exterior reflected the interior functions; the fifth and sixth floors were marked by a colonnade on the Broadway façade that, in turn, signified the location of a large ornate and glass-domed rotunda and the locations of the offices of the company's directors. Beneath the colonnade were located the business offices of the insurance company, and above were the tenant floors. In a contemporary account, architectural critic and historian Montgomery Schuyler (1843–1914) had this to say about this skyscraper's façade:

It is plain that the comparative failure of the Manhattan Life Building, as an architectural work, has come from the deviation from this general scheme [tripartite organization], or rather from the failure to arrive at this general scheme. As a matter of fact the building lacks the unity in variety that comes from an assemblage of related and interdependent parts. The spectator is left in doubt which is the beginning and which the middle. As to the end there is no question. The building above the cornice culminating in the slender and graceful belvedere, is in itself a well-studied and effective composition, scarcely surpassed in its own kind by anything that has been done since. But below the main cornice the subdivision of the front is such as to reduce [produce?] a confusion and uncertainty fatal to unity.[28]

Schuyler harshly criticized the façade's organization. He admired the belvedere, but he avoided stating the obvious: the belvedere had been "done" hundreds of times *before*, for hundreds of years. The belvedere was more ecclesiastical than anything else, being modeled upon the church towers of Europe, principally those of Italy. This giant copper bauble "made" the building; it was the skyscraper's exclamation point, and it is what propelled the Manhattan Life Building into the record books. The skyscraper held the title of "World's Tallest Building" for some seven months until the Philadelphia City Hall wrested away the title. The Manhattan Life Building was demolished in 1963, to almost no cries for its salvation.

PHILADELPHIA CITY HALL, PHILADELPHIA, 1901

It is one of the very highest structures ever reared by the hand of man. The marble work on the tower rises to a height of 337 feet, 4 inches. Above this will rise iron work supporting a heroic statue of William Penn.[29]

The Gilded Age's other metal-topped giant besides the Manhattan Life Building was the Philadelphia City Hall. No other *civic* project was taller or larger; it was the greatest of its age and the greatest of its type. Its footprint, a colossal 181,525 square feet, was larger than that of the United States Capitol and every other government and private office building yet constructed.[30] At 548 feet, it was the tallest *building* on Earth; in this country only the Washington Monument was taller, by a mere seven feet. At its completion, only people at the very top of the 984-foot-tall Eiffel Tower (not a *building*) and those drifting in hot air balloons were further from the ground. The Philadelphia City Hall was the epitome of one-upmanship and of America's insatiable but deserved pride; steeped in history and jacketed in metal, this skyscraper was the ultimate Gilded Age construction project.

On January 3, 1871, architect John McArthur, Jr. (1823–1890), was appointed architect of this project in his adopted city. McArthur, a native of Scotland, arrived in America as a youth and served an apprenticeship as a carpenter before pursuing a career in architecture. Throughout his career, he designed a wide range of building types and many homes for the wealthy and noted of Philadelphia. None would be as important as the Philadelphia City Hall, and no other would so wholly consume his energy, skill, and time. This project, having grown to mammoth proportions, would only be completed 11 years after his death and would become the structure for which he would be most remembered. McArthur was served by a staff of noted Philadelphia architects: Thomas Ustick Walter (1804–1887) was named "consulting architect" and was put in charge of all the building's detailing; architect John Ord (born 1850), like McArthur a native of Scotland, was named "principal assistant" and upon McArthur's death became "chief architect"; William Bleddyn Powell (1854–1910), originally serving as "assistant architect," eventually served as "chief architect" and saw the Philadelphia City Hall to its final completion in 1901. Alexander Milne Calder (1846–1923), another Scottish-born artist, was the master sculptor and was responsible for the design, execution, and placement of a staggering 250 white marble sculptures that adorned the building's interior and exterior.

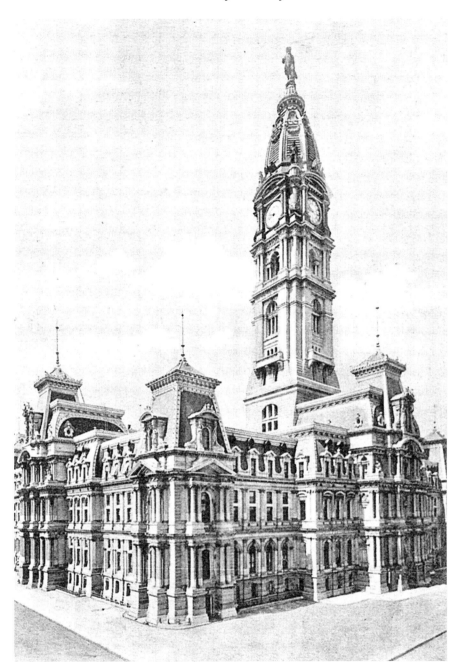

Philadelphia City Hall (author's collection).

Construction of the French Baroque-styled Philadelphia City Hall commenced with its groundbreaking ceremonies on January 27, 1871. Other significant dates include August 12, 1872, when the structure's first foundation stone was laid; July 4, 1874, when the cornerstone was laid; and the month of November 1894, when the statue of William Penn was installed in 14 sections to finally top out the building, signaling its exterior completion. On November 30, 1894, portions of the building opened to the public, and the nine-story 548-foot-tall Philadelphia City Hall entered the record books as the tallest building on Earth. On June 26, 1901, after a 30-year con-

struction period, the architect officially turned the building over to municipal officials as a completed project.

The skyscraper's statistics were staggering: the building cost approximated $26 million to construct, originally contained 695 rooms, 20 elevators, three miles of public corridors, and 14 entrances. Mansard roofs, pediments, Corinthian columns, garlands, busts, and caryatides were well represented on the city hall's exterior. The usual cast of characters also appeared, including allegorical representations of the virtues and vices, law and justice, and a host of mythological animals. The tower featured four lighted clocks at the 360-foot level, and topping all was Calder's 37-foot-tall, 27 ton bronze statue of William Penn.[31] The statue could be seen for miles and was the talk of the town. Newspapers everywhere reported on Philadelphia's new skyscraper, and at least one recorded the following humorous account:

> The big statue of William Penn which surmounts the tower of the Philadelphia City Hall faces the old Penn Treaty Park. This displeases the citizens who get only a rear or profile view of the statue. So, to please everybody, J. Chester Wilson has proposed to put the statue on a revolving pedestal, which will be turned around once every twenty-four hours by means of clockwork.[32]

Needless to say, this "revolutionary" idea was never pursued. But this report does illustrate the popularity of public statuary, and it lends insight into the concerns voiced by ordinary citizens regarding the placement of public art and its opportunity to be viewed by those who have paid for it.

The singular and most powerful element of the city hall emerges from the core of the broad-based building, its stone- and metal-clad tower. The entablatures, located midway between the Palladian openings and the clock faces, are the demarcation points, the strata that separate the stone from the cast iron sections of the tower. From the sidewalk level to this point, a distance of 337 feet four inches, the tower is a fully bearing-walled building faced with white marble and gray granite.[33] This section boasts wall thicknesses anywhere from 22 feet at its base to two feet at its highest elevation. At this point in the sky, the construction method changes dramatically: some 8,000 tons of iron and aluminum were employed to

Philadelphia City Hall, detail of rooftop statue of William Penn (author's collection).

form the internal framing and the external covering of the walls and elongated dome of the City Hall.[34] An 1893 newspaper article stated:

> Much interest has been aroused by the electroplating of the iron work of the Philadelphia city hall [*sic*] tower with aluminum. It is expected that three years will be occupied in completing the work as the process of aluminum plating is very tedious, and there is a surface of 50,000 square feet to be covered. The iron is first given baths of caustic soda, of dilute sulphuric acid and of copper solution in immense tanks 28 feet long, 4 feet wide and 5 feet deep. The aluminum tank holds about 7,000 gallons and receives the work after it has been dipped. Nearly 10 tons of aluminum will be required to coat the whole surface.[35]

Although it took considerably less than three years for the aluminum coating procedure to be completed, the process was undoubtedly successful. An 1894 reporter penned the following concerning the dome's surface and its elaborate embellishments:

> One of four bronze figures which will grace the corners of the tower at the base of the dome is already in position. These pieces will average fifteen tons each. In the lower portion of the dome will be four clock-faces, facing in each direction. These will each be twenty-one feet in diameter, and will be surmounted by four bronze eagles, each of which will weigh five tons. The plates which will form the outside covering of the dome are of iron, with a coating of copper and an outside covering of aluminum.[36]

During the Gilded Age, exterior statuary was considered an invaluable ingredient in architecture, and the skyscraper was no exception. Costs and the efforts expended were incidental to the overall effect desired and to the impact the building might have on posterity. The Philadelphia City Hall was a preeminent example:

> The last of the four gigantic bronze eagles that will perch on the top of the city hall tower for ages to come will be hoisted up to its dizzy position before the week closes. Including the big figure of William Penn, which weighs 54,000 pounds, the entire weight of all the bronze statues and groups on the tower is 182,000 pounds. This weight is three times in excess of the amount that it was estimated the tower would have to carry, and the cost of the figures was underestimated by $150,000. The height of the tower had to be increased twenty feet to accommodate them, which entailed an additional cost of $45,000. However, now that the immense and costly shaft is near completion, it is believed to be good for a life of 1,000 years at least.[37]

By August 1895, the Philadelphia City Hall's tower statuary was almost complete. The great shaft was finished, but the completion of its adornment was still months in the future:

> Three of the allegorical groups have been finished and have already been set in place upon the tower. These are the Swedish woman and child, the Indian woman and child, and the Indian brave and dog, the last of which was placed in position but a short time ago. The fourth group, the Swedish man and boy, which is now in the process of casting, completes the set. The figures are intended to represent the two widely different peoples who preceded Penn in the settling of Philadelphia. The Swedes, with their civilization and peaceful pursuits, are symbolized by the boy reading at the feet of the man, and the sheep reclining at the woman's feet. The Indians, man and woman, are shown by the artist in all the picturesque savagery of dress which characterized the aborigine. The last of the groups is to be finished in five months. The casting of these four pieces, each of which is twenty-four feet high and weighs between 18,000 and 20,000 pounds, has been a stupendous undertaking. Each group is made up of forty-eight sections, each of which occupied the undivided attention of a skilled artisan for nearly a month.

So much for the allegorical human figures which occupied of the Gilded Age's preoccupation with sculpture. The article continues upon the remainder:

> The work upon the four bronze eagles that are to occupy positions between the four groups is even more tedious and delicate. The feathers make it necessary for the molder to divide each of the eight

sections into innumerable small pieces, to permit of the proper casting of the whole. Each of these bronze eagles will weigh 4,300 pounds, and all will be finished within four months. The preparation of the pedestal, or tower, to support these statues, is rapidly advancing. Each section of the iron work as it comes from the aluminum-plating shop is shipped at once to the City Hall, where it is set in position. The work of coating the iron work with aluminum requires, of course, considerable time, each separate piece being subjected to a series of washings and "picklings."[38]

The Philadelphia City Hall resided on the cusp between centuries-old load-bearing-wall technology and that of the new iron framing and the subsequent curtain wall that was revolutionizing the way buildings were being built. Here stood a hybrid of sorts, a skyscraper built utilizing two systems of construction, while employing motifs from the ancient world. In this one building, many cultures and time periods resided, not in conflict, but in a holistic expression of unity according to the vision of John McArthur, Jr.

The Philadelphia City Hall was largely the work of immigrants, not only in its design but in its construction. It remains the story of *people*, a tale written in stone, bronze, and aluminum. The very plastic tower of the Philadelphia City Hall is a giant talisman. Its walls are filled with mythology, allegory, and metaphor; these are walls of stories and of technology, of Palladio and of Penn. Here stands a pompous monument to the Gilded Age, to the inspiration of the French Baroque, and to the perseverance of not one city, but of a country and of its people.

MILWAUKEE CITY HALL, MILWAUKEE, 1895

This bit of municipal mirth and architectural extravagance was once America's second tallest building. Standing 350 feet, the Milwaukee City Hall ranked second in height only to the Philadelphia City Hall, a position it held for four years until it was bested by New York's 382-foot-tall Park Row Building. Height notwithstanding, Milwaukee's premier civic building remains a preeminent example of Gilded Age flamboyance and a rare specimen of "Americanized" Flemish Baroque architecture.

The building's final appearance was the result of a design competition sponsored by the city of Milwaukee. Five firms entered the competition and each produced drawings and much consternation among the judges and the public:

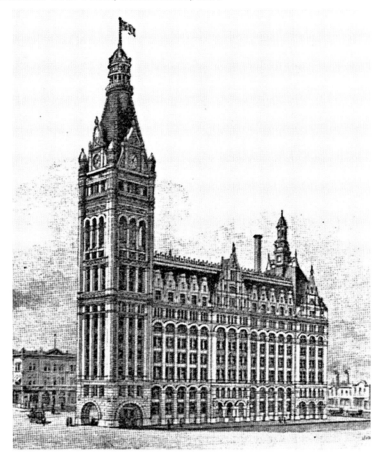

Milwaukee City Hall (author's collection).

Any person who has touched foot in Europe can not [*sic*] but have been impressed with the immeasurable difference that exists between the public buildings there and here. There local pride is often concentrated in its cathedrals or town hall, while here, on the contrary, the courthouse or city hall is almost universally the just subject of public derision. The most common and vulgar of buildings in appearance, they rarely possess even the virtues of good plan, light and ventilation, all such unimportant details having been sacrificed upon the altar of ignorance.[39]

Some in America revealed an inferiority complex regarding America's architecture, *vis-à-vis* that of Europe's. Others, of course, disagreed and insisted that nothing was "sacrificed upon the altar of ignorance," and that American architecture was simply the product of decades of European influence. The opinions of city politicians and those of business and professional men converged upon one design, produced by a 50-year-old Milwaukee architect, Henry C. Koch.

In the same way that the Philadelphia City Hall was designed and built by Scottish immigrants, the Milwaukee City Hall was designed and built by German immigrants. Liberty's "golden door" was propped open in those years, and whole families, some members of which harbored vivid memories of how European buildings looked, poured into America and helped to design its civic and corporate monuments. Neo-Baroque buildings, in all of their permutations, made a remarkable impact upon contemporary architects here, and Milwaukee's city hall was just one example. Its architect, Henry C. Koch (1841–1910), was a native of Hanover, Germany.[40] Koch arrived in America with his family in 1842, and before becoming an architect, he served in the Civil War as a private from Wisconsin. In 1870, he founded the firm of H. C. Koch & Company in Milwaukee, and afterward designed more than 300 buildings.

The Milwaukee City Hall's construction, like its Philadelphia counterpart, was a monumental undertaking. The cornerstone was laid on February 24, 1894, with construction lasting 23 months until the building's dedication on December 23, 1895. Weighing 38,500 tons, the nine-story Milwaukee City Hall employed eight million bricks (3.7 million were used just

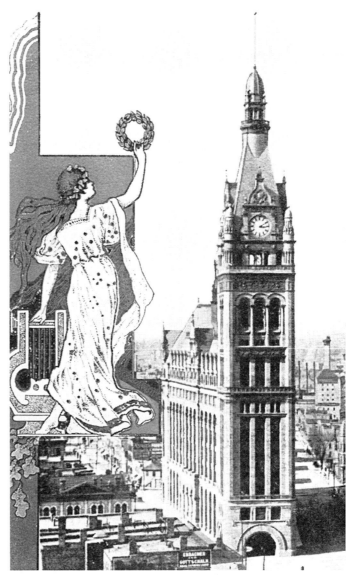

Milwaukee City Hall, a romantic image (author's collection).

in the tower), 42,000 square feet of mosaic and marble flooring, and tons of stone, copper, iron, and steel:

> The entire frame work of the new City hall [*sic*], posts, beams, trusses and skeleton frame supporting tower are made of steel. Even the flag pole which is 70 feet long and weighs 4,800 pounds is made of steel. The ornamental iron work comprising the stairs, elevator enclosures, corridor railings and the fascias on the corridors are made mostly of cast iron electro plated in bronze.[41]

Upon completion, the public and city officials were treated to the delight of riding in four hydraulic passenger elevators, each operated by steam-driven pumps. Even the governor of Illinois, John P. Altgeld, a man who was certainly familiar with the modern skyscrapers of Chicago, praised the building:

> Milwaukee has also constructed ... in the modern style of building of steel and stone, a towering and imposing structure for a city hall. Its solid walls rise a monument of strength, of beauty.... The proud and dignified palace of the municipal government will, it is hoped, endure for centuries.[42]

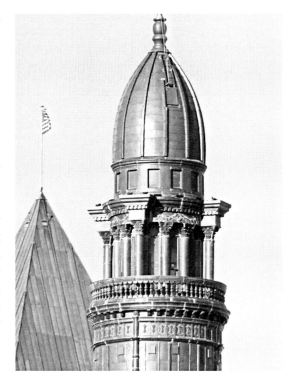

The Milwaukee City Hall's landmark tower still impresses. From 1895 until 1899 the bullet-shaped cupola of the Milwaukee City Hall marked the top of America's second tallest building. Only the very top of the Philadelphia City Hall was higher (photograph by author).

In Governor Altgeld's speech there was no inferiority complex regarding America's architecture *vis-à-vis* that of Europe's; he graciously referred to Milwaukee's City Hall as a "proud and dignified palace." The city hall was, in fact, loosely modeled upon one of the largest commercial buildings of the late Middle Ages. In the Belgian town of Ypres (pronounced "eep") still stands the Cloth Hall, with its prominent clock and bell tower that rises 230 feet above the sidewalk. Architect Henry C. Koch borrowed elements from this guild hall completed in 1304, refashioned them to his own liking ("Americanized" them), and employed these elements in his design of the neo-Baroque Milwaukee City Hall. Like the Cloth Hall, Milwaukee's City Hall features a belfry, a giant spire, a four-faced clock, a steeply pitched roof with dormers, turrets, arcades, and much detailing. The image of a guild hall, where once Northern European merchants bought and sold wool and cloth, was appropriated for a civic building in America, a place where politicians could do the buying and selling. The Milwaukee City Hall was not the typical Renaissance-inspired building; Koch's scheme

Henry C. Koch (1840–1910). (*Notable Men of Wisconsin*, Williams Publishing Company, Milwaukee, 1902, 249).

borrowed from Ypres, in *Northern Europe*, where the cultures, climates, and technologies differed substantially from those of Rome and Athens. Its façades are not adorned with semi-clothed gods and goddesses. There are no Corinthian colonnades, no pediments, and no overt references to allegorical beings with deep and hidden messages. With this building, a different vein of the late Renaissance/early Baroque was utilized to the satisfaction of the city's Northern European stock.

Milwaukee's city hall hints at the Renaissance with its employ of more readily expected props: composite capitols, dentil and egg-and-dart courses, escutcheons, and prominent acanthus leaf friezes. Separating the walls of warm orange brick are broad areas of chocolate-colored terra cotta. Carefully placed are foliate designs incorporating fleur-de-lis, festoons, and the busts of lions and wolves. Terra cotta spandrels fea-

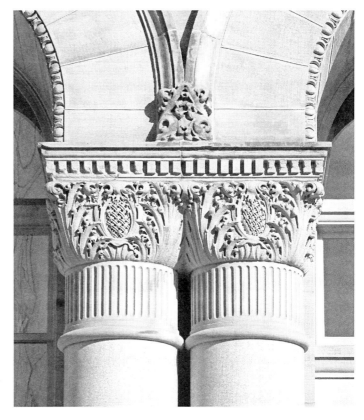

Limestone becomes butter-like in the hands of master sculptors, as evidenced with the stone of the Milwaukee City Hall (photograph by author).

ture wood nymphs, shields, and wreaths. Enormous corner finials and urns, also executed in terra cotta, decorate the massive bell tower roofed with copper. The Winkle Terra-Cotta Company of St. Louis supplied, on 109 train cars, all of the terra cotta used for this structure.[43]

Contemporary newspaper accounts were kind in their critiques of Milwaukee's newest skyscraper. They remarked upon the tower's stateliness and the fine proportions of the "wedge-shaped affair." One said the structure was "an extremely well-designed building, arranged to suit the requirements of the different departments to as great a degree as the character of the ground would permit, and it is in many respects handsome."[44] This author further stated:

> More like a modern palace than a municipal business house, with tower rearing aloft, beyond the dizziest heights attained by any other structure in the city; with its turrets and spires, its spacious belfry from which will peal the biggest bell on the continent, and with its spacious offices and corridors and complete equipment, stands the new Milwaukee city hall [*sic*].[45]

Another writer was equally complimentary:

> The Northwest Magazine pictures Milwaukee City Hall as one of the finest municipal buildings in the United States — as "a worthy monument to the civic pride and energy of a well-governed and progressive city," adding that "in architecture it resembles the mediaeval hotels de ville in France and Belgium."[46]

Although the Milwaukee City Hall has two towers, the taller one to the south is the building's real *tour-de-force*. It is this one that contains the enormous four-faced clock and the belfry

with its giant bell. It is with the city hall that Milwaukee entered into a celebrated tourney, the "battle of the bells" and the "contest of the clocks." Sometimes with architecture, size *does* mean everything, and the Gilded Age was no exception. Competitions between cities were especially and eagerly pursued by townsfolk and politicians alike. So it was with the Milwaukee City Hall.

In keeping with the neo-Baroque design, the new building most certainly was expected to feature a belfry and a sizable bell:

> Bell founding attained perfection in Holland in the sixteenth century. The bells of the famous founders of those days are still plentiful throughout the low countries, in the Netherlands, Holland and Belgium, and are hung still in many historic belfries, such as those of Bruges, Antwerp, Mechlin, Ghent, Amsterdam and Louvain.[47]

The author further explains:

> The history of bells is full of romantic interest. They have been associated with all kinds of religious and social rites and with almost every important historical event. Their influence on architecture is remarkable, for it was not until their common use that towers and spires rose above the level of the roofs of public buildings. Many a chapter in history has been rung in and out by bells. Their peals have announced many of the greatest events in public life.

With history on their side, Milwaukee politicians insisted upon a tall tower and that a large bell be included in the initial design. Architect Koch responded with a delightful appendage. What *was* important to civic boosters and cigar-chomping politicians was the height and size of the tower and the bell:

> The bell which is to sound the hours and ring in resonant reverberations from the lofty tower of Milwaukee's municipal building will rank among the great bells of the world and will be only exceeded in size on the American continent by the new bell of a Roman Catholic church at Cincinnati, the great bell at Montreal being about equal in weight to that of Milwaukee. The city hall bell will be hung in the large belfry in the tower of that building, which has a triplet of high open windows on each face. A column between two of these apertures will be temporarily removed to admit it. The bell will be struck with a ponderous hammer operated by electric power. Its weight will exceed 25,000 pounds. Its height is nearly 8 feet and its circumference at the rim nearly 27 feet.[48]

Cincinnati's entry came in at 16 tons, Montreal's at 13 tons, and Milwaukee's at 12-and-one-half tons. In 1897, according to contemporary accounts, Milwaukee's City Hall harbored the third-largest bell in North America.

Every "modern" belfry, it was thought, must house a public clock, and so it was with the Milwaukee City Hall. Milwaukee's tallest skyscraper boasted one large clock mechanism with four clock faces. These, the "fourth in size among the big clock faces of the world," were brightly lighted at night and were quite compelling to those who were unfamiliar with such clever invention:

> The chief interest, however, centers in the tower clock whose great faces will overlook the town

Like "leaf men," there were "leaf children." These cling and peer out from the limestone walls and carved foliage, to the delight of passersby. Leaf children were seen as being less troublesome than their adult counterparts; they represented the next generation, symbols of rebirth and of human continuity. Each of a dozen "leaf children" possesses a different personality; whether impish or pensive, they do entertain (photograph by author).

from a height of over 200 feet. The minute hands will be eight feet long. As there are four faces it will require considerable power to keep the hands in motion. The advantage of compressed air for this purpose is its great power.... Though the faces of the city hall clock will not be the largest in the world, they will be a great deal larger than any dials the people of Milwaukee ever used. The Pabst building clock dials are ten feet across, while those of the city hall will be fifteen feet in diameter. The next largest dials are those of the Chronicle building in San Francisco, sixteen and one-half feet. The faces of the great Westminster clock in London are twenty-two and one-half feet across and the dials of the new town clock of Minneapolis will have a diameter of twenty-three feet and four inches.[49]

The heights of buildings and the sizes of bells and clocks intrigued some, and for others these statistics were barely of passing interest. Soon the sizes of ocean liners and the speeds of various locomotives, automobiles, and "aero-planes" would also fascinate some of the citizens of Gilded Age America. Milwaukee's city hall was a product of one-upmanship, the result of decades-old municipal rivalries here, like those of centuries-old rivalries that occurred between the cities of Europe; it could not have been less.

CALL BUILDING, SAN FRANCISCO, 1896

Fancy tops, like the Milwaukee City Hall's bullet-shaped dome and the polyhedral dome atop San Francisco's Call Building, appeared upon numerous skyscrapers. The variations of dome types were many, but most hailed from Italian or French Baroque prototypes. For the Call Building, the architects employed both French *and* Italian Baroque variations for inspiration, which ultimately produced one of America's most celebrated domed skyscrapers. The Call Building was the West Coast's answer to New York's recently completed World Building (1890). These skyscrapers were similarly sized, the homes to large city newspapers, spoke the same architectural language, and were sponsored by European immigrants.

In 1846, one of those immigrants, a man by the name of Claus Spreckels (1828–1908), arrived in New York from his native Hanover, Germany.[50] Spreckels was a gifted businessman, and, very soon after arriving in America, he began a grocery business. He relocated to San Francisco to found a brewery and a fortune. Spreckels ultimately established the Bay Sugar Refining Company, the Western Beet

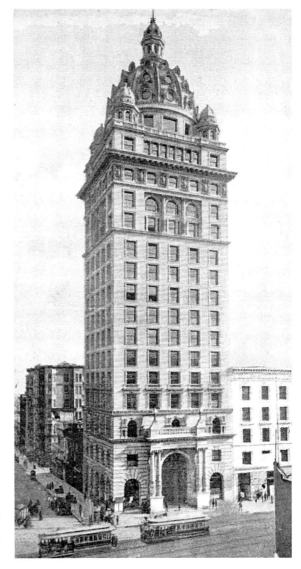

San Francisco's Call Building (Reid Brothers, 1896) as it appeared just before the earthquake and fire of 1906. Although still standing, one cannot find this building today; its Baroque detailing was erased years ago (author's collection).

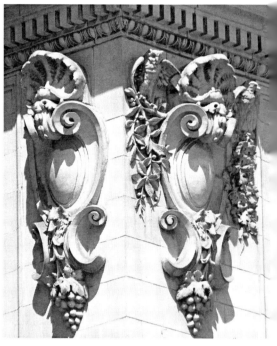

This red terra cotta decoration adorns Milwaukee's 12-story, 170-foot-tall Railway Exchange Building (Jenney and Mundie, 1901). The elaborate cartouche, a Renaissance product, is flanked by a row of ovoid shapes (eggs) and vertical daggers (darts) which were ancient Greek symbols of life and death. At the turn of the 20th century, academic classicism was quite popular for business buildings of all sizes, including the Call (Reid Brothers, 1896) and Commercial Cable (Harding & Gooch, 1897) (photograph by author).

Renaissance-inspired terra cotta decorates the corner of Milwaukee's 14-story, 200-foot-tall Wells Building (H. C. Koch & Company, 1901). An owl clutches a juniper branch, and an eagle holds an oak branch. Foxes and grapes are the real players, here wryly referenced is "The Fox and the Grapes" of *Aesop's Fables*. Ornamentation similar to this decorated the walls of San Francisco's Call Building—now all removed (photograph by author).

Sugar Company, the Pajaro Valley Consolidated Railroad, and became the owner of the Oceanic Steamship Company. He developed sugar cane plantations in Hawaii, sugar beet refineries in California, and a sugar refinery in faraway Philadelphia. In short, he was the consummate Gilded Age empire builder and was crowned the country's "Sugar King." Upon his death, Claus Spreckels's worth was figured in excess of $50 million, ranking him as one of the wealthiest entrepreneurs of the age; in 1908, the average working man earned between $200 and $400 *per year*, so by comparison Spreckels's wealth was staggering.

In 1895, the *San Francisco Call*, the very successful and celebrated Pacific Coast newspaper, was purchased by Spreckels. Within a short time and in an altogether competitive act, Spreckels ordered the construction of San Francisco's tallest skyscraper, a building to eclipse in height and prestige the city's other and rival newspaper, the *San Francisco Chronicle*. In 1890, the Chronicle Building was completed to the designs of Chicago architect John Wellborn Root. It stood ten floors, 208 feet and was the tallest building for its time in that city. Spreckels would have none of that and ordered his architects, the firm of Reid Brothers, to construct something far taller and grander.

During the Gilded Age and for some time thereafter, the firm of Reid Brothers was considered the most prominent architecture firm in San Francisco. It was founded by brothers James and Merritt Reid in Evansville, Indiana, in 1879.[51] The firm relocated to San Francisco in 1889 and soon gained a reputation for designing in the various Renaissance styles, with a particular affinity for the French Beaux-Arts. Lead designer James Reid was a graduate of the Massachusetts Institute of Technology and of the prestigious École des Beaux-Arts. His architectural training

The phoenix (regeneration) and griffin (vengeance) represent powerful forces in nature, according to ancient Greek legend. Here, smooth and sumptuous terra cotta images of these forces appear on the façade of Chicago's Railway Exchange Building (D. H. Burnham, 1901) (photograph by author).

Chicago's 17-story, 220-foot-tall Railway Exchange Building (D. H. Burnham, 1901) boasts terra cotta panels based upon Greek mythology and cartouches with the entwined letters "R" and "E." Also present are scantily clad forest nymphs, who, according to Greek texts, were said to perform "erotic feats of all descriptions." The symbolic imagery is curious as this skyscraper was constructed to house multiple *railroad* interests; there are no façade references to steam engines or locomotives, only to the mythology of the ancients (photograph by author).

was steeped in the styles most employed for large and expensive projects like the Call Building, and his European (particularly Parisian) education served him well for this San Francisco project. In a typically colorful style indicative of its time, the Call Building's construction was announced:

> San Francisco is soon to have a skyscraper of majestic proportions and altitude, fairly piercing the clouds that hang over the Pacific coast…. The structure will be 15 stories high, the tallest building west of Chicago … [and it] will represent an investment of $1,000,000 in round figures.[52]

Claus Spreckels did not build just *any* office building in 1896, he constructed a dream. The Call Building was an astonishing structure, an instant landmark, a colossal achievement secured by a one-time, almost penniless German immigrant. It was San Francisco's tallest building and visible from almost anywhere in the city, precipitous hills notwithstanding. Its footprint, on the corner of Third and Market streets, measured 70 by 75 feet (modest by most standards) and it stood a proud 19 floors, 315 feet. It had a 5,000-ton steel frame, and it was faced with cream-colored sandstone and gray granite from Oregon and sugar-colored marble from California. White-glazed terra cotta, like so much sweet frosting, was applied where history dictated. The Call Building's main entrance was marked by a 35-foot-high arch, an opening that measured 20 feet wide and was flanked by pairs of Renaissance-inspired columns. A balustrade and giant light standards further emphasized the importance of this monumental entry portal. Building façades featured Palladian-based openings, classically "correct" entablatures, decorative spandrels, and an arch-order system at the 12th and 13th floors. Few metropolitan newspapers had a finer home office.

All the Renaissance wall decoration could not compete with the skyscraper's summit. It was the great dome that enclosed the building's top three floors and really defined this skyscraper.

Here rested the ultimate neo–Baroque prize, a majestic dome that measured 65 feet in diameter and stood 45 feet in height; its profile was unmistakable, its form a treat for the eyes. This polyhedral (eight-sided) dome, covered by tons of glazed terra cotta, was perforated by 24 lucarne windows and accented by large steel ribs. The truly unique aspect of the Call Building's top was its "crown" of four smaller domes. No other Gilded Age skyscraper was so over the top; none featured a total of *five* domes.

Originally the executive offices of Claus Spreckels's business empire occupied the 15th floor. The *San Francisco Call* claimed space in the basement for its pressrooms. The 13th floor was occupied by the newspaper's editorial and art departments, and the 14th was the home to the composing and stereotype departments. The 16th floor, technically in the "drum," was the location of an exclusive public restaurant and was identified by its large, rectangular windows. Within the dome's first floor, the 17th, was hidden the San Francisco Club, a private retreat founded by the building's owner. The highest occupied floor was the 18th, and it was the home to the Reid Brothers' architectural firm. The tiny 19th floor provided attic space and stairway access to the glass-sided lantern above. Tenants inhabited the remainder of the skyscraper's space.

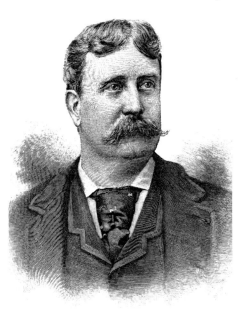

Daniel Hudson Burnham (1846–1912), the preeminent proponent of pompous walls and antique decoration *(Harper's New Monthly Magazine*, Vol. LXXXV, November 1892, "The Designers of the Fair," p. 874+).

San Francisco's earthquake of April 18, 1906, gutted the Call Building. The skyscraper burned for days, destroying the tower's interior and disfiguring its exterior. The superb pile of Baroque inspiration was faithfully reconstructed, and by 1938, the Call Building was robbed of its historic ornamentation and its five domes — this time forever. A "modernization" erased Spreckels's dream tower and deprived San Francisco of its tall Gilded Age landmark. Now known as the Central Tower, the once-proud skyscraper is no more, and its invisible 5,000-ton steel frame is the only link to its once-glorious past.

COMMERCIAL CABLE BUILDING, NEW YORK, 1897

The Commercial Cable Building stood at 20–22 Broad Street, in lower Manhattan, for 68 years. It was demolished for the same reason that its predecessor was: economic pressures due to land value appreciation. In 1895, a brownstone building was razed to make way for the 21 story Commercial Cable Building, a structure that was home to a giant communications company, to firms representing gold and copper mining interests, and to a host of "financial agents of all types." An old, revered, and storied restaurant, Delmonico's, became a casualty of this inevitable change:

> The old restaurant has for years been the dining place of hundreds of New York's best business men. Lorenzo Delmonico ... began to cater to the palettes of financiers, at 22 Broad Street. The bankers knew good things when they saw them, and Lorenzo quickly mounted to fame and fortune.... Jay Gould often visited the restaurant. He ate sparingly of the plainest dishes and drank tea. "Boss" William M. Tweed and "Slippery Dick" Connelly feasted here like lords.... In one word, every great man in the Wall street [*sic*] district, and many who were not great men, were devotees of Delmonico's. What schemes were hatched there, what companies floated, what financial battles planned, no man can estimate.[53]

Until 1895, Delmonico's was the favorite haunt of New York's power brokers. After 1897, Delmonico's site became the location of a skyscraper in which innumerable secret dramas were also conceived inside the extravagant walls. The owner and builder of that skyscraper was the Commercial Cable Company, a business incorporated in 1883 as an installer and operator of submarine cables (under-ocean telegraph lines). Its goal of connecting "all points on the globe" by means of those cables, yielded enormous profits for its founders, John William Mackay (1831–1902) and James Gordon Bennett (1841–1918).

Born in Dublin, Ireland, Mackay arrived in America at the age of nine. His family chose to immigrate to New York City, and, by the age of 20, Mackay chose to seek his fortune in California and Nevada. First as a gold miner, then as an operator of silver mines, Mackay eventually achieved considerable financial success. After forming a partnership with three other entrepreneurs in 1869, it took only four years for Mackay and his associates to discover one of the largest silver veins in the West. This mine produced over $400 million in silver, and it made John William Mackay, once a poor Irish immigrant, an American millionaire.

In 1884 and flush with cash, Mackay, always the entrepreneur, solicited the help of James Gordon Bennett to establish the Commercial Cable Company. Bennett was the owner and publisher of the *New York Herald*, a profitable newspaper begun by his Scottish-born father

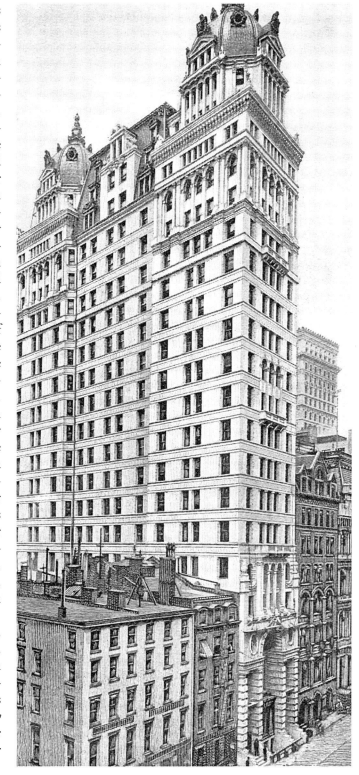

Manhattan's Commercial Cable Building (Harding & Gooch, 1897) was once the pride of Broad Street (*American Architect and Building News*, December 11, 1897).

and given to him in 1867. The *New York Herald*, founded in 1835, had the highest circulation of any daily newspaper in the country and subsequently produced both money and power for its owner. Bennett was the proverbial Gilded Age tycoon. He represented, and indeed belonged to, the upper echelon of New York society. His wealth was legendary, and he had no scruples about displaying it in the form of lavish yachts, opulent private railcars, and luxurious mansions. This Manhattan *bon vivant* entered into partnership with millionaire mining magnate Mackay with every intention of breaking the transatlantic cable monopoly controlled by none other than Jay Gould, through his ownership of the Western Union Telegraph Company.

Until 1884, when the Commercial Cable Company was formed, all telegraph communication to Europe was via transatlantic cables owned by the Western Union Telegraph Company. Mackay's and Bennett's "upstart" company provided fierce competition, and a bitter trade war ensued. Mackay would not consider failure an option for Commercial Cable, as this report attests:

> John W. Mackay, President of the Commercial Cable Company, at present in London for a few days on his way home to America, has during his brief stay in Europe concluded all the arrangements necessary to make the success of the Mackay-Bennett cable an absolute certainty. The Commercial Cable Company, wishing to be independent of any land lines, which, as the experience of other companies has shown, are subject to constant interruptions, caused by gales and snow storms, have ordered their cable to be laid double, not only across the Atlantic, but also through the entire distance to their landing points in New York and Massachusetts.... The route has been carefully chosen. With a view to avoiding the danger of possible damage from ships' anchors, both cables will run down the coast from Nova Scotia in a depth of water of not less than one hundred fathoms.... Mackay, who is determined that the new cable company shall be a success, has looked after every detail, and procured every means which a liberal expenditure can command and the skill of the most experienced electricians can suggest for providing against all eventualities.[54]

After some three years of Gould's attempt to crush the new competition and with the laying of the two Mackay-Bennett lines by Commercial Cable to the "old" continent, the trade war ceased and Gould's monopoly was broken. Jay Gould, the one-time eater of "the plainest dishes" and drinker of tea at Delmonico's, now feasted upon the bitter dish of a personal and financial setback.

Immediately after Delmonico's demolition, construction began upon what was to become New York's sixth-tallest skyscraper. After being in business for over a decade, the Commercial Cable Company concluded that a tall headquarters building was necessary due to the company's growth; the structure was also to include rentable space as an income generator. A site at 20–22 Broad Street, just south of the New York Stock Exchange, was selected for the company's new skyscraper home. The New York architecture firm of Harding & Gooch was summoned to prepare plans. George Edward Harding (1843–1907), a native of Bath, Maine, graduated from Columbia University, clutching a degree in the field of structural engineering. William Tyson Gooch joined Harding in the architecture office in 1889, and in 1891 they entered into a six-year professional partnership.

Harding & Gooch drew the plans, completed in November of 1895, for a slab-like skyscraper 46 feet wide by 154 feet deep. It would fill the narrow site between Broad and New Streets and face the rear of the Manhattan Life Insurance Building to the west across New Street. It was to be tall and imposing, and it had *two* domes; no other Manhattan skyscraper at that time had two domes. The Commercial Cable Company created not only a spectacular addition to the lower Manhattan skyline, but the company also created an ostentatious display of wealth so characteristic of the Gilded Age. A drawing, included in the pages of a Chicago newspaper, made some Chicagoans envious, in part due to the height limitations temporarily imposed there:

The illustration of the Commercial Cable Company's projected twenty-one-story building, Broad and New streets, New York, shows the class of monumental construction Chicago is missing by the limitations of the building ordinance under which owners must operate here. The structure in question is a true tower, 300 feet high, built and braced as such, and offering no liability from fire or other cause to its neighbors because it is fireproof, and properly constructed. Chicago, which made the erection of this splendid structure possible [the skyscraper *type*], cannot now equal or exceed it, because of the hasty action of the common council in fixing a height for office building construction not in line with the business destiny of this city; a true metropolis but, unfortunately, not understood by all.[55]

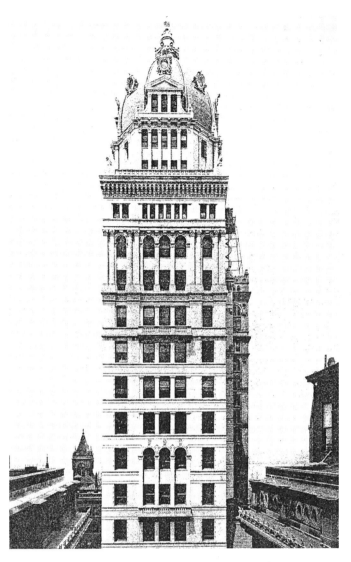

The Commercial Cable Building (Harding & Gooch, 1897), detail of building top (*American Architect and Building News*, December 11, 1897).

When the Commercial Cable Building opened to the public on May 1, 1897, its six electric elevators whisked visitors to all levels occupied by the company and to tenants such as stockbrokers, investors, and financiers. This "tower of money" softly blurred the fond memories of Delmonico's dishes and the gentle aromas of expensive cuisines. Recollections of times past were supplanted by the sounds of typewriters, telephones, and counting machines. The Commercial Cable Building originally cost $2.7 million to build; it contained 142,000 square feet of rentable space, and stood 21 floors, 304 feet tall. Most importantly, it surpassed in height its rival Western Union Telegraph's home office building (standing only six blocks to the north) by 11 floors and 74 feet! Here was a monument to an age, not to one Gilded but to one of the 17th century. The Commercial Cable Building was one of six skyscrapers that the firm of Harding & Gooch designed in lower Manhattan.[56] It was the tallest and easily the most ostentatious, and at least one architecture critic did not like it. Seeming to ignore its blatant Baroque borrowings, the critic, writing in *The Architectural Record*, reflected upon other shortcomings: "The Commercial Cable building is about the most importunate structure in New York ... [this skyscraper] is about the most obstreperous structure to which the new construction has given rise."[57] After also writing that the Commercial Cable Building was "a piece of studied impertinence," and that it "reeks of a rowdy picturesqueness like cowboy slang," the brutal critique continued by focusing on the skyscraper's summit and its two domes:

It cannot be said that the designer has not considered the distant view. It is for the benefit of the distant viewer that he has put a huge brass knob at either end of the top, giving his skyline two competing features in place of one dominate feature. One of these alone, as we have seen, from a point of view which is apparently accidental, so far as he is concerned, makes an effect of a swaggering and tumultuous kind. The two together make no effect at all, except of aggravating the incongruity between this building and its neighbor, the effect of which it might have improved and cumulated.[58]

Regarding the façade design, the magazine voiced the following:

The uncertainty about where the middle ends and the top begins is confusing and painful. As for the shaft, the central features of a balcony and a triple arch, whereby the architect has apparently attempted to relieve the monotony of nine equal and similar stories, the result of his labor is that he has managed seriously to impair the effect the succession of stories would have had if he had left them alone.... Really it is only the five-story base which is well enough seen to count, and, unfortunately, this is extremely bad.... The crudity of this is really atrocious, and it is its most noticeable quality, although there is not a notion here which would be worth a more respectful elaboration. What notions there are are mere freaks, such as the row of grotesques over the main archway with a cable (delightful pun) passed from mouth to mouth.[59]

Architecturally, the Commercial Cable Building was part church, part palace, but all Baroque. Domes, columns, temple fronts, indeed much of the traditional classical repertoire, were used here to powerful effect. Forms from the French 17th century were harvested to rear a skyscraper fit for American business. The headquarters for a company that exploited the relatively new invention of the electric telegraph (1844) and of modern electronic communication across continents was, ironically, not housed in a more modern building, a structure that employed some of the tenets of the forward-looking Chicago School. Geography and convention dictated how the Commercial Cable Building was to look, despite the cries of critics. It would have simply been unfathomable for members of the elite New York establishment to have erected a building designed in the manner of Chicago's Monadnock Block (1891) at 22 Broad Street, in New York City. Corporate kings like Vanderbilt, du Pont, Astor, Mackay, Bennett, and Gould would never have located their company's headquarters in a building as denuded of ornament as the Monadnock Block. Questions would have swiftly surfaced regarding the lack of a dome, of columns, and of little temple fronts like those atop the Commercial Cable Building. They would have searched in vain for sculptures of Roman gods, allegorical Greek figures, mythological beasts, and elements like "grotesques over the main archway with a cable passed from mouth to mouth," employed as a metaphor for the newly invented cable communication industry.

The design staff of Harding & Gooch mustered all its expertise and responded according to the whims of their client, and thus the Commercial Cable Building was born. The critic employed by the *Architectural Record* best sums up just how the designs of such buildings originate:

Why, then, does the producer of it [the Commercial Cable Building] go on producing and to produce? There can be but one answer. He gives owners what they want practically, and owners neither know nor care, so long as the architect does that, what he does artistically. At least if they know they do not care, and if they do not care they do not know. The moral of the result seems to be that architecture, in commercial buildings, is the architect's personal amusement. He must not indulge in it to the prejudice of practicality, but if he produces what his clients want, his architecture may be as good or as bad as it likes, without affecting his professional success. That seems to be the fact, and it is not without its encouraging side. For if clients do not interfere to prevent bad architecture neither do they interfere to prevent good.[60]

GILLENDER BUILDING, NEW YORK, 1897

The baroque period felt strongly attracted to constructions which seemed to defy the force of gravity.[61] — Sigfried Giedion (1888–1968)

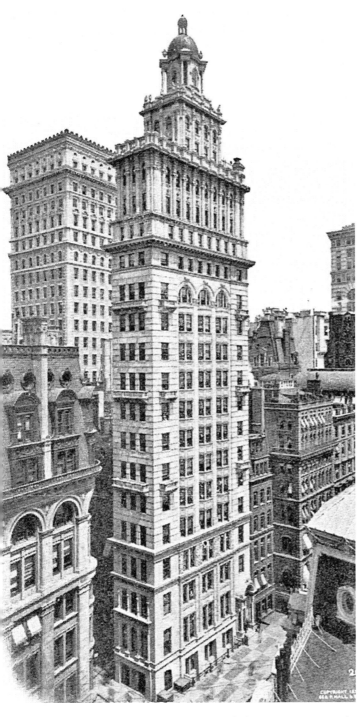

Manhattan's Gillender Building (Berg & Clark, 1897) was once the pride of Nassau Street (author's collection).

Like the nearby Commercial Cable Building, the Gillender Building was quite simply another delightful manifestation of the Gilded Age. Its façades were also inspired by history; its roof was topped by an abundance of architectural extravagance borrowed from Baroque Europe. As exact contemporaries, these two domed cousins defined the Wall Street skyline like no other two buildings had till then; now they are both gone.

The Gillender Building, located at One Nassau Street, was like a delicate perfume bottle, elegantly thin and tall with a decorative stopper on top. This skyscraper stood on a plot of land that measured only 26 by 73 feet, and it rose to a gravity-defying height of 21 stories, 273 feet. The Gillender Building, completed in 1897, was faced with gray granite, limestone, blond brick, and cream-colored terra cotta. The structure, like the neighboring Commercial Cable Building, was considered "modern, with every convenience" and judged "completely fireproof." Because of its perceived modernity and excellent business location, the building quickly became, and remained, fully rented. The Gillender Building became the home to stockbrokers, bankers, law firms,

and real estate men. Its largest tenant was the Manhattan Trust Company, a firm that occupied the basement and floors one through three. Higher up were the law offices of Gillender, Fixman & Mumford.[62]

The site of the Gillender Building was not occupied by a famous restaurant, as in the case of the Commercial Cable, but it was occupied by the seven-story Union Building, an Italian Renaissance-inspired product of the 1860s. This building, too, was a favorite of New York's business elite, and it was the headquarters of Jay Cooke's financial empire.[63] The illustrious Cooke (1821–1905) was a flamboyant financier, railroad magnate, and victim of the infamous Panic of 1873; while located in the Union Building, Cooke was forced into bankruptcy and was linked to multiple financial scandals. In 1895, the storied parcel at 1 Nassau Street saw the demolition of the Union Building, a structure owned by Helena Gillender Asinari (d.1932). The New York firm of Berg & Clark was retained by her to design the Gillender Building.[64]

Philadelphia native Charles I. Berg (1856–1926) and Edward H. Clark began the practice of architecture together in 1880. It was Berg, a graduate of the École des Beaux-Arts and former member of the noted firm of Cady, Berg and See, who was credited for the design of the Gillender Building.[65] Berg's schooling and certain professional expectations allowed for no other resolution to the appearance of the Gillender Building. He was a hostage of the late Renaissance and the Baroque periods; the Gillender's façades were loose interpretations of French and Italian Renaissance palaces of the 17th century. Berg adhered to the tripartite formula for the building's overall disposition, but he gleefully played with the façades' detailing. The skyscraper's main entrance was far offset to the north, destroying an otherwise perfectly symmetrical Nassau Street façade. It featured an arched canopy and attenuated columns. Above were carefully placed balconies; these tiny balustraded exterior spaces were deliciously romantic and apt additions. In between these balconies clung three parallel rows of bay windows, tall visual elements that promoted the sense of external movement generated from an internal force; this device rendered the façade perpetually active. Surmounted by large arched openings, the whole was a fine interpretation of Baroque characteristics.

Lording over all the band courses, cornices, striated walls, consoles, pilasters, and carvings was the Gillender's *piece de resistance*, its rooftop belvedere. A three-story, telescoping tower was appropriated from the sacred world and used for the profane. For this belvedere, perhaps Berg was moved by the Baroque towers of the Cathedral of Santiago de Compostela (Fernando Casas y Nuova, 1738–1749) located in northwestern Spain.[66] Maybe one of the belfries of the Cathedral of Zaragoza, Nuestra Senora del Pilar (Francisco de Herrera, 1677) was studied as a possible model for the American skyscraper's top.[67] Consisting of a heavily decorated two-story "box," the belvedere also included four pairs of columns and a diminutive copper dome with lantern. Figuring prominently within this whole composition were positioned 20 large urns. To the ancient Greeks and Romans, these vessels "from which the waters flowed" symbolized abundance, prosperity, and fertility; their inclusion here were certainly appropriate for a building that housed profit-searching businessmen. The belvedere's exact visual sources will forever remain unknown. But what is certain is that Berg gave to lower Manhattan, and to his client, an architectural history lesson.

In 1910, and after standing a scant 13 years, the Gillender Building was demolished to make way for a new and much taller skyscraper. The eight-story Stevens Building, a Wall Street stalwart and neighbor of the Gillender, was also removed. On April 30, 1910, the *New York Times* reported:

> With the destruction of this modern steel skyscraper [the Gillender Building] will go the old Stevens Building, forming an "L" around it on both Wall and Nassau Streets, and as soon as these two structures are razed to the ground work will begin on the erection of the thirty-two-story Bankers' Trust Company Building, which will occupy one of the most desirable corners in the financial district.[68]

The Gillender Building was a premier Gilded Age landmark that eloquently spoke of its own time and of the aesthetic values held dear by the people who erected and enjoyed it. Here existed a tall money-making machine, a skyscraper that, due to its slenderness and height, seemed "to defy the force of gravity."

SOHMER BUILDING, NEW YORK, 1898

The influence of the École des Beaux-Arts was more pronounced in New York than anywhere else in America. French-inspired American commercial buildings, including dainty skyscrapers like the Sohmer Building with its neo-Baroque tower, became ubiquitous during the Gilded Age in Gotham. The architectural firm responsible for the design of the Sohmer Building was that of Maynicke & Franke. Robert D. Maynicke (1849–1913) and Julius Franke (1868–1936) formed a Manhattan-based partnership in 1895 that lasted until Maynicke's death. Maynicke, a native of Germany, was an architecture graduate of New York's Cooper Union and served an apprenticeship in the firm of George B. Post. Franke, also a product of Post's office, was born in New York City and for two years trained at the École des Beaux-Arts. While in partnership many Manhattan skyscrapers were credited to their combined design skills, skills owing much to the influence by the then-popular Beaux-Arts style.[69]

The French Beaux-Arts was a style favored not only by architects but also by real estate developers. One such entrepreneur was New Yorker Henry Corn, who constructed a rather diminutive office building at 170 Fifth Avenue, southwest corner 22nd Street, that owed much to the aesthetic principles of the late French Renaissance/Baroque. Completed in 1898, the 14-story building soon came to house the corporate headquarters and showrooms of the Sohmer Piano Company and a variety of other tenants; as the major tenant, the naming rights were Sohmer's.

Corn's Sohmer Building was a charming commercial structure that captured the awe and admiration of the neighborhood; with the completion of the nearby Flatiron Building in 1902, the Sohmer Building's magic was supplanted. The Sohmer was a simple slab of a structure with a decorative Baroque-inspired tower placed on one side. A partial mansard roof marked the 12th floor, and Renaissance detailing helped to enliven the street walls. Large windows wrapped the first two floors and signified the locations of showrooms devoted to Sohmer's pianos. A two-story, eight-sided, telescoping tower with balustrade and urns was designed to anchor the east end of the building. This pointy aerie was not seamlessly integrated into the body of the building, though; rather, it seems to have been plopped on top as an afterthought, albeit a delicious afterthought.

A man by the name of Sohmer must have liked the building; he filled much of it with his pianos. Hugo Sohmer (1846–1913), born in the Black Forest of Germany, moved to New York at the age of 14. While in Germany, Sohmer studied piano making under the finest of supervision.[70] In 1872, Hugo Sohmer, musician and piano maker, founded Sohmer & Company in New York.[71] Sohmer's principal production facilities were in Astoria, Queens, but Sohmer's showroom was on fashionable Fifth Avenue. In New York City alone, at that time, there were 171 piano manufacturers, and despite stiff competition, Sohmer Pianos received high accolades.[72] Contemporary advertisements stated:" The superior excellence of the Sohmer Piano is to be found in its volume, purity, and richness of tone, and solidity of construction."[73] Over a decade before Corn built this skyscraper, Sohmer & Company had established itself as a major player in the piano world:

> From three pianos a week in 1872 to forty in 1887, the growth of the Sohmer & Co. name and reputation has been steady and with no step backward.... Among musicians, it is well understood that the Sohmer piano combines a rich, pure tone of great volume and sympathetic quality with a

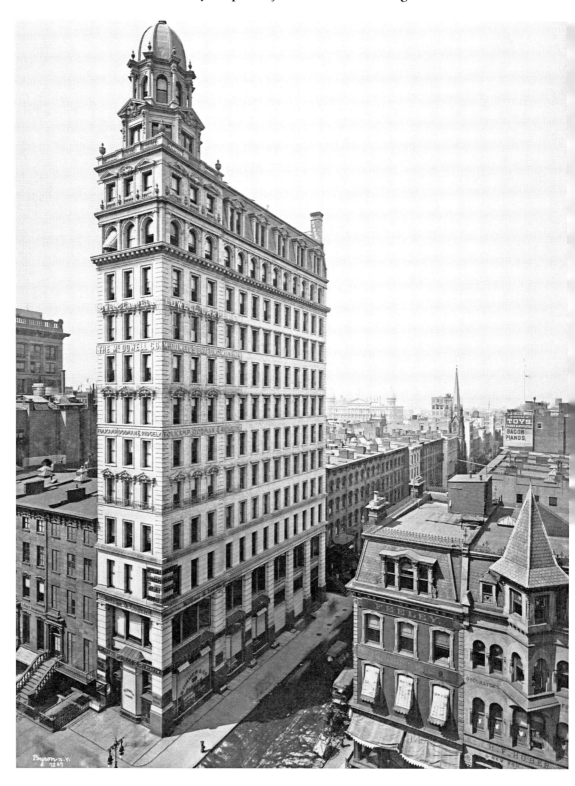

The Sohmer Building (Maynicke & Franke, 1898) was Manhattan's palace of pianos (Fifth Avenue and 22nd Street, 1899, Museum of the City of New York, Byron Collection, 93.1.1.18000).

precision, delicacy and responsiveness of touch seldom found in other instruments, and characteristics which also make it the prime favorite among artists for both concert and private use. This firm makes every variety of pianos, square, upright, and grand, and constantly striving to meet every demand, has produced the Bijou Grand, the smallest grand piano ever made, and the most practical novelty yet presented to the public.... The name of Sohmer & Co. has become a synonym for liberality and enterprise throughout both continents, and the future of the house cannot fail to worthily sustain the past record and achievements.[74]

Despite the firm's popularity and its 117-year history of musical accomplishment, Sohmer & Company closed in 1989. The firm's most lavish showrooms and upper-floor office spaces remain, though they no longer feature the sweet sounds of their piano and typewriter keys. In 2000, the Sohmer Building's upper floors were converted into residential condominiums, with the first floor remaining devoted to commercial uses. Helping to announce its conversion and owing to a typically Gilded Age extravagance, the Sohmer Building's dome was appropriately gilded with some 2,700 sheets of 24 carat gold. Currently this 5,000-square-foot little tower serves as a deluxe duplex residence.

PARK ROW BUILDING, NEW YORK, 1899

The modern office building ... is not to be judged by the usual architectural standards. It professes to be nothing more or less than it is — a strictly utilitarian structure, admirably adapted to its purpose of housing the greatest possible number of business men upon a limited area in the city business center.[75]

The above 1899 observation appeared in an article announcing the completion of New York's Park Row Building. The author, however, failed to realize that although the skyscraper was a relatively new invention, it was indeed judged by the "usual architectural standards." Materials, proportions, and function, among a multitude of other criteria, have always been the yardsticks by which architecture was judged, and the *skyscraper* was no exception. The Park Row Building was assessed using the same criteria, and by no means was this building ever considered just a utilitarian structure; it always oozed extravagance.

The Park Row Building's name was a result of its location in lower Manhattan, 15 Park Row. It was completed in 1899, and for a short time it was also known as the Ivins Syndicate Building, owing to the man who envisioned erecting New York's tallest skyscraper. William Mills Ivins, Sr. (1851–1915), was born into a family of simple means in Freehold, New Jersey, the son of an English Quaker father and a French Huguenot mother. He grew up in Brooklyn, New York, and eventually found his way to the law school at Columbia University, from which he graduated at the tender age of 22. Before long, attorney Ivins became known as a political reformer, taking on the Tammany power brokers in Manhattan and the "Brooklyn Ring" in the big city to the east. He would become an unsuccessful Republican candidate for mayor of New York, dabble in real estate, and serve as partner in W. R. Grace & Company. One such endeavor found him as the head of an investment syndicate, a group of business people whose primary focus was to make money.[76] The opportunity presented itself to take ownership of a parcel on Park Row and to erect a skyscraper that would generate income indefinitely.[77] The Ivins Syndicate, as it became known, contracted with an established New York architect by the name of Robert H. Robertson to produce the plans for a very tall, speculative building to be christened the Park Row.

Robert Henderson Robertson (1849–1919) was a native of Philadelphia, the son of Scottish-born parents. An 1869 graduate of Rutgers College, Robertson practiced architecture first in his home town, then later he relocated to New York and labored in the architectural offices of George B. Post and Edward Tucker Potter. Robertson was adept at designing in all the historic

styles, taking a special fancy to the work of the Gothic Revivalists and of the medieval, as reinterpreted by Henry Hobson Richardson. During his professional career, Robertson designed several important libraries, churches, office buildings, and substantial homes. But perhaps he is best remembered for his two tallest skyscrapers, the American Tract Society and the Park Row.[78]

Robertson's resultant moneymaker for the Ivins Syndicate towered over City Hall Park in lower Manhattan. The skyscraper's statistics were staggering and were recited as a form of entertainment by sidewalk superintendents and newspaper wags alike: it stood 29 floors, 382 feet above the sidewalk, making it New York's tallest building and the country's second tallest, topped only by the Philadelphia City Hall at 548 feet. Furthermore, the Park Row Building contained 950 offices that daily housed some 4,000 people; it boasted 2,095 windows, weighed 20,000 tons, and cost the sum of $2,400,000 to erect.[79] Eight electric Sprague Company elevators whisked an estimated 20,000 people to appointments high in the tower each business day.

Without fear of contradiction, it was the two domed towers atop the Park Row Building that aroused the public's fascination with the new skyscraper. They were the highest points in Manhattan, they were privately occupied — therefore off limits to the general public — and they were absolutely enticing to those romantics of the Gilded Age. The skyscraper's cornice topped out at 336 feet above the sidewalk, while its twin towers, each 24 feet wide, touched the 382-foot mark. Individually the towers housed three penthouse office suites and were surmounted by a copper-clad dome and lantern. For these towers, Robertson undoubtedly drew architectural inspiration from the churches of Baroque Europe, from the pages of design and history books featuring such structures. Double-domed churches of the 17th century were sprinkled throughout Europe, but it was the design of architect Filippo Terzi (1520–1597) for the Church of Saint Vicente da Fora (1582–1627), in Lisbon, Portugal, that arguably comes in as the architecturally closest and most possible progenitor for the top of this American skyscraper.[80] Quite simply, these lofty trinkets were the icing on the cake for this otherwise quite ordinary office building. The original purpose and description of one of those towers, inhabited by a Mr. Richard Croker, follows:

> Richard Croker has outrivaled Balshazzar and the hanging gardens of Babylon. In his new office in one of the "Twin Towers" of the Park Row office building he will survey a wider range of influence and power, and will have the claim unchallenged that no monarch in any age had a higher throne.... He will have a private dining room, attended by a special chef; a private bath walled with marble and marble floored, and into which the man in the moon alone could steal a peep. He will have a private elevator and a private reception room. To the man of business he will be found only in his office, several floors below. To his friends he will extend in his private rooms the hospitality of a home.[81]

Living like Nero and living discretely was important to this Mr. Richard Croker:

> Mr. Croker has shrewdly arranged to keep one strong hand on the purse of political power. An ingenious mind is revealed in the shrewd rearrangement of the main offices of the company. A partition has been placed here, a new door there; a political caller may confer with him and pass out un-observed by any one else who may be waiting to gain attention. Three doors will have to be passed, three attendants satisfied as to the urgency of a caller's business before Mr. Croker will be reached. Once in Mr. Croker's office, there will be no fear of observation from the outside. No one will be able to peer into his windows. These offices will be on the twenty-sixth floor and take the whole floor area — forty-one rooms in all in the original plans.... The private dining room and reception room on the twenty-ninth floor will be reached by two private elevators preserved especially for the use of Mr. Croker and his assistants.[82]

Purposeful deception and ultimate privacy were characteristics of Tammany Hall, and who better to continue their practices than Mr. Richard Croker, a Tammany Hall boss? Richard Croker (1841–1922) was born in Ireland, settled in New York, and in 1869 was elected a New

York City alderman. In 1886, after garnering a series of political appointments, Croker became the boss of the corrupt Democratic organization in New York City named Tammany Hall. Widespread disclosures of political corruption during Croker's rule caused Croker to abdicate his position in 1901; he returned/fled to Ireland only to die there a very wealthy man. In an example of supreme irony, the crooked Croker was a tenant in an office building owned by Ivins, a staunch opponent of Tammany Hall and political chicanery. The Park Row Building's twin towers served an architectural purpose, but also, because of their remoteness, it appears that at least one of them played a role as a den of Tammany graft.

When finished, the Park Row Building drew the critical attention, much of it negative, of both press and public alike. The always respected, but often feared, architecture critic Montgomery Schuyler (1843–1914) referred to the Park Row Building as a "horned monster," owing to his obvious dislike of the rooftop towers.[83] Other correspondents remarked in the positive, but barely: "It will, we think, be admitted that his treatment of the towering pile of the Park Row building [*sic*], the architect, Mr. R. H. Robertson, has produced a very satisfactory effect."[84]

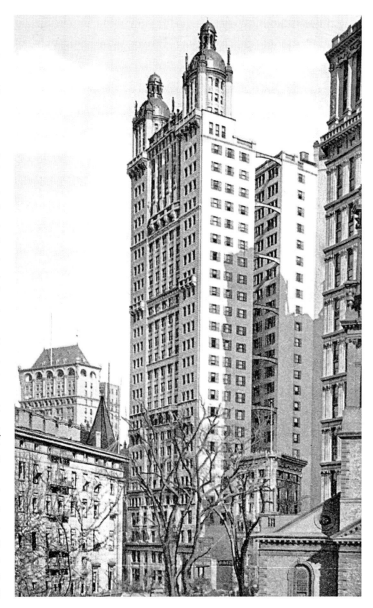

The Park Row Building (Robert H. Robertson, 1899), a Gilded Age monument once referred to as a "horned monster" (author's collection).

Shortly after its completion, Robertson evidently felt the need to explain and to defend his design for the Park Row Building to the public:

From the architect's point of view the planning of a building nearly 400 feet high, with a base of only 100 feet offers many difficulties. The necessity of a façade nearly 350 feet high is apt to result in the bald, staring appearance of a chimney or a tower, which is both ugly and painful to the sight. The architect's method of relieving this tendency is by treating the stories in groups of four or five. This lessens the effect of extreme height. At the same time the width is made to seem greater than it really is by the addition of heavy cornices and projecting balconies.

While it is perhaps too much to expect that a skyscraper shall become an object of beauty these various devices do much to give the building personality and distinction and to lessen the effect of perfectly blank, staring walls. The architect's aim is realized if the building can be made to look less than its real height without losing any of the imposing characteristics of its true proportions.[85]

The opinions of Robertson could not be more diametrically opposed to the new thinking of the Chicago School in general and to those ideas of Louis Sullivan in particular. To assert that it is difficult to expect that a skyscraper could be considered "an object of beauty" seems awfully shortsighted for that time, especially when Robertson must certainly have been aware of the struggle of others to beautify their skyscrapers by using a variety of methods available to architects during the Gilded Age. Instead of seeing the skyscraper as a "proud and soaring thing" and as a total unit "without a single dissenting line," Robertson compartmentalized his façades by introducing multiple heavy cornices and "grouping" his floors into collections of stories "four or five" high. As a result, the Park Row Building rises hesitantly in fits of starts and stops; it stutters upward rather than effortlessly rising to meet the sky as does its contemporary only blocks away, the Bayard-Condict Building (Louis Sullivan and Lyndon P. Smith, 1899). Additionally, a skyscraper's "real height," its *raison d'être*, should be celebrated, not hidden and apologized for.

The walls of the Park Row Building originally featured four giant freestanding statues supported by large consoles at the fourth-floor level and four elongated figures perched high above at each dome. The fourth-floor figures remain; the others were removed years ago. These were the work of J. Massey Rhind, and they depicted allegorical figures of antiquity as was so commonly done then. Ivins, Croker, and the public expected to see domes, statuary, and heavy cornices, and they would not be disappointed. The Park Row Building represents a true missed opportunity at exploring modernity. As the city's tallest skyscraper, it took on the mantle of instant landmark, and remains still as one of the most significant Gilded Age buildings of any type, anywhere.

One-Forty-Seven Fifth Avenue, New York, 1897

One-Forty-Seven Fifth Avenue was not just a building: it was a *force*, an imposing mountain of stone that took command of its corner site, a charge that it never relinquished. Here still stands a superb example of Beaux-Arts architecture with neo–Baroque flourishes. It once housed cloth importers, millinery and lace manufacturers, the offices of woolen mills, and the makers of curtains and draperies. It was constructed in the heart of New York's "Ladies Mile," one of the nation's finest and largest shopping districts during the turn-of-the-century. This concentrated neighborhood was a Gilded Age bevy of exclusive dress shops, jewelers, furriers, galleries, giant department stores, and piano showrooms like those in the Sohmer Building just one block away. One-Forty-Seven Fifth Avenue was not only filled with splendid shops, its first floor was once partially occupied by the Hungarian-American Bank, an enterprise devoted to "promote Hungarian exports to America and to facilitate money order business between Hungarians in America and their mother country."[86] New York, the "Great Melting Pot," was, after all, the home to some 110,000 Hungarians by 1900, and many of them were indeed "people of means."[87] Cosmopolitanism, capitalism, and simple human energy drew this bank here.

This skyscraper was completed in 1897 to the plans of Maynicke & Franke to stand ten floors, 154 feet above Fifth Avenue. An opulent addition completed three years later was undertaken by architect Henry Edwards Ficken: he added a neo-Baroque corner tower and dome housing three floors and bringing the building's total height to an even 200 feet. Henry Edwards Ficken (1844–1929) was born in London, England, was educated there, and continued his architectural training after arriving in New York in 1869. Ficken was employed in the New York

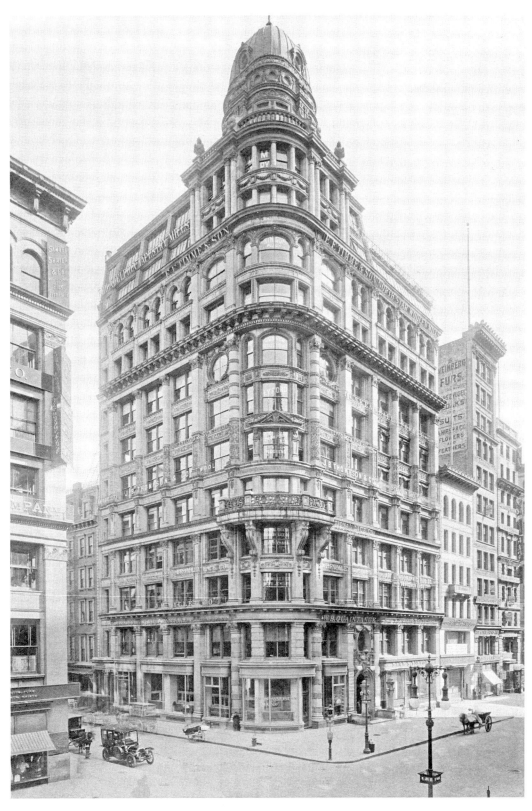

New York's One-Forty-Seven Fifth Avenue Building (Maynicke & Ficken, 1897) still cuts an impressive profile on Fifth Avenue (One-Forty-Seven Fifth Avenue, photograph by Wurts Brothers, Museum of the City of New York, Print Archives).

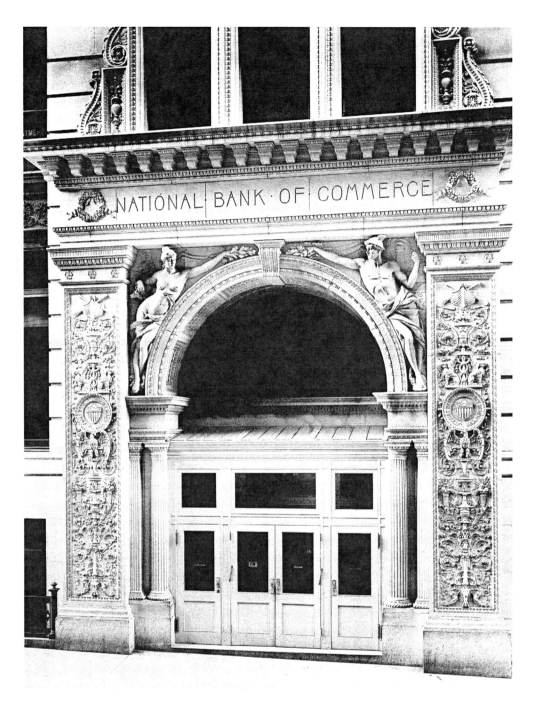

Like all major skyscrapers in New York, including the One-Forty-Seven Fifth Avenue Building (Maynicke & Ficken, 1897), an elaborate entrance was mandatory. New York's National Bank of Commerce (James B. Baker, 1897) stood 19 floors, 264 feet above the northwest corner of Nassau and Cedar streets, some two miles south of One-Forty-Seven Fifth Avenue. As one of the tallest of its time, this skyscraper also boasted an exceptionally ornate entrance where classical mythology provided the setting. Venus was not only the goddess of beauty, but she was associated with coinage, weights, measures, writing, and was seen as a protector of commerce. Mercury, one of Venus's many lovers, was the god of commerce, communication, travel, and wealth. During the Gilded Age it was fitting to employ these figures at a bank's entrance, since the general populace was well aware of mythology and the attributes of the deities. The National Bank of Commerce Building was demolished in 1964, and its elaborate entrance was conducted to a landfill (*The American Architect and Building News*, May 14, 1898, no. 1168. The Heliotype Printing Company, Boston. Negative by H. H. Sidman, New York).

office (the other was in Boston) of Gambrill & Richardson before starting his own practice in Manhattan.[88] It was Ficken's addition to One-Forty-Seven Fifth Avenue that truly propelled this skyscraper into the realm of Gilded Age extravagance and historic recognition.

One-Forty-Seven Fifth Avenue was the epitome of profusion. Its façades were thick with decoration, crowded with banded pilasters, columns, garlands, consoles, circular windows, and Beaux-Arts squiggles. Its Fifth Avenue entrance gushed with neo–Baroque details, while its garret windows occupied the top floors and recalled those of Paris. Urns and a balustrade embraced its greatest singular architectural element, its ribbed and copper-clad dome. Lucarne windows and more circular ones announce this to be the most coveted and intimate space to occupy. Though currently a residential building, One-Forty-Seven Fifth Avenue remains one of those rare architectural examples of the glamour and excitement of the Gilded Age.

Temple Bar Building, New York, 1901

> Architecture, like government, is about as good as a community deserves.... If sometimes architecture becomes frozen music, we have ourselves to thank when it is a pompous blare of meaningless sounds.[89] — Lewis Mumford (1895–1990)

Were the three cupolas atop the Temple Bar Building meaningless extravagances? In the whole of this composition, were these extremities "meaningless sounds"? These questions were answered silently regarding these cupolas in the mind of George L. Morse, the architect, as he put pencil to paper. He undoubtedly asked himself many questions while designing this famous Brooklyn office tower; he relied on his knowledge of history and of the buildings of faraway lands to guide his mind and his hand. George L. Morse, like others, borrowed from the "design bank" and found himself heavily in debt.

Art and architecture scholar Lewis Mumford paraphrased German poet Johann Wolfgang von Goethe's (1749–1832) famous quote, "I call architecture frozen music" to decry the sorry state of American architecture, as he saw it. What might Mumford have said about the Temple Bar Building? He might have noticed a confused composition, the façades layered, segmented, and boxed like some giant puzzle. He might have glared at the French Baroque-styled cupolas, clad with copper and iron-trimmed, these giant ornaments with arch-pedimented windows and iron cresting. He might have scoffed at the four, two-story-tall banded Ionic columns at the skyscraper's main entrance, columns that compartmentalized the building's three openings, further dicing up the façade. Perhaps ... he saw none of it. Those who did see the building were principally the lawyers who paid to be in it. The Temple Bar Building was constructed near the Brooklyn City Hall and various court and municipal buildings, banks and other major businesses in what was once America's fourth-largest city.[90]

The design of the still-standing Temple Bar Building obviously passed muster with its architect, George L. Morse (1836–1924), a prominent Brooklyn practitioner until his retirement in 1910. Morse, a native of Bangor, Maine, was responsible for almost singled-handedly giving early Brooklyn a skyline of its own. He designed the Mechanics Bank, the Strauss Building, the nine-story Brooklyn Eagle, and the "chateau" topped 11-story Franklin Trust Company buildings; Morse was also responsible for the designs of large churches and many prominent Brooklyn homes. His Temple Bar, completed in 1901, was for a time Brooklyn's tallest building at 13 floors, 164 feet.

The Temple Bar Building was a French neo-Baroque composition, a giant example of Gilded Age extravagance. Its walls were alive with contradictions of movement: the observer's eye was not permitted to slide up the façades effortlessly; there were too many band courses and cornices, too many pedimented windows, balustrades, and balconies. The eye's eventual reward

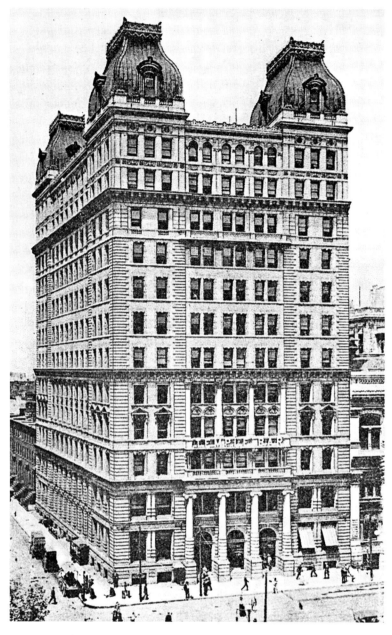

For a short time, Brooklyn's Temple Bar Building (George L. Morse, 1901) was that borough's tallest skyscraper (author's collection).

manifested itself in the cupolas on top, those bulbous "noise-makers" that gave this skyscraper nothing if not distinction.

One other disconnect, considering the overt French style of its architecture, has always been this skyscraper's English-based name: Temple Bar. The term "Temple Bar" refers to a Baroque-styled stone gateway designed by Sir Christopher Wren (1632–1723), and completed in 1672. This fanciful gateway separated the city of London from Westminster, and it remains near the Law Courts in the Strand. This area of London was traditionally populated by solicitors and barristers, much like the Temple Bar Building was originally the home to Brooklyn attorneys. The allusion is specious; still it conjures up images of Gilded Age attorneys practicing within the confines of this early Brooklyn skyscraper.

SINGER BUILDING, NEW YORK, 1908

This elegant spindle was the product of four self-made men: Singer, Bourne, Alexander, and Flagg. The Singer Building was a consequence of the Singer Sewing Machine Company's desire to display its values architecturally, and in a larger sense this skyscraper accurately reflected those same values the Gilded Age held so dearly. This Beaux-Arts skyscraper with Baroque leanings was symbolic of wealth, corporate success, and Parisian propriety, all qualities then admired by many Manhattanites. The Singer stood as a splendid product of its own time and place.

Ernest Flagg, the Singer Building's architect, had plenty of time to immerse himself in the richness of Parisian buildings when, as a young man, he studied architecture at the École des Beaux-Arts. Like other Gilded Age skyscrapers, no single structure was the model for the Singer

Building, but rather it was very similar to any number of structures in the French capital. One office building in particular that Flagg may have seen in architectural periodicals of the period was that of a six-story structure on a prominent corner of the *Place de la Bourse* and described as "a high standard of commercial design."[91] This business building was completed in 1898, and it bore a striking resemblance to its much taller New York cousin.

Typical of the Parisian prototypes, the Singer building shared with them prominent mansard roofs, red brick, patinated copper spandrels and trim, and a love of decoration derived from

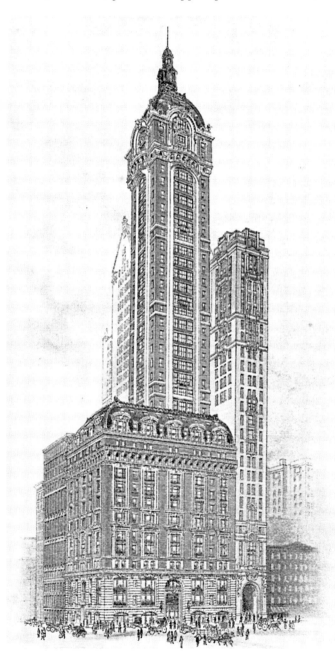

French Baroque sources. Additionally, the Singer Building possessed a dreamlike quality. It exuded a sense of fantastic imagery, of expressive, inventive shapes and forms culminating in its bulbous top; its unique shape was easily identifiable on the skyline of Manhattan. This 47-story skyscraper did not celebrate the steel frame that supported it; instead, its walls concealed its skeleton with tons of brick, copper, and terra cotta, much of it nothing more than extraneous wrappings. Although it can be argued that the central portion of each of the tower's façades does reveal, through its use of metal and glass, that these areas are simply curtain walls and nothing more, the argument is not wholly convincing. This was no Reliance Building, no Guaranty Building. The Singer Building was the antithesis of the "less is more" skyscraper. The building's walls were highly "active" in true Baroque fashion, its tall tower a riotous display of extroverted forms.

Isaac Merritt Singer (1811–1875) never viewed this building that bore his name. Unlike Pulitzer, Spreckels, MacKay, and Pabst, Singer would never see the fruits of his labor in the form of a skyscraper that either he or the company he founded would

For a short time, Manhattan's Singer Building (Ernest Flagg, 1908) was the world's tallest skyscraper (author's collection).

construct. Singer was born in the New York hamlet of Pittstown, of very humble Scottish immigrant parents.[92] As an astute inventor, Singer improved upon an existing but somewhat handicapped version of the rudimentary domestic sewing machine. In 1851, Isaac Merritt Singer patented his redesign of the sewing machine, and he began the Singer Manufacturing Company; Singer later relocated to New York, and he renamed his firm the Singer Sewing Machine Company. By 1863, Singer's company was recognized as the world's largest manufacturer of sewing machines, and by 1889, it was the first to develop and market a sewing machine employing an electric motor. Having retired to the south of England in 1863, Singer missed most of his company's accomplishments: by the end of the Civil War, the company possessed 74 manufacturing plants, annually producing over 100,000 sewing machines, and the Singer Sewing Machine Company was considered America's first multinational company with factories in four European countries. In 1875, Singer, the humble-started self-made man, died in his 115-room mansion worth an estimated $13 million.

Without Singer, it is doubtful the names Frederick Bourne and Douglas Alexander would be of note. Frederick Gilbert Bourne (1851–1919) was president of the Singer Sewing Machine Company from 1889 to 1905. During his tenure, he oversaw the construction of the ten-story headquarters building that was completed in 1898, and that later served as the base of the Singer tower.[93] Bourne, a product of very humble means and social standing, joined as the Singer company secretary, and by the age of 38 became company president. This self-made millionaire resided at the exclusive Dakota Apartments (Henry Janeway Hardenberg, 1884) on Manhattan's Upper West Side, and owned a 1,000-acre estate on Long Island. Furthermore, he contracted with Ernest Flagg to design a castle on Dark Island (completed in 1904) in the middle of the

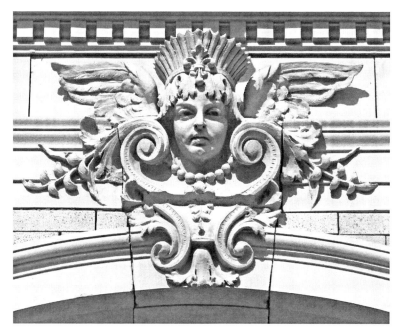

St. Lawrence River and a 110-room mansion named "Indian Neck Hall" on a 2,500-acre estate, also in upstate New York. In his spare time, Bourne served as a commodore of the New York Yacht Club. The Gilded Age was good to Bourne.

Bourne's successor was the British-born Sir Douglas Alexander (1864–1949). Educated as an attorney, Alexander entered the Singer Sewing Machine Company in 1891. He was promoted to president in 1905, a position he held until his death 44 years later. It was during Alexander's presidency that architect Ernest Flagg arrived at the final design for the Singer Building, with, of course, Alexander's blessing.

Aristocrats of the Gilded Age often displayed exotic images on the fronts of their palatial homes *and* on the façades of the skyscrapers in which they directed the work of hundreds. This terra cotta sculpture appears on a mansion's façade that dates from 1896. Visitors are confronted by a female with hair resembling acanthus leaves and who wears an Oriental-inspired crown; she is accompanied by volutes, angelic-based wings, and a prominent *fleur-de-lis* (photograph by author).

During the Gilded Age, architectural expression included limestone panels, such as this found on a façade of a Chicago business block of 1892. Bell flowers, foliate patterns, and disembodied heads with silly expressions were accepted by an urban culture used to viewing the fantastic. The Singer Building was a product of that culture, and its design, too, borrowed much from French Baroque sources (photograph by author).

Ernest Flagg (1857–1947) was well connected with the well-heeled. His professional success depended on that. On his maternal side, Flagg's cousin was none other than Cornelius Vanderbilt II, the grandson of Commodore Vanderbilt and the individual credited for paying Flagg's way through his three year stint at the École des Beaux-Arts (1888–1890). Besides Frederick Gilbert Bourne, Flagg designed homes for wealthy publisher Charles Scribner and other New York aristocrats, including R. Fulton Cutting, Alfred Corning Clark, O. G. Jennings, and Lewis Gouverneur Morris. Flagg's architectural office was situated high in the Mills Building Annex at 35 Wall Street, a location advantageous for chance encounters with potential moneyed patrons. The Gilded Age was good to the Brooklyn-born Flagg, too.

Throughout Flagg's long and distinguished career

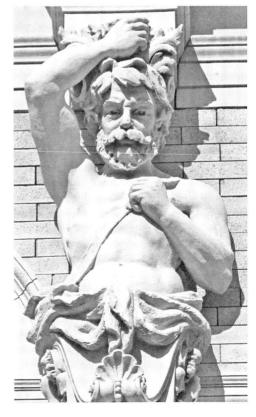

A bearded rustic executed in terra cotta serves as a telemon on the wall of an executive's mansion, designed in 1896. Such carvings were commonplace on prestigious homes prior to the turn of the 20th century. New York's St. Paul Building (George B. Post, 1899) is the ultimate example of such a practice as applied to a skyscraper (photograph by author).

he designed considerably more than just palatial houses for the wealthy. He adopted and, in fact, reveled in history, particularly in the medieval and the Renaissance periods, and as a result of his French schooling, Flagg became the ultimate Beaux-Arts architect. Flagg purposefully chose not to design in a more streamlined (translated: modern) mode, one without the overt references to foreign cultures and of centuries long past. He was not open to the modern, to the Chicago School, and, frankly, neither was New York.[94] His houses were pompous, and his Gilded Age clients loved them.

Flagg's greatest commission was that of the Singer Building, completed in 1908. Capping a three-phase building project that began with the completion of the original Singer Building in 1898 was the scheme to construct a giant skyscraper at 149 Broadway. The "1898 building" was partially dismantled, then enlarged, and an office tower erected behind and adjacent to the original Beaux-Arts headquarters. The result was an office complex with a delicate, yet top-heavy, 47-story exclamation mark which lies squarely in the realm of the Baroque. The building was ornament laden, and due to its colorful exterior it avoided the solemnity of other nearby towers. The Singer Building, at 612 feet tall, was declared the "World's Tallest" at its topping-out ceremony on October 3, 1907. Of course, additional work was necessary inside and out, and on May 1, 1908, the Singer Building was officially opened to the public and to hundreds of Singer employees.[95]

The Singer Building represented the culmination of the efforts of Bourne, Alexander, and Flagg to validate the achievements of the Singer Sewing Machine Company, and it was a monument to the man who founded the company, Isaac Merritt Singer. Regrettably, this corporate icon, the tallest Beaux-Arts structure ever constructed, was demolished in 1967.

Chapter Five

Towers, Dragons
and the Stuff of Dreams

You lofty and dazzling towers, pinnacled, red as roses, burnish'd with gold!
Towers of fables immortal, fashion'd from mortal dreams![1]
— Walt Whitman (1819–1892)

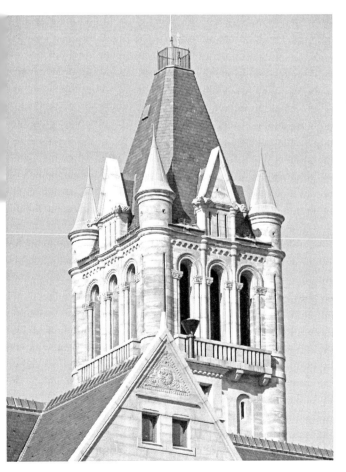

Romanticism found a strong foothold in American architecture during the Gilded Age, not as one single *style* of architecture, but as an attitude or an approach to viewing the past with architecture as its medium. Romanticism revealed itself in many ways, by many guises or forms, and, as a notion, it emerged in music, painting, sculpture, literature, poetry, and, too, in skyscraper

Milwaukee's 190-foot-tall Federal Building (Willoughby J. Edbrooke, 1899) remains a cheerless Gilded Age skyscraper. The granite tower's ominous presence and forlorn appearance were derived from the architecture of the medieval fortress; by the 19h century, and despite the fact that invading armies and dragons were no longer constant threats, the architectural forms continued to be employed. In castles, archers and slingers were shielded behind tall arched openings — as with this building — and would rain down arrows and all sorts of lethal projectiles upon the skulls of invaders (photograph by author).

153

design. Within the realm of architecture, the Romantic movement appeared as a revival of forms, motifs, designs, and decoration that *emotionally* recalled the past. Its motivation was to elicit the emotions, to indulge the senses, and to encourage one to dream or fanaticize about idyllic times, of places and events of centuries past. The architecture of Europe's Middle Ages sufficed well for costuming America's skyscrapers during the Gilded Age.

The Medieval Inspiration

Essential to 19th-century romanticism in architecture, in both Europe and America, was the recalling of the fictitious, the idealized, and the mythical. Architects worked from inspiration, from the images of castles, bell towers, battlements, chateaux, and cathedrals. Their *reality* did not matter and, in many cases, the fervor of romanticism *invented* forms — buildings and fragments — that *never* existed. Romanticism based upon architecture of the Middle Ages involved the process of invoking the imagination, recording myth in stone, and employing unbound sentimentality by the artist and architect.

During the Gilded Age, American architects designed in the styles of the neo-classical, Renaissance, and romantic style simultaneously. Where the other two architecture types were more concerned with the intellect — mathematics, ideal proportions, and the understanding of the world through empiricism and scientific observation — medieval romanticism originated from more visceral sources.

Romanticism based upon the Middle Ages grew from the "fear center" of human thought and experience; personal and public defense, punishment based upon spiritual and religious beliefs, and various cultural superstitions contributed to an architecture rooted in fear and the attainment of safety. Architecture of the Middle Ages was also rooted in tales of chivalry, handsome princes, beautiful damsels, heroic knights, and benevolent kings. Surely, it was these

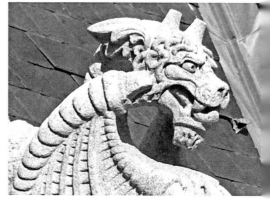

The firedrake, a product of the medieval mind, was employed on Milwaukee's Federal Building for architectural authenticity. The firedrake was a horrific creature that was thought to be able to fly, breathe fire at will, and according to some, sent "flames on the earth and left behind it a black trail of ruin and death." For the faithful of the Middle Ages, the firedrake's warning was clear: with the absence of piety one's well-being was sure to be fleeting. For Gilded Age office workers, these carvings served as sources of visual entertainment (photograph by author).

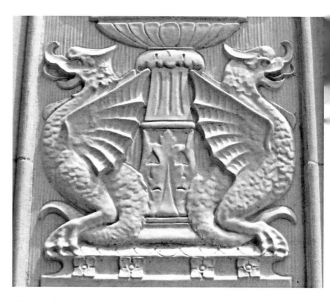

The much-feared fire-breathing firedrake of European folklore appears in this terra cotta panel. This carved image was produced by the Northwestern Terra Cotta Company of Chicago, and it appears at the entrance to a 30-story skyscraper there (photograph by author).

elements of lore that Gilded Age archi-
tects wanted associated with their sky-
scraper designs.

Some American romantics looked
to the Romanesque style for creativity.
Thousands of village and country
churches, larger abbey churches, and
monasteries were raised from the ninth
through the 12th centuries. These
Romanesque buildings drew artistic
inspiration from Roman, Byzantine,
Carolingian, Viking, and Celtic prece-
dence. The Romanesque style, often
characterized by massive stone ar-
cades, formidable walls, and Christian-
inspired decoration, communicated se-
curity and permanence. If this design
approach or style once pleased Charle-
magne and King Arthur, American
architects reasoned, it should certainly
please contemporary investors, indus-
trialists, and the public.

Other architects favored the appear-
ance of Gothic England and France
during the 12th through 16th centuries
and dressed their tall business buildings

Europeans of the Middle Ages believed the *basilisk* could
breathe fire, and its glance was thought to cause instant
death. The only method of its destruction was to set a mir-
ror in front of it so the basilisk would reflect its demonic
power back to itself, thus causing its own demise. This bit
of superstition is poised at the entrance to an early *Amer-
ican* skyscraper; strangely, the basilisk also "represented
kingly power which annihilates all who do not show it due."
It is impossible to know if the building's original owner
was aware of the bizarre symbolism (photograph by author).

in cloaks of carved stone, pointed arches, and towers sporting gargoyles. The Gothic-styled
solemnity soothed sinners and promised salvation, and if the Gothic style once pleased medieval
masses, architects reasoned, it should certainly please investors, industrialists, and the public.

The Pious Ones

On the pages of this chapter are depicted
the people of the European Middle Ages. Study
their faces. These carvings reminded some Amer-
icans of their origins. These faces, emerging from
the walls of 19th century American churches and
homes, spoke to the congregants and residents,

Above, left: This image from a Gothic Revival church may have been based upon the face of a contemporary
parishioner, but in reality this was the bust of a medieval person; this is a Gilded Age, limestone-carved
reminder of times long past. Turn-of-the-century parishioners passed by her image regularly, which rein-
forced the concept of viewing medieval artwork upon the walls of contemporary buildings — like sky-
scrapers (photograph by author). *Right:* The faces of medieval town or country folk were often drawn,
concerned, and melancholy. Purposeful yet careworn, these medieval-inspired faces peer from beneath
folds of cloth. Executed in red terra cotta, this man depicts a merchant, a theologian, a reclusive man of
books, or maybe a sorcerer. People like these existed seven centuries before the invention of the skyscraper,
yet their images remained potent enough to be included upon the façade of a building completed in 1899
(photograph by author).

and they gossiped about life during the 12th century. These time-traveling interlopers were the shopkeepers, the farmers, the friars, and the merchants. These were the craftsmen, the maidens, the rogues, the nobles, and all who once mingled in the same streets and purchased victuals at vendor carts. It was the faces of these that regularly greeted people at the church's front door, and it was these stone ancients who were gently jostled as others of their ilk, though more lively, assembled inside.

On Sunday mornings, both banker and architect passed through doorways flanked by stone ghosts. Some prayed in buildings that recalled the architecture of quaint English country churches. Others prayed in the cool, cavernous confines of cathedral-like spaces. Still others slept in. Each worshipper, each banker, and each architect was exposed to the images of people who last breathed some 40 generations earlier; the past was never far away. Stone walls alive with carvings of the great, the near great, and the common man were mingled with images of monsters, grotesques, and creatures known to inhabit the underworld. American churches, New World structures appropriated and cherished the forms and ways of the Old World. So, too, was it with the American skyscraper.

The medieval mind believed that the world was flat. Townsfolk were certain that dragons inhabited the forests of faraway places, and that great harm would come to those who ventured out at night. Myths, miasmas, and monsters, witches and warlocks, and things that went bump in the night were attributed to unchallengeable stories told by family elders. Folklore, not science, ruled the day.

Although decorating a church façade completed during the Gilded Age, here is the portrait of a common person who performed common roles in a culture dominated by the early Christian Church. This is the type of individual who feared firedrakes, demons, devils, witches, plagues, and perhaps most of all, the early Christian Church (photograph by author).

A sense of melancholy permeates each medieval-based face. Plague, famine, drought, and sin were of utmost concern to these folks. The horrors of Hell would befall anyone who disobeyed church doctrine; disease and a multitude of afflictions would be visited upon any unbeliever, any person deemed evil as judged by their peers. Wars, insurrections, taxes, and torture further eroded any sense of security for these souls. Although carved in the 19th century for a church executed in the romantic English Gothic style, one knew, even then, that these were the faces of the Middle Ages, that these were the people of *their times*, that these were the faces of the pious; those believed to be sinners would not have been so represented.

Architects borrowed and, indeed, slavishly copied the forms familiar to the nobleman, the friar, and the fair maiden for buildings dedicated to mammon. The banking, investment, and insurance industries looked to architects to produce for them tall buildings that communicated concepts of strength, permanence, and security. Architects mined the moun-

This androgynous figure, inspired from the sculptures of medieval Europe, conveys sadness with a modicum of hope. The implication was that if one did not lead a pious life, one could degrade into a grotesque creature such as this. Cruel medieval beliefs were sustained and made manifest on the façades of some Gilded Age skyscrapers (photograph by author).

tains of medieval designs to satiate those elected to pay for such structures, and so, many early skyscrapers resembled, at least in part, the churches, palaces, and castles that were part of *medieval* culture. During the Gilded Age, copies of these structures were appropriated by American culture too, adopted by enlightened minds that believed the world was round.

Not every architect subscribed to the idea that the architecture of medieval Europe was appropriate for America, the new and modern land of the free. Certainly not every critic thought so. Frank E. Wallis, architect and critic, described in 1910 some of the architects who interpreted and foolishly applied these earlier styles to American buildings as "half-trained, half-finished practitioners." He felt their interpretations were shallow, and the centuries-old motives that originally created these buildings were no longer valid. Furthering his viewpoint, Wallis exclaimed, "Students and traveling draftsmen brought home to America sketches of these buildings [medieval], and they were weakly reproduced on this side." The chastisement continued, albeit with some praise for one special "practitioner":

> The late H. H. Richardson, architect of Trinity Church in Boston, especially devoted himself to the interpretation of the Romanesque architecture, and did it brilliantly, though he paid the penalty as a specialist in having a horde of *incompetent imitators* [italics added] who did no honor to the ancient style. With them anything and everything became Romanesque provided it was clumsy, brutal, and built of brownstone.[2]

He said it: "incompetent imitators." He sounds as angry as Louis Sullivan, and maybe he was. But he was not alone. There were others who questioned the wisdom and, indeed, habit of including in stone the archaic values, *derived from the stuff of dreams*, upon the walls of the American skyscraper.

Scary Things

> The infliction of cruelty with good conscience is a delight to moralists. That is why they invented Hell.— Bertrand Russell (1872–1970)

Throughout France, England, Italy, Germany, and Spain, buildings were built for all the usual reasons that our species builds them; many structures, though, were designed and constructed with the underlying motive to educate the populace in the ways of the dogmatic and influential early Christian Church. During the European Middle Ages, religious buildings featured animated walls, both exteriors and interiors, that related Bible parables in stone and glass to the illiterate. Inherent in this artistic proselytizing process was the possibility that a vengeful God could, or would, wreak havoc upon the disbelievers, the unrepentant, the "unwashed and unholy." To maintain piety among the European masses, scary things were invented.

Romanesque and Gothic art and architecture could do that — reinforce piety — and, indeed, these disciplines were

This limestone-carved demon appears on the façade of a residential skyscraper in Chicago. The building was designed as late as 1928 by the firm of McNally & Quinn. Its pedigree is obvious (photograph by author).

Monkey-faced grotesques lean outward from their precarious perches. Medieval Europeans termed the monkey a mischievous and evil creature, a tempter of mankind. It can be surmised that these granite sculptures depict creatures that were certainly no friends of mankind, beasts from Hell whose only wish was to inflict pain and suffering upon the masses. That said, their presence here is more than curious (photograph by author).

employed as tools to that end. Medieval churches were signboards; their walls were advertising vehicles decorated with mythic monsters, grotesque semi-humans, and demonic-based creatures looking to exact punishment upon the sinful. The saints, angels, and the Holy Family also figured prominently and were no doubt included as a foil and to provide some modicum of comfort to the terror-stricken. It was generally known that for the unrepentant, these creatures would mercilessly hunt the hapless victim and consume the doomed individual — usually after dark. Salvation was promised but was not always attained. Hence, one might conclude that European Christians were destined to manifest an array of neuroses unlike any the world had yet witnessed, despite the plethora of bolted doors and windows. Safety was offered only inside, by plenty of church attendance and by prodigious amounts of prayer. Scary wall carvings were the ultimate warnings.

Along with their meager possessions, some European immigrants also brought fear to America through architecture, by the inclusion of centuries-old myths and monsters upon the walls of 19th- and 20th-century buildings. They did this, more or less unwittingly, and one could suppose under the academic belief of

Appearing upon the exterior of a prominent Chicago house completed in 1904 is this rendition of a demon, or perhaps the Devil himself (photograph by author).

"architectural correctness"; to be true to the medieval, one must include scary monsters on the walls of a building executed in the medieval style. In America there were uncountable examples of Christian churches, Roman Catholic *and* Protestant, decorated with the same types of imagery used to instruct and, in fact, scare the Hell out of earlier European Christians. Universities, colleges, public schools, and civic buildings were also participants in this organized appropriation of beastly figures.

Similar in motive to the mythologies of ancient Greece and Rome were the legends of merry old England. English myths and legends are replete with fantasy creatures and engaging stories of peasant life and the exploits of the nobility. These were didactic tales, stories meant to enlighten and deliver a sense of morality to the English populace, especially to those considered the unruly and wonton. They explained to English people, in easily digestible terms, what was good and what was bad to do, what and whom to beware of, and how to behave in order to be considered a pious individual.

English fantasies were effective. These stories were related from generation to generation with the all the vigor the storyteller could conjure up. Told after dark, these

Gilded Age businessmen, mid-level managers, and various entrepreneurs lived in residences that sported carvings like this. They were frightful creations that sprang from the pages of old English mythologies. One traditional saying from Cornwall goes like this: "From witches and wizards, and long-tailed buzzards, and creeping things that run along hedge bottoms, Good Lord deliver us" (photograph by author).

A fashionable house, completed in 1893, no doubt home to a well-heeled professional, was the recipient of this bit of limestone carving. Featured is a demon figure peering from forest overgrowth, an interloper from medieval England (photograph by author).

Emerging from his leafy lair is this goat-legged creature known as a satyr. Satyrs inhabited the countryside, were considered forest deities, and attended to the whims of Dionysos, the Greek god of wine. Associated with lust and pastoral drunkenness, the satyr's presence above the main entrance to Milwaukee's eight-story Caswell Building (Van Ryn & De Gelleke, 1907) may seem justifiably enigmatic to contemporary minds, a Chicago School structure with a few mythological remnants (photograph by author).

fables took on a more profound meaning. Animated tales of fairies, pixies, brownies, gnomes, elves, witches, and wizards were shared by candlelight. Giants, dragons, and a host of creepy creatures were included for good measure. Children often laid awake nights.

The cast of characters were inventive indeed. The origins of each of these fantasies and their respective beings were many; from village to village and throughout all of England, their meanings and sources often contradicted.

The English-invented "fairy" was derived from the Latin term *fata*, or the Fates. First interpreted by the English as "fay," the term eventually became "fairy" and its character and purpose drastically altered. Fairies were defined by some as being spirits of the dead; fairies were believed to reside below ground, to live deep below the dark forest floor. Other well-meaning storytellers insisted that fairies were the spirits of unbaptized children. Henry Bett, in his book *English Myths and Legends*, states that "the fairies are averse to religious symbols, or indeed to any mention of religion. They often disappear when the name of God is uttered. The fairies who are known as 'knockers' in the mines of Cornwall detest the sign of the cross. All fairies greatly dislike bells."[3] It is unknown how the issue of baptism, or more precisely the lack of it, was reconciled with the fact that fairies evidently despised Christian religious symbolism. Bett also states: "Another detail that links the belief in fairies with a prehistoric race of man is the primitive arithmetic of the elves. No fairy is recorded as being able to count beyond *five*."[4]

It was commonly believed that fairies would steal unattended babies from their cribs, and on some occasions they were known to leave a changeling in place of the newborn human. English parents were convinced that a changeling was an unwanted child fairy, a mischievous and malevolent infant with an "emaciated and wizened look." For the ultimate protection of a parent's child, a Holy Bible would often be placed in the baby's cradle.

If bankers, industrialists, and company owners were comfortable with various forest-based creatures adorning their homes, then why not employ them on the façades of the buildings in which they work? They did. A host of gnomes, imps, sprites, putti, and leprechauns played roles in residential architecture and upon the walls of skyscrapers; folkloric types like these greeted visitors at home *and* at work (photograph by author).

Pixies and brownies lacked the threatening aspect of the fairies and were simply felt to be an annoyance. More often they seemed to confound the English farm folk by messing with their fields, grain, animals, and farm tools. For the farmer's wife, each morning would bring a new discovery. Her flour, bread, butter, and cheese would be stolen, or her kitchen chairs and table disturbed.

By comparison everyone was aware that goblins and demons existed for no other reason but to inflict great harm on people through the magical powers they were said to possess. Goblins stood no more than three feet tall, were skinny, brown colored, and usually bald. They were grotesque creatures with twisted faces and pointy ears and teeth. Their only friends were the local witches whom they protected and for whom they carried out spells. Goblins were noted for being ferocious creatures, excessively mean and vindictive. Their avoidance, at all costs, was the proper approach for commoner and nobleman alike.

It was a fact known to country and village folk that witches and warlocks roamed the forests and fields in the dead of night. They were often in search of young maidens for the purpose of devouring them — after tenderizing them in a large copper pot. Of course a witch traveled via broomstick, wore a pointy cap, cast demonic spells on her enemies, and brewed magic potions while reciting such incantations as: "Double, double, toil and trouble; Fire burn,

A malevolent creature of the woods, executed in terra cotta, oversees the Chicago sidewalk in front of a commercial building of the early 20th century. This demon emerged only at night and scared the dickens out of children and adults alike (photograph by author).

and caldron bubble."[5] It is now known to country and village folk alike, that by the year 1700 an estimated 200,000 women were put to death in Europe for being witches.[6]

There are English folk tales of giants, some one-eyed, that would catch an unwitting man, slaughter him, and grind his bones to make bread. Another story describes one giant being especially fond of devouring young children.

Regarding the strolling dragons said to be found in the English countryside, there was no end to the tales of their capers. They were considered ill-omened, to say the least, for their power was perhaps the most destructive and immediate. Typically, English-derived dragons could level entire forests or villages with one snort of their fire-laden breath. These beasts were most often described as being green-colored, serpent-like, and covered with scales. Dragons had pointed wings, a mouth filled with fangs, horns on its spiky head (or heads), and a long whipping tail. And they were big. Most accounts "confirm" that they were larger than the average commoner's house. These creatures were fast, agile, and wholly destructive, having no redeeming value to human beings. Dragons were invented as something to be feared.

All these spooky things, all these strange creatures, and scary little people did not remain exclusively in sculptured form on the walls of European buildings. They traveled, rightly or wrongly, and they came to rest in stone upon the façades of the tallest of America's buildings.

The Great Migration

They attended colleges and universities, some with ivy-covered walls and significant populations of gargoyles. They attended churches, some with walls generously decorated with

animated "warnings." They lived in large homes, some guarded by gnomes, leprechauns, sprites, and the heads of farm animals. "They" were the wealthy, the industrialists, the tycoons, the bankers, and railroad men — the aristocrats of the Gilded Age.

And somehow, by some mysterious, mythical action, the sculptural elements of European fear and dread jumped — they migrated — onto the walls of America's new skyscrapers. Scary monsters leaped from the village churches, the great cathedrals, the college lecture halls, and the walls of city mansions onto the façades of America's tallest business buildings. What were once common sights to medieval eyes, now appeared in America, in modern, industrialized America.

One profound difference existed, and it had to do with *motive*. Some English churches were purported to house mystic religious relics, and, as such, their façades, although considered solemn, were arguably part theater. No American skyscraper boasted of having the clay from which Adam was fashioned. No American skyscraper ever housed a shriveled body part of any saint. No American skyscraper ever displayed the spear that pierced the side of Jesus, the noose of Judas, or a wood sliver of the True Cross. No American skyscraper was the destination of religious pilgrims. Despite these differences, traditional religious iconography appeared on the walls of America's secular buildings.

Business leaders and their architects were comforted by continuity; they were familiar with these sculpted forms of myth. The general consensus was that large corporations, housed in skyscrapers that resembled castles or chateaux, should have scary monsters, not only in positions of authority, but on the walls of their headquarters. Without this mythical zoo, the new tall buildings looked downright naked, and, besides, these dreaded creatures guaranteed architectural legitimacy. Dragons, serpents, crazy-looking birds, and the torsos of semi-humans appeared at once. Old World folklore made a comeback and, indeed, played an encore on the façades of the following 12 American skyscrapers.

Chicago's seven-story Oliver Building (Holabird & Roche, 1908) served originally as the headquarters of the Oliver Typewriter Company. This skyscraper is adorned by the cast iron busts of adult rams, ancient symbols of virility and creative energy (photograph by author).

This is the "Tower in Madison Square." New York architect Stanford White (1853–1906) selected the Giralda, a 15th-century bell tower adjacent to the Cathedral of Seville, for the model of this Manhattan structure. The extravagant skyscraper, completed in 1891, stood 16 floors, 304 feet above the sidewalk, ranking it New York's second-tallest building. The Madison Square Garden Tower, replete with romantic imagery and the inspiration of poets, was demolished in 1925 (author's collection).

The Tower in Madison Square

The builder taught the earth-bound clay
To soar to beauty, light, and power.
Why, builder, why, since Babel's day,
Must mortals love a tower?

Speak, Giotto's marble lily! Speak,
Fair Pisa's giddy, winding stair!
And thou, old, island-vistaed peak,
In Venice' pillard square!

Where Egypt's balmy relics lie
Of kings by death increased in pride,
The obelisk against the sky
Lifts up its scriptured side.

O'er barren crag and frozen shore,
On massy fortress, dark and strong,
Gray towers, above an iron door,
Adorn the ancient wrong.

Mysterious form! In many a land
Despots and priests thy charm employ.
Proud in the town where thou dost stand
A handmaid unto joy.

— Theodore C. Williams[7]

MORTIMER BUILDING, NEW YORK, 1885

From 1885 until its demise in 1920, the Mortimer Building stood on the southeast corner of New and Wall streets in lower Manhattan. It was positioned at the epicenter of the world's money markets, of international finance, banking, and commodity trading, and its many tenants hailed from those industries. The nine-story Mortimer Building replaced a four-story brick block by the same name, one which was constructed by a Mr. Richard Mortimer in 1835. And in a decidedly romantic act, the granite slab that spelled "Mortimer" was removed from the old and positioned upon the new building, just above its arched entrance; a desire for continuity and unbridled sentimentality justified this.

Businessman and executor of the Mortimer estate, W. Y. Mortimer, erected the building as an investment property according to the plans of New York architect George B. Post. The skyscraper's foundations were laid in June 1884, and, astonishingly, by March 1885, the building was completed. The exterior walls were of granite, terra cotta, and yellow brick imported from Milwaukee; it fronted 57 feet on Wall and 65 feet on New Street. Interior accommodations included two passenger elevators, steam heating, mahogany woodwork, marble trimmings, and inlaid tile floors. All stairways were of iron and stone, and its manager boasted: "The building is as thoroughly fireproof from top to bottom as possible."[8] Years after its completion, the Mortimer Building was further described:

> It is one of the landmarks of Wall Street and for over thirty years has been one of the best known office structures in that busy centre of the city. Although but nine stories high it was regarded, when erected in 1884 [*sic*], as one of the pioneers in tall buildings. The late George E. [*sic*] Post was the architect. It was well designed and well built and, despite its age of more than a quarter century, it is in excellent condition and has always been well rented.[9]

Architect Post employed the French Romanesque style to describe his Wall Street addition. The structure did not rise effortlessly; it was, instead, a striated mountain, vertically separated

New York's Mortimer Building was designed by the prolific architect George B. Post in a decidedly romantic style (*American Architect and Building News*, January 22, 1885).

into two-story tiers by four substantial band courses. A prominent arched entryway recalled the designs of medieval churches; here was a typical Romanesque opening but an atypical entrance path. A sinuous staircase enticed visitors in, up, and around, to the building's door. Entering the Mortimer became an adventure whereby one could wonder about dragons, fire-breathing salamanders, or a hydra or two lurking inside. This picturesque pile also included a family of caryatides that resided at the eighth-floor level, characteristic round-arch windows, a variety of pedimented windows, and a host of stone carvings. The intersection of a pyramidal roof and a mansard roof simply added to the exterior drama and reinforced the concepts of Romanticism and whimsy to the Mortimer Building's visual cacophony.

Chamber of Commerce Building, Cincinnati, 1888

Henry Hobson Richardson (1838–1886) would, on occasion, wear in his architectural office a dark-colored, hooded monk's robe complete with belt-ropes festooned with enormous tassels. His substantial beard, pumpkin-round face, and chubby fingertips would poke out from within the wrapped layers of cloth. His enormous frame (he stood well over six feet and weighed in excess of 300 pounds) and costume glided between drafting tables and architectural models, allowing him to supervise his staff of conventionally dressed underlings. He was photographed in the heavy garb and relished his image as a 12th-century friar, as an architect changeling.

Richardson was the man responsible for the design of Cincinnati's Chamber of Commerce Building of 1888. He was immersed in the past, the Romantic past of France, Spain, Germany, and the once-powerful Byzantine Empire. He was very well educated, having attended Harvard College in Cambridge, Massachusetts, and the École des Beaux-Arts in Paris. Richardson traveled extensively throughout Europe from 1859 to 1865, recording the great buildings of those storied lands, each valley village distinct from his native St. James Parish near New Orleans, Louisiana. The Brookline (Boston), Massachusetts-based architect was noted for his interpretive originality, design clarity, and enormous talent. The affable Richardson amassed

Cincinnati Chamber of Commerce Building, Cincinnati's castle of the sky (author's collection).

a prestigious portfolio of work, designs that included many public libraries, churches, office buildings, train stations, court house and municipal buildings, private homes, and college halls. He was considered a brilliant designer, and he won multiple design competitions, one of which, in 1885, was for a group of Cincinnati merchants.

The Cincinnati Chamber of Commerce commission demanded "a great and dignified hall of assemblage ... [one that] shall be combined with an 'office building'—that every possible foot of space shall be put to use in ways that are often quite at variance with the chief use of the building, and that as many such feet as possible shall be *secured by vertical extension*."[10] Translated: the merchants' organization of some 2,000 members requires a substantial amount of income-generating tenant space, space inside of a *skyscraper*. The structure's site measured 100 by 150 feet, and it was to rise entirely within those confines.

Richardson looked to the Romanesque churches, monasteries, and castles of Germany and France for design inspiration and ultimately produced a giant building, an assertive stone pile that soared eight floors, 188 feet above the streets of Cincinnati's central business district.[11] The Chamber of Commerce Building was officially dedicated and opened to the public on January 29, 1889, almost three years after Richardson's death.[12] A contemporary periodical described the new skyscraper in the following, albeit embellished, terms:

> Cincinnati ... has just completed one edifice that she need not be ashamed of—a structure whose massiveness, symmetry and architectural completeness are not surpassed, if equaled, *by any similar building on this continent.*[13]

The heart of the project, the "hall of assemblage," was located on the second floor; it measured a whopping 140 feet long by 68 feet wide; it rose 48 feet high—column free—and it was appropriately and lavishly decorated. Banking offices were located on the building's first floor, with retail shops and a restaurant. As an engineering *tour de force*, three office floors and an attic were suspended over the chamber's hall by a lattice of iron girders and beams.

The exterior of this modern castle was dazzling; the skyscraper was faced with pink Milford (New Hampshire) granite and topped by a giant hip roof, clad with red tiles. Its hundreds of windows could only reflect drabness, for this was an outstanding architectural and social landmark, a polychromed fortress, a visually energized bastion of commerce in central Cincinnati. The building mimicked the ideal, the picturesque Teutonic castle, and it enticed observers to imagine banners flying, to conceive of chivalrous acts of heroism, and to visualize "enemy pedestrians" suffering the slings and arrows of the chamber's defenders. Impenetrable rock walls, and round turrets and spires, conspired to entertain, to conjure up images of the 12th century in the minds of Cincinnatians, to seduce people into dreaming of benevolent nobility and of ladies-in-waiting. Here, Romanticism was made manifest; it could not have done less, nor achieved more.

Though the Cincinnati Chamber of Commerce was advertised as being "entirely fireproof," fate tragically intervened on the evening of January 10, 1911. A kitchen grease fire spread uncontrollably in its upper stories and quickly engulfed the entire structure. The skyscraper was burned beyond any attempt to rebuild it; only portions of its battered walls stood, and in true Romantic fashion its crumbled remains must have recalled the haunting paintings of ruined abbeys and the desolate forests of Casper David Friedrich (1774–1840), considered the most purely Romantic of German landscape painters.[14]

Northwestern Guaranty Loan Building, Minneapolis, 1890

Louis F. Menage (1850–1924) represented the worst aspect of the Gilded Age. He was a scoundrel, a fraud, and a thief during a period when commerce went virtually unregulated, and

too many corporate titans were devoid of ethics. He was the epitome of the "robber baron" persona, a man who practiced his crafty ways during this most raucous period in American business history. Menage was also the man responsible for the erection of the Northwestern Guaranty Loan Building.

A native of Rhode Island, Menage arrived in Minneapolis, where in 1874 he opened a real estate office. Within a few short years, he came to control a real estate and construction empire; Menage founded the Menage Realty Company, the Northwestern National Bank, and the Northwestern Guaranty Loan Company. His "empire" was based upon borrowed money, concocted profits, fraudulent mortgages, specious contracts, and phony paper. Menage was "successful" just long enough to see to the completion of his monument, the Northwestern Guaranty Loan Building, in 1890. By 1893, the Minneapolis real estate speculator, who spent $1 million dollars to erect the city's

Northwestern Guaranty Loan Building, Minneapolis's castle of the sky (author's collection).

tallest skyscraper, was in dire legal straits. Menage's empire collapsed into bankruptcy when investors, creditors, and the courts realized the numerous improprieties Manage orchestrated. Charged by a grand jury for embezzlement, Louis F. Menage made a hasty retreat for Guatemala, and in 1905, the Northwestern Guaranty Loan Building was sold to the Metropolitan Life Insurance Company of New York.

Like Menage, this skyscraper was all about façades. The Northwestern Guaranty Loan Build-

ing was a muscular pile of stone, a grandiose monument deceptively hiding a delicate, interior light court of iron and glass. Designed by Milwaukee architect Edward Townsend Mix (1831–1890), this Minneapolis pioneer stood 12 floors, 218 feet high. It was faced with New Hampshire green granite on its first three floors — some of these stones weighed as much as two tons — while the remaining walls were laid-up with red Lake Superior sandstone. It contained 400 offices, six metal-cage passenger elevators, and a plush rooftop restaurant.

This Minneapolis entry was indeed an extravagant Gilded Age skyscraper. Some critics found it pretentious, with architect Cass Gilbert calling its design "stupid and in bad taste."[15] The office building's design drew from Romanesque monasticism, but it explored an exterior of unrivaled plasticity; its exterior was abundantly modeled by chunky stones, leaping arches, and an almost crenellated roofline. It was a building on steroids, a brash and loud building that demanded attention — perhaps not unlike its builder. Its façades rippled like muscles under a tight shirt, and it featured two arched entrances, each measuring a whopping 15 feet wide by 22 feet high. Bracketing these entrances were stout round columns with deeply carved capitals that featured acanthus leaves, Celtic designs, and a host of foliate patterns. Drapery of carved stone, emblazoned with "Guaranty Loan Co." folded gently over rusticated blocks. At the roofline, a 40-foot-tall belvedere pushed skyward, adding a dynamic thrust at the skyscraper's corner. The building was, figuratively and literally, a downtown Minneapolis heavyweight — it weighed some 100,000 tons — and despite its longtime popularity, the Northwestern Guaranty Loan Building was erased from the cityscape in 1962.

The bust of a dozing king adds medieval-inspired comedy to the wall of the 14-story University Club of Chicago (Holabird & Roche, 1909) (photograph by author).

OWINGS BUILDING, CHICAGO, 1890

One day, a Mr. Francis P. Owings (1854–1910) of Chicago, Illinois, amassed all his money in one place. After counting his pile, Owings discovered he had not a penny more than ten dollars. This, he reckoned, was his seed money from which he would grow his empire. It was the

The dozing king's wife, a rather homely queen (photograph by author).

1880s, and he was in America, the land of opportunity. Even better, he was in *1880s Chicago*, a place of boundless possibilities, a place of energy, optimism, and of unbridled entrepreneurial spirit. Mr. Owings, a man of humble beginnings, a man who hailed from the small village of Alton, Illinois, was determined to succeed financially, and that he attempted in the 1890s.

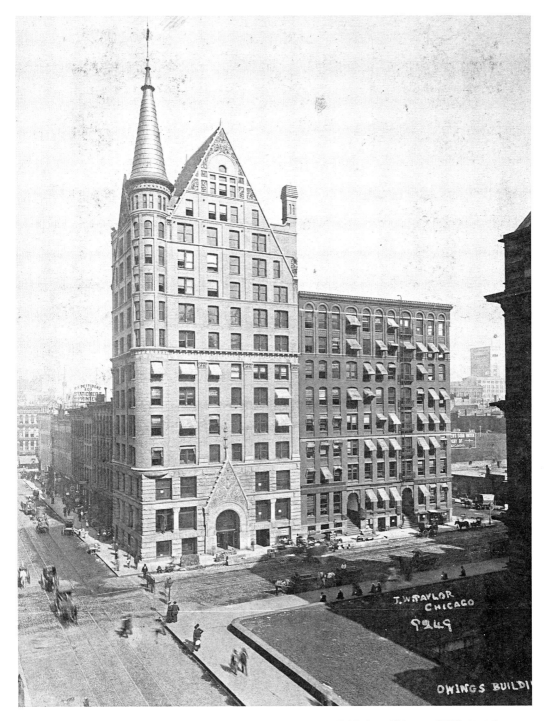

Chicago's Owings Building (Chicago History Museum, J.W. Taylor, Chicago, ICHi-52339).

With that ten dollars, Owings purchased an option to lease a parcel of land located on the southeast corner of Dearborn and Adams Streets in the heart of Chicago's booming financial district. With colorful New York investor and financier Hetty Green — known in certain circles as "The Witch of Wall Street" — and her loan to him for $150,000, Owings began to transform his recently leased parcel.[16]

Ownings announced that his site, measuring 50 by 73 feet, would be fully occupied by a

handsome skyscraper that was to cost the princely sum of $350,000. A design competition was held to select the most appropriate building. The competition winner was the Chicago-based firm of Cobb & Frost. Their entry included a decidedly romantic summit, a top with steep gables and a fanciful tower with conical cap. Chicago, indeed America, had seen nothing quite like it; although Europe had.

In proper Gilded Age fashion, this real-life Horatio Alger character named Chicago's newest skyscraper after himself. The Owings Building stood 14 floors, 216 feet above the sidewalk. It boasted three hydraulic-driven passenger elevators, a frame of cast iron columns and girders, first-floor retail shops, and 168 offices on its upper stories. The skyscraper rapidly filled with law and investment firms and local coal companies. Mr. Francis P. Owings, of Chicago, Illinois, made good on his last ten bucks, but only for a short while.

What *did* make Chicago's business and cultural world notice the new Owings Building

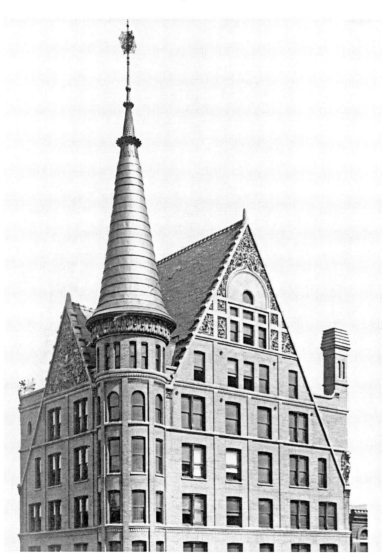

was not the number of offices it possessed, nor was it the skyscraper's elevator count. What distinguished this skyscraper from its nearby rivals was its design. Described by a Chicago newspaper in 1888, the Owings Building was to "suggest a Nuremberg castle and have a clock dial 12 feet in diameter."[17] The exterior clock never materialized, but the romantic allusion to a German castle certainly did. In describing the new skyscraper, a reporter for a local newspaper stated that the building "is considered one of the finest in the city from the standpoints of convenience, strength, and architectural beauty."[18] The reporter was obviously a romantic.

The designers of the Owings Building were Henry Ives Cobb and Charles Sumner Frost (1856–1931). Cobb, born in Brookline, Massachusetts, and Frost, a native of Lewiston, Maine, studied

Owings Building, detail of building top (Owings Building, Chicago Il, 1890. Henry Ives Cobb, architect. Historic Architecture and Landscape Image Collection, Ryerson & Burnham Archives, The Art Institute of Chicago. Digital File #19805 copyright The Art Institute of Chicago.)

architecture at the Massachusetts Institute of Technology. In 1888, they formed a partnership in Chicago that lasted ten years. It was they who were responsible for robbing history to pay the present. Cobb and Frost looked for inspiration in the designs of Romanesque palaces and fortifications of the Rhine River valley. Their client desired a castle, and a castle he got.

The Owings Building was a thin building with elegant proportions and delicate detailing. Thin stringcourses vertically divided the building cake-like, into eight layers. Its three-story base was composed of large rusticated stone blocks, while the remainder of the building was finished with brown brick and tan terra cotta. In one way, however, the Owings's brick type actually drew from ancient sources: "The brick used in this edifice were the first in the Western world to imitate in shape and color the brick used by the ancient Romans in the Eternal City."[19]

The skyscraper's upper stories were a Romanesque extravaganza. Gable ends were highly decorated with medieval-inspired foliate designs. A foursquare chimney stack poked upward, and as a warning to any intruders, oversize griffins precariously perched high on its walls. The *piece de resistance*, of course, was the glorious corner turret with a 50-foot-tall conical top and elaborate finial. Clad in shiny copper, it could be seen for miles, and its form really drove home the castle imagery desired. Those who harbored vivid imaginations knew that this was the home to Rapunzel and her long braids that would unite her with the handsome prince.[20] With an iconic tower such as this, almost any German fairy tale (Rumpelstiltskin also comes to mind) would suffice in fixing this element in the imaginations of children and adults; architecture worked to delight on many levels.

Owings, the self-made man and clever speculator, was eventually involved in a widely reported bankruptcy. By certain accounts, Owings secured his original lease from a "W. W. Strong and wife." While the skyscraper was only partially erected, Owings mortgaged the property a second time then watched as the tall structure was finally completed. The Strongs bought the mortgages in 1896, six years after its completion, and took the building right from under Owings's allegedly shifty hands. He lost his original capital of $10 and the building he sponsored. Owings did not live long enough to see his skyscraper demolished in 1940. With its demise, all those with vivid imaginations struggled to live happily ever after.

UNION TRUST BUILDING, NEW YORK, 1890

Once located on the greatest skyscraper corridor in New York, the "Avenue of Heroes," the Union Trust Building stood on the east side of lower Broadway, between Wall Street and Exchange Place. This location was in the heart of New York's financial district and just 20 feet west of the New York Stock Exchange, across New Street to the east. During its existence, this skyscraper was the home to the Union Trust Company of New York (founded in 1864) and to many stock brokerage and law firms.

New York architect George B. Post was responsible for the design of this 11-story, 196-foot-tall building. Although appearing as a solid block, the building concealed a central light court that measured 20 by 50 feet. Interior offices with operable windows faced the court and enjoyed abundant light and fresh air. A double-height banking room occupied the second floor and was topped by an iron and glass skylight; the structure's front façade honestly acknowledged the location. The Union Trust Building was clearly a tripartite skyscraper; its walls of light gray-colored granite were divided into an expressive base, a repetitive mid-section, and a decisive and flamboyant top.

Architect Post looked to the buildings of the French Romanesque period for part of his design. He looked to the heavy stonework, compound arches, and foliate designs from French monasteries, churches, and fortresses constructed during the tenth and 11th centuries. A castle at street level sweetens into a country chateau above. Here, ten stories up, Post seemed to have

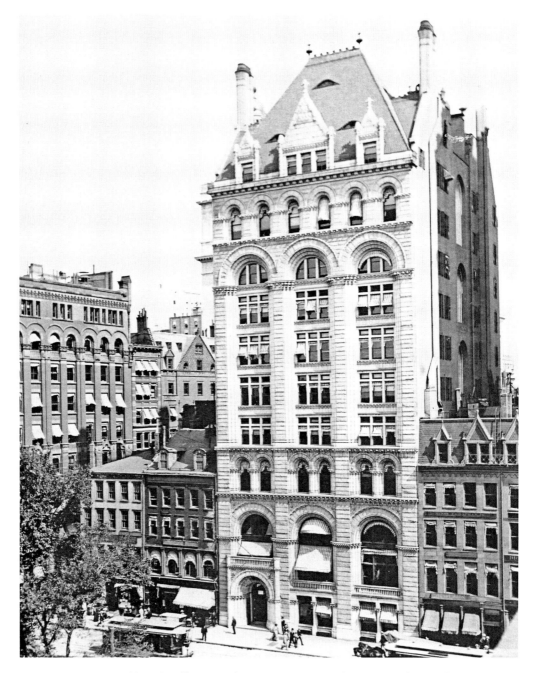

Union Trust Building (Toeffler, Tompkins Square, New York, 1891) (author's collection).

borrowed, with few changes, the architecture found at Fontainebleau, the home of Francis I. The pavilion of the Cour du Cheval, by Gilles le Breton (constructed 1528–1540), could very easily have been the model for the skyscraper's top. In all, the Union Trust Building was a carefully composed, elegant design that was praised at the time of its completion. For years afterward, the building was fully rented and served the bank well. Despite its success as an investment, financial pressures from competing real estate concerns demanded its removal from the scene. In 1929, the Union Trust Company Building of New York was wantonly demolished.

BETZ BUILDING, PHILADELPHIA, 1891

This Gilded Age behemoth was a verbose sentence in stone, and as a contemporary of Chicago's Monadnock Block, there could not have been a more dissimilar pair. Philadelphia's Betz Building was a Teutonic tower, a commercial castle, a 19th century dream building wrapped

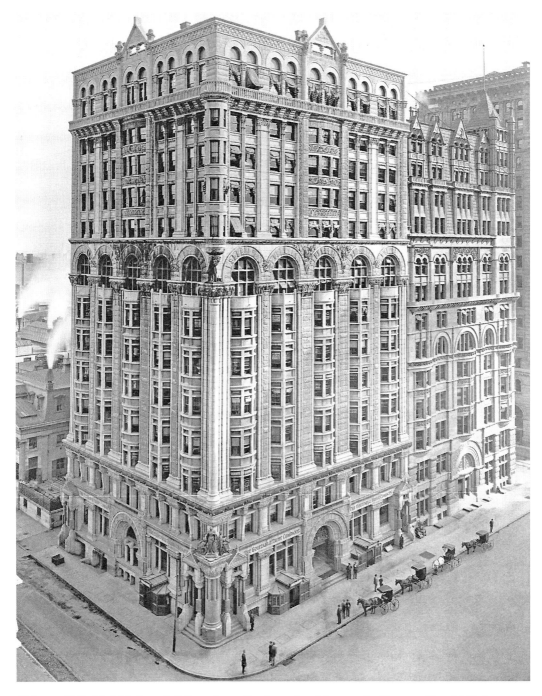

This was Philadelphia's Betz Building. Immediately to the right was the 13-story Girard Life Insurance Building (Addison Hutton, 1889) (Photograph Collection Prints & Photographs Division, Library of Congress, LC-D4-12942).

in ancient stories and medieval myths. This skyscraper was the vision of a poor immigrant who made good and who made a lot of money.

John F. Betz (1831–1908) was born in Germany, immigrated to America at an early age, and when he was 14 years old, became apprenticed in a New York brewery. Arriving in Philadelphia in 1867, Betz worked at a brewery that he would eventually purchase, enlarge, and develop into a fortune-making enterprise. He invested in Philadelphia real estate, became quite wealthy, and would come to construct one of that city's first skyscrapers.

A Philadelphia architect renowned for his designs of mansions and large institutional projects, William H. Decker (1856–1908) was selected to design the Betz Building, his largest and tallest commission. Decker, a noted Philadelphia architect, was born in Covington, Kentucky. He was educated in the public schools of Evansville, Indiana, and came to be apprenticed in the office of Indianapolis architect Joseph Curzon. At the age of 20, Decker moved to Philadelphia and worked as a draftsman. In 1880, William H. Decker opened his own architecture office in that city, where he practiced for the remainder of his life. He appears to have had no formal training, as in attending an American university's school of architecture, working in the atelier of a European master, or attending Paris's École des Beaux Arts. It is believed he never traveled to Europe to view the great architecture there firsthand. Despite what may be have been considered professional shortcomings then, Decker did manage to secure the commission to design one of the Gilded Age's most elaborate skyscrapers.

Rising on the corner of Broad and Chestnut Streets, the Betz Building stood 13 floors, 201 feet tall. Upon its completion, the Betz immediately ranked as a premier corporate tower that housed the offices of such noteworthy tenants as R. G. Dunn, the Equitable Trust Company, and the Lawyers' Club of Philadelphia.

The Betz Building's façades were, in today's vernacular, clearly over the top. They were a profuse amalgam of detailing that represented a type of medieval silliness; bay windows, flat windows, arches, columns, pilasters, pediments, masks and statuary compete for attention in a contest of excess. A carved bust of Betz also appeared on the façade, as well as large allegorical figures perched on the building's main corner at the second- and eighth-floor levels. Perhaps this was the epitome of the Gilded Age skyscraper, a building without bounds, a showy box wrapped in old European clothes. The Betz Brewery is no more, and neither is that immigrant boy's skyscraper. In 1926, and after standing only 35 years, the Betz Building was demolished.[21]

A. J. STONE BUILDING, CHICAGO, 1892

A scalawag and real estate investor named Albert J. Stone sought a location to erect a "neighborhood skyscraper," one far from Chicago's central business district. On that city's near west side, at the intersection of Ashland, Ogden, and West Madison Streets, he purchased a vacant triangular parcel ripe for development. It was a small plot of land by most standards, capable of holding only one skyscraper, one building with no back or front, one tall building visible from all directions. The site was surrounded by heavily traveled streets, thoroughfares plied by horse-drawn omnibuses and wagons, and, later, by electric street cars and horseless carriages. The immediate neighborhood was composed of stately homes, imposing churches, and tree-lined streets of brick; Germans, Scandinavians, and the Irish lived there. Albert J. Stone also lived there.

A shadowy figure, Stone's early life, education, and biographical profile are as murky as was the Chicago River. His professional life seems to have been plagued by a series of scandalous lawsuits; Stone's millionaire father-in-law, Amos J. Snell, was murdered by an unknown assassin, after which Stone mounted unsuccessful legal challenges to Snell's estate, and he was hounded by multiple creditors (prominent Chicago businessmen, banks, and railroad interests) from

whom he borrowed substantial amounts of money. Nonetheless, in February 1890, exactly two years after his father-in-law's murder, Stone shrewdly purchased the real estate he had eyed for his namesake skyscraper.

Chicago architect Alfred Smith (1841–1898) was commissioned by Stone to design a tall office building with the provision for a community bank to be located on its lower floors. Smith, a native of Toronto, Canada, was an acclaimed architect of private residences, apartment buildings, and many churches, most of which were constructed in Chicago. The A. J. Stone project would be his tallest endeavor.

On September 1, 1892, the ten-story A. J. Stone Building was pronounced completed and was opened to the public. A local newspaper spoke glowingly about the new skyscraper on Chicago's west side:

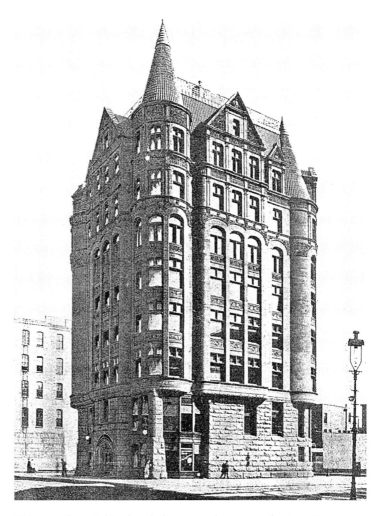

This was the neighborhood skyscraper known as the A. J. Stone Building (author's collection).

> The building is ten stories and basement, with a roof garden from which the visitors surveyed Chicago from gaslight in the evening. The building, rising like a tower among residences, commands one of the finest outlooks in the city, and the whole West Side was spread out below the spectators in magnificent panoramas, with the long lines of gas and electric lights outlining the streets for miles around. The Auditorium and the Masonic Temple rose like companion monuments on the lake shore, their lights twinkling back a welcome to the new building on the West Side.[22]

The same newspaper report further stated:

> Mr. A. J. Stone was at home to his friends in his new "A. J. Stone Building," ... yesterday, from 3 o'clock until 9. About 300 prominent business men and their wives and daughters called to inspect the new building and congratulate Mr. Stone on having changed a neglected triangle which had been an eye-sore to one of the most populous districts of the West Side into an ornament and monument of beauty.[23]

Then just a month later, on October 9, 1892, the *Chicago Daily Tribune* reported the following:

> The A. J. Stone Building ... is to be occupied as a World's Fair [World's Columbian Exposition of 1893] hotel. The building was erected as an office building, and is occupied as such on the first two

floors. The main floor is occupied by several real-estate firms and a safety deposit company, who will remain. The tenants on the second floor only hold leases to May 1, 1893, which will enable the entire building from the second floor up to be used for hotel purposes. The building contains between 100 and 300 rooms, and as a hotel will be known as "Chicago View." It is to be remodeled as an office building after the Fair.

A. J. Stone realized that a quick buck could be made with a temporary change in the building's operation. Times were tough in the office building rental market, especially away from Chicago's center, so some quick gamesmanship would place this building in the thick of incoming tourist dollars, thanks to the World's Fair.

This skyscraper proved to be a versatile investment, a chameleon of sorts, depending upon the financial climate of the times. It was monumental in size for its neighborhood, a visible landmark for visitors to the city. It stood 100 feet tall, was faced with brown granite and "chocolate pressed brick," and was designed in a "modification of the French Renaissance known as the flamboyant."[24] Whether it was French or German, or even Renaissance, was a matter open to interpretation. In essence, it was a "modification" of a centuries-old European architectural style and applied to an American office skyscraper.

The A. J. Stone Building was a romantic pile indeed, drawing inspiration from German Romanesque models. To many, the stone-faced office building — soon to be a hotel — was like a storybook castle. The skyscraper's two-story granite base clearly communicated a defensive posture; its thick, few-windowed walls were seemingly built as required protection against an onslaught of battering rams. The surrounding streets became as moats, while its cone-topped towers or turrets with conical spires harbored archers and fire throwers. Its very defensible main entrance was slipped underneath the weighty stones of a Roman arch. This skyscraper harkened from the world of German ecclesiastical buildings, those having been erected during the 11th century in the Rhine River region. Subtle borrowings originated with Trier Cathedral (1016–1047 CE) and Worms Cathedral (c.1110–1200 CE), two exemplars of German Romanesque architecture. Like these antecedents, the A. J. Stone Building offered a rugged roofline, a top punctuated by dormers, cone-topped towers jacketed with red tiles, and four-square chimney stacks. Circular and semi-circular stone towers, like those of the A. J. Stone Building, were common features in German Romanesque architecture, and they appeared here, too. Terra cotta decoration, only in the forms of various foliate patterns, was generously applied to the building's upper, smooth-faced stone walls.

After seven decades of service to the community, functioning as a bank headquarters, providing office space to numerous small firms, and being the home to a university of health sciences, the castle-like A. J. Stone Building was deemed obsolete. This lone tower, this neighborhood giant of the Gilded Age, was demolished in 1962, and with that, the old neighborhood of Germans, Scandinavians, and the Irish was forever altered.

Woman's Temple, Chicago, 1892

The Woman's Temple was a skyscraper built by people with a mission, in much the same way as churches of 10th-century Europe. The temple, designed upon medieval aesthetics, served as the headquarters for the Woman's Christian Temperance Movement (WCTM), a religious-based society founded in 1874 by Francis Willard (1839–1898). The nationwide organization, with over one million members and chapters in most cities, focused upon eliminating the production and consumption of alcohol, promoting women's rights and suffrage, and the cessation of family violence. Chicago's Woman's Temple served as the nexus for the institution, and it was described by a contemporary "as a sermon in mystic correspondences, its rounded corners expressing an attitude of Christian aggressiveness and its turrets thrusting heavenward to express

the aspirations of the woman's union." Along with "Christian aggressiveness," the movement extolled the virtues of temperance, purity, mercy, and justice.

The Woman's Temple was an aggressive building. It possessed powerful massing, forbidding and canted walls, deep reveals, and dormers, all of which were generously borrowed from the defensive architecture of the Romanesque period. Stout and masculine, the temple conveyed to the observer less about femininity than it did about armored pike men and soldiers with crossbows. It was an athletic composition, with arches stretching and leaping over wide openings and broad spaces, and rounded towers pushing outward from its torso. Its large blocks of granite communicated security, permanence, and impenetrability. Above its gray Maine granite base were nine stories of deep red brick and similarly colored terra cotta trim. A massive and very steep mansard roof, with two more floors tucked beneath, topped off the composition. It was the sky-

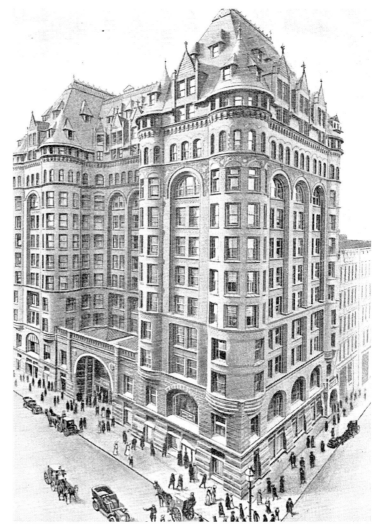

Chicago's Woman's Temple was ultimately a monument to futility (author's collection).

scraper's grandiose roof that suggested influences from the French Renaissance.

Chicago architect John Wellborn Root of the firm Burnham & Root drew the plans. He conceived of this skyscraper as a rather romantic pile, a building critics and historians variously rooted in Romanesque or early French Renaissance architecture; the royal chateaux of the Loire valley often came to mind, with the Chateau de Chenonceaux (1515–1523) overlooking the River Cher in central France, often cited as a potent point of departure. Nonetheless, the medieval architecture of Europe was again employed for an American 20th-century skyscraper.

The temple's cornerstone, a granite block weighing ten tons, was laid on November 1, 1890 (less than three months later, architect Root would die of pneumonia). The skyscraper's site, on the southwest corner of LaSalle and Monroe Streets in the heart of Chicago's financial corridor, measured 190 by 96 feet. It was a large project by most standards; the temple would stand 13 floors and 185 feet, contain 300 offices, and cost the princely sum of $1.5 million. Seven passenger elevators would transport some 15,000 persons daily. The temple was sponsored by, paid for, and partially occupied by the WCTM. By its completion in 1892, four large Chicago-based

banks and a host of insurance, law, and brokerage firms would occupy the remainder of the building. The temple was more than an income generator for the WCTM; it was a symbol, too:

> In the Temple designed for the Woman's Christian Temperance Union, the problem presented to the architect contained a motive of sentiment and aspiration, which demanded expression in a building chiefly commercial. The triumphant fulfillment of these two elements of the equation makes this structure perhaps the most beautiful building of its kind yet erected.[25]

Whether or not the building was beautiful is a matter of interpretation. The emphasis, declared here, was that the architect had to interpret into his design the qualities of "sentiment" and "aspiration." Sentimentality and romantic architecture are often inseparable, and with the Woman's Temple John Root employed romanticism without reserve:

> A great deal of sentiment was involved in the building of the "Woman's Temple" of Chicago — the W.C.T.U. building. It was a thing to which the organization could "point with pride" as a tangible and impressive proof that the Temperance Union was a body of consequence. It represented the plans and hopes of a number of leading members and was the joy and admiration of the rank and file.[26]

Again, "sentiment," "pride," and *hope* come to the fore. The Woman's Temple, a splendid skyscraper and a shrine to abstinence, was the ultimate symbolic statement that this organization could have produced. Planned atop the building, but never executed, was the utmost in symbolic references to the building's owner: a "fleche of gold bronze seventy feet in height surmounted by a beautiful form of a woman in the attitude of prayer."[27] The sculpture was further described as being a "beautiful form of a woman, with face upturned and hands outstretched to heaven in prayer" appealing to God to deliver America — the land of the "rum cursed" — from legalized liquor trafficking. The planned composition could not have been more emotive.

Of course, contributing to the overall romance of the Woman's Temple was its very design, its thousand-year-old architecture. The fortress aesthetic was not unique, but it was indeed inspiring to some. The Woman's Temple and the 22-story Masonic Temple (also by Root and about one-half mile away) were exact contemporaries. Though both were termed "temples," there was one significant difference: one was "dry," and the other would happily include alcohol-serving restaurants and bars. Such were the vagaries of Gilded Age Chicago. In 1933, seven years after the Woman's Temple was demolished, National Prohibition was repealed.

PRUDENTIAL BUILDING, NEWARK, 1892

Upon its completion in 1892, Newark's Prudential Building was billed as the "Largest Building in the State of New Jersey." The building served as the home office and headquarters of the insurance giant; that is, this was the first of four skyscrapers constructed there as a "corporate campus."[28] This visual powerhouse stood 11 floors, 150 feet above downtown Newark, and it was the brainchild of none other than New York architect George B. Post.

The Prudential Insurance Company was indeed a Gilded Age success story. It was founded in Newark in 1875 as "The Prudential Friendly Society," and within three decades it amassed enough cash and clout to erect the greatest collection of medieval skyscrapers owned by a single company anywhere in America. The "Main Building," stretching back a full block, was officially opened for business on December 3, 1892. It was a stone-clad behemoth whose design certainly adopted the castle concept. The main office block resembled the "great keep" of a castle, the innermost structure containing the nobles' living apartments, chapels, amour, and wealth. Resemblances to the Prudential Building's design can be found throughout Germany and include Eltz Castle (Rhineland, 1157), Schloss Hornberg (Baden-Wurttemberg, 1184), and perhaps most of all the Cochem Castle (Rhineland-Palatinate, 1190). Cochem Castle is of particular note as it

features a 150-foot-tall, foursquare "great keep" with a prominent hip roof. Four circular bartizans (fortified exterior rooms supplied with lookouts and loopholes for archers) anchor the keep's corners, and each is topped by a cone-shaped cap. Multiple dormers, emerging from within the stone-faced building's mass, complete the composition. With the Prudential Building, Post did not slavishly copy any specific German castle, but his inspiration was certainly derived from the German medieval.

Newark's Prudential Building featured foundation walls that were 14 feet thick, while above walls slimmed to five feet. These were composed of huge blocks of Indiana limestone and were articulated with compound arches and heavily carved spandrels. This romantic fortress, topped by multiple finials and much cresting, possessed interior work areas that were then considered the most modern available. The skyscraper's hundreds of tenants worked in a steel-frame building, and they were served by electric elevators, hot- and cold-running water, ample water closets for both sexes, telephones, and steam heat. After five decades as the home office, the Prudential Insurance Company decided that this extravagant skyscraper would be replaced with something more modern. In November of 1955,

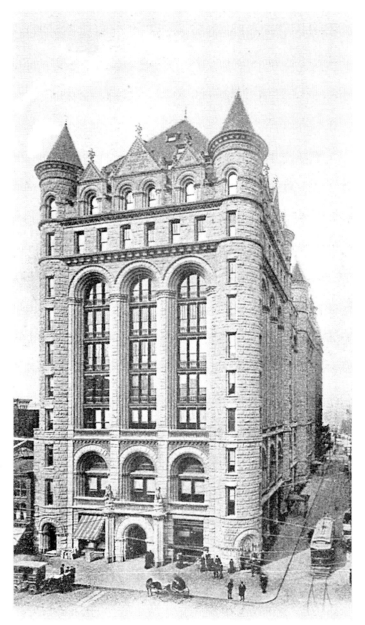

Newark's castle-like Prudential Building (author's collection).

demolition commenced on this medieval impostor, and soon after, *this* Prudential Building was completely erased from the scene. After 92 decades, Cochem Castle still delights.

FISHER BUILDING, CHICAGO, 1896

Chicago's still-standing Fisher Building, employing much exotic artistic license, is the epitome of architectural extravagance, but only of a unique yet reserved type. This skyscraper does not have a rooftop dome or cone, or oversized columns with gigantic garlands, or any naked women peering down on passersby. It does possess a façade design based, at least in part, upon the last name of its builder; the Fisher features walls replete with sea creatures romping, swim-

ming, and slithering all over a Gothic-inspired armature. There are the proverbial cherubs, but here their presence is purely obligatory.

The story of this strange and modern office skyscraper begins with its builder, Lucius George Fisher (1843–1916), the son of Lucius Sr. and a member of Chicago's illustrious Field family (as an aside, and recalling the influence of the ancients, the very name *Lucius* originated in ancient Greece). This colorful fellow was educated at Beloit College, participated in the Pike's Peak gold rush, and served the North during the Civil War. After military service, Fisher worked for a number of Chicago-based paper-manufacturing companies. In 1871, as a result of advancements and shrewd business dealings, Fisher became owner and president of the Union Bag and Paper Company. The magnitude of the corporation was described as follows:

> This company purchased all the business and good-will and patents of the leading bag manufacturers of the country. Its capital is $27,000,000. It owns large tracts of timber lands, eighteen paper mills, several wood pulp mills and makes about 20,000,000 bags a day.[29]

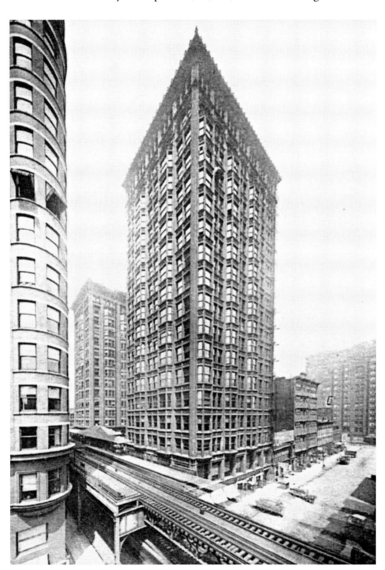

As early as 1886, Fisher invested in real estate, too. In 1892, Fisher, with a "syndicate of Chicago capitalists," leased a one-story building located on the northeast corner of Dearborn and Van Buren Streets. They agreed to a three-year term with an annual rental rate of $16,000. In less than two weeks, Fisher and the syndicate sublet that same property to others, also for three years, but at $25,000 per year. Their quick flip earned them a $9,000 annual profit. By 1894, this parcel would be Fisher's to own, and in place of the one-story structure would rise Fisher's whimsical skyscraper.[30]

D. H. Burnham & Company was chosen as architect, with Charles B. Atwood (1849–1896) as architect-in-charge. The contractor was none other than the famous skyscraper builder, the George A. Fuller Company.[31] Contemporary newspaper accounts prematurely praised the skyscraper's design:

The Fisher Building was a proud moment for the Chicago School—albeit with Gothic detailing (author's collection).

It will be one of the handsomest structures in the country, the contracts will be let soon, and the great work pushed uninterruptedly to completion. The buildings north of and adjoining the store proper are now being removed preparatory to operations.[32]

At the time of its completion it was rumored that, for inspiration, architect Atwood looked to the design of Rouen Cathedral, a 13th-century landmark in northern France.[33] That Cathedral was considered "a masterpiece of lacy stonework" that featured walls of glass divided only by thin columns with diminutive capitals. The abundance of glass lightened the visual weight and allowed ample sunlight into the sanctuary of the cathedral, while the structural bones of stone celebrated the advanced engineering of the period.

For the Fisher Building, Atwood also employed large expanses of glass and relatively thin structural bones — not of stone — but of steel wrapped with terra cotta to satisfy the advanced engineering of *its* period. Furthermore, Atwood also complied with the Chicago School's tenets on lightness, transparency, and the maturation of the curtain wall.[34] The noted architectural historian and critic Carl W. Condit (1914–1997) perhaps said it best when he described the Fisher Building's façades as "open and airy grace."[35]

Remarkably, the 18-story Fisher Building was completed after only nine months of construction. It stood 235 feet, and it boasted a complete steel frame, six steam-driven passenger elevators, and a full tenant roster. This skyscraper also housed the offices of the Union Bag and Paper Company, the corporation Fisher formed 25 years earlier, and the Wheeler, Fisher & Company, a subsidiary of Union Bag; by 1912, the Union Bag and Paper Company "controlled about 75 percent of the entire output [as sales] of such articles in the United States."[36]

Today, the walls of the Fisher Building still provide

A bony salamander and a sea monster, fashioned of orange terra cotta, stealthily creep down the wall of the Fisher Building. During the medieval ages, the salamander was seen as a creature to be feared as it was thought to breathe fire and spit hot embers. The sea monster was also to be avoided (photograph by author).

Visitors to the Fisher Building are introduced to the preposterous escapades of a jovial putto riding a sea monster (photograph by author).

pedestrians with a delightful undersea adventure. Visible in orange-speckled terra cotta are crabs, fish, shells, and fanciful sea creatures. Rounding out the façades are a variety of *fleurs-de-lis*, ogee arches, trefoil designs, crockets, shields, eagles, and clumps of Gothic-inspired foliage. Despite a nod to the Gothic, Atwood's response was creative and well within the realm of the Chicago School of architecture. Unlike other skyscrapers, where decoration was included because of its ancient meanings and mythologies, many of the Fisher Building's decorations were included simply as a lark.

Before he died in 1916, Lucius George Fisher earned tycoon status and lived with his wife and children in one of Chicago's most celebrated residences of the Gilded Age, the Nickerson Mansion (Burling & Whitehouse, 1883).[37] Built by the founder of the First National Bank of Chicago Samuel M. Nickerson (1830–1914) the "Marble Palace," as it was called, was purchased by Fisher in 1900 after Nickerson moved to New York. The house was described as an "opulent palace with alabaster, onyx, and twenty-seven varieties of marble" within. The Fishers maintained the home and contributed "a few stuffed animal heads and their collection of antique weapons" to the walls of their three-story, 24,000-square-foot "Palace."[38]

TRINITY BUILDING, NEW YORK, 1905

The English castle was the focus of medieval society and the townsfolk, farmers and peasants looked to this fortification for protection in time of war and social strife. The castle was constructed to provide security and it symbolized the power of the king and his nobles. The castle *was* the power.

Francis Hatch Kimball was a romantic. In 1894, he completed the design for New York's Trinity Building, which could have been a rather typical office skyscraper located on lower Broadway, but it was not. In the very best tradition of English Gothic architecture, Kimball included a castle-form in 1905, a still-powerful image, as the culmination of the building's vertical climb to the clouds. This little extravagance, more symbolic than functional, thrust the building beneath into the realm of the unusual, into the realm of fantasy, and into a world of knights and damsels. After a century, the Trinity's dreamy belvedere-topped tower remains one of the most delightful architectural elements anywhere in New York.

Gilded Age corporations enjoyed embracing historical styles for the buildings they would erect and inhabit. One favorite style was the Gothic, as it conjured up romantic notions of distant lands, medieval folklore, spirituality, scholasticism, fraternity, and most of all, continuity. Tradition, integrity, and a noble lineage, whether contrived or not, meant as much to the newly opened firm as it did to the more seasoned firms of Wall Street. A solid corporate image meant much, and one symbol of strength, of power, and of security was the *castle*. With the introduction of some Gothic ornamentation — with its overt Christian connotations — the result was a potent and proper product. Investors felt secure. The Wall Street crowd was satisfied; the imagery sufficed. It was in this milieu that architect Kimball was employed and in which he felt duty-bound to design the new skyscraper in harmony with the existing context. Immediately south of the Trinity Building stood the venerable Trinity Church (Richard Upjohn, 1846) and its historic graveyard. Certainly, Kimball was cognizant of the importance of this site.

The construction of the 25-story Trinity Building was undertaken by the United States Realty and Improvement Company, a corporation formed in 1901 through a series of consolidations. In tandem with the Trinity, this syndicate also had constructed the 21-story United States Realty Building (Francis Hatch Kimball, 1907) immediately to the north and across Thames Street.[39] The United States Realty Building was erected with one important difference: it possessed no belvedere tower, no castle imagery to seduce the public.

The Trinity Building is a thin, 308-foot-tall slab. Its footprint measures only 68 feet along

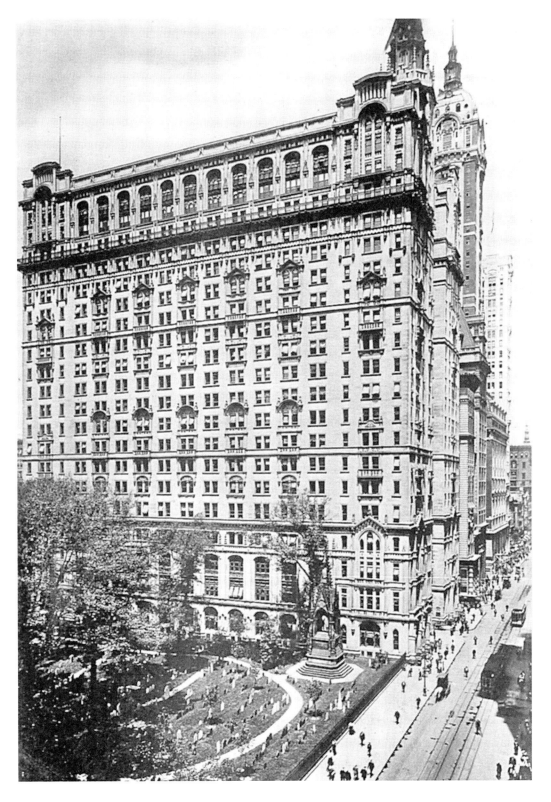

Trinity Building, front view (Irving Underhill, New York, photographer, 1913) (author's collection).

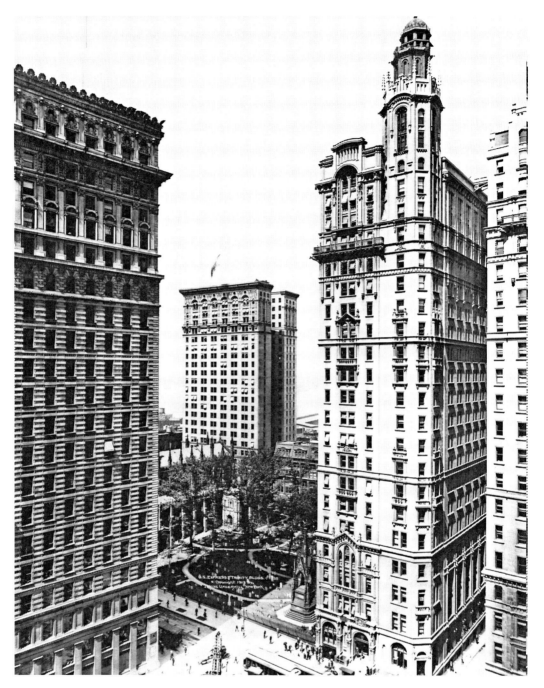

The Trinity Building's romantic tower. Appropriately, gargoyles still reside here (author's collection).

Broadway, and it stretches westward 260 feet to Trinity Place. The skyscraper rises sheer but is layered in appearance as if it were eight separate and distinct buildings piled one atop the other. Its south façade displays a rich tapestry of carefully placed parts and pieces, especially balustrades and window hoods, strictly governed by the locations of stone band courses. The building's base is of pink-colored Maine granite, while the remainder of the building is faced with Bedford (Indiana) limestone.

Above, right: This terra cotta creature occupies the corner of an 1899-completed collegiate building, not a skyscraper. Frightening inventions of medieval Europe were placed on the walls of ecclesiastical *and* scholastic buildings. Parishioners and students had to be kept from sin, and it was believed that the fear of a hellish retribution — taking the form of an attack by demonic creatures — would be sufficient. Constant reminders were thought to be effective (photograph by author). ***Left:*** Flying creatures, demons, and dragons were also affixed to American skyscrapers. This one, on a college science building completed in 1899, resembles those on New York's Trinity Building of 1905 (photograph by author).

It is from this skyscraper's northeast corner, at the 21st floor, that the whimsical tower and belvedere grow, indeed begin to separate from the building proper to become a freestanding tower. It emerges simply and effortlessly, appearing as a pure and quite natural appendage. The four-story, eight-sided tower telescopes twice, with the belvedere capped by a copper dome. Here, Gothic architecture is celebrated as nowhere else on the building; eight spiky pinnacles and blind openings masquerading as loopholes (thin wall slots from which archers could wreak havoc on invaders) appear on all sides. A menagerie of gargoyles and grotesques protect this fortress, and instead of viewing the rolling, dark emerald colored hills and glens of merry old England, these beasts glare down on the crowded streets and pitched rooftops of lower Manhattan.

Liberty Tower, New York, 1909

The 385-foot-tall Liberty Tower still stands in the heart of Manhattan's insurance district. It is located only four short blocks north of the New York Stock Exchange and just one block east of where the Singer and City Investing Buildings once stood. Its location was of primary importance to the bankers, lawyers, and stock brokers who once filled its 32 floors. This splendid Gilded Age tower is now occupied by condominium owners, some perhaps the descendants of those businessmen and women who made buildings like this the paragons of commerce.

Chicago-based architect Henry Ives Cobb designed this French Gothic-inspired skyscraper as speculative office space for a business consortium. This was a serious building and it meant business; it remains a respectful, even a quiet building, a well-behaved and proper tower. Absent are a plethora of sculptural groups, screaming monsters, carved angels, and a host of other Gothic-inspired architectural devices.

The Liberty Tower is simply a tall shaft of repetition, a rather commonplace terra cotta-clad pillar of 28 stories, with a splendid four-floor French Gothic palace plopped on top. Cobb's sentimental opus defines the building: the fanciful chateau, borrowed from the hillsides of the Loire Valley, provides a delightful silhouette on the Manhattan skyline. The rooftop chateau echoes the tower's dimensions at 58 by 82 feet, a size much smaller than many of the grand houses of similar style that once lined Fifth Avenue.

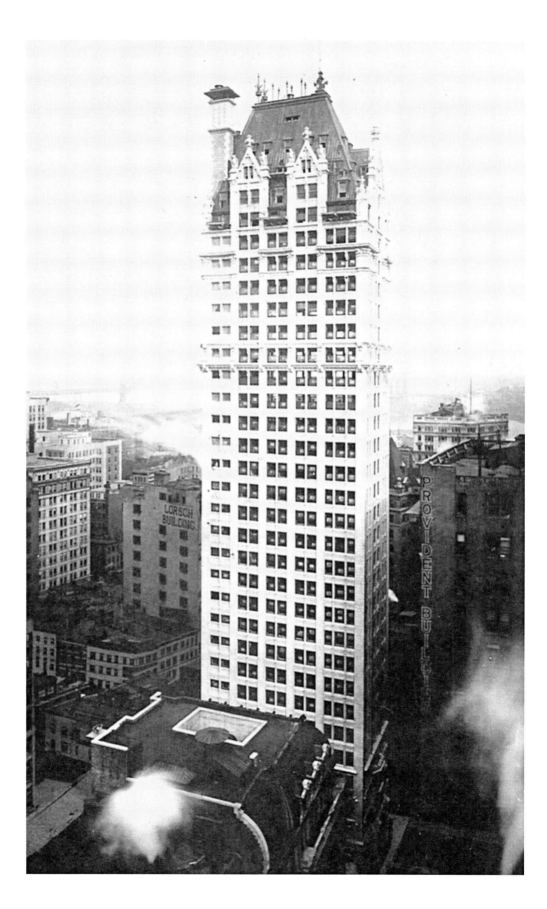

Still, during the eight-hour business day, those who worked in the penthouse offices of the Liberty Tower could pretend they, too, were nobility, that they were part of the French aristocracy ... if only for a short while. Tycoons and secretaries were served by five electric elevators that whisked them to their aerie, and there they labored beneath a giant and steeply pitched hip roof with intersecting gables. Multiple penthouses were shielded behind three-story-high dormers with large windows. Generous balconies provided inspiring views of the financial and insurance district, and if one was bold enough to brace against the railing and glance upward, the reward would be a breathtaking view of the tower's green copper roof, its castle-like windows, and a forest of iron finials at its very summit. Each dormer was topped by a giant poppyhead finial and flanked by perched American eagles, all executed in white terra cotta. No other chateau occupied such an improbable height.

The Liberty Tower remained in the hands of the original speculators who constructed it until 1919 when the Sinclair Oil Company purchased it for use as their headquarters. Sinclair remained there as the major tenant for 26 years. Throughout the numerous changes of ownership since then, no damage was inflicted upon the delicate exterior of this magnificent old skyscraper. The pinnacles, finials, and various Gothic-inspired doodads remain, as do the romantic musings of those who pass by.

Harking back to the times of castles and queens is this sculpture of an elegant noblewoman. It rests upon the wall adjacent to the main entrance of a residential skyscraper in Chicago, completed in 1908 (photograph by author).

Opposite: The Liberty Tower, standing 32 floors, remains a neo-Gothic landmark in lower Manhattan (author's collection).

Chapter Six

Eclectic Explorations

No person who is not a great sculptor or painter can be an architect. If he is not a sculptor or painter, he can only be a builder.[1]— John Ruskin (1819–1900)

Architecture, as an intellectual discipline, is occasionally presented with a situation in which a building's style defies easy classification. When this does occur, the subject building is termed "eclectic." Great importance is placed upon categorization in the *science* of architecture, upon a method of efficiently organizing structures into periods, types, and styles. Sometimes this works. But when an architect exercises a healthy dose of artistic license, his design ventures into the category of the eclectic.

Skyscrapers, too, periodically defy easy categorization and sometimes fall into the realm of eclecticism, and this chapter presents the most lucid examples. During the Gilded Age especially, the design inspiration for a skyscraper was occasionally drawn from multiple sources where no one singular cultural or historical source was employed for the tower's design. Certainly it can be argued that every Gilded Age skyscraper was the product of multiple, even conflicting, sources of architectural design on a small scale, but that alone does not place the subject building in the realm of being "eclectic." What does, however, identify an "eclectic skyscraper" is an overt attempt upon the part of the architect to intentionally celebrate diversity in his design to the point of total avoidance of a particular, or decidedly *singular*, "style."

Many of the earliest skyscrapers, those completed from 1850 to 1875, were eclectic in nature, aesthetically challenged structures that belied the struggle that architects encountered when confronting skyscraper design. One popular typology was the "block with tower." A more-or-less cubic "office box" was surmounted by a tall tower, an appendage situated either at the structure's corner, or at the mid-point of its principal façade. Often ill-proportioned and ungainly, these stone- or brick-faced towers were highly decorative and served as belfries with one or more clock faces. Too often, and to these buildings' detriment, the tower was at architectural odds with the building upon which it rested. These towers, occasionally visible for miles, also served as "memory cues," as popular identifiers for the corporations that constructed them; in this sense they functioned as potent urban objects and served the public in the truest sense of the term "landmark." Their nighttime illumination reinforced their presence in the community and their role in the life of the city.

During the years immediately following the events at Appomattox Courthouse, the sharing of ink and paper documents by two exhausted men and their softly-spoken promises to halt

Perhaps one of the most preposterous skyscrapers of the Gilded Age was Chicago's eight-story Indian Building (O. J. Pierce, 1889). The tower recalls the architecture of 12th-century temples found in India, Burma, Cambodia, and Thailand. More specifically, the Indian Building does more than hint of the exotic and historic; it suggests the central tower of Cambodia's Temple of Angkor Wat (Chicago History Museum, photographic print of Indian/Wells-Monroe Building, IChi-64856).

hostilities between Northern and Southern states, American commercial architecture sought expression in *height*, not purely for height's sake, but also for a multitude of other compelling reasons. Many of these new office towers were indeed eclectic manifestations of their well-trained, often European-educated, architects. And as discussed, these were amalgamations, structures of diversity, and confections of great height — some even described as exotic. The "hopes and dreams" of financiers, developers, real estate men, building contractors, subcontractors, and hundreds of trades and skilled craftsmen were welded into these developments. Indeed, the future well-being of sponsoring companies and their investors rested in the success of these new, tall buildings. Skyscraper proponents were keenly aware that *height*, not only the *aesthetics* of their investment, also drove the success of their real estate portfolios. And, some thought, eclecticism as a tool of potential profit was an appropriate means to an end and that their hopes and dreams would materialize.

American Heroes

The Gilded Age knew not of German-born architect Ludwig Mies van der Rohe. The Gilded Age was way before "less is more" (his dictum), and, in fact, this period was essentially about "more is more" or even "more is never enough." American bankers and financiers wanted building façades filled with decoration. Clients, too, wanted buildings covered with all manner of creatures big and small, real or imagined. Figured prominently were Greek and Roman heroes, ancient mythological creatures, and the elements and images based upon the folktales from the Rhine, Danube, and Loire river regions. Almost all skyscraper façades were, in some way or another, European derivatives.

But what of American heroes and the elements and images based upon the folktales from the Hudson, Missouri, and Mississippi river regions? Why did these not figure prominently upon the façades of *American* skyscrapers? Was it not true that architecture records a culture's beliefs and values? Were American beliefs and values in some way lacking? The answers: many reasons; sometimes; no.

By the time of the Gilded Age, America had a rich and utterly fascinating repertoire of heroes, folktales, and legends, mostly homegrown or reconstituted by former Europeans. And with the inclusion of those originating from dozens of Native American peoples, no architect or builder could claim a lack of *American* subject matter for decorative purposes. The possibilities were almost endless, and, as a new architectural form, the skyscraper demanded a new way of thinking and a new type of ornamentation, new demands that ultimately fell upon deaf ears. Some Gilded Age skyscrapers would morph into canvases of mythological figures and become the foci of

Adonis-like figures often appeared on building façades. According to Greek mythology, Adonis was a handsome young shepherd boy and the love of goddess Aphrodite. This terra cotta bust dates from 1890, and in the best tradition of the Gilded Age, this hero graces the façade of a prominent residence (photograph by author).

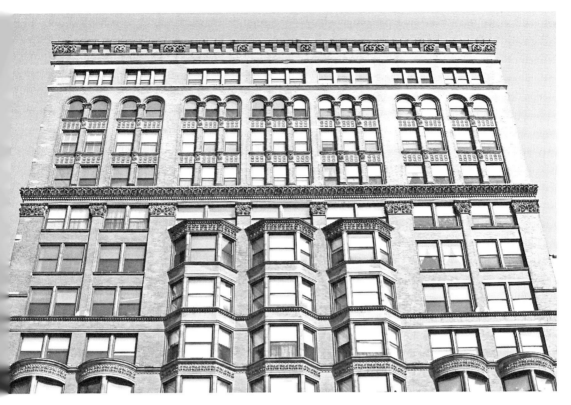

The façade of Chicago's 16-story, 200-foot-tall Manhattan Building (William Le Baron Jenney, 1891) is part castle, part aqueduct, part temple, and entirely muddled. The search for clarity in skyscraper design was elusive even during the Gilded Age (photograph by author).

William Le Baron Jenney (1832–1907) (*Harper's New Monthly Magazine*, Vol. LXXXV, November, 1892, "The Designers of the Fair," p. 874+).

"medieval folklore painters"; their walls were places where reality was dismissed in favor of the imagined.

It appeared that no architect explored the possibilities of having a bust of Daniel Boone, Benjamin Franklin, Meriwether Lewis, William Clark, Paul Revere, or Johnny Appleseed on any skyscraper wall. These people were historically documented folk heroes, they actually existed, and most importantly, they were immediately known by those living during the Gilded Age. These American heroes promoted goodness, humanity, and charity, and they never persecuted the innocent or the helpless. By this definition, Greek and Roman gods were no heroes.

In 1899, statues of Atlas, the Greek superman, were installed on the façade of New York's St. Paul Building. Three separate but similar poses were staged in a decided homage to the titan Atlas, but nowhere on the skyscraper was there a statue, bust, relief, or any image of the building's namesake, St. Paul. In lieu of any reference to the Early Christian apostle, pagan-based figures held sway. Though named after the neighboring St. Paul's Chapel,

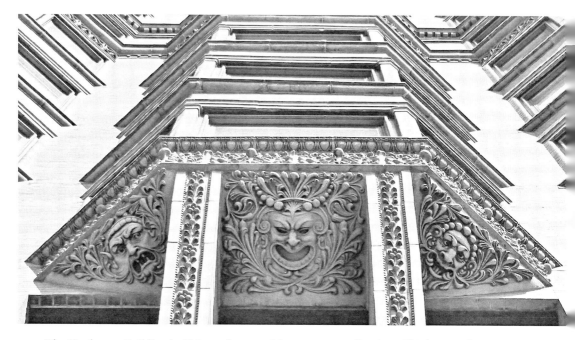

The Manhattan Building in Chicago features this terra cotta collection of frightening forest (photograph by author).

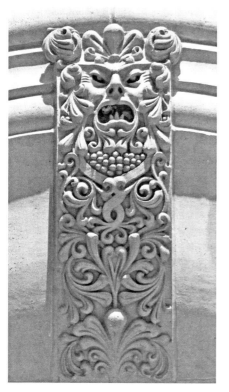

it is not unreasonable to have expected to see the martyred saint rather than that of a grimacing and somewhat disfigured product of Greek mythology ... times three.

Americans, too, had exaggerations, larger-than-life folk heroes. Paul Bunyan, Pecos Bill, and Rip Van Winkle were also gentle heroes, but only fictional ones. These, too, were culture stars to some during the Gilded Age, yet they appeared on no skyscraper façade. Minerva, Ceres, Atlas, and Mercury did. Leaf men, gnomes, dwarfs, leprechauns, and putti did, too.

Native Americans were rarely represented on the walls of the skyscrapers of the Gilded Age, although one building made reference to these "people of novelty." The Manhattan Life Building featured a bust of a Native American within a decorative spandrel located at its main entrance. This was done with reference to the island of "Manhatta" and the tribes, the Manhattoes, Lenape, and Canarsie that originally inhabited the famous island. After all, the Manhattan Life Insurance Company's name was derived from a Native American Indian place name.

What of Native American myth and folklore? Are leprechauns, pixies, gnomes, and goblins any more deserving

A tortured, devilish figure in orange terra cotta surprises on the façade of the Manhattan Building. It appears that architect William Le Baron Jenney enjoyed employing figures like these on the façades of his office buildings (photograph by author).

to be carved onto an American office building or to stand stoically in front of a pretentious house, than are Pukwudgies?[2]

The Wampanoag (pronounced WAMP-ah-nog) Nation is a Native American culture that originally lived in what are present-day Massachusetts, Rhode Island, Connecticut, and parts of New York's Long Island. It was believed that these hearty souls were those who met the Pilgrims as they put ashore at Plymouth Rock, and who, sometime in the 1620s, participated in the first Thanksgiving. Members of this tribe only number 2,300 (United States Census for the year 2000), but their centuries-old legends are still remembered. Today's Wampanoag tribal territories, especially those located in the Freetown-Fall River State Forest in Massachusetts, are said by the Wampanoag to be populated by Pukwudgies.

The Pukwudgies physical and temperamental description is eerily similar to other forest-based beings that appear in European folklore. It is believed that these, like their cousins across the ocean, emerged before recorded time. Yet, the comparative parallels are striking. Pukwudgies are reported to be from two to three feet tall. They have large pointy noses, fingers, and ears, are gray in color, and occasionally glow. They are covered in dark hair and are ugly as sin. And they are mean.

Pukwudgies are said to routinely attack and ruthlessly kill people. Walking alone in a darkened forest may invite such circumstances, as they are known to surprise their human prey. Much of their onslaught ability is based upon the Pukwudgies' capacity to appear and disappear at will.

They are said to be able to miraculously create fire, à la the English-based dragon. And like goblins and demons, Pukwudgies possess the dubious ability to control the souls of those they have slaughtered. They are adept at using magic, and, when not too perturbed, they will simply annoy or kidnap the unsuspecting.

These Pukwudgies were indeed monsters. No Gilded Age American skyscraper has the image of a Pukwudgie carved into its façade, nor should it have. The choice of which mythological creatures should appear, if any, seems not to have been capricious but drawn from European precedent and culture. The Wampanoag's Pukwudgie was no better or worse than the Englishman's goblin or demon. Goblins, fairies, sprites, gnomes, and other European-based beings appear, rightly or wrongly, countless times on countless buildings.

America boasted famous and accomplished authors, scientists, politicians, soldiers, inventors, explorers, and financiers. By the 1890s, the steamship, sewing machine, phonograph, bicycle, telegraph, telephone, light bulb, dynamo, steam locomotive, and the cash register were known.[3] These life-changing inventions did not appear on any skyscraper façade of the Gilded Age. Harps, lyres, wine jugs, urns, chariots, swords, and shields — everyday items of antiquity — did.

The American landscape was equally compelling to early settlers as that of both Greece and Italy were to its early settlers, and, in fact, America's real estate withheld vast secrets from the prying eyes of explorers until much later. Still, vast tracts remained unexplored and harbored strange, unidentified creatures swimming and lurking in the deepest regions of America's lakes and forests. What of these? Had the American bison, American eagle, moose, beaver, or grizzly bear no worth for architectural expression? Firedrakes, griffins, and dragons evidently did.

Arguably, America's greatest indigenous animal was the American bison. More commonly known as a "buffalo," the ancestors of the American bison (a word actually derived from the Greek) are believed to have emigrated from Siberia by means of an ancient land bridge or ice shelf that once connected the continents of North America and Asia. Having arrived in the Great Plains some 10,000 years earlier, the buffalo had a wide range, and eventually its popula-

Above: Medieval humor and horror can be found on the walls of the ten-story University Club of Chicago (Holabird & Roche, 1908). *Left:* This limestone carving can delight with a silly sleeping serf. *Middle:* An ominous sea monster carved onto a medieval-period wall was intended to frighten fishermen into prayer before any excursion onto a lake or river. Here, this deformity was intended as a small element of pure theater. *Right:* A forest creature with grisly talons crouches and watches on the façade (photographs by author).

tion numbered upwards of 100 million just before the advent of the Civil War. New arrivals, Europeans, were fascinated by the imposing beasts of America's Great Plains; there were no such animals in the vineyards of France, none in the glens of Scotland, and none roaming the canal banks of Venice.

The buffalo was a noble animal; it cut an imposing profile, it provided sustenance to native peoples, and, what was most important from an architectural and philosophical standpoint, the buffalo really existed. Here was a beast that one could feed, touch, photograph, and, indeed, kill as a trophy. No man or sorcerer dreamt this one up, no priests invented the buffalo or bestowed unto it magical powers of flight or of a special kinship with a cadre of gods, or imbued it with mystical powers over the daily lives of men and the doings and conditions of beasts, crops, or the weather. The buffalo never had dominion over the lights in the night's sky. But it existed.

The buffalo, as a powerful animal image of the New World, offered much to artists and architects of the Gilded Age, but only painters and sculptors explored the artistic possibilities available to herald the buffalo. No railroad whose tracks extended westward into the buffaloes' domain would dare honor that beast by having its image on a railroad's headquarters building: It was pointed out by the managements of Western railroads that enormous buffalo herds could delay a train for days out on the prairies. Rather than celebrate their existence as a noble American animal by including its image on a skyscraper façade, buffalo were considered a nuisance, and their extinction was mandated.[4] Bankers, insurance brokers, and speculative real estate men agreed: A buffalo bust was not as majestic as a lion bust.

It was not until 1929, with the completion of the New York Central Building (Warren & Wetmore), that the buffalo got its due. Buffalo heads, executed in terra cotta, were positioned on the façades of the 35-story headquarters of the New York Central Railroad, the engine of Cornelius Vanderbilt's fame and fortune.[5] Gilded Age skyscrapers featured no buffalo images on any façades; one could find no grizzly bear, beaver, or white-tailed deer busts or relief sculptures either. There were, though, countless dragons, firedrakes, griffins, and chimeras on skyscraper façades. Actual, real American animals were sacrificed; they were ignored in favor of beasts that were manufactured in the minds of the ancients.

Politics, aesthetic formulae, racism, sexism, and ethnocentrism explain much. Though any number of big and little beavers surrendered their pelts to John Jacob Astor's furriers, no beaver image ever emerged on any of New York's Astor-sponsored buildings. Various Vanderbilt family-erected buildings featured neither steamship nor locomotive, no passenger rail car, not even a caboose on any façade. No beer stein appeared on the Pabst Building, not one sewing machine on the Singer. Still, each was gratuitously covered with ornamentation, the results of selective and eclectic explorations.

Nine Gilded Age skyscrapers fall into the category of the truly eclectic. Certainly some of the other featured skyscrapers selected for this study could be classified as being at least partially eclectic, but these that follow seem to best fulfill the description. The Gilded Age was one not only of ostentation, but of variety.

> From the earliest times the old have rubbed it into the young that they are wiser than they, and before the young had discovered what nonsense this was they were old too, and it profited them to carry on the imposture.[6] — W. Somerset Maugham (1874–1965)

MUTUAL LIFE INSURANCE COMPANY BUILDING, BOSTON, 1875

In 1842, Alfred Pell, an individual with extensive insurance company background, and businessman Morris Robinson founded the Mutual Life Insurance Company of New York. Although chartered and headquartered in Manhattan, the company's success demanded a regional office building be constructed in Boston. The 1875 result, after two years of construction, was an extravagant office tower which stood seven floors, 234 feet above the intersection of Milk and Pearl Streets. A writer for a Boston newspaper echoed the city's pride:

> The general impression produced is one of imposing dignity and grandeur combined with exceeding grace, there being nothing finer in the city than the lofty and symmetrical central tower, showing up proudly high above all the neighboring structures.[7]

The Boston architecture firm of Peabody & Stearns was responsible for the design of the once-tallest building in all of New England, the country's second-tallest office building, ranking only after New York's Tribune (Richard Morris Hunt, 1875). Formulaic in massing, the "block with tower" structure's footprint measured 61 by 127 feet. The building rose 130 feet to the top of the main roof, with its clock tower climbing another 134 feet.

The Mutual Life Insurance Company Building was decked out with every type of period finery available. Drawing inspiration from France, its exterior walls were profuse with Renaissance arches, columns, pediments, and a host of carvings (reclining figures, eagles, garlands, animal masks, etc.). It was faced with white marble from the Tuckahoe (New York) quarry; this pure white stone was a prized material and here was masterfully spread like so much frosting on a cake. A two-story-tall mansard roof was punctured with ten lucarne windows, and it was further pierced with two Gothic-inspired dormers, complete with appropriate finials.

The building's strongest visual element was its clock tower. Centered on the Milk Street façade and facing Post Office Square, the tower was the neighborhood's focal point. In a larger sense, it visually commanded the financial district's public square, and it energized the space as a cathedral's spire did in a medieval town; in an ecclesiastic and ancient sense, the tower was this skyscraper's *axis mundi*, the vertical thread that connected heaven and earth. Architecturally, the tall tower was an amalgam of Renaissance, Gothic, and Romanesque elements fused upon an ungainly armature. Delighted Bostonians and their visitors could ascend to the observatory near the top of the spire for an unobstructed view of their crusty city and harbor. The Mutual Life Insurance Company Building, this Gilded Age confection and monument to America's early insurance industry, was swept away in 1922.

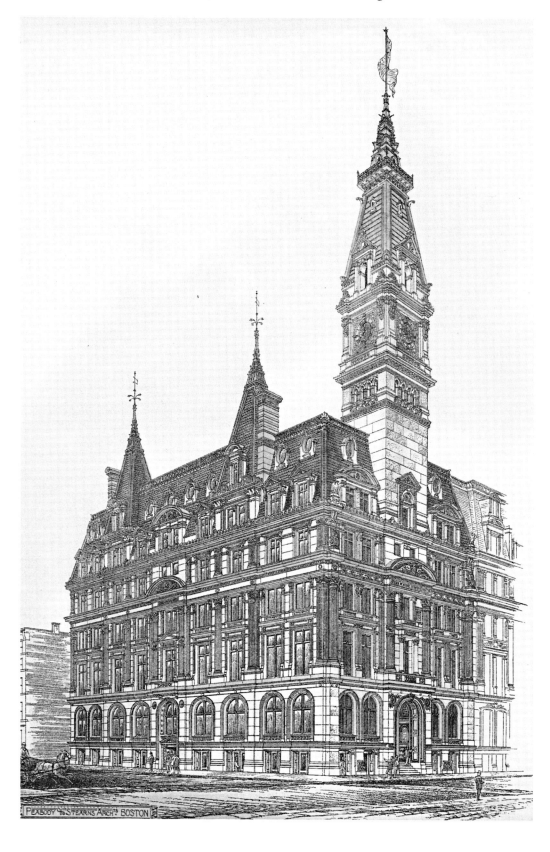

NEW YORK TRIBUNE BUILDING,
NEW YORK, 1875

One man responsible for creating extravagant symbols of success was Richard Morris Hunt. Hunt was an architect extraordinaire, the "dean of American architecture." He was born in Brattleboro, Vermont, and for one year (1846) he studied architecture at the École des Beaux-Arts. Settling in New York, Hunt established a successful practice and quickly became a favorite of the Manhattan aristocracy. His repertoire included numerous mansions, hospitals, churches, office buildings, and even the stone-faced pedestal for the Statue of Liberty (1886). One of his tallest designs was also a record-holder, the tallest skyscraper anywhere, an office building and the headquarters for the *New York Tribune*.

Nothing quite like it had been seen before. A daily newspaper, the *New York Tribune*, erected a building nine stories tall, one that climbed 260 feet above the sidewalks of lower Manhattan. The eclectic New York Tribune Building was opened to the public on April 10, 1875. The skyscraper boasted of French and Italian lineage, spiced with imagery of Lombardic towers of the 12th century. Its exterior was composed of dark red, white, and black brick. Cream-colored granite trim whipped the walls into a kaleidoscope of color, while arches, dormers, giant corbels, brick piers, and spandrels collided into a frenetic whole. This was no whispering giant, further evidenced by its off-center

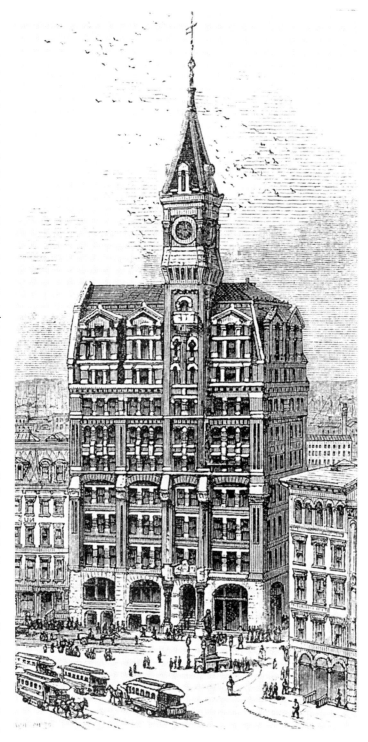

The Tribune Building was once the talk of the town (author's collection).

Opposite: Boston's Mutual Life Building, a typical skyscraper of the block-and-tower type (*American Architect and Building News*, March 9, 1878).

The Tribune Building, after its upward extension (author's collection).

clock tower, a derivation of a Florentine campanile, complete with charging gargoyles and pointy cap. The tower, emerging from the office block, featured a clock face on each of its sides; the faces measured 12 feet in diameter, and each counted the hours in *Roman* numerals. The New York Tribune Building was demolished in 1966.

ELWOOD BUILDING, ROCHESTER, 1879

Rochester's seven-story Elwood Building was noted for its many gargoyles (*American Architect and Building News*, August 12, 1882).

Dr. Frank Worcester El-
wood (1850–1899) was an
accomplished instructor in the
Harvard Medical School, the
same institution from which he
graduated in 1874. Elwood was
chief medical officer in the
Boston office of the Employers'
Liability Association of Lon-
don, England, and a member
of the Massachusetts Medical
Society and other professional
organizations. It was he who
had the Elwood Memorial
Building (as it was sometimes
called) built in Rochester, New
York, in remembrance of his
father, Isaac R. Elwood (1800–
1863), a Rochester alderman

Gargoyles like this were perched around the top of the Elwood Build-
ing. This example dates from 1899 and was located on the corner of
a college *science* building. Academic science, at least with its archi-
tecture, took a back seat to mythology and the fears of medieval
Europe. Corporate office towers set the pace (photograph by author).

and Western Union Telegraph Company executive. Rochester architect James G. Cutler (1843–
1927) was responsible for the eclectic design of this speculative office building. Not only did
Cutler play the role of successful architect, he also acted as inventor, businessman, and politician,
serving as the mayor of Rochester, New York from 1904 to 1907.[8]

The stone-faced Elwood Building was yet another example of a block-with-tower sky-
scraper. The building stood seven floors; its decorative clock tower elevated the structure to
some 175 feet above the street. Elements of the French Second Empire style predominated, with
a seventh-floor mansard roof and decorative Renaissance-inspired masks carved at the first- and
seventh-floor levels. Adding a French Gothic element to the mix were the inclusion of 16 gar-
goyles, one pronounced iron finial atop each of six dormers, and one elongated tower complete
with an attenuated pyramidal cap, topped with a medieval-styled finial. Gothic-inspired floral
carvings were generously placed upon the Elwood Building's exterior, which added a delightful,
almost whimsical, element to an otherwise serious business building. The wrecker's ball removed
this early skyscraper in 1967.

BALTIMORE & OHIO BUILDING, BALTIMORE, 1880

Baltimore architect Ephraim Francis Baldwin (1837–1916) knew that the mansard roof con-
veyed elegance and sophistication; he knew that it was the latest Paris fashion and that almost
every American client wanted one. The owners of the prosperous Baltimore & Ohio Railroad
Company, not wanting to be left behind, wished for that which was considered cutting-edge
design — a mansard roof — and Baldwin complied. The year 1880 marked the completion of the
railroad's headquarters building in Baltimore. This skyscraper, finished with a whimsical clock
tower, was a visual delight that promised musings of faraway places and times long past.

Baldwin, a native of Troy, New York, studied architecture and engineering at the Rensselaer
Polytechnic Institute. A conservative designer whose principal focus was church architecture,
Baldwin produced many designs in all "acceptable" ecclesiastical styles. He drew the plans for
office buildings, public halls, and hotels but was best remembered as the "official architect" (and
one of the company directors) for the Baltimore & Ohio Railroad Company.

Baldwin's eclectic scheme consisted of a seven-story, 150-foot-tall building to be served by

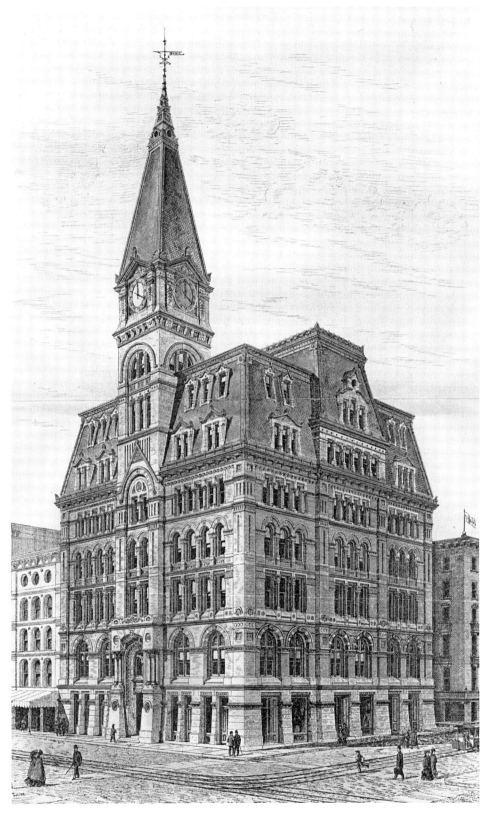

The eclectic Baltimore & Ohio Building was one of the first skyscrapers in Baltimore (*American Architect and Building News*, August 14, 1880).

two elevators and faced with Baltimore pressed brick, granite, Cheat River stone, and terra cotta. Architecturally, this was where the medieval meets the mansardic, where an English Gothic office block was topped by a colossal Paris-inspired mansard roof and a clock tower with a steeply pitched pyramidal roof. Details included battered castle-like granite walls for the first floor, Gothic-styled window openings, and a pedimented clock done in the best of the Renaissance tradition, one that included acanthus leaf acroteria. Windows were of the "best plate glass," and those of the second floor had upper sashes of "beautiful stained glass." Polished granite columns marked the skyscraper's main entrance, while the exterior walls were embellished with "rosettes and figures of railroad designs."[9] The Baltimore & Ohio Building was one of over 1,500 buildings that perished in the 1904 fire that swept through downtown Baltimore.

WASHINGTON BUILDING, NEW YORK, 1884

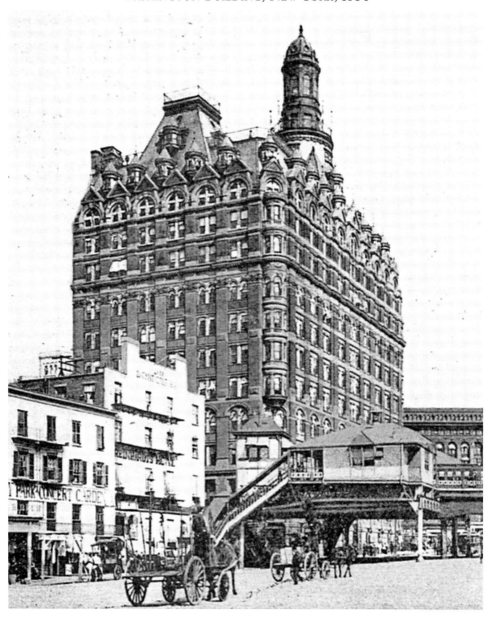

When completed in 1884, the Washington Building was New York's second-tallest skyscraper, standing 13 floors, 258 feet on lower Broadway. This still-standing landmark, overlooking Battery Park and the tip of Manhattan, was the product of two men, Cyrus West Field and Edward H. Kendall. Cyrus West Field (1819–1892), a native of Stockbridge, Massachusetts,

moved to New York at the age of 15. After humble beginnings, Field prospered from various business investments, and by the age of 33 this financier was worth in excess of $250,000. Although a successful venture capitalist, Field's fame was principally derived from his 1866 oceanic exploits as he was the first to successfully lay transatlantic communication cables between Europe and America. Consequently, he headed the Atlantic Telegraph Company and became yet another Gilded Age rags-to-riches story. Edward H. Kendall (1842–1901) was a Boston-born architect, from whose office sprang the delightful façades of the Washington Building. Kendall studied architecture at the École des Beaux-Arts and later secured a position with noted Bostonian architect Gridley Bryant (1816–1899). Kendall eventually gravitated to New York and found employment in the office of Arthur D. Gilman (1821–1882). During Kendall's professional career, he designed an array of office buildings, hotels, and several Fifth Avenue mansions. The Washington Building and the Equitable Life Assurance

Cyrus West Field (1819–1892) (author's collection).

Building (with Gilman and Post, 1870) are considered his most important commissions.

The Washington Building was a spirited composition executed in red-colored brick and terra cotta. Kendall designed it in an English style, complete with a French-derived mansard roof sporting 43 gable windows. Exterior walls were a lively mix of detailing: arched and flat-topped openings, oriels, pilasters, capitols, garlands, dentils, and a wide selection of foliate carvings. All of these architectural contrivances were overwhelmed by the sheer mass of the structure; actually C-shaped in plan, the Washington feigned a broad-based box of offices.

The singular element that decisively placed the Washington Building in the realm of the romantic was the iron-clad "lighthouse" perched atop.[10] Certainly the building could have been considered complete without this observation tower, but in true Gilded Age fashion, it was included, at least in part, as a decorative bauble. A drum base supported the eight-sided tower; openings were glazed, and at the very top rested a Renaissance-inspired dome, complete with eight lucarne windows. An outside observation platform that ringed the tower afforded visitors unparalleled views in and the possibility of hearing the songs of the sirens. Here rested New York's version of Alexandria's lighthouse.

HALE BUILDING, PHILADELPHIA, 1890

Upon its completion, derision from the official architectural establishment was heaped upon Philadelphia's Hale Building. Completed in 1890, the Hale was the distorted dream of Philadelphia architect Willis G. Hale (1848–1907) and represented the employ, indeed the

Opposite: **The Washington Building before its romantic exterior was erased decades ago (author's collection).**

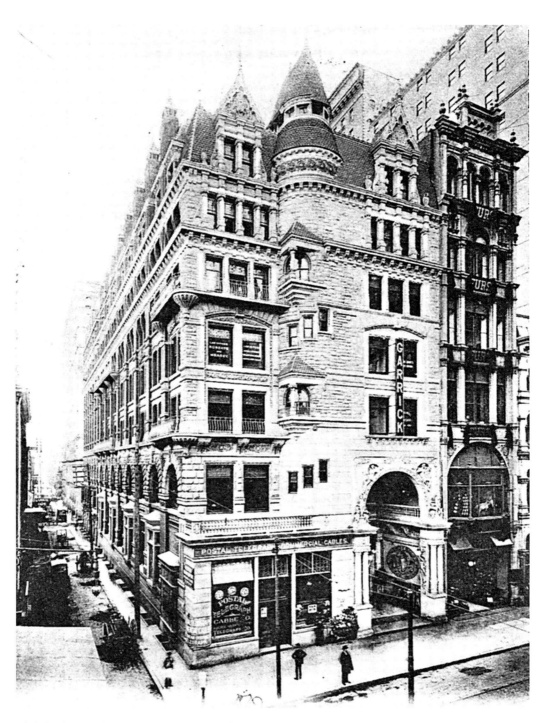

Philadelphia's Hale Building ranks as one of the most puzzling of all skyscrapers (*The Cosmopolitan*, Vol. XI, No. 1, May 1891–October 1891, "The New Philadelphia," The Cosmopolitan Publishing Company, New York, p. 46).

immersion, of total artistic license by one very courageous architect. Was this seven-story office building meant to house accountants and lawyers? Was this the home to elves, urchins, and imps? Would one hear the wails of clients receiving attorney invoices, or would one detect the giggles and hoots of leprechauns as they peered from their mountain-like hideaways, their private outcroppings in the craggy tower? The answer was a Gilded Age toss-up.

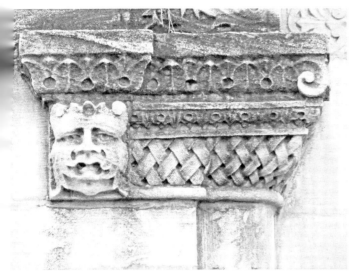

Above, left: As from a medieval castle, this sculpture echoes the values of English romantic imagery during the Gilded Age (photograph by author). *Right:* As unusual as the Hale Building was, so too was some of the building sculpture during the Gilded Age. Much was based upon the tales and mythology of merry old England, like this stone-carved example, also completed in 1890 for an apartment tower in Chicago. This artwork was based upon any number of "Grisly Worm" legends like those of the Lambton Worm or the Sockburne Worm. Legend says coiled worms with grotesque but human-like faces inhabited the streams and forests of the English countryside (photograph by author).

Willis Gaylord Hale (1848–1907) was responsible for the controversial design of the Hale Building, the structure he owned and that which housed his regional architecture practice. He was born in Seneca Falls, New York, was schooled at the Academy of Seneca Falls, Lake Cayuga Academy in Aurora, New York, and graduated from Auburn High School in that city. He studied architecture as an apprentice in a number of firms headquartered in Buffalo, New York. Eventually he found his way to Philadelphia, where he apprenticed in the offices of Samuel Sloan and John McArthur, Jr., both celebrated practitioners. In 1872, Hale temporarily relocated to Wilkes-Barre, Pennsylvania, where he began his own architecture practice, but by 1876 returned to Philadelphia, where he continued his practice until his death. Throughout his career, Hale is credited with designing over a hundred buildings.

The Hale Building was his most extravagant office structure; a few of his private homes were equally extreme. His namesake office building stood seven floors and was faced with Indiana limestone, brick, and terra cotta. For the Hale Building, elements of German and French castles and fortresses nestled in the Rhine Valley may have been this architect's design inspiration. Baroque church architecture of Italy might also have contributed to the skyscraper's grandiose entrance and ridiculous corner tower. Romanesque-style masonry walls topped by pointy rooftop caps recalled the architecture of medieval Spain and appeared boldly in this whimsical composition. Featured were a second-story arcade, double-height pilasters, multiple band courses, columns, much intricately carved foliate patterns, heavily carved dormers, Roman arches, segmental arches, porches, and bay windows. Classically inspired columns and reclining figures — à la Michelangelo — greeted visitors but were aesthetically at odds with the remainder of the building. The variety of architectural elements on the Hale's façades alluded to the concept of an architectural zoo. Gilded Age propriety was assaulted by this eclectic exploration into the absurd.

As already stated, the Hale Building was met with many negative reviews. One particularly

scathing opinion was credited to the indomitable (but accurate), critic of the *Architectural Record*, Montgomery Schuyler:

> Consider the Hale Building, how it grows. The problem was to erect a seven-story office building with a narrow front on the principal street, and with rooms devoted to similar purposes and of similar dimensions throughout. The danger was that this uniformity would produce monotony. There is nothing of which your Philadelphia architect is so afraid as of monotony. In fact it is the only architectural defect of which he seems to go in fear. Variety he must have at all cost, and by securing variety he makes sure that he has avoided monotony, whereas in truth his heterogeneousness is more tiresome than any repetition could be.... [E]very precaution has been taken, and with success, to insure that the building shall lack unity, shall lack harmony, shall lack repose and shall be a restless jumble.[11]

Others enjoyed the Hale Buildings' playfulness. Perhaps, for some, this rock pile recalled the castles and spooky battlements pored over by boys and girls in children's fantasy books. In any case, and probably more for civic pride, the following was written about the Hale Building shortly after its opening:

> The [Hale] building is one of the handsomest structures in the city, being seven stories in height, surmounted by a tower; the Chestnut Street front of rock-faced Indiana limestone, the Juniper Street front an attractive combination of brick and terra-cotta, ornamented with projecting balconies of stone.[12]

Well, so much for drastically differing opinions. Willis Gaylord Hale must have heard them all; not unlike today, academic and sidewalk critics seemed to be everywhere. Tragically, in 1896, a fire destroyed the architecture office of Hale, and when he died in 1907, it was rumored that Hale was destitute.

The Hale Building remains standing in downtown Philadelphia, but it is a shadow if its once-extravagant self. Throughout multiple ownerships over the years and due to the dozens of retail tenant alterations, the first three floors have been defiled. As a whole, the Hale Building appears considerably worn and tired, romantic in its remnant state — like the old castles of Europe, ghostly and forlorn.

Masonic Temple, Chicago, 1892

From its very inception, Chicago's Masonic Temple was hailed as "an architectural marvel." Norman T. Gassette, speaking for the Masonic organization responsible for the skyscraper's construction, boasted, "It will be the largest building on earth [*sic*] and in many ways totally different from any other structure in existence."[13] Hyperbole aside, the Masonic Temple was indeed very large, "totally different," and stood for only 47 years.

This eclectic office tower was the home to Chicago's Masonic lodges (private fraternal organizations) and served as headquarters of the Knights Templars and Masons Life Indemnity Company of Chicago. Gassette and Chicago real estate businessman Abraham Gottlieb (d.1894) were the skyscraper's principal proponents, with Gottlieb being the "builder." The architectural firm responsible for the design was none other than Chicago's noted and prolific Burnham & Root. The Masonic Temple's cornerstone was laid on November 6, 1890, and the press quickly reported on the structure:

> All the arts of the present century will be employed to embellish its interior and give it an attractive exterior, and no expense will be spared to make it one of the most, if not the most, complete structure in existence.

Adding a reassuring note to the public and future tenants, the press further reported: "The structure will be entirely of steel and absolutely fireproof, so far as materials and the skill of man can make it."[14]

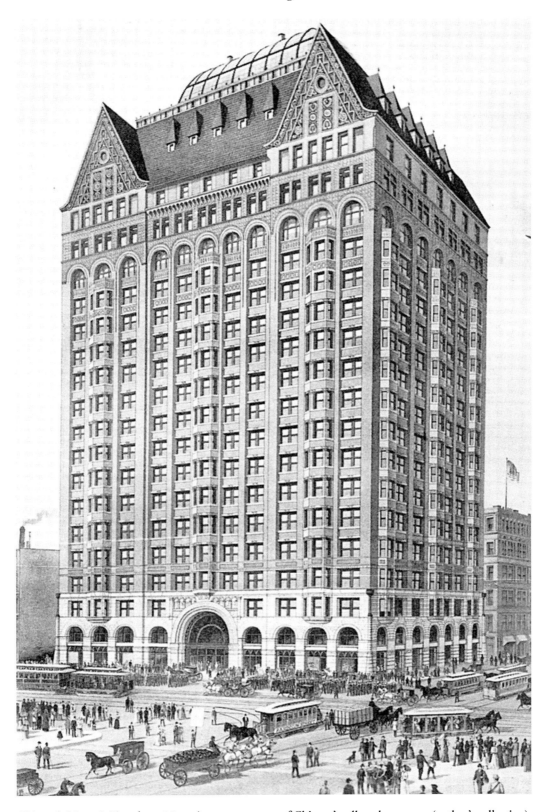

Chicago's Masonic Temple, at 22 stories, was once one of Chicago's tallest skyscrapers (author's collection).

After only one year, the Masonic Temple's copestone (a protective cap atop a wall), was laid, signaling the completion of the building's structural system. On November 5, 1891, the press reported the event:

> The copestone of the giant structure at the corner of State and Randolph streets, known as the Masonic Fraternity temple, will be placed in position by Past Grand Master John C. Smith, with all the imposing ceremonial of the Masonic order. The occasion will be a unique one in the history of Masonry in the United States, from the fact that while the ceremony of dedication is a usage as ancient as the order itself, never before will it have been observed to crown with fitting rites the completion of a temple of such vast and imposing proportions as the edifice erected by Chicago's Masons. The superb building, to the completion of which the Masons of every country have for some months looked forward with a very natural pride, is the largest and most perfect structure of its kind on the face of the earth. It is, moreover, peculiarly fitted for the uses for which it is intended. In the great hall at the top of the building a regiment could perform its evolutions, and the occupants of a good-sized town could find accommodations within its massive walls.[15]

Upon completion in 1892, the Masonic Temple stood 22 stories, 300 feet high and claimed a footprint that measured 170 by 114 feet. The skyscraper housed a number of Chicago's Masonic lodges within its public-restricted top four stories, floors that included more than 100 private lodge rooms. Also housed within the skyscraper were 543 public offices on floors three through 18, with ten retail stores on floors one and two. Servicing its restaurants and a public-welcome rooftop observatory were 14 glass-walled passenger elevators. A splendid central atrium was topped by a glass dome which allowed sunlight to penetrate into the building's core. The Masonic Temple welcomed visitors by means of a grandiose, stone-faced, arched entrance that measured 42 feet high by 28 feet wide. Once inside, visitors could dine at the "largest restaurant in the city," and peruse the skyscraper's shops. What was considered unique by the press was best expressed in the following:

> The floors of the building will not be numbered as in ordinary structures, but each will be designated by an appropriate and suggestive name. Each floor will have a twelve-foot corridor, and on every one of these corridors or avenues, as it is proposed to call them, stores and offices will be rented. As there are to be no arbitrary partitions in the building, lessees can have rooms of any dimension, varying from 10x14 to 60x100, large enough for a cigar stand or a pretentious shopping emporium.[16]

Gassette further expounded upon the unusual floor-naming decision long before building completion:

> The halls and corridors on the various floors will be named and numbered as are the streets and avenues of a city. Instead of being known as the first floor, the main corridor of the second story will be called Gurney street [sic] in honor of T.T. Gurney. This is the only name as yet decided on, but all the streets will be named after Masonic notables. The idea of giving them names is to do away with all ideas of altitude. The building will be eighteen [sic] stories high, and the mere mention of the seventeenth or eighteenth story might discourage some people, if they were looking for an office.[17]

A bizarre floor-naming system, coupled with fuzzy thinking and secret but ancient Masonic rituals, distinguished this Gilded Age skyscraper from most. A little Romanesque, a little French Chateau, and an awful lot of design chutzpah tag this skyscraper an explorer, an adventurer in the world of the eclectic. The Masonic Temple was both big *and* quaint, and it amused the minds of those who belonged to the secret societies of 19th century Masonic orders. Passersby, too, were dazzled by its height, decorated brick and terra cotta walls, and apparent modernity. Its arcades and bay windows, its steeply pitched roof, and its delicious little dormers made for great, almost devious, fun; the mind's eye supplied mischievous melodramas and mirth-filled

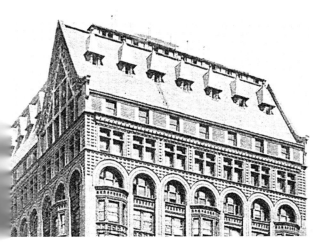

Masonic Temple, detail of building top (author's collection).

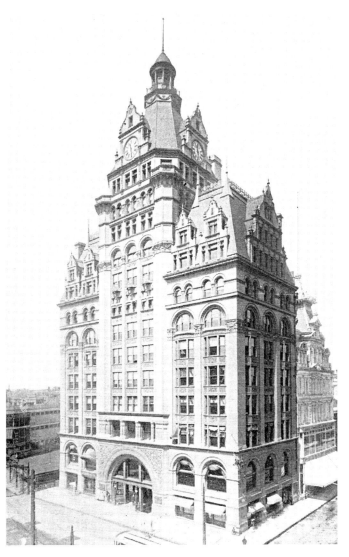

adventures of its inner goings-on. Secular rituals, immersed in mystery and privacy, were potent forces that teased those denied admittance to the upper "private floors." The temple's ominous roof, while jealously sheltering its members, provided beguiling entertainment to the outside world through endless conjecture. In 1939, all mystery was revealed when the Masonic Temple was laid bare by the wrecking ball.

PABST BUILDING, MILWAUKEE, 1892

Milwaukee's Pabst Building, constructed by a German immigrant and beer baron, once rose cliff-like from the edge of the Milwaukee River, a slow-moving workhorse waterway littered with docks and barges. This was a river that was anything but an idyllic image of Germany's Rhine with its river-carved mountains and fairy castles, but it was close enough for brisk imaginations and foggy recollections of times long past. For some, this skyscraper recalled the exploits of Hansel and Gretel, or perhaps the heroic adventures of children, kings and queens, and winged forest creatures featured in Dutch and Flemish folklore. In any event, the Pabst Building's architecture was deeply rooted in the design traditions of northern Europe. Its walls were decorated with garlands, heraldry, angels, cherubs, and an abundance of foliate carvings to subtly suggest a forest. High above the street there loomed a "castle," a place

Milwaukee's Pabst Building was the epitome of Gilded Age extravagance with a large dollop of traditional Germanic elegance (author's collection).

Above, left: The dreaded "leaf men" of European lore could attack a weary, unsuspecting traveler at any moment. This "leaf man" watches over the main entrance to Milwaukee's Federal Building (Willoughby J. Edbrooke, 1899) and the poor souls who must pay their taxes as tribute. *Right:* A "leaf man," a pagan symbol of fertility, originated in early Roman history and in many parts of Europe. Typically, he is shown surrounded by foliage with leaf forms emerging from his mouth. The concept: humanity becomes one with nature. By the 11th century, the "leaf man" even appeared on the walls of Christian churches and cathedrals. Gilded Age skyscrapers, executed in the German Romanesque or Renaissance styles, would have been remiss not to include such beings. This example is on the façade of Milwaukee's Federal Building (photographs by author).

inhabited by princes and fairies, a place safe from the beasts that lurked beyond its tall walls. This was the result of imagination, of the daydreams of generations of children as they rode the streetcars, clanging as they went over the bridges spanning the lazy, dark river below. Milwaukee brewery baron Frederick Pabst (1836–1904) ordered this skyscraper built. Chicago architect Solon Spencer Beman (1853–1914) was chosen by Pabst to design the steel-framed skyscraper.

The construction of Milwaukee's tallest office building, a speculative venture, was completed on May 1, 1892, and stood 14 floors, 235 feet tall. Its footprint measured 60 by 130 feet, and it contained three electrically driven, "rapid" elevators, and an extensive law library on its tenth floor. The skyscraper was faced with tan brick, and trimmed with tan-colored terra cotta, limestone, and copper. Dormers, cupolas, balconies, iron cresting, and a multitude of finials completed the fantasy. The building's 200 offices were topped by a giant, eight-sided, steeply pitched roof that featured four dormers, each housing a clock with a lighted face; a bell inside rang out the hours. Above this picturesque pile was a cupola and at street level stood a 35-foot diameter arched entrance of carved limestone. Early news stories trumpeted the structure, describing its design as being "of the Renaissance style of architecture, a style resulting from the antique but much more free as to bounds."[18] (Interpretation: an eclectic exploration.) A newspaper account further reported:

> From an architectural standpoint the new block will be a marvel and one calculated to attract attention throughout the country. In many respects it will show an advance and improvement upon modern office building architecture and the running of columns [steel] to the top from the base above the second story ... is a decided and bold departure from anything heretofore attempted in the United States.

Continuing:

> This building will be absolutely fire proof, no partition therein having any load to support. These partitions can be located and changed at will. There will be private vaults to many of these offices, together with improvements in arrangement, light and convenience. It has been the aim of the architect in these respects to surpass any office building yet constructed in this country. The floors

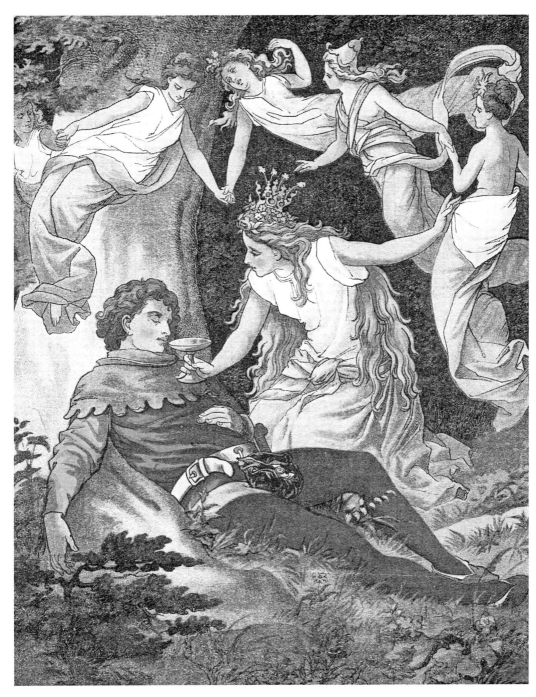

The characters portrayed here would have undoubtedly felt especially at home in a world of buildings like the Hale, Owings, or Pabst. Fantasy architecture was popular with some clients and architects because, consciously or unconsciously, the sources of inspiration employed were introduced to them when they were young. Between the covers of books like "Hours in Fantasy Land" of 1883 were a host of castle images and the people who inhabited them. The forests held many surprises, including fairies, wood nymphs, leaf men, dwarfs, dragons, wicked queens, and witches. Forest men or "rustics" could be either benevolent or malevolent, and they had powers over the flora and fauna of the forest and human infants. All of these, in some form or another, appeared upon the façades of more than a few American skyscrapers during the Gilded Age (author's collection).

from the second to the thirteenth stories all comprehend these features and will be practically alike and almost of equal desirability. From the tenth to the thirteenth floors the most quiet and desirable offices in this building will be found. High up above the dust and noise of the city, they are so arranged both as to light and ventilation that they will be most desirable, and the view which they will command will be worth a premium to every customer or client that may have business there.[19]

Upon its completion, Milwaukee's Pabst Building became the favorite of office-space seekers, and it quickly rented its office space to one major bank and to a host of attorneys, accountants, and other business firms. Despite its popularity with the financial community, and despite its popular and unique "fantasy façade," the structure met a dubious fate in 1980. It was then that the angels and the cherubs and all the rest tumbled to the ground during its demolition; it was then that none of these lived happily ever after.

AMERICAN TRACT SOCIETY BUILDING, NEW YORK, 1896

The work of the society is so stupendous in its magnitude that it challenges the admiration of Christendom.[20]

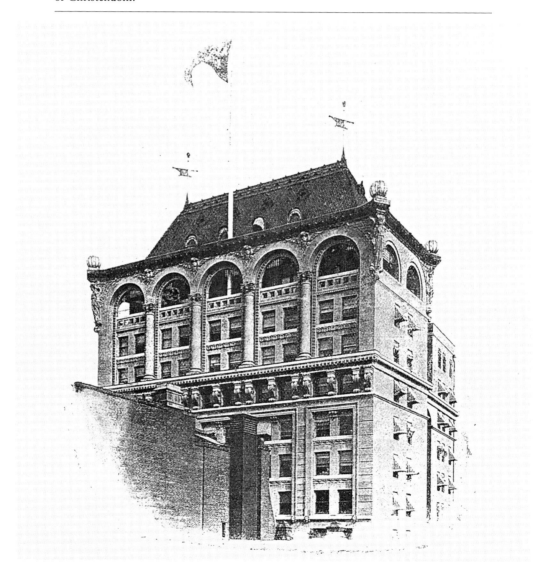

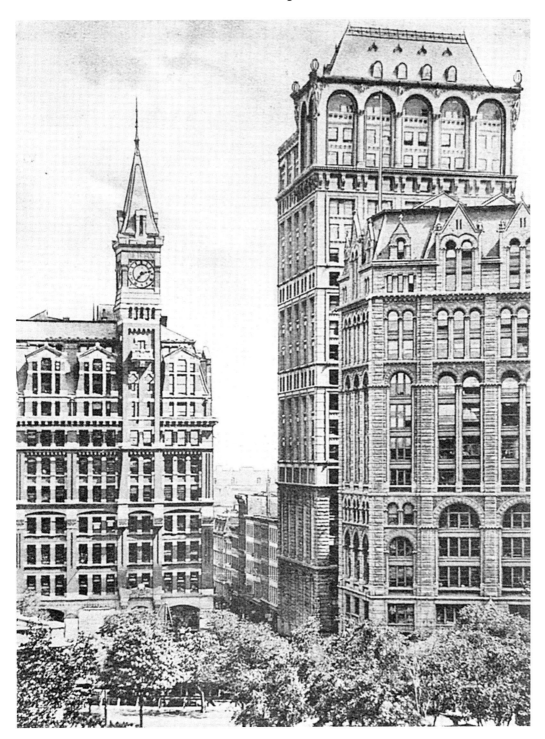

American Tract Society Building (author's collection).

Opposite: American Tract Society Building, detail of building top (*The Architectural Record*, Vol. VI, No. 2, October–December 1896, p. 218).

Eclecticism knew no bounds with the design of New York's American Tract Society Building. Its façades freely borrowed from the Renaissance, from the Romanesque, and from the "utilitarian modern," as it was understood then. The building offers a peculiar tripartite organization: a Romanesque-inspired base, with rough-cut stone and attenuated arches that recall the architecture of the aqueducts of Italy; a mid-section with smoothly finished walls and crisply cut window openings devoid of any extraneous decoration — a thoroughly modern approach; and a visually exciting and detailed top highlighted by much Renaissance decoration and a giant hip roof.

Manhattan-based architect Robert H. Robertson was responsible for the design of this 23-story, 306-foot-tall building — once New York's sixth-tallest skyscraper. The building's footprint measured roughly 94 by 100 feet; it initially contained some 700 offices and was outfitted with six hydraulic elevators. Originally its main entrance was an overt example of Renaissance architecture, which included a marble doorway with all the trimmings featuring toga-draped, reclining figures. A public restaurant was located on the 23rd floor, one of the first eateries atop a skyscraper. Architectural critics, past and present, asserted that the American Tract Society Building did not soar as did Louis Sullivan's skyscrapers; they claimed it was not conceived of as being "tall," and that it lacked a *single* architectural expression. Rather, its design was muddled, and it appeared as six stacked office boxes. Despite the architectural criticism, the building still stands and is now home to several hundred highly coveted residential units.

This extravagant skyscraper was constructed by, and served as the headquarters of, The American Tract Society, a Christian organization founded in 1825 and dedicated to the production and dissemination of Christian literature. Its home office building was designed to "provide a depository of evangelical nonsectarian literature in the various languages of the world." An 1894 article, published during this skyscraper's construction, boasted that the society produced "12,400 distinct publications in 150 languages." This article further points out that "in 68 years 30,000,000 volumes have been distributed, besides 415,000,000 tracts and 220,000,000 copies of periodicals. The missionary colportage system employs, on an average, about 175 missionaries annually, who have made more than 14,500,000 family visits." Further proselytizing claimed that some "7,000 Protestant families were found in 1893 without the Bible, and all were gratuitously supplied."[21] In keeping with the society's religious zeal, the building's four corners — at the 22nd-floor level — featured 15-foot-tall, terra cotta angels, all with wings fully extended,

seemingly poised for fending off a demonic attack. Directly above these were large metal spheres, representations of the earth and the religious proselytizing yet to be done. Originally anchored to its exterior and adding to the building's overall allure were the busts of lions that menacingly peered downward to pedestrians far below.

Curious contradictions abound with the American Tract Society Building's façades. Questions regarding the sacred and the profane arise with this Christian "tower of mammon" and its location in the heart of the world's capitalist playground. The society's profit provided for the

As if carved by a Gothic stonemason, this hapless individual appears on the wall of an American church. The purpose of this carving, completed in 1892, served as a warning to worshippers against blasphemy, lying, and gossip. The American Tract Society would no doubt have approved of such ornamentation (photograph by author).

skyscraper's expensive marble entrance, a delightful display of pagan symbolism and decoration.[22] Lion heads, combined with Roman arcaded façades, are certainly suggestive of Rome's Flavian Amphitheatre, a place where the big cats feasted upon early Christians. The arch-order system that embraces the building's top echoes the Roman triumphal arches sprinkled throughout its empire; the arcades, symbols of Roman might and ingenuity, supply an amusing finale for a building dedicated to the spread of Christianity and its missionaries' oaths of piety, charity, and poverty. Due to these curiosities and contradictions, this skyscraper's rather pompous design could easily have been the home to a large financial — secular — institution.

Conclusion

Above all, America's Gilded Age skyscrapers were pioneers. Their extravagant facades were testaments to their age; their heights pointed to a future of super-tall skyscrapers found throughout the world. Seek them out, learn from them — now.

Of the 51 extravagant skyscrapers featured in this book, only 19 remain standing. Time, neglect, and indifference have taken their toll upon a superb body of work. Despite the criticisms hurled at them a century ago, despite the contempt some may feel for them today, these early skyscrapers were once considered by many as the highest urban achievements of mankind. Though viewed as oddities of sorts, they deserve our attention and respect.

These old skyscrapers embodied the inspiration of their times; they reflected the values, the knowledge, the engineering, and the artistry that flowed through the supple hands of architects and engineers, through the muscular arms and torn hands of stonemasons, marble carvers, and bricklayers. These were their monuments; they were assembled with pride and destined to last for decades after their builders' passing. Nineteen of these still whisper to us of Greek gods, of Roman myths, of medieval beasts, and of times long past … our past. These 19 skyscrapers are not their creators' tombstones but our legacy; they remain tangible history lessons far greater than any book.

Chapter Notes

Chapter One

1. John Ruskin, *The Seven Lamps of Architecture* (Boston: Dana Estes, 1849), The Lamp of Sacrifice, 15.

2. The Holy Bible, Mark 5:9. This was a demon's response to Jesus Christ's question posed to a possessed man.

3. New York Life Insurance Building, Jenney & Mundie, 14 stories, 166 feet tall, completed 1894. This building still stands on LaSalle Street in Chicago's financial district.

4. "Ready for Business: Mineral and Mining Board Completes Its Organization," *The Daily Inter Ocean* (Chicago) 29 Dec. 1895: 20, col. D.

5. Ibid. Italics added.

6. "Chicago's Mining Exchange: It Was Formally Opened Up for Business Yesterday," *The Denver Evening Post* 22 Jan. 1896: 8, col. E. Italics added.

7. Charles Dickens, *A Christmas Carol* (London: Chapman & Hall, 1843).

8. "The Best Ten Buildings in the United States," *Bangor Daily Whig & Courier*, 27 June 1885: 1, col. E. Newspaper reprinted the results from *American Architect*.

9. Walt Whitman, "Passage to India," in *Leaves of Grass* (Philadelphia: David McKay, 1900).

10. Ayn Rand, *The Fountainhead* (1943; rpt. New York: New American Library, 1971), 166.

11. Louis H. Sullivan, *Kindergarten Chats and Other Writings* (1918; rpt. New York: Dover, 1979), 77. It is important to note here that Louis Sullivan published his writings in architectural journals serially beginning in 1901; only later would these become a book known as *Kindergarten Chats*.

12. Ibid.

13. Louis H. Sullivan, *The Autobiography of an Idea* (1924; rpt. New York: Dover, 1956), 290.

14. Sullivan, *Chats*, 47.

15. Ibid., 208. Italics added.

16. Sullivan appreciated and employed a wide range of ornamentation for his office buildings, most of which was foliate in inspiration. It is true, too, that he employed lion heads on the façades of the Union Trust Building (St. Louis, 1893, with Charles K. Ramsey), and extensively included statues of shield-bearing lions and eagles for the aforementioned structure, and for most of his small town banks executed late in his career. His façade for the Bayard (Condict) Building (New York, 1897, with Lyndon P. Smith) features six angelic figures emerging triumphant from a "forest" of foliate decoration; this is perhaps the closest Sullivan comes to employing mystical or supernatural figures on any of his office buildings. Furthermore, the exterior of Sullivan's Schiller (Garrick Theater) Building (Chicago, 1892) did indeed feature busts of famous composers—*real people* who lived and substantially contributed to European and American culture. Mythological creatures held no magic for Sullivan.

17. Sullivan, *Chats*, 200.

18. Ibid., 206.

19. Ibid., 207.

20. Robert Twombly, *Louis Sullivan His Life and Work* (New York: Viking Penguin, 1986), 404.

Chapter Two

1. Le Corbusier, *Towards a New Architecture* (1931; rpt. New York: Dover, 1986), 19.

2. Marcus Whiffen and Frederick Koeper, *American Architecture*, 2 vols. (Cambridge: The MIT Press, 1981), 224.

3. Herbert Read, *A Concise History of Modern Painting* (New York: Frederick A. Praeger, 1959), 12.

4. The Piccirilli studio produced sculpture for some fifty years, and, at its closing, many records of their achievements were found to be lost. Besides large corporate projects, the studio also produced work for large civic monuments as well as memorials (in cemeteries too) for the celebrated.

5. Henri Matisse, *Notes of a Painter*, 1908

6. I reference *only* the "original" Monadnock Block of 1891 (the north half) by Burnham & Root.

7. Thomas Eddy Tallmadge, *Architecture in Old Chicago* (Chicago: University of Chicago Press, 1941), 145. As quoted from a speech given to the Western Society of Architects, November 18, 1886.

8. Harriet Monroe, *John Wellborn Root: A Study of His Life and Work* (1896; rpt. Park Forest, IL: The Prairie School Press, 1966), 141. Harriet Monroe (1860–1936) was an American editor, scholar, literary critic and patron of the arts.

9. Ibid.
10. Edwin M. Bacon, *Boston Illustrated* (Boston: Houghton, Mifflin, 1886).
11. Frank E. Wallis, *Old Colonial Architecture and Furniture* (Boston: G. H. Polley, 1887).
12. Frank E. Wallis, *How to Know Architecture: The Human Elements in the Evolution of Styles* (New York: Harper & Brothers, 1910), 300.
13. Ibid.
14. Ibid.

Chapter Three

1. Edwin Lutyens, *Country Life*, May 1915: 8.
2. Louis H. Sullivan, *The Autobiography of an Idea* (1924; rpt. New York: Dover, 1956), 314–316.
3. Miranda Bruce-Mitford, *The Illustrated Book of Signs & Symbols* (New York: DK, 1996), 91.
4. Le Corbusier, *Towards*, 19.
5. Copyright 1984, The Saul Zaentz Company, all rights reserved, used with permission.
6. Louis Sullivan did design one building for the Exposition, the Transportation Building. The structure housed the latest examples of various forms of human transportation, including multiple locomotives. The building was painted deep red and green (all the others were bright white), trimmed in silver and gold, and it was of a new, very personal design. The building was immense: 256 by 690 feet, with an attached annex measuring 425 by 900 feet. It was 166 feet tall. As described by others, its architectural style varied from Romanesque to something called "Oriental." It was derided by many as being "severe" even "Wagnerian." The Transportation Building was famous for its "Golden Door."
7. Sullivan, *Autobiography*, 325.
8. Ibid., 322.
9. Ibid., 324–5.
10. Instead of constructing a collection of ancient-based temples, perhaps the Exposition's building and planning committee(s) could have allowed for one modern steel frame, glass-walled building to have been constructed. One ten-story building could have been erected allowing people to ride to its top to view the Exposition from a "modern" *American* building type, one that would have highlighted *America's* contribution to the building art. After all, the heights of some of the Fair's classical buildings were equivalent to skyscrapers of that day. After the Exposition's six month run, the landmark skyscraper could have remained — much like the Paris' Eiffel Tower of four years earlier.
11. Adam Smith, *Wealth of Nations* (1957; reprint, London: J.M. Dent and Sons, The Aldin Press, 1957), vol. 1, chapt. 11, 157.
12. The New York headquarters stood seven floors, 145 feet, and was a mansardic palace; one critic ranked it an early skyscraper of "opulence and unexcelled stature."
13. Arthur D. Gilman worked with architects Edward H. Kendall (1842–1901) and George B. Post (1837–1913) in designing the New York headquarters.
14. "Western Union Telegraph Building," *The Aldine*, January 1875: 258. Italics added for emphasis; comparisons to Europe and "Old World" structures are of special note.
15. Ibid.
16. Henry F. Withey and Elsie Rathburn Withey,

Biographical Dictionary of American Architects (Los Angeles: New Age, 1956), 488.
17. Claude Bragdon, "Architecture in the United States III: The Skyscraper," *The Architectural Record*, August 1909, 95.
18. Due to a 1922 remodeling and widening of the building, the original exquisite proportions were modified with: two columns and two caryatids were added to the façade.
19. J. Massey Rhind, "Proposed Treatment of Figures to be Placed on the American Surety Company's Building, Corner Broadway and Pine Street, New York City," *The American Architect and Building News*, 25 May 1895: 83.
20. M. Quad in New York World, "New York's Six O'clock," *Bismarck Daily Tribune* (Bismarck, ND) 24 June 1891: col. E.
21. In actuality, the McKim design enlarged and totally remodeled an existing building (Griffith Thomas, 1870) that already served as the headquarters of the New York Life Insurance Company. All remaining adjacent parcels were cleared for the giant expansion project which included the now landmark-designated block-long office block, and a decorative clock tower.
22. "New York Life Building: Broadway, Leonard and Elm Streets," *The Evening Post* (New York), 27 February 1897: 5, col. A. Real estate advertisement.
23. "The Attempt to Kill Sage," *Bismarck Daily Tribune* (Bismarck, ND), 10 December 1891: col. E.
24. "A week, unusually full of disasters…," *The Congregationalist* (Boston), 10 December 1891: Issue 50, 10, col. A.
25. "A Crowd of Rich Men," *The Atchison Daily Globe* (Atchison, KS), 1 January 1892: 1, col. D.
26. "Ibid.
27. Ibid.
28. The Illinois Steel Company became part of the Federal Steel Company, another J. P. Morgan-controlled manufacturer. On February 25, 1901, the United States Steel Corporation was incorporated with the merging of ten companies, one of which was Federal Steel.
29. "St. Paul Building," *The Evening Post* (New York), 27 February 1897: 5, col. A. Advertisement for tenants.
30. His "Sugar Trust" was accused of fixing prices, tax evasion, and monopolistic practices, but despite these business "setbacks," Henry Osborne Havemeyer died very wealthy.
31. The Havemeyer family, including brothers and nephews of Henry O. Havemeyer, each had a professional role in the sugar empire. It was Theodore Augustus Havemeyer (1839–1897), Henry Osborne's nephew, who contracted with George B. Post to design the Havemeyer Building in lower Manhattan. This building served as the headquarters of their sugar business, and it stood 14 floors, 192 feet tall, was of cage construction, and contained six hydraulic passenger elevators. It stood on the east side of Church Street between Dey and Courtlandt streets. In design, the Havemeyer Building was decidedly Romanesque, except for its top four floors where classically-derived ornamentation was featured. Architect Post employed the use of giant atlantes at this level as support devices for an oversize cornice. The Havemeyer Building was demolished in the 1950s.
32. Vitruvius, *The Ten Books On Architecture* (1914; rpt. New York: Dover, Inc., 1960), 188–189.
33. Sarah Carr-Gomm, *The Dictionary of Symbols in Western Art* (New York: Facts on File, 1995), 34.

34. In all fairness to George B. Post, even Louis Sullivan — the great "organic ornament" proponent — included giant figures on the façades his Union Trust Building (St. Louis, 1893, with Charles K. Ramsey). On this fifteen-story building, Sullivan originally included gigantic lion figures each holding heraldic shields (now removed). These figures, all six of them, appeared bombast, especially considering the delicate foliate-based ornamentation elsewhere on the building.

35. Although Karl Bitter (1867–1915) was born in Vienna, Austria, he was known as one of America's most celebrated architectural sculptors. He arrived in America in 1889 and was befriended by New York architect Richard Morris Hunt, who introduced him to many important clients. When the St. Paul Building was demolished in 1958, the *atlantes* were carefully removed for preservation. Reportedly, these three large figures currently reside in Holliday Park, a sculpture park in Indianapolis, Indiana.

36. Paul Goldberger, *The Skyscraper* (New York: Alfred A. Knopf, 1981), 38.

37. Upon its completion in 1902, the Flatiron Building was ranked the *seventh tallest* in New York. Taller skyscrapers included (in order): Park Row (29 floors, 382 feet), Manhattan Life (17 floors, 348 feet), St. Paul (26 floors, 308 feet), American Surety (23 floors, 306 feet, later revised to 312 feet), American Tract (23 floors, 306), and the Empire (20 floors, 293 feet). *World Almanac and Book of Facts* (New York: New York World, 1904), "Height of Prominent Buildings in Manhattan Borough," 539.

38. The Fuller/Flatiron Building's dimensions are: 190 feet along Broadway, 173 feet along Fifth Avenue, and 87 feet on 22nd Street. In plan it forms a right-triangle: the 90-degree angle is formed on the corner of 22nd and Fifth. It's north "rounded façade," that fronting on 23rd Street, measures only six feet wide.

39. George A. Fuller was a graduate of Andover College and further studied at the Boston School of Technology. He studied architecture in the office of his uncle, J. E. Fuller, an architect in Worcester, Massachusetts. After one year there, Fuller entered the Boston office of Peabody & Stearns and was quickly made a partner and head of that firm's New York office.

40. Eventually the George A. Fuller Company would relocate, with the completion of the Flatiron Building, to New York City. It would maintain principal offices in Philadelphia, Washington, D.C., and Chicago. In 1970, after being in business for eighty-six years, the firm closed and the "Fuller" name, seen at dozens of skyscraper jobsites, would be seen no more.

41. Harry S. Black married Fuller's daughter when she was seventeen; they divorced in 1905. Black died of an apparent suicide, by revolver, in 1930. *New York Times* July 20, 1930.

An excerpt from Gene Coughlin, *The American Weekly*, "Heartbreaks of Society," date and edition of column unknown, stated: "He [Black] was at home with I-beams, stresses and blueprints, but he wasn't at home with the society figures who began to frequent his town house and his country estate near Huntington, L. I." http://harrysblack.com/AllondaleSummerResidencein-HuntingtonLongIsland.html. 6/2/2009.

42. Earle Schultz and Walter Simmons, *Offices in the Sky* (Indianapolis: Bobbs-Merrill, 1959), 58.

43. Starrett would eventually leave the Fuller firm and found his own construction company, the Starrett Brothers, Inc., of New York City. His firm will be credited for erecting the Empire State Building (Shreve, Lamb & Harmon, 1931) and dozens of other significant structures.

44. Originally the Flatiron Building boasted twenty office suites per floor, six hydraulic-driven passenger elevators, and one restroom per floor — alternating men's and women's. Heat and electric light were provided to tenants by basement-located steam and electric "plants." The skyscraper contains 241,000 square feet of rentable office space.

45. Susan Tunick, *Terra-Cotta Skyline New York's Architectural Ornament* (New York: Princeton Architectural Press, 1997), 25, 145.

46. Ada Louise Huxtable, *The Tall Building Artistically Reconsidered: The Search for a Skyscraper Style* (New York: Pantheon Books, 1982), 5.

47. This "borrowing" was observed by many architects and critics throughout the years that the building "existed." Recognition was first recorded/published by Montgomery Schuyler only after viewing architectural drawings of the skyscraper. See Montgomery Schuyler, "The Evolution of a Skyscraper," *Architectural Record*, November 1903, 329–343.

48. These were the following: Western Electric (10 floors, 1889), New York Telephone (7 floors, 1890), Fidelity & Casualty (11 floors, 1894), Metropolitan Telephone (15 floors, 1896), Townsend (12 floors, 165 feet, 1897), and the Washington Life Insurance (19 floors, 273 feet, 1898).

49. After Eidlitz retired, the firm's name was changed to McKenzie, Voorhees & Gmelin (1910–1926), then it continued as Voorhees, Gmelin & Walker (1926–1938) after McKenzie's death.

50. These included the Missouri Pacific, the Texas and Pacific, the International and Great Northern, and the Wabash (the result of a merger of the Pittsburgh, Carnegie & Western and the Pittsburgh, Toledo & Western railroads).

51. During the late nineteenth century this western Pennsylvania city was spelled "Pittsburg." After a public referendum held in 1911, the city officially tacked on an "h" to "burg" and officially changing "Steel City's" name to "Pittsburgh."

52. Completed in 1894 at a cost of $6.5 million, this behemoth recalled the medieval French walled city of *Carcassonne*.

53. Currently, the site of the Wabash Building is occupied by the twenty-two story, Four Gateway Center (Harrison & Abramovitz, 1960).

54. "A Giant Building: New York to Have Highest Office Structure," *New York Times*, 27 April 1906.

55. A real estate syndicate lead by Dowling purchased the real estate necessary for the erection of the planned 32-story Adams Express Building at 61 Broadway (Francis Hatch Kimball, 1914). *New York Times* 28 February 1912, 17. One year earlier, in 1911, Dowling, through City Investing, purchased the 19-story Washington Life Building (Cyrus L. W. Eidlitz, 1898). *New York Times* 5 April 1911, 16.

56. Dowling served as the director of the New York Life Insurance Company, City Bank Farmers Trust Company, East River Savings Bank, and the National City Realty Corporation. Immediately before founding City Investing, Dowling served as president of the United States Realty and Construction Company.

57. Joseph P. Day, ed., *Practical Real Estate Methods*

for Broker, Operator & Owner (New York: Doubleday, Page, 1909), 273.

58. Actually eight buildings were constructed from 1891 to 1919 to house all of the company's home office operations. See Barbaralee Diamonstein, *The Landmarks of New York* (New York: Harry N. Abrams, 1993), 415.

59. Sarah Bradford Landau and Carl W. Condit, *Rise of the New York Skyscraper 1865–1913* (New Haven: Yale University Press, 1996), 361.

60. Hegeman was a director of the Metropolitan Bank, National Surety Company, Dime Savings Bank, and the Hamilton Trust Company. Social organizations, too, were important to him. He maintained close associations with The Holland Society, the King's County Historical Society, the National Geographic Society, and the Westchester Chamber of Commerce.

61. Barbaralee Diamonstein, *The Landmarks of New York II* (New York: Harry N. Abrams, 1993), 415.

62. The firm of Parker, Thomas & Rice seemed never to stray too far from their Beaux-Arts backgrounds. In 1916, the twenty-two-story Baltimore Gas & Electric Company Building was completed to their designs. It was a tripartite skyscraper with all the usual props. Eight-foot tall allegorical figures were positioned upon its front façade representing Knowledge, Light, Heat, and Power. Mary Ellen Hayward and Frank R. Shivers, Jr., *The Architecture of Baltimore: An Illustrated History* (Baltimore: Johns Hopkins University Press, 2004, 242.

63. The new headquarters was completed in 1921 and designed by the German-born, Baltimore architect Otto G. Simonson (1862–1922). Though he designed the new headquarters building — in a decidedly Georgian style no less — Simonson retained his architectural office on the third floor of the downtown-located Maryland Casualty Building.

64. Matthew Weinreb and Fiona Biddulph, *Metropolitain: A Portrait of Paris* (London: Phaidon Press, 1994), 186–187.

Chapter Four

1. William Cowper, *The Task*, bk. 2, "The Timepiece," l, 606, 1785.

2. Edmund Jungenfeld was an expert not only in brewery building *design* but also in the *brewing* of beer. Jungenfeld applied (with a Charles G. Mayer) for a patent entitled "Apparatus for Cooling Beer" on September 26, 1882 (Pat. #265,123, Assigners to the Empire Refrigerating Company of St. Louis).

3. "Dr. McLean's Block and Palace Tower," editorial, *Frank Leslie's Illustrated Newspaper* 11 December 1875: 223, col. A.

4. Ibid.

5. Ibid.

6. Ibid.

7. Douglas Keister, *Stories in Stone: A Field Guide to Cemetery Symbolism and Iconography* (New York: MJF Books/Gibbs Smith, 2004), 15–16.

8. "Pulitzer's Building: An Entertainment for Thousands of Guests Prepared," *Daily Evening Bulletin* (San Francisco), 10 December 1890: 3, col E.

9. "Newspaper Removal," *The News and Observer* (Raleigh, North Carolina), 27 November 1890, col. B.

10. "The New York World yesterday…," *The Daily Inter Ocean* (Chicago) 11 December 1890, 4, col. D.

11. "Gotham Gossip: Rise of the World under the Direction of Joseph Pulitzer…," *The Daily Picayune* (New Orleans), 8 December 1890, 7, col. D. This article further points out the following: The wrought iron piers vary from 23 inches in diameter at the base to 8 inches at the top, their thickness ranging from 1½ inches to ⅛ of an inch. They are strengthened by (undecipherable) pieces, some columns having as many as eight. They are built in sections and steel plates are inserted at each floor. To these plates are riveted the steel beams which carry the floors — the largest single pieces of steel ever made in this country. There are 750 wrought iron columns, aggregating 3 miles in length: 2000 anchors; 50,000 bolts and 150,000 rivets, making altogether about 5,000,000 pounds of steel and wrought iron."

The article continues: "Taking up other materials we find that there were required in this construction 4123 cubic yards of concrete, 9133 cubic yards of sand, 600 barrels of plaster of Paris, 2700 barrels of lime, 2473 barrels of Portland cement, 12,891 barrels of Rosedale cement, 5,714,000 hard brick (not one of which is visible), 108,000 buff brick and 63,480 glazed brick. The brick alone would build 250 ordinary brick homes."

12. "The success of the New York World…," *Yenowine's News*, 2 February 1890, 4, col. C.

13. "Gotham Gossip," 7. This article does indeed do more than suggest that Pulitzer *did* have his hand in the design for which he was paying: "The building was designed by Architect George B. Post, upon lines laid down in some important respects — notably the dome and entrance — by Mr. Pulitzer. The style of architecture is Renaissance with a tendency to Venetian detail."

14. Ibid.

15. Ibid.

16. "Out on a Morning Ride," *The Galveston Daily News*, 5 May 1891; 6, col. A. Italics added.

17. Hans von (H. V.) Kaltenborn (1878–1965) was a noted, insightful, and analytical newspaper reporter, and later a celebrated radio commentator. He appeared as himself in the classic science fiction film *The Day the Earth Stood Still* (Twentieth Century–Fox, 1951).

18. "Brooklyn's Exciting Night," *New York Times*, 9 November, 1898.

19. "New Building of the Eagle," *New York Times*, 20 November 1902.

20. Boyington's largest and tallest contribution to the city was the Chicago Board of Trade Building (1885), a nine-story, 322-foot tall structure — the city's tallest until 1900.

21. Lewis Mumford, *The Brown Decades* (1931; rpt. New York: Dover, 1971), 50.

22. John M. Killits, ed., *Toledo and Lucas County, Ohio 1623–1923*, 2 vols. (Chicago and Toledo: S. J. Clarke, 1923), 273–4. Unless Fallis and Walbridge spoke and arranged the entire project in 31 days, it is doubtful that Fallis' memory was accurate. Walbridge died on January 31, 1893. Since Horace S. Walbridge died in 1893, it is *assumed* that his then thirty-eight-year-old banker son, Thomas H., saw to the completion of the project, probably in 1895.

23. Other works by this somewhat enigmatic architect were the Paulding County (Ohio) Courthouse (1886), the Toledo Public Library (1890), and the Walbridge Building (1895), an eight-story office structure of "iron and brick construction." E. O. Fallis served as president of the Toledo Chapter of the American Institute of Architects from 1914 to 1916 and maintained his professional offices in the tower of the Nasby Building until his retirement.

24. "Clocks with Nerves: Refuse to Do Reliable Work When Placed in High Buildings," *Rocky Mountain News* (Denver) 31 January 1897, 19, col. F.

25. "Highest in the World: The New Home of the Manhattan Insurance Company," *The Milwaukee Journal*, 21 September 1893, 9, col. C.

26. "Science of Weather," *Morning Oregonian* (Portland), 5 July 1896, 19, col. A.

27. Ibid.

28. Montgomery Schuyler, "The Works of Francis H. Kimball and Kimball & Thompson," *The Architectural Record*, Vol. VII, No. 4, April–June 1898: 479–518.

29. "News Observations," *The News and Observer* (Raleigh, NC), 14 May 1887: Issue 142, col. B.

30. "The New City Hall," *The North American* (Philadelphia) 2 August 1882, col. H.
This article lists the following buildings and their respective *footprint* areas in square feet: The United States Capitol, 117,840; Chicago Post Office/City Hall, 70,446; Philadelphia Post Office, 67,121; Cincinnati Post Office/Courthouse, 59,100; New York Post Office, 49,322; St. Louis Court House/Post Office, 45,028; and the Baltimore Court House, 29,500.

31. William Penn (1644–1718) was an early colonist, scholar, writer, and founder of the "Providence of Pennsylvania" and of the city of Philadelphia.

32. "People and Events," *The Daily Inter Ocean* (Chicago), 9 May 1895, 6.

33. "Philadelphia's Fine Building," *The Milwaukee Sentinel*, 18 May 1887; 4, col. F. This article states: "The last block of marble has been placed in the Philadelphia city hall [sic]….The marble work upon the tower rises to a height of 337 feet, 4 inches. Above this will be iron works supporting the heroic statue of William Penn."

34. "The tower of the Philadelphia City Hall…," *Boston Investigator*, 24 September 1890, 6, col. E.

35. "Aluminum Plating," *The Vermont Watchman* (Montpelier), 14 June 1893, 6, col. B.

36. "The Highest Tower," *The Milwaukee Sentinel*, 16 October 1894; 10, col. G.

37. "Philadelphia's City Hall Tower," *The Daily Inter Ocean* (Chicago) 10 August 1896, 11, col. C.

38. "The World of Art," *The Daily Inter Ocean* (Chicago), Issue 133, 4 August 1895, 27, col. A.

39. "The City Hall Plans: Proposed Competition from an Architect's Point of View," *The Milwaukee Sentinel*, 8 November 1891, 10, col. G. One can assume that because of the rather scathing criticism of the text, the author simply signed the piece "Architect" to avoid further controversy and/or professional scorn.

40. Herman J. Esser, project architect at the firm of H. C. Koch & Company and overseer of construction on the Milwaukee City Hall project, and Paul Riesen, the general contractor for the project, were also German natives.

41. "Men Who Built the City Hall," *The Milwaukee Sentinel*, 16 October 1895, 1, col. A.

42. "The New City Hall," *The Milwaukee Sentinel*, 17 October 1895, col. A. Governor Altgeld gave this speech at Milwaukee's Semi-Centennial Celebration Meeting, held on October 15, 1895.

43. The Winkle Terra Cotta Company was founded in 1889 by Joseph Winkle in St. Louis (Susan Tunick, *Terra-Cotta Skyline*. [New York: Princeton Architectural Press, 1997], 139). The Winkle Terra Cotta Company was also responsible for the terra cotta ornamentation found on Louis Sullivan's landmark Wainwright Building (St. Louis, 1892).

44. "Completed at Last: Finishing Touches Being Put on Milwaukee's Municipal Palace, Million Dollar City Hall," *The Milwaukee Journal*, 23 November 1895, col. A.

45. Ibid.

46. "From the Book Table," *The Milwaukee Sentinel*, 23 August 1897, 4, col. E.

47. "City Hall Bell and Its Rivals," *The Milwaukee Sentinel*, 20 September 1896, 14, col. A.

48. Ibid.

49. "A Huge Tower Clock: Fourth Largest One in the World for the City Hall," *The Milwaukee Journal*, 11 August 1895, col. G.

50. Unfortunately, the name "Spreckels" has also been found spelled "Spreckles." This is one of those times when this author has chosen to acquiesce to the more common of the two versions.

51. James William Reid (1851–1943) and Merritt J. Reid (1855–1932) were natives of St. John, New Brunswick, Canada. The other brother, Watson Elkinah Reid (1858–1944), was the youngest and joined the firm later, only to leave the firm in 1899 and return to his home in New Brunswick.

52. "A Sugar King's Skyscraper: Claus Spreckels Building a Big Home for the San Francisco Call," *The North American*, 4 September 1895, 2, col. G.

53. "Gotham Gossip," *The Milwaukee Journal*, 4 December 1895, 4, col. G.

54. "The New Atlantic Cable," *Daily Evening Bulletin* (San Francisco), 15 February 1884, col. D.

55. "Chicago Real Estate: Some Fine Improvements," *The Daily Inter Ocean* (Chicago), 24 November 1895, 31, col. A.

56. The six were: Commercial Cable (1897), 21 floors, 304 feet; R.G. Dunn (1897), 15 floors, 223 feet; Home Life Insurance (1894), 12 floors, 208 feet; Gerken (1895), 13 floors, 200 feet; Queens Insurance (1896), 15 floors, 195 feet; Postal Telegraph (1892), 13 floors, 192 feet.

57. "The Work of George Edward Harding & Gooch," *The Architectural Record*, July–September 1897, Vol. VII, No. 1, 114.

58. Ibid., 116.

59. Ibid., 116–117.

60. Ibid., 117.

61. Sigfried Giedion, *Space, Time and Architecture* (1941; rpt. Cambridge: Harvard University Press, 1982), 125.

62. Letter received from The New York Public Library, U.S., Local History & Genealogy Division, 7 February 1996. "New York City directories give the office of Augustus T. Gillender at 1 Nassau St., the same as the offices of the Gillender building. We assume that as a major tenant the building was named after Mr. Gillender." Further research revealed the following: Augustus Theophilus Gillender (1843–1925) formed a law partnership (Gillender, Fixman, & Mumford) with Ezekiel Fixman and William Woolsey Mumford. Any relationship between Augustus Theophilus Gillender (the lawyer) and Helena L. Gillender Asinari (the Gillender Building owner) cannot currently be substantiated nor denied.

63. "Record Price for Manhattan Land," *Real Estate Record*, 18 December 1909, 1128, col. 2.

64. Helena Gillender Asinari, through inheritance believed from her father, for decades controlled the parcel on the northwest corner of Wall and Nassau streets. Her father, Eccles Gillender (1810–1877) was a millionaire tobacco merchant. It is rumored the skyscraper was named after him by his daughter.

65. Charles I. Berg went on to design other New York skyscrapers: Ashford Building (12 floors, 1908), Langsdorf Building (12 floors, 1908), Charles Building (14 floors, 1911), and the Hotel Touraine (12 floors, 1923).

66. Doreen Yarwood, *The Architecture of Europe* (New York: Hastings House, 1974), 403, image 791.

67. Ibid., image 794.

68. "Skyscraper Going; Higher One Coming," *New York Times*, 30 April 1910, 7, col. 5.

69. Henry F. Withey and Elsie Rathburn Withey, *Biographical Dictionary of American Architects (Deceased)* (Los Angeles: New Age, 1956), 218, 402.

Other Gilded Age skyscraper office buildings designed by Maynicke & Franke were: New York Commercial Building (1896), 349 Broadway (9 floors, 1897), 598 Broadway (12 floors, 1898), Germania Bank Building (6 floors, 1898), 632 Broadway (12 floors, 1899), 133 Fifth Avenue (9 floors, 1899), and the Merchant's Bank of New York (see) (13 floors, 1900).

70. Alfred Dolge, *Pianos and Their Makers* (Covina, CA: Covina Publishing Company, 1911), 320.

71. Joseph Kuder (1831–1913), a Viennese musician and piano craftsman, was a junior partner.

72. Smithsonian Institution Research Information System (SIRIS), *Sohmer & Co. Records, 1872–1889* (Washington, D.C.: 2009), 1.

73. *Frank Leslie's Illustrated Newspaper*, 24 October 1891, 192, col. A. Advertisement.

74. "The Piano Manufacture," *Frank Leslie's Illustrated Newspaper*, 23 April 1887, 155, col. A.

75. "The Tallest Modern Office Building in the World," *The Milwaukee Sentinel*, 1 January 1899, 5, col. D.

76. Two other prominent members of the syndicate were Charles Ranlett Flint (1850–1934) and George Rowland Read (1849–1927). Flint, a Maine native, was best remembered as the founder of the Computer Tabulating Recording Company, later renamed IBM. Flint was involved in the shipping business of W. R. Grace and formed the American Chicle and American Woolen trusts; he was known as the "Father of Trusts." Read, a Brooklyn native, was described as a "real estate agent, broker and auctioneer."

77. The building's original owners, the Ivins Syndicate, "flipped" the building soon after its completion, selling it to the investment banker August Belmont, Jr. Belmont (1853–1924) was president of the IRT (Interborough Rapid Transit)—part of New York's subway system—which established its headquarters in the Park Row Building.

78. Other New York skyscrapers by Robertson include the Lincoln (9 floors, 1890), McIntyre (10 floors, 191 feet tall, 1892), Mohawk (9 floors, 1891), and the Corn Exchange (11 floors, 1894).

79. "Most Wonderful Sky-scraper Ever Built," *Weekly Rocky Mountain News* (Denver) 2 February 1899, 8, col. F.

80. See Doreen Yarwood, *The Architecture of Europe* (New York: Hastings House, 1974), 362.

81. "Richard Croker's Luxurious Offices," *The Milwaukee Journal*, 19 April 1899, 6, col. E.

82. Ibid.

83. Montgomery Schuyler, "The Skyline of New York, 1881–1897," *Harper's Weekly*, March 1899, 295. Schuyler was both an American journalist and an architecture critic, despite *not* being professionally trained in architecture. He was considered one of the leading architecture critics of the Gilded Age and afterward, and

in 1891, with other writers, he founded the important design magazine, *Architectural Record*. He served on the staff of the *New York Times* (1883–1907) and was managing editor of *Harper's Weekly* (1885–1887). Schuyler was also a member of the American Institute of Architects and wrote much about art, music, and literature.

84. "Tallest Modern," 5.

85. R. H. Robertson, "The Tallest Building in the World," *The Denver Evening Post*, 28 May 1899, 13, col. A.

86. "Hungarian-American Bank," *New York Times*, 5 December 1911. According to Jaffray Peterson in *Sixty-Five Years of Progress and A Record of New York City Banks* (New York: Arno Press, 1980, p.65), the Hungarian-American Bank was a short-lived venture; it was organized in 1905 and "went into voluntary liquidation on January 24, 1912."

87. Kenneth T. Jackson, ed., *The Encyclopedia of New York* (New Haven: Yale University Press, 1995), 575.

88. Charles D. Gambrill (1832–1880) and Henry Hobson Richardson (1838–1886) formed a partnership in 1867 that lasted until 1874. During that time and while in that firm's office, Ficken was principally responsible (with Richardson) for the design of Brattle Square Church (1874), a Boston landmark.

89. Lewis Mumford, *Sticks & Stones* (1924; rpt. New York: Dover, 1955), 69.

90. After the Greater New York consolidation that occurred in 1898, Brooklyn was absorbed into New York City went from being a stand-alone city to the status of one of the five Boroughs of New York City. In 1890, Brooklyn followed New York, Chicago, and Philadelphia as most populous with a population of 806,343.

91. Anthony Sutcliffe, *Paris: An Architectural History* (New Haven: Yale University Press, 1993), 135.

92. Some sources cite Oswego, New York, as Singer's birthplace.

93. It was also under his administration that the adjacent Bourne Building, also by Ernest Flagg, was completed in 1899. This fourteen-story structure (demolished 1968) was constructed due to the company's tremendous growth and multinational business standing.

94. Certainly, before designing the Singer Building, Ernest Flagg must have been aware of the modern appearances of these noted contemporary skyscrapers: Wainwright, St. Louis (Louis Sullivan and Charles K. Ramsey, 1892); Guaranty, Buffalo (Louis Sullivan, 1896); Rockefeller Building, Cleveland (Knox and Elliott, 1903); Chicago Building, Chicago (Holabird & Roche, 1904).

95. For a more detailed account of the Singer Building and its construction, see Joseph J. Korom, Jr., *The American Skyscraper, 1850–1940: A Celebration of Height* (Boston: Branden Books, 2008), 273–276.

Chapter Five

1. Walt Whitman, "Passage to India," in *Leaves of Grass*, (Philadelphia: David McKay, 1900).

2. Frank E. Wallis, *How to Know Architecture* (New York: Harper & Brothers, 1910), 297.

3. Henry Bett, *English Myths and Legends* (New York: Dorset Press, 1991), 10.

4. Ibid.

5. Shakespeare, *Macbeth*.

6. Miranda Bruce-Mitford, *The Illustrated Book of Signs & Symbols* (New York: DK, 1996), 78.

7. Theodore C. Williams, "The Tower in Madison Square," reprinted from *The Century*, Vol. 47, Issue 1, Nov. 1893, p.159.

8. "The Mortimer Building: A Notable Addition to the Business Structures on Wall-Street," *The New York Times*, 15 February 1885.

9. "Mortimer Building Future," *The New York Times*, 15 December 1918.

10. Mariana Griswold Van Rensselaer, *Henry Hobson Richardson and His Works* (1888; rpt. New York: Dover, 1969), 98. Italics added.

11. More precisely, the building stood 113 feet to the roof's base, and rose another 75 feet to the roof's ridge.

12. Henry Hobson Richardson died of kidney disease, at age forty-eight, on April 27, 1886.

13. "The New Chamber of Commerce Building, Cincinnati," *The New York Times*, 22 December 1888, 313, col. A. Italics added.

14. See, especially the painting, *Abbey Under Oak Trees* (1809–1819), by Caspar David Friedrich.

15. Larry Millett, *Lost Twin Cities* (St. Paul: Minnesota Historical Society Press, 1992), 223.

16. "The Owings building, at Dearborn and Adams streets, Chicago, valued at $350,000, changes ownership recently under curious circumstances," *The Idaho Avalanche*, 13 March 1896, col. D.

17. "Reality and Domes," *The Daily Inter Ocean* (Chicago), 27 May 1888, 18, col. A.

18. "What the Architect Says," *The Daily Inter Ocean* (Chicago), 18 February 1889, 331, col. E.

19. Frank A. Randall, *History of the Development of Building Construction in Chicago* (Urbana: The University of Illinois Press, 1949), 156.

20. Rapunzel was a figure in one of the German fairy tales collected and published in 1812 by the Brothers Grimm.

21. In place of the Betz Building, the Lincoln-Liberty (now Philadelphia National Bank) Building was constructed. Designed by John Torrey Windrim, this tower stands 28 floors, 472 feet tall.

22. "An Ornament to the Street," *The Daily Inter Ocean* (Chicago), 2 Sept. 1892, 3, col. E.

23. Ibid.

24. "The Pride of the West Side," *Chicago Daily Tribune*, 15 Oct. 1890, 1.

25. Harriet Monroe, *John Wellborn Root: A Study of His Life and Work* (Park Forest, IL: The Prairie School Press, 1896), 148.

26. "A great deal of sentiment...," *The Indiana State Journal* (Indianapolis), 23 November 1898, 4, col. D.

27. In Gothic church architecture, a "fleche" was a type of spiky steeple often found surmounted atop the crossing of the nave and transepts. Architect Root's original drawings depict this rooftop spire centered atop the Woman's Temple.

28. The grouping of medieval-like buildings became a small city unto itself, not unlike the mountain-top walled villages of Germany's tenth century. The North Building (eleven floors, 268 feet), and the Northwest Building (ten floors, 120 feet) were completed in quick succession. In 1901, the final tower, the West Building (eleven floors, 145 feet) was added and completed the ensemble. All were designed by George B. Post. See Joseph J. Korom, Jr., *The American Skyscraper, 1850–1940: A Celebration of Height* (Boston: Branden Books, 2008), 140–141.

29. Frederick Clifton Pierce, *Field Genealogy* (Chicago: Hammond Press, 1901), 300.

30. "News Miscellany," *The Daily Inter Ocean* (Chicago), 25 December 1892, 19, col. D.

31. "Eighteen Stories High," *The Daily Inter Ocean* (Chicago), 7 May 1895, 5, col. E. The George A. Fuller Company would erect its own headquarters skyscraper, the Fuller Building, later known as the "Flatiron Building" in New York, in 1902.

32. Ibid.

33. Rouen Cathedral, whose tallest spire reached 495 high, ranked it the tallest building in the world for a short time. Rouen was also *twice* the height of the Fisher at 235 feet.

34. Foreman, Ford & Company of Chicago supplied and installed all the Fisher Building's windows. The glass contract amounted to over $30,000, a princely sum for the year 1895. "Large Contract Signed," *The Penny Press*, 31 October 1895, col. G.

35. Carl W. Condit, *The Chicago School of Architecture* (Chicago: University of Chicago Press, 1964), 113.

36. The Manual of Statistics Company, *The Manual of Statistics* (New York, 1912), 789.

37. National Park Service, *Samuel M. Nickerson House* (Arlington: Historic American Buildings Survey, n.d.) HABS No. Ill-1052, 4.

38. Ibid.

39. Harry S. Black, president of the George A. Fuller Construction Company (the builder, financier, and owner of the Flatiron Building), also helped to form the United States Realty and Improvement Company.

Chapter Six

1. John Ruskin. *Lectures on Architecture and Painting* (New York: John Wiley & Sons, 1891), Lectures I and 2 (addenda), 94.

2. For curious and unknown reasons, "Pukwudgie" is a capitalized word; demons, pixies, goblins, gnomes, etc., are not normally capitalized.

3. The statues or busts of Fuller (Flatiron Building), Pabst, Singer, or Pulitzer did not appear on their namesake skyscrapers. Christopher Columbus did appear on Chicago's Columbus Memorial Building, and William Penn did appear on the Philadelphia City Hall.

4. As their numbers tragically dwindled, the United States government authorized the production of the "buffalo nickel," a coin that was produced from 1913 until 1938, well after the Gilded Age.

5. Susan Tunick, *Terra-Cotta Skyline: New York's Architectural Ornament* (New York: Princeton Architectural Press, 1997), 85.

6. W. Somerset Maugham, *Cakes and Ale*, ch. 2, 1930.

7. "An Insurance Palace: The New Building of the New York Mutual Life Insurance Company to Be Erected at the Corner of Milk...," *Boston Daily Advertiser*, 30 January 1874, col. B.

8. Cutler invented the office building mail chute, a system whereby tenants on upper floors of a skyscraper could insert a letter into a slotted chute allowing for the mail to gather inside a decorative receptacle on the first floor. Cutler patented his invention, and he then founded the Cutler Mail Chute Company. The ubiquitous, lobby-located mailbox was key to his substantial wealth. The Elwood Building was the first skyscraper to employ his device.

9. George W. Howard, *The Monumental City, Its Past History and Present Resources* (Baltimore: J.D. Ehlers & Co., Engravers and Steam Book Printers, 1878), 847–848.

10. During a 1921 remodeling of the Washington Building, much of its exterior ornamentation was removed, including the lighthouse tower.

11. Montgomery Schuyler, "Architectural Aberrations," *Architectural Record*, Oct.–Dec. 1893, 207–210.

12. George Abishai Woodward, *Philadelphia and its Environs: A Guide to the City and its Surroundings* (Philadelphia: J. B. Lippincott, 1898), 39.

13. "The Masonic Temple Will Be the Largest Building on Earth," *The Los Angeles Times*, 7 December 1890, 6, col. C.

14. "An Architectural Marvel: The New Masonic Temple at Chicago," *The Daily Picayune* (New Orleans) 10 November 1890, 4, col. F.

15. "Chicago's Masonic Temple: Its Copestone to Be Laid With Imposing Ceremonies on Friday," *The Milwaukee Sentinel*, 5 November 1891, col. G.

16. "An Architectural Marvel," 4.

17. "Largest Building on Earth," 6.

18. "The New Pabst Block," *The Milwaukee Sentinel*, 1 March 1891, col. D.

19. Ibid.

20. "A Tall Tract Building: The Twenty Story Structure Being Erected by the American Tract Society," *Bismarck Daily Tribune* (Bismarck, ND) 7 June 1894, col. A.

21. Ibid.

22. The entrance echoed the design of a Roman temple complete with Ionic columns, fret and egg-and-dart enrichment, dentil courses, foliate-carved panels based upon Roman designs, and two suggestively-dressed figures reclining above the doorway.

Bibliography

"Abraham Gottlieb Dead: The Builder of The Masonic Temple in Chicago." *The Milwaukee Sentinel*, 10 February 1894.

"Aluminum Plating." *The Vermont Watchman* (Montpelier) 14 June 1893.

Anness Publishing Limited. *Dragons: An Anthology of Verse and Prose*, New York: Smithmark, 1996.

"An Architectural Marvel." *The Daily Picayune* (New Orleans) 10 November 1890.

"The Attempt to Kill Sage." *Bismarck Daily Tribune* (Bismarck, ND) 10 December 1891: col. E.

Ayer, Dr. J.C. *Ayer's American Almanac 1874*. Lowell, MA: Dr. J. C. Ayer & Company.

_____. *Ayer's American Almanac 1879*. Lowell, Massachusetts: Ayer, Dr. J. C. Ayer & Company.

Bacon, Edwin M. *Boston Illustrated*. Boston: Houghton, Mifflin, 1886.

Bacon, Mardges. *Ernest Flagg: Beaux-Arts Architect and Urban Reformer*. New York: The Architectural History Foundation/The MIT Press, 1986.

"The Best Ten Buildings in the United States." *Bangor Daily Whig & Courier*, 27 June 1885.

Bett, Henry. *English Myths and Legends*. New York: Dorset Press, 1991.

Birkmier, William H. *The Planning and Construction of High Office-Buildings*. New York: John Wiley & Sons, 1898

Boyer, M. Christine. *Manhattan Manners: Architecture and Style, 1850–1900*. New York: Rizzoli International, 1985.

Bragdon, Claude. "Architecture in the United States III: The Skyscraper." *The Architectural Record*, Vol. XXVI, No. 2, August 1909.

Broadbent, Geoffrey. "Neo-Classicism." *Architectural Design*, Vol. 49, No. 8–9.

"Brooklyn's Exciting Night." *New York Times*, 9 November 1898.

The Brothers Grimm. *Hours in Fairy Land*. New York: McLoughlin Brothers, 1883.

Bruce-Mitford, Miranda. *The Illustrated Book of Signs & Symbols*. New York: DK, 1996

Bullfinch, Thomas. *The Age of Fable*. Philadelphia: Courage Books, 1990.

Campbell, Joseph, and Bill Moyers. *The Power of Myth*. New York: Anchor Books, 1988.

Carr-Gomm, Sarah. *The Dictionary of Symbols in Western Art*. New York: Facts on File, 1995.

Cashman, Dennis. *America in the Gilded Age*. New York: New York University Press, 1984.

"Chicago Real Estate: Some Fine Improvements." *The Daily Inter Ocean* (Chicago), 24 November 1895.

"Chicago's Masonic Temple: Its Copestone to be Laid With Imposing Ceremonies on Friday." *The Milwaukee Sentinel*, 5 November 1891.

"City Hall Bell and its Rivals." *The Milwaukee Sentinel*, 20 September 1896.

"The City Hall Plans: Proposed Competition From an Architect's Point of View." *The Milwaukee Sentinel*, 8 November 1891.

"Clocks with Nerves: Refuse to Do Reliable Work When Placed in High Buildings." *Rocky Mountain News* (Denver), 31 January 1897.

Clubbe, John *Cincinnati Observed Architecture and History*. Columbus: Ohio State University Press, 1992.

"Completed At Last: Finishing Touches Being Put On Milwaukee's Municipal Palace, Million Dollar City Hall." *The Milwaukee Journal*, 23 November 1895.

Condit, Carl W. *The Chicago School of Architecture*. Chicago: University of Chicago Press, 1964.

"A Crowd of Rich Men." *The Atchison Daily Globe* (Atchison, KS), 1 January 1892.

Day, Joseph P., ed. *Practical Real Estate Methods for Broker, Operator & Owner*. New York: Doubleday, Page, 1909.

Diamonstein, Barbaralee. *The Landmarks of New York II* New York: Harry N. Abrams, 1993.

Dolge, Alfred. *Pianos and Their Makers* Covina, CA: Covina Publishing Company, 1911.

Doyle, John H. *A Story of Early Toledo*. Bowling Green, OH): C. S. Van Tassel, 1919.

"Eighteen Stories High." *The Daily Inter Ocean* (Chicago), 7 May 1895.

Frank Leslie's Illustrated Newspaper, New York, 24 October 1891.

"From the Book Table." *The Milwaukee Sentinel*, 23 August 1897.

"A Giant Building: New York to Have Highest Office Structure." *New York Times,* 27 April 1906.

Giedion, Sigfried. *Space, Time and Architecture*. 1941; rpt. Cambridge: Harvard University Press, 1982.

Goldberger, Paul. *The Skyscraper*. New York: Alfred A. Knopf, 1991.

"Gotham Gossip." *The Milwaukee Journal*, 4 December 1895.

"Gotham Gossip: Rise of the World under the Direction of Joseph Pulitzer…." *The Daily Picayune* (New Orleans), 8 December 1890.

"A great deal of sentiment…." *The Indiana State Journal* (Indianapolis), 23 November 1898.

Griswold Van Rensselaer, Mariana. *Henry Hobson Richardson and His Works*. 1888; rpt. New York: Dover, 1969.

Harris, Cyril M. *Illustrated Dictionary of Historic Architecture*. 1977; rpt. New York: Dover, 1977.

Hayward, Mary Ellen, and Frank R. Shivers, Jr. *The Architecture of Baltimore: An Illustrated History*. Baltimore: Johns Hopkins University Press, 2004.

"Highest in the World: The New Home of the Manhattan Insurance Company." *The Milwaukee Journal*, 21 September 1893.

"The Highest Tower." *The Milwaukee Sentinel*, 16 October 1894.

Howard, George W. *The Monumental City, Its Past History and Present Resources*. Baltimore: J.D. Ehlers & Co., Engravers, and Steam Book Printers, 1878.

"A Huge Tower Clock: Fourth Largest One in the World for the City Hall." *The Milwaukee Journal*, 11 August 1895.

"Hungarian-American Bank." *New York Times*, 5 December 1911.

Huxtable, Ada Louise. *Kicked a Building Lately?* New York: Quadrangle Books/The New York Times Book Company, 1976.

_____. *The Tall Building Artistically Reconsidered: The Search for a Skyscraper Style*. New York: Pantheon Books, 1982.

Ingram, J. S. *The Centennial Exposition*. Philadelphia: Hubbard Brothers, 1876.

"An Insurance Palace: The New Building of the New York Mutual Life Insurance Company to be Erected at the Corner of Milk and…." *Boston Daily Advertiser*, 30 January 1874.

International Correspondence Schools. *A Textbook on Architectural Drawing*. Scranton: International Textbook Company, 1897.

Ives, Halsey C. *The Dream City: A Portfolio of Photographic Views of the World's Columbian Exposition*. St. Louis: N. D. Thompson, 1893.

Jackson, Kenneth J., ed. *The Encyclopedia of New York City*. New Haven: Yale University Press, 1995.

Jenkins, Elizabeth. *The Mystery of King Arthur*. New York: Coward, McCann Geoghegan, 1975.

Jones, Owen. *The Grammar of Ornament*. 1856; rpt. London: Doring Kindersley Limited, 2001.

Kay, Jane Holtz. *Lost Boston*. Boston: Houghton Mifflin, 1980.

Keister, Douglas. *Stories in Stone: A Field Guide to Cemetery Symbolism and Iconography*. New York: MJF Books/Gibbs Smith, 2004.

Killits, John M. ed. *Toledo and Lucas County, Ohio, 1623–1923*. 3 vols. Chicago and Toledo: S. J. Clarke, 1923.

Koeper, Frederick. *American Architecture*. 2 vols. Cambridge: MIT Press, 1987.

Korom, Joseph J., Jr. *The American Skyscraper, 1850–1940: A Celebration of Height*. Boston: Branden Books, 2008.

Landau, Sarah Bradford, and Carl W. Condit. *Rise of the New York Skyscraper 1865–1913*. New Haven: Yale University Press, 1996.

"Large Contract Signed." *The Penny Press*, 31 October 1895.

The Manual of Statistics Company. *The Manual of Statistics Stock Exchange Handbook*. New York: The Manual of Statistics Company, 1912.

"Masonic: The Chicago Masonic Temple Will Be the Largest Building on Earth," *The Los Angeles Times*, 7 December 1890.

Mayer, Harold M., and Richard C. Wade. *Chicago: Growth of a Metropolis*. Chicago: University of Chicago Press, 1969.

McCue, George, and Frank Peters. *A Guide to the Architecture of St. Louis*. Columbia: St. Louis Chapter, American Institute of Architects, University of Missouri Press, 1989.

"Men Who Built the City Hall." *The Milwaukee Sentinel*, 16 October 1895.

Millett, Larry. *Lost Twin Cities*. St. Paul: Minnesota Historical Society Press, 1992.

Minne-Seve, Viviane, and Herve Kergall. *Romanesque and Gothic France: Architecture and Sculpture*. New York: Harry N. Abrams, 2000.

Monroe, Harriet. *John Wellborn Root: A Study of His Life and Work*. 1896; rpt. Park Forest, IL: The Prairie School Press, 1966.

"The Mortimer Building." *The New York Times*, 15 February 1885.

"Mortimer Building Future." *The New York Times*, 15 December 1918.

"Most Wonderful Sky-scraper Ever Built." *Weekly Rocky Mountain News* (Denver) 2 February 1899.

Mumford, Lewis. *The Brown Decades: A Study of the Arts in America, 1865–1895*. 1931; rpt. New York: Dover, 1971.

_____. *Sticks & Stones*. 1924; rpt. New York: Dover, 1955.

Murray, Alexander S. *Who's Who in Myth and Legend*. London: CRW, 2004.

National Park Service. *Samuel M. Nickerson House*. Arlington: Historic American Buildings Survey, HABS No. Ill-1052, n.d.

"The New Atlantic Cable." *Daily Evening Bulletin* (San Francisco), 15 February 1884.

"New Building of the Eagle." *New York Times*, 20 November 1902.

"The New City Hall." *The Milwaukee Sentinel*, 17 October 1895.

"The New City Hall." *The North American* (Philadelphia), 2 August 1882.

"The New Pabst Block." *The Milwaukee Sentinel*, 1 March 1891.

"New York Life Building: Broadway, Leonard and Elm Streets." *The Evening Post* (New York) 27 February 1897.

"The New York Public Library, U.S., Local History & Genealogy Division." Letter to author. 7 February 1996.

"The New York World yesterday…." *The Daily Inter Ocean* (Chicago), 11 December 1890.

"News Miscellany." *The Daily Inter Ocean* (Chicago), 25 December 1892.

"News Observations." *The News and Observer* (Raleigh, NC), 14 May 1887.

"Newspaper Removal." *The News and Observer* (Raleigh, NC), 27 November 1890.

"An Ornament to the Street." *The Daily Inter Ocean* (Chicago), 2 September 1892.

"The Owings building, at Dearborn and Adams streets, Chicago, valued at $350,000, changed ownership recently under curious circumstances." *The Idaho Avalanche*, 13 March 1896.

"People and Events." *The Daily Inter Ocean* 5 May 1895: 6.

Peterson, Jaffray. *Sixty-Five Years of Progress and A Record of New York City Banks*, New York: Arno Press, 1980.

"Philadelphia's City Hall Tower." *The Daily Inter Ocean* (Chicago), 10 August 1896: .

"Philadelphia's Fine Building." *The Milwaukee Sentinel*, 18 May 1887.

"The Piano Manufacture." *Frank Leslie's Illustrated Newspaper*, 23 April 1887.

Philip, Neil. *Myths & Legends Explained*. London: Dorling Kindersley Limited, 2007.

Pierce, Frederick Clifton. *Field Genealogy*. Chicago: Hammond Press, 1901.

"The Pride of the West Side." *Chicago Daily Tribune*, 15 October 1890.

"Pulitzer's Building: An Entertainment for Thousands of Guests Prepared." *Daily Evening Bulletin* (San Francisco), 10 December 1890.

Quad, M. "New York's Six O'clock." *Bismarck Daily Tribune* (Bismarck, ND) 24 June 1891.

Radding, Charles M., and William W. Clark. *Medieval Architecture, Medieval Learning*. New Haven: Yale University Press, 1992.

Rand, Ayn. *The Fountainhead*. 1943; rpt. New York: New American Library, 1971.

Randall, Frank A. *History of the Development of Building Construction in Chicago*. Urbana: University of Illinois Press, 1949.

Read, Herbert. *A Concise History of Modern Painting*. New York: Frederick A. Praeger, 1959.

"Real Estate Notes." *Chicago Daily Tribune*, 9 Oct. 1892.

"Reality and Domes." *The Daily Inter Ocean* (Chicago), 27 May 1888.

"Record Price for Manhattan Land." *Real Estate Record*, 18 December 1909.

Rhind, J. Massey. "Proposed Treatment of Figures to be Placed on the American Surety Company's Building, Corner Broadway and Pine Street, New York City." *The American Architect and Building News*, 25 May 1895.

"Richard Croker's Luxurious Offices." *The Milwaukee Journal*, 19 April 1899: 6, col. E.

Robertson, R. H. "The Tallest Building in the World." *The Denver Evening Post*, 28 May 1899.

Ruskin, John. *Lectures on Architecture and Painting*. New York: John Wiley & Sons, 1891.

_____. *Little Masterpieces*. Ed. Bliss Perry. Doubleday & McClure Co., 1901.

_____. *The Seven Lamps of Architecture*. Boston: Dana Estes, 1849.

"St. Paul Building." *The Evening Post* (New York), 27 February 1897.

Schultz, Earle, and Walter Simmons, *Offices In the Sky*. Indianapolis: Bobbs-Merrill, 1959.

Schuyler, Montgomery. "Architectural Aberrations." *Architectural Record*, Vol. 9, October–December 1893.

_____. "The Evolution of a Skyscraper." *Architectural Record*, Vol. XIV, No. 5, November 1903.

_____. "The Skyline of New York, 1881–1897." *Harper's Weekly*, March 1899.

_____. "The Works of Francis H. Kimball and Kimball & Thompson." *The Architectural Record*, Vol. VII, No. 4, April–June 1898.

"Science of Weather." *Morning Oregonian* (Portland), 5 July 1896.

Scribner, Harvey, ed. *Memoirs of Lucas County and the City of Toledo*. 3 vols. Madison, WI: Western Historical Association, 1910.

Shand-Tucci, Douglas. *Built in Boston*. Boston: New York Graphic Society, 1978.

"Skyscraper Going; Higher One Coming." *New York Times*, 30 April 1910.

Smith, Adam. *The Wealth of Nations*. 1776; reprint. London: J.M. Dent and Sons, The Aldine Press, 1957.

Smithsonian Institution Research Information System (SIRIS). *Sohmer & Co. Records, 1872–1889*. Washington, D.C., 2009.

Souchal, Francois. *Art of the Early Middle Ages*. New York: Harry N. Abrams, 1968.

Speltz, Alexander. *Styles of Ornament: A Pictorial Survey of Six Thousand Years of Ornamental Design*. New York: Gramercy Books, 1994.

Stern, Robert A. M., Thomas Mellins, and David Fishman. *New York 1880: Architecture and Urbanism in the Gilded Age*. New York: The Monacelli Press, 1999.

"The Success of the New York World...." *Yenowine's News*, 2 February 1890.

"A Sugar King's Skyscraper: Claus Spreckels Building a Big Home for the San Francisco Call." *The North American*, 4 September 1895.

Sullivan, Louis H. *The Autobiography of an Idea.* 1924; rpt. New York: Dover, 1956.

_____. *Kindergarten Chats and Other Writings.* 1918; rpt. New York: Dover Publications, Inc., 1979.

Sutcliffe, Anthony. *Paris: An Architectural History.* New Haven: Yale University Press, 1993.

"The Tallest Modern Office Building in the World." *The Milwaukee Sentinel*, 1 January 1899.

Tallmadge, Thomas Eddy. *Architecture in Old Chicago.* Chicago: University of Chicago Press, 1941.

Tauranac, John, and Christopher Little. *Elegant New York: The Builders and the Buildings, 1885–1915.* New York: Abbeville Press/Cross River Press, Ltd., 1985.

Thorndike, Joseph J., Jr., ed. *Three Centuries of Notable American Architects.* New York: American Heritage, 1981.

Toman, Rolf. *Romanesque Architecture Sculpture Painting.* Köhn: Konemann, 2004.

"The tower of the Philadelphia City Hall...." *Boston Investigator*, 24 September 1890.

Tunick, Susan. *Terra-Cotta Skyline: New York's Architectural Ornament.* New York: Princeton Architectural Press, 1997.

Twombly, Robert. *Louis Sullivan His Life and Work.* New York: Viking, 1986.

Venturi, Robert, Denise Scott Brown, and Steven Izenour. *Learning From Las Vegas.* Cambridge: MIT Press, 1972.

Vitruvius. *The Ten Books on Architecture.* Trans. Morris Hicky Morgan. New York: Dover, 1960.

Waggoner, Clark, ed. *History of the City of Toledo and Lucas County Ohio.* New York and Toledo: Munsell, 1888.

Wallis, Frank E. *How to Know Architecture.* New York: Harper & Brothers, 1910.

"A week, unusually full of disasters...." *The Congregationalist* (Boston) 10 December 1891.

Weinreb, Matthew, and Fiona Biddulph. *Metropolitain: A Portrait of Paris.* London: Phaidon Press Limited, 1994.

Western Union Telegraph Company. "Western Union Telegraph Building." *The Aldine*, Jan. 1875.

"What the Architect Says." *The Daily Inter Ocean* (Chicago), 18 February 1889.

Whiffen, Marcus, and Frederick Koeper. *American Architecture*, 2 vols. Cambridge: MIT Press, 1981.

Williams, Theodore C. "The Tower in Madison Square." In *The Century.* New York: The Century Magazine, Vol. 47, issue 1, Nov. 1893, p.159.

Williams Publishing Company. *Notable Men of Wisconsin.* Milwaukee: Williams Publishing Company, 1902.

Withey, Henry F., and Elsie Rathburn Withey. *Biographical Dictionary of American Architects (Deceased).* Los Angeles: New Age, 1956.

Wolner, Edward W. *Henry Ives Cobbs' Chicago: Architecture, Institutions, and the Making of a Modern Metropolis.* Chicago: University of Chicago Press, 2011.

Woodward, George Abishai. *Philadelphia and its Environs: A Guide to the City and Surroundings.* Philadelphia: J. B. Lippincott, 1898.

"The Work of George Edward Harding & Gooch." *The Architectural Record*, Vol. VII, No. 1, July–September 1897.

"The World of Art." *The Daily Inter Ocean* (Chicago), 4 August 1895.

Wright, Frank Lloyd. *Frank Lloyd Wright: An Autobiography.* Petaluma, CA: Pomegranate, 2005.

Yarwood, Doreen. *The Architecture of Europe.* New York: Hastings House, 1974.

Index